Imagining the popular in contemporary French culture

Edited by
DIANA HOLMES
and DAVID LOOSELEY

Manchester University Press
Manchester and New York
distributed in the United States exclusively by Palgrave Macmillan

Published by Manchester University Press
Oxford Road, Manchester M13 9NR, UK
and Room 400, 175 Fifth Avenue, New York, NY 10010, USA
www.manchesteruniversitypress.co.uk

Distributed in the United States exclusively by
Palgrave Macmillan, 175 Fifth Avenue, New York,
NY 10010, USA

Distributed in Canada exclusively by
UBC Press, University of British Columbia, 2029 West Mall,
Vancouver, BC, Canada V6T 1Z2

British Library Cataloguing-in-Publication Data
A catalogue record for this book is available from the British Library

Library of Congress Cataloging-in-Publication Data applied for

ISBN 978 07190 7816 3 *hardback*

First published 2013

Typeset in Minion by
Koinonia, Manchester
Printed in Great Britain by
The MPG Books Group, Bodmin

Imagining the popular
in contemporary French culture

Manchester University Press

Introduction
Imagining the popular: lowbrow, highbrow, middlebrow

Diana Holmes and David Looseley

Our aim in this book is to explore how the French in the twentieth and twenty-first centuries have come to imagine the popular in particular and distinctive ways: how popular-cultural texts or forms have, variously, been produced and received, theorised and judged. We are interested, then, in both discourse and practice in contemporary French popular culture.

This ambition is not quite as straightforward as it might seem. First, 'discourse' and 'practice' cannot always be neatly distinguished. Certainly, by discourse – or, more accurately, discourses – we partly mean what Morag Shiach (1989: 1) in her analysis of British popular-cultural discourse defines as 'distinctive ways of talking about the cultural role and significance of the people' – ways which can be found in essays, the media, public debates, and so on. But 'ways of talking' about the popular can also be embedded in popular-cultural texts and practices themselves, whether explicitly or in the form of pervasive but untheorised assumptions about popular aesthetics. We are therefore interested in discourses both 'on' and 'of' popular culture.

Second, just as historians of Europe are forced to speak, for example, of the 'long 1960s', we have become more sharply aware in editing this book that the 'contemporary' is longer than one might think. The question we have encountered is not simply how far the cultural past has shaped the present, but how far twenty-first-century culture, characterised by the digitally reproduced, the portable, the dematerialised and the consumer-driven, leads us to understand differently the cultural history of the popular going back into the nineteenth century. We propose therefore to both explore the present and revisit the past as a single endeavour.

More slippery still, of course, is our actual object of study, for 'popular culture' is an amorphous, polysemic category. The complexity of Shiach's word 'cultural' scarcely requires comment and 'the people' is no less

problematic. But such problems are aggravated when one is working with English and French terminologies simultaneously. When, for example, the French ethnologist Denys Cuche (2004: 69) comments, just as we have commented, that 'from the start, the notion of popular culture suffers from a semantic ambiguity, given the polysemic nature of each of the two terms it contains,'[1] can we be entirely sure that the semantic ambiguity is the same in both languages and cultures, even though French naming practices in this area are clearly changing under the influence of English? This is the shifting, liminal territory that forms the context of our book.

Traditionally, *populaire* has referred to the poorly educated peasantry or proletariat, as in the expression *les classes populaires. La culture populaire* thus denotes the artefacts, representations, beliefs and practices of these social groups. Although this sense is weakening with globalisation, it has remained operative in France for much longer than in the anglophone world, where 'popular culture' in everyday usage (in the media, for example) has subsumed this 'folk' sense and today designates the texts, products and practices of the majority and, thence, the entertainments that have the majority as their target audience. This contemporary English sense embraces the commercially mediated artefacts made instantly available by mass industrialised forms of production and new technologies: pop music, television, romantic fiction, social networking and so on.[2] In French, on the other hand, such products and practices have conventionally, and pejoratively, been designated *la culture de masse* – an eloquent difference nicely illustrated in Rioux and Sirinelli (2002: 30), when one contributor to their edited volume, who is tracing the impact of Americanisation in France, feels compelled to explain to his francophone readership that 'popular' in American English does not mean 'issuing from the people but popular in terms of the extent of its dissemination', whereas the English term folk culture is closer to 'what in French is called *populaire*'.[3]

This said, as Shiach discovered in the British context, the different categories of 'folk', 'mass' and 'popular' can often describe much the same cultural phenomena, or at the very least overlap. Shiach therefore adopts (1989: 1) a broad definition of popular culture which we too will adopt, at least as our starting point: 'cultural texts and practices outside the sphere of the dominant culture', i.e. those which have been 'marginalized, repressed or ignored' (1989: 5) by that culture. As this suggests, the notion of popular culture is essentially ideological and ethical in that it is bound up with cultural democracy, an issue which runs through our book.

Beyond this, it is more productive in our view to approach the popular as an unstable discursive construct within which there is nevertheless a loose coherence. As John Storey argues (2003: xii), again in the anglophone context, 'although the term popular culture can be articulated to carry a range of different meanings, what all of these have in common is the idea of *popularis* – belonging to the people. Therefore, each of the different ways in which popular culture is formulated carries with it a definition of "the people"'. Our objective, premised on the idea that these different formulations require equally diverse modes of analysis, is to sharpen incrementally, from chapter to chapter, our understanding of what popular culture signifies in contemporary France not only semantically but culturally – how it is practised, thought about and argued over – in the hope of devising a more precise critical language for discussing it.

This enterprise is important and timely. In English-speaking countries, the academic study of contemporary popular cultures has been commonplace for some time, in large part due to the development of Cultural Studies, a field that remains predominantly anglophone even today. Cultural Studies is, of course, as Willis observes (2000: xx), a '"non-disciplinary" discipline' and 'a field of at times intractable complexity'. But one relatively straightforward statement we can make about it is that it has significantly validated contemporary anglophone popular cultures as objects of academic enquiry. This has not, however, been the case with French popular culture, at least until quite recently. And even when it has, a recognisably or consciously 'Cultural-Studies' perspective has not generally been applied.[4]

Although various collective overviews of modern French culture in English cover popular texts and practices (for example, Forbes and Kelly 1995; Kidd and Reynolds 2000; Finch 2010), there are still remarkably few scholarly books in English devoted exclusively to them. Dauncey (2003) provides a useful introductory overview of contemporary popular forms (music, radio, television, and so on), primarily for student use. Further back, Horn (1991) undertook a similar endeavour, while Rigby (1991) devoted a seminal research monograph to the discourse of popular culture in France, from the *éducation populaire* movement of the late nineteenth century to major public intellectuals in the late twentieth, such as Certeau and Bourdieu, methodically tracing the semantic shift from folk to mass. But Rigby concentrated on discourse alone, not the actual texts of popular culture. Moreover, much has changed since the publication of his book, now out of print.

Doubtless one reason for this relative neglect is, precisely, the semantic complexity we have been discussing, coupled with the difficulty of mapping approaches associated with Cultural Studies on to French ways of thinking about popular culture. But it also has arguably to do with the nature of French Studies as a discipline in anglophone universities. Although it is now commonplace to speak of 'French Cultural Studies', especially in the UK,[5] the university subject variously called 'French' or 'French Studies' or 'French and Francophone Studies' still has a predominantly literary emphasis – 'literary' here meaning works of fiction or thought viewed by the academy as canonical or – to use a term more resonant for this book – high-cultural. Even when cinema became a recognised part of French Studies, a canon of films deemed worthy of attention soon developed, largely in response to the consecration of the New Wave: Truffaut, Godard, Rohmer and others. And even in those UK institutions where undergraduate syllabuses have shown greater openness by including, say, francophone popular music or television, research has not always kept pace.

A related explanation is that French Studies in English-speaking universities, and especially in paradigmatic institutions like Oxford and Cambridge, has tended to model itself on France's own canon-making traditions. For a long time, such scholarly concern with popular culture as there was in humanities disciplines in metropolitan France tended to focus on its historic, folk dimensions, with particular emphasis on the written word in the form of chap-books (*littérature de colportage*). In the social sciences, some French scholars, such as Poujol and Labourie (1979) or Grignon and Passeron (1989), did start researching specific sociological or ideological dimensions of French popular culture, though still largely within the broad parameters of its traditional French sense. It was only in 2002, with Rioux and Sirinelli's ground-breaking *La Culture de masse en France de la Belle Époque à aujourd'hui* (Mass culture in France from the Belle Époque to today) that a cultural history of the popular in the twentieth century in its broadly anglophone sense appeared, though still using the term 'mass culture', albeit without the pejorative bias it has conventionally carried.

A third reason is that French research on popular culture, in whatever sense, still tends to be carried out behind disciplinary partitions, chiefly history, sociology and anthropology. Cultural Studies has not taken off as a 'post-disciplinary' (Barker 2000: 5) methodology in the French academy as it has in other countries. The core texts that gave birth to Cultural Studies in Britain – Hoggart, Williams, Adorno and the

Frankfurt School, various American writings on the mass media – were not in fact translated into French until relatively late, if at all; and they made little impact other than as 'useful warnings that did not concern France' (Rioux and Sirinelli 2002: 265). Even in the early 2000s, with a new generation of scholars looking to engage with it, Mattelart and Neveu (2003: 6) still speak of 'a French provincialism which frowns at the mere mention of the mysterious term "Cultural Studies"'[6] and which, reprehensibly in their view, simply ignores it. When Cultural Studies has been addressed in France, it has often been negatively (even, up to a point, in Mattelart and Neveu's own case), or else somewhat eccentrically. One illustration of the latter phenomenon is the curious destiny of Richard Hoggart in France. While in anglophone Cultural Studies, Hoggart, as Rigby observes (1994), is sometimes seen (rightly or wrongly) as an old-fashioned Leavisite, in France he has been revered for his down-to-earth avoidance of the 'militant populism' that, for the French, makes Cultural Studies so problematic.

Yet the provincialism that Mattelart and Neveu criticise has not all been on one side. While the French academy's neglect of Cultural Studies no doubt did delay less negative engagements with mass popular culture until very recently, British, American and other anglophone Cultural Studies still tend to focus only on anglophone cultures, despite their supposedly global purview. If France shows up on the radar at all, it is as an apparently inexhaustible supplier of handy theoretical power-tools for interpreting anglophone cultures. But Cultural Studies scholars have usually taken little interest in the seismic sociocultural shifts in France which have helped produce those tools, most notably the emergence of 'mass culture'. Judging by some work in Cultural Studies, or at least the vulgarised versions of it that reach the media, one might think that the everyday cultural experience of the French is dominated by the high theory of celebrity intellectuals immovably installed in Left Bank cafés and absent-mindedly puffing on Gauloises. Hence the ironic franglais expression '*la French theory*'. Indeed, another of Neveu and Mattelart's well aimed criticisms is precisely Cultural Studies' caricatural theoreticism, as purveyed in journals like *Theory, Culture and Society*. Today, they maintain, it is perfectly possible to write a substantial study of shopping, for example, that contains virtually no empirical data:

> This cavalier attitude to the empirical is often combined with an ostentatious claim to elevation and depth which takes the form of piling up intimidating references as a badge of high intellectuality. The very notion of 'French Theory', that epistemological monstrosity, is highly symbolic.

The term invites us to treat the best known and most esteemed authors of French intellectual life (Bourdieu, Derrida, Foucault, Ricœur) as a coherent group. This kind of academic spiritualism is rarely matched by an ability to situate such works in the scientific context and social logic from which they emerged, or by any great concern with the theoretical incompatibilities that exist between such writers, who in some cases have nothing in common but a French passport. (Neveu and Mattelart 2003: 88)[7]

In an increasingly transcultural, transnational age, such ethnocentric caricatures have to be challenged, purely on intellectual grounds.

Yet focusing on texts and practices from a non-anglophone culture, engaging with but unconstrained by the perspectives of Cultural Studies, also has practical benefits. It allows us to start afresh and to ask different questions, questions which have implications that extend at least across the 'West' or advanced capitalist societies and which can illuminate the study of contemporary cultures more generally. What makes France in particular so exemplary in this regard is that it has been a laboratory in which late-modern engagements with the established modernist categories of high and low can be observed *in vivo*. Its approach to the 'popular' is at once typical and highly distinctive. It has struggled to go with the postmodern flow but without letting itself be washed away by it, to accommodate to the profound cultural changes that have overtaken the West while endeavouring not to let them undermine its commitment to a national culture and, from 1789, a lay republicanism. From the medieval period when the idea of 'France' began to be a reality, French culture has become in Alison Finch's words (2010: 3) 'much more thoroughly permeated than Anglophone by a common literary and intellectual history, one that is viewed with pride'.

Because of a greater degree of state voluntarism in articulating and imposing a unified national identity, and a correspondingly greater emphasis on 'high' culture as the marker of a Frenchness associated with rationalism, intellectualism and good taste in the seventeenth and eighteenth centuries, the new forms of industrialised popular culture generated in the nineteenth and twentieth, with their commercial origins and their association in many cases with bodily and primal rather than cerebral pleasures, were long viewed with suspicion in France. The result has been that the Adornian view of popular culture as a debased and debasing mass culture has had more purchase there than in the UK or USA, especially at establishment level (Chapter 1). Indeed, one dominant representation of France is that it has always despised mass culture. A different, though connected, representation has France embracing lowbrow culture yet

somehow never quite getting it right, throwing out quality, experiment and nuance with the bathwater of tradition. French television (Chapter 5) is usually the classic instance here, or perhaps France's early pop music (Chapter 2).

However, it could and will be argued that an intriguing and distinctive third way between these two extremes has developed, in the form of a middlebrow sensibility – or what a Bourdieusian perspective might call a legitimated popular culture. *Chanson*, cinema (Chapter 4), crime fiction (Chapter 3), and to an extent colloquial language (Chapter 6) are all 'popular' practices which nonetheless enjoy a certain legitimacy and prestige, having become instances of what we might describe as the 'high popular'. Perhaps, then, as Rioux and Sirinelli suggest (2002: 24), the study of mass culture 'has become essential for a proper understanding of contemporary societies but also, more broadly, of the societies of the twentieth century as a whole; all the more so as it has been during the century as a whole that discourses on – and, most frequently, against – that culture have blossomed'.[8] This possibility will inform our book historically and conceptually, as we explore what specific forms the experience of mass culture has taken in France.

Our conception of the book – indeed the book project itself – also derives from the Popular Cultures Research Network (PCRN), of which all five contributors are members. The apparent anglocentrism of Cultural Studies mostly comes down to a simple lack of linguistic competence, especially in the UK as a result of a succession of benighted government policies for Modern Languages. The PCRN was founded in 2005 by a small group of French Studies academics at the University of Leeds (UK)[9] to serve as a mediator in this respect. Our aim was to establish a broad, international and interdisciplinary research community stretching far beyond French Studies and modern languages to embrace the humanities more generally, the social sciences and, naturally, Cultural Studies. The plural 'popular cultures' was chosen to underline the network's roots in modern-languages disciplines and the need for dialogue with other disciplines. Research in modern languages often 'locates' cultural phenomena in various ways, focusing particularly on relationships with places and spaces in the form of nations, regions, localities and other communities with specific linguistic and cultural histories. The PCRN, then, neither privileges the anglophone world and globalisation, nor simply ignores them. On the contrary, anglophone cultures figure strongly among the 'located' cultures the network is interested in, but in a creative and unassimilated exchange with other located cultures that anglophone

Cultural Studies has neglected. This allows us to bring together diverse cultural contexts, histories and imaginaries in the form of dynamic inter-disciplinary encounters.

This dialogic element also means not simply importing uncritically the standard theoretical approaches of Cultural Studies but asking whether, for differently located cultures, different approaches need to be adopted. Cultural Studies in the last thirty years has been characterised by its concern with relations between culture and power and, following Bour-dieu, with the ways in which the categories of high and low consolidate social difference and render it 'natural'. Valuable and seminal though much of this work has been, it has broadly speaking emerged from social-science perspectives which have shifted attention away from text. Indeed, in anglophone Cultural Studies, textual analysis is often seen as old-fash-ioned, or as problematic insofar as it can lead to a hermetic 'textualism' which ignores the objective conditions of the social world. Our aim is to redeploy humanities perspectives in order to help bridge these extremes of textualism and sociologism, by combining textual study of various kinds with the study of historical, national, socio-political or discursive contexts, as appropriate.

For the French Studies wing of the PCRN, the more specific ambition has been to unpick the web of meanings and applications of the terms *culture populaire* and *culture de masse* and identify the discursive specific-ities that underpin them. Our contention is that the development of mass popular culture in France has produced a paradigm shift, one which helps explain the burgeoning of cultural theory since the 1950s. In an intellec-tual environment traditionally fixated on high culture, especially litera-ture, as a vector of national identity, the growing popularity of lowbrow and middlebrow forms and practices, and especially the impact of the audio-visual, has destabilised entrenched cultural norms and stimulated the growth of multiple, self-reflexive, conflictual discourses about culture. Our aim is to dissect this paradigm shift via six discursive formations which will serve as case studies: politics, music, fiction, film, television, and language. While eschewing panoramic coverage, we have not chosen these case studies at random, for they have, we contend, played a seminal role in the re-imagining of French cultural identity.[10] Since each case study demands customised analytical tools, we have not sought to stan-dardise approaches across chapters, though the assumption that today's conceptualisations of the popular cannot be understood without histor-ical contextualisation runs throughout the volume. The principal point of departure here is the mid- to late nineteenth century, when mechanical

reproduction of cultural artefacts became technologically possible and French society became recognisably modern: urbanised, industrialised, near-universally literate, connected through systems of mass transport and communication, technologically and politically able to turn cultural artefacts into commodities. But each chapter finds its own chronological level and all chapters concentrate primarily on the period from 1945 to the present day. Our analytical methods variously combine elements of sociology, sociolinguistics, Cultural and Media Studies, literary and film studies, and public-policy studies. A comparably wide corpus of materials has also been used as primary sources, again varying by case study: creative works and statements made by their creators, polemical or theoretical writing, historical documents and debates, examples of linguistic variation and so on. Amidst this diversity, the book nevertheless reveals important overlaps and commonalities, which will be teased out in a brief conclusion. We will also return in those closing remarks to the contention that underpins the whole study: that analysis of any contemporary culture and of its relationships with the complex realities of national identities in the twenty-first century is seriously incomplete and hence distorted without the dimension of the popular.

David Looseley's opening chapter deals with the ways in which the French have defined culture politically since nineteenth-century industrialisation produced a mass proletarian consumer base for cultural products. In both the theory and practice of governments a powerful binary was established between, on the one hand, an authentically national 'high' culture that transcends material interests and, on the other, the degraded, market-driven products of 'mass' culture. On the whole, Right and Left were for a long time united in the belief that it is the State's political duty to manage and regulate the cultural field, and thus to elevate majority tastes to appreciate the 'highest and best' in the national canon, thereby fostering national unity and sustaining a perennial sense of French identity as rooted in the brilliance of French language and culture. Meanwhile, of course, technological progress and the development of increasingly international entertainment industries pulled steadily in the opposite direction, and the combined forces of State education, selective State funding and the discursive demonisation of debased 'mass' forms failed to resist the public's enthusiasm for compelling fictions, catchy songs and the irreverent pleasures of the lowbrow. Looseley also traces those moments when governments, generally of the Left, have tried to give political form to a more inclusive notion of culture that would take

seriously people's own definition of their cultural tastes, from the 1936 Front Populaire, through Jack Lang's ambivalent attempts in the 1980s to support a 'postcolonial reconfiguration of popular culture', to the recent avatars of those attempts at European level, in the forms of 'cultural diversity' and 'intercultural dialogue'. These moments are echoed too in the work of the handful of theorists, most notably Michel de Certeau, who have argued for the democratic vibrancy of popular forms by emphasising the agency of their consumers. On the whole though, as France becomes an increasingly multicultural and globalised society, the tension between commitment to a national self-image premised on élite cultural values, and the reality of majority cultural practices, remains, albeit in plural and evolving forms.

In his second chapter, Looseley combines a brief history of French popular music with an account of those discourses that have defined and constructed the meanings of 'pop' for France. One element of French particularism to emerge is the importance of the '*chanson*' category, aligned with hegemonic notions of Frenchness through its emphasis on text and the self-expression of the lone '*auteur*', yet also hugely adaptable. Focusing principally on evolving constructions and uses of *chanson*, Looseley shows how it plays its part in the nineteenth-century emphasis on a mythical rural past embodied in folk songs, and is then commercialised and 'massified' through entertainment forms such as the *café-concert*, only to be rapidly recuperated in opposition to the 'foreign' forms of music-hall, jazz, and later rock, techno, etc. The chapter tellingly undercuts the indigenous/imported binary evident in this last strategy: rock, for example, is shown to function not simply as an American import imposed by commercial interests, but as a musical form that can be appropriated and adapted for purposes of self-assertion and contestation by young people in different national contexts, just as 'American' hip-hop and rap would later be by minority-ethnic youth groups. Furthermore, while in the musical as in other cultural fields, the French cultural and political establishments have persistently subscribed to a certain model of 'Frenchness' – defined in terms of head and heart rather than body – and rejected 'foreign' musical genres in its name, on the ground, or in the street, people have largely practised a pick'n'mix policy that mingles indigenous and foreign, commercial and 'authentic', to match their own increasingly hyphenated senses of identity. Since the Lang era, state policy has moved closer to a recognition of the eclectic, self-reflexive reality of the French musical landscape, though Looseley also concludes with a sharp illustration, drawn from reality TV, of the fact that 'binary thinking is still alive and well'.

Chapter 3 moves to the popular dimension of French literary culture. As the first two chapters also show in different ways, the manipulation of language to understand, represent and change reality has been central to France's sense of its own mission in the world since the nation's earliest days, and the written word is thus the site of particular passion and controversy. Diana Holmes traces a short history of the popular novel since mass literacy and new technologies democratised reading in the mid-nineteenth century, and she interweaves with this a study of how popular reading tastes have been depicted, judged and shaped by public discourses, from parliamentary debates to state and Church policies, marketing pitches, theoretical interventions and readers' own commentaries. She finds certain continuities, for example in the types of reading pleasure valued by readers to the present day (and often standing in stark opposition to those most prized by élite culture) and in the near-consensus of dominant groups, however politically opposed, on the corruptive power of absorbing stories. She also underlines the diversity of novels classified as 'popular', for although certain characteristics of popular fiction remain constant over decades and even centuries, success with a wide popular audience also frequently depends on sensitivity to the moment, on topicality or response to a specifically located mood or tension. This is a matter of form as well as of thematic content, and makes for considerable variety in those novels that reach the widest readership. Explaining and exemplifying the note of disdain that still resonates through most critical and 'high' media discourse on popular fiction, Holmes disputes its assumptions, arguing for the cognitive and affective complexity of 'mimetic' readings and for the need, in any account of French literature, to pay proper attention to the stories read by the majority.

French popular film, the subject of Chapter 4, is for many a contradiction in terms: French cinema has long been associated with high culture, and despite the iconoclastic verve and youth appeal of the Nouvelle Vague, the longer-term impact of this hugely influential movement was to reinforce perception of French film as self-reflexive and demanding rather than aimed at a wide audience. Yet the French film industry has thrived through wars, recessions, powerful competition from Hollywood and the US free-trade lobby, and has done so through the consistent box-office appeal of comedies, thrillers, star vehicles and the (often critically derided) use of visually thrilling cinematography and eclectic, technologically adept and emotionally compelling narrative techniques: domestic reality and external perception of what constitutes 'French cinema' differ significantly. David Platten defines cinema as an intrinsically popular medium:

not only does its visual storytelling appeal across levels of education and class, but the ontological shift its invention produced in the subject's relationship to space, time and other subjectivities (literally seeing the world from another's point of view) applied, and gave pleasure, to the mass of the population. Developments in cinema's wonderful capacity to take us elsewhere continue to thrill a socially diverse public, and to inflect their vision in the widest senses of the word. Comedy, the most popular genre of all in France, is shown to invite at once an incipiently subversive irreverence for normative social values, through the bodily release of laughter, and the more cerebral, but still democratically accessible, pleasure of *seeing the illusion* – for we watch comedy from a dual perspective, on the one hand appreciatively aware of the artifice it involves, and on the other simply taking pleasure in the effects this artifice produces. The capturing and the (often sumptuous) rendering of a contemporary mood, evident in some of the biggest box-office hits across a variety of genres, also offers the pleasures of reflection in both senses of the word to a wide popular audience. Through analysis of some of French cinema's greatest commercial successes, this chapter interrogates the nature and the meaning of *popular* in relation to film.

Television, the subject of Chapter 5, presents the interesting case of a relatively young medium whose function and forms had to be defined within a context of already developed debates over the high/popular divide. Lucy Mazdon shows that the possible contradiction in television's twin aims – to disseminate national values and 'high' culture (in the UK, the Reithian imperative to educate) and to entertain a mass audience – was posed with particular acuity in France, where the democratisation of high culture had long been central to national identity and to what the State perceived as its duty. In the early days of TV, the new medium lent itself to the political agenda of a paternalistic President de Gaulle, and was harnessed to a Malraucian (André Malraux was de Gaulle's Minister of Cultural Affairs) programme of introducing citizen-viewers to the 'highest and the best' of French culture. However, these top-down aims were necessarily interwoven with entertainment values: for the medium to thrive, audiences needed to be gained and kept. Mazdon shows how the popularisation of TV then went hand-in-hand with a gradual dismantling of State control through the 1970s and 1980s, but also demonstrates that a liberal model of television as essentially responding to audience taste has always coexisted (and still does coexist) with an allegiance, apparent in audience behaviour as well as in government policy, to a model of TV as a national forum and a vital component of specifically French cultural life.

Both in its still popular capacity to relay and discuss unfolding national as well as international realities from a distinctively French perspective, and in its contrasting and intensifying shift towards fragmentation, commercialisation and individualised rather than collective modes of viewing, TV exemplifies the twin threads of allegiance to French exceptionalism and market-driven alignment with Western (ultimately North American) norms that characterise French cultural life.

In the final chapter, Nigel Armstrong tackles a question central to the book's endeavour: the relevance of popular language for wider perceptions of what constitutes 'popular culture'. If there is evidence, in France as elsewhere, of a broad 'bottom-up' levelling of linguistic style, replacing the previously hegemonic belief in a correct 'standard' language to which all must aspire, this is attenuated in France by powerful factors that militate in favour of a continuing consensus on linguistic standards. One of these has to do with a historical French centralism that, through policies that included education and military conscription, minimised regional variations in accent and vocabulary, and certainly separated these from linguistic markers of social class (unlike in the UK). Another of these factors, encountered throughout this book, is French Republicanism's powerful ideal of an inclusive, uplifting high-culture-for-all that resists any social levelling 'down' of language as of any other form of culture, viewing respect for the popular (in the sense of majority cultural practice) as mere populism, and as undemocratic in that it fosters the incapacity of most citizens to participate fully in a valuable national culture. This ideology cuts across the Right/Left divide, and arises no doubt, in part, from France's sense of being under siege, a nation that has always been a beacon of linguistic and cultural excellence now threatened from without by the dominance of (American) English and by industrialised cultural forms. Linguistic standards, then, like cultural ones, come to be seen, Armstrong argues, as 'a rule-system ... from which people deviate to the extent that they are not highly educated'. Nonetheless, a certain 'levelling down' is apparent, for example in the spoken language's near-universal abandonment of the '*ne*' component of the negative. This, Armstrong contends, is no simple effect of a post-1968 glamourisation of proletarian style, nor of a grassroots refusal of deference. Language production is central to the individual's presentation of her or his identity, and as such is intertwined, perhaps even more than choices of cultural consumption, with the complex, multiple weave of contemporary French identity, that includes not only nation but also ethnicity, class, region, generation, gender, sexuality and no doubt more.

In short, this book deals with the ways in which popular culture has been defined, lived, enjoyed, fought over, imagined and re-imagined, in a nation that has long placed the meaning and status of culture at the heart of its identity.

Notes

1 'la notion de culture populaire souffre à l'origine d'une ambiguïté sémantique, compte tenu de la polysémie de chacun des deux termes qui la composent'.

2 Certainly, this brief summary of English usage could itself be contested but this book is not the place to do so.

3 'le terme *popular* ne signifi[e] nullement issu du peuple, mais populaire par l'ampleur de sa diffusion et le terme *folk culture* s'apparent[e] plus à ce que, en français, on dénomme populaire'. I have adjusted the tenses here to avoid confusion. In the original, Portes uses the imperfect tense because he is arguing that the need to distinguish between 'mass' and 'popular', a distinction that is 'normal in Europe', has only recently been noted in the USA, pp. 29–30. He thus seems to be implying that rather than European terminology lagging behind anglophone usage, it is the other way round.

4 It is difficult to do more than generalise here: the parameters of academic research, both francophone and anglophone, constantly shift.

5 It was in the UK that the journal *French Cultural Studies* was founded in 1990.

6 'un provincialisme français qui fait froncer les sourcils au seul énoncé du terme mystérieux de *Cultural Studies*'.

7 'Ce rapport désinvolte à l'empirie se combine souvent à une revendication ostentatoire de hauteur et de profondeur qu'exprime l'empilement des références intimidantes tenues pour des blasons de haute intellectualité. La notion même de French Theory, ce monstre épistémologique, est des plus symboliques. Le terme invite à traiter comme un ensemble cohérent les auteurs les plus connus du monde intellectuel français (Bourdieu, Derrida, Foucault, Ricœur). Ce spiritisme universitaire s'accompagne peu souvent d'une capacité à replacer ces œuvres dans le champ scientifique et les logiques sociales qui les ont vues se développer, pas davantage d'une grande attention aux incompatibilités théoriques entre des auteurs dont le seul point commun est parfois le passeport français.'

8 'est devenue nécessaire pour une bonne compréhension des sociétés contemporaines mais aussi, plus largement, de celles de l'ensemble du XXe siècle, d'autant que c'est au fil du siècle tout entier que les discours sur – et, le plus souvent, contre – cette culture ont fleuri'.

9 On PCRN, see http://www.leeds.ac.uk/smlc/Popularculturesresearchgroup. htm. The founding members at Leeds were Nigel Armstrong, Diana Holmes, David Looseley and David Platten. Looseley was its convenor and director, from 2005 to 2010.

10 We could arguably have selected more topical case studies for the same purpose: social networks, for example, or wikis or the iPhone. But we specifically wanted to research the development and impacts of the popular diachronically rather than adopting a synchronic 'French popular culture today' approach more suggestive of a textbook.

1

Politics and pleasure: inventing popular culture in contemporary France

David Looseley

France is an invention, a conceptualisation. (Kuisel 1996: 5–6)

Introduction

This first chapter focuses on political conceptualisations of popular culture in France, by which I mean conceptualisations developed by governments, parties, national institutions and the kind of public intellectuals who, as Ahearne (2010: 2) puts it, 'have moved in and out of positions within public policy processes'. Other chapters in this volume will be concerned with popular-cultural artefacts themselves. My focus here is on how such artefacts have been institutionally represented over time. For if, as Kuisel claims, France itself is an invention, a conceptualisation, this is in part due to the way its popular culture has represented it and been represented by it.

No single chapter could chart such representations in all their variety. Rigby (1991) devoted an entire book to analysing the 'cultural discourse' of popular culture in France from the *éducation populaire* movement to major public intellectuals like Certeau and Bourdieu. And these two themselves reflected on the sociology, history and meanings of the popular. More recently, Rioux and Sirinelli (2002) have traced the shifting responses of French intellectuals to mass culture, including Morin, Baudrillard and others. What has yet to be undertaken at any length is a critical historical account of the part played by the French state in shaping such responses. Rigby does deal with the subject relatively briefly (see his Chapters 5 and 6) but, published some twenty years before the present one, his monograph could not take stock of major developments in the creative industries (digital technologies, reality TV, electronic dance music and so on), the ways in which institutions and intellectuals have reacted to those developments and, vitally, new

research. Anglophone Cultural Studies, for example, has pointed up new ways of thinking about popular culture which stress political economy in an attempt to correct an over-emphasis in the 1970s and 1980s on creative consumption. In particular, the once standard evocations of subcultural 'resistance' and consumer sovereignty in response to the hegemony of the dominant culture have been challenged as populist for taking insufficient account of the social and institutional structures that shape consumption practices.[1] More importantly, there has been a surge since the mid-1990s, especially in the UK, of humanities-based textual and historical research on French cultural policy, which is helping us better understand the complex distinctiveness of the French 'cultural state' (Fumaroli 1991). With the help of this new research, my aim is to explore historically how the French political and cultural establishments have conceptualised the lowbrow in relation to the highbrow, how they have proposed institutionalised but mutating and contested classifications of the popular in the public sphere.[2] Although such acts of classification are undoubtedly political in that they involve relations of power, as cultural theorists like Stuart Hall have long argued, my perspective here, in keeping with the ambitions spelt out in the Introduction, will primarily be that of cultural history rather than Cultural Studies, in order to move on from such reiterated theoretical positions and arrive at a more contextualised, 'located' analysis of the French case.

As Rioux and Sirinelli argue (2002: 273–4), France is one of the few countries where culture in all its forms has consistently and intimately been bound up with the state. Government policy has long functioned as a mechanism of legitimation and has forged a hegemonic view of culture in which can be identified a succession of narratives concerning what Gramsci called the 'national-popular'. While the other narratives examined in this book, concerning music, fiction, film, television and language, have more obviously contributed to shaping national representations of the popular, the narratives of the state have, I believe, furnished the discursive conditions, the medium in which these other conceptualisations have evolved. My underlying thesis is that, more than in the UK or America, the French state, within which I include France's cultural and political élites generally, has been responsible for variously authorising, policing or managing public distinctions between highbrow and lowbrow, what is marginalised and what is included; and that it has come to play these roles while cultural practice in civil society has proliferated and steadily contested such distinctions. The French state's engagement with the popular can therefore be seen as a discursive space

in which dominant classifications of highbrow and lowbrow have been forged and various negotiations between republican universalism and contemporary cultural change have been conducted.

In *Politics and Popular Culture* (1997), the political scientist John Street insists: 'The market is not a neutral instrument, it is a political arrangement' (1997: 16). From this standpoint, he deconstructs both political and cultural populism. He argues that the superficially attractive notion that 'popular choice' dictates both political power and popular culture, that politicians simply represent the people and that popular culture is simply popular expression, is 'highly suspect'. This is because '"the people" are as much a rhetorical as a political fact. Politics is in large part an attempt to secure pre-eminence for one version of the people over another' (Street 1997: 17). The tabloid press, for example, or the makers of reality TV, may use sales or viewing figures to back their claim to be satisfying popular demand, but nobody knows what the people is or what it wants. In fact, Street concludes, the people 'do not have a "voice"; they are given one by opinion pollsters, commentators, journalists, politicians, interest groups. The "people" are created through the ways in which they are represented and spoken for' (Street 1997: 18). Therefore, he urges, the populist reading of popular culture, just like the populist reading of politics, 'needs to be replaced by an approach which understands popular culture in terms of the institutions that create it and the political ideologies that inform it' (1997: 19).

Street's argument, though based on the anglophone world, helps highlight the exemplary status of France as an extreme case of how popular culture is shaped by institutional and ideological power. Certainly, there is also a degree of political pragmatism here. Any government spending tax revenue on promoting the arts and culture is obligated to concern itself with the 'popular' in some sense, simply because, however the arts and culture are defined, the most persuasive rationale for such spending, at least before neo-liberalism swallowed all in its path, was always that it supposedly enabled all classes and identities to access or practise the arts, for whatever purpose. In France, until de Gaulle returned to power and created the Fifth Republic in 1958, this had traditionally been the task of the state education and beaux-arts systems, both under the umbrella of the Education ministry. But in 1959 an autonomous Ministry of Cultural Affairs came into existence under André Malraux, dedicated to promoting what the new minister explicitly called 'popular culture'. At this point, the ideological dimension of French cultural policy becomes more apparent. Now problematically separate from the education system, this vulnerable

fledgling, in need of an alternative cultural mission from that of its parent department, adopted the popular as its driving force. Indeed, the history of French cultural policy may be understood as the history of the Ministry's attempts to define popular culture and, in the process, delineate a different route to culture from that of the education system.

From folk culture to mass culture: popular culture as 'Other'

As we saw in the Introduction, *populaire* has traditionally referred to the uneducated or poorly educated lower classes: the peasantry and the urban proletariat, or 'popular masses' (*masses populaires*). French writing on the popular has until recently foregrounded this sense. There has also been a propensity in sociological writing, influenced by Bourdieu (to whom I will return), to treat popular culture as the culture of the 'dominated'. Even Grignon and Passeron (1989: 33–38), who take issue with this 'miserabilism' by citing Richard Hoggart somewhat questionably (see Rigby: 129),[3] still see its opposite, relativistic populism, as merely an inverted confirmation of a hegemonic high culture.

For a long time, then, work on the 'popular' in France, by focusing on class domination in this way, could engage only indirectly or inadequately with 'popular' culture in the vernacular English sense, which implies a culture that by the pleasures it affords straddles class boundaries. Certainly, the social and human sciences began taking an interest in the 'mass media' several decades ago. Yet a panoptic history of the cultural products and practices associated with the media did not appear until 2002 with Rioux and Sirinelli's *La Culture de masse*.[4] Its distinctiveness lies precisely in the wider-angled lens it uses, drawing out the constitutive relationships between creation, circulation and reception which its editors see as forming a single chain.

Avoiding knee-jerk miserabilism, Rioux and Sirinelli's overarching argument is that mass culture is not a dominated culture imposed by capitalism; nor can it be seen as a class culture or neatly distinguished from high culture. Mass culture in reality straddles or combines publics and genres. At the heart of this process, of course, are the cultural or creative industries, which are crucial to a rounded historical understanding of the shift from the French *populaire* to the English 'popular'.

The folk sense of *populaire* overlaps to an extent with the anthropological meaning of the word 'culture': the ways of doing and being and the everyday practices through which diverse social groups express themselves and acquire an identity. Clearly, something we might call

culture populaire in this sense had existed through untold centuries in pre-industrial France – in the form of family life and traditions, dwelling space and artisanship, cooking and eating, customs and dialects (Grignon and Passeron 1989: 39–43) – but without being of any great concern to contemporary French élites. But what is important for the present chapter is the steady transformation from the middle of the nineteenth century of popular culture, in this practical, semi-utilitarian sense,[5] into mass culture, as urbanisation, industrialisation, leisure and consumption developed. This transformation induced new thinking about 'the people' and the 'masses' which brought about the 'invention' of popular culture as a concept (Storey 2003), followed by a succession of re-inventions.

Working-class culture was initially constructed as what Middleton (2003: 1) calls the 'Low-Other' of high culture. The popular thus only came into being as a recognised category of cultural discourse in order to legitimate the classical arts' claim to distinction and to defuse the threat of its difference. From the outset, the invention of popular culture is inseparable from a political, establishment 'version' of it.

In French discourses of the Third Republic, the particularism or 'communitarianism' (*communautarisme*) implied in this anthropological conceptualisation conflicted with the ideology of republican universalism developed since 1789, for which 'culture' had traditionally been seen as normative, singular and national. Hence what Hewitt (1999: 353) describes as 'a profound distrust of the recreational pursuits, the tastes and the habits of the urban working class' among the bourgeoisie. This distrust was inflamed by the popular uprisings of 1848 and 1871, the steady development of socialism, and quite simply the unknowability of the working class, born of the stark segregation of the two classes in the mid-nineteenth century. In Britain, for example in Matthew Arnold's *Culture and Anarchy*, there was a similar sense that the working class was a barbarous and potentially powerful unknown – 'the people of the abyss' as Jack London (1903) would ambivalently call Eastenders at the start of the twentieth century. In France, the perceived alterity of the urban poor was also informed by the shock of otherness experienced during France's imperial ventures, as it undertook its supposedly 'civilising mission'. Indeed, for Grignon and Passeron (1989: 31–2), 'class ethnocentrism' was actually more virulent than colonial ethnocentrism in its refusal to acknowledge a cultural life in the French working class.

The problem for those in France who feared this uncultured domestic Other more than they did the foreigner was that from the middle of the nineteenth century – well before Americanisation and earlier than

elsewhere in Western Europe (Rioux and Sirinelli 2002: 16) – an incremental process of societal democratisation was under way in which the uneducated masses were developing distinctive new tastes for symbolic goods and leaving folk culture behind. This was brought about in particular by the steady rise in literacy and general educational level, from the *loi Guizot* of 1833 which marked the beginning of the French state-education system, to the emergence of a popular press: a million daily papers were printed in 1870, three million only ten years later, and around ten million by 1914 (Rioux and Sirinelli 2002: 81–2). From 1862, school libraries (*bibliothèques populaires*) were introduced; and in 1905 the publisher Arthème Fayard launched its cheap 'Livre populaire' series, followed by Tallandier with 'Le Roman populaire' (Rioux and Sirinelli 2002: 77, 73 and 93 respectively). Thus, as Chapter 3 will demonstrate, literacy became a major force for social and cultural change: 90 per cent of the over-20s could read at least partially by the eve of the Great War (Rioux and Sirinelli 2002: 77). Literacy, however, was only the beginning.

At the end of the nineteenth century, other cultural and technological advances were contributing to the rise of mass culture. The *cafés-concerts* from the 1850s to the 1890s, followed by the English-style music hall into the 1920s, meant that the working population was exposed to new, international entertainments, rather than simply those that had sprung up 'naturally' over centuries and were deemed anodyne. The flamboyant music hall of the 1920s helped produce the star phenomenon (Yvette Guilbert, Maurice Chevalier, Mistinguett, and others: see Chapter 2), which the arrival of talking cinema then transformed by turning celebrity faces, styles and manners into paradigms in the national imaginary through the process of identification-projection analysed by Morin (1972 [1957]). Hollywood also, of course, exposed the French to collective representations from the anglophone world of love, sexual behaviour, music and sophistication which American jazz had already begun to disseminate in the 1920s. Such representations were largely alien to the more insular French, as demonstrated by the astonishment caused by Josephine Baker's sexualised and racialised shows in 1925 (see Chapter 2). By the 1930s, France's record industry, still far behind the USA's, was introducing new international sounds like '*le jazz-hot*' and swing, which were swiftly appropriated by white French performers and more widely disseminated. Radio was bringing these sounds into people's homes, domesticating and individualising tastes.

By the 1930s, then, France was opening up to an international range of cultural pleasures, identified by disapproving French intellectuals with

America and the decline of Europe,[6] and to which governments too were beginning to react. For if this new lowbrow culture produced by mechanical reproduction had the effect of massifying and standardising, it also atomised, undermining national solidarity. The rise of the star neatly illustrates this paradox. As Gaffney and Holmes argue (2007: 8), while 'a culture of stardom works to promote belief in the supreme importance of individual qualities and choices, rather than the determining power of class or income, and in the free perfectible individual', it also potentially offers governments the strategic myth of an 'imagined community' (Anderson 1991), one supposedly based on a classless shared culture, despite the still real differences of class, gender and location. As we shall see, this inbuilt ambivalence in mass culture and 'the mingled threat and promise of the American Other' (Gaffney and Holmes 2007: 13) caused successive governments to engineer different responses to it, from resistance to recognition.

From folk culture to high culture democratised

The rise of urban mass culture in the nineteenth century met with organised resistance due to a cultural pessimism which assumed that widespread literacy and the unmediated access it would give to the popular press and cheap fiction would prove politically divisive – as corrosive to the nation's well-being as it had been to Emma Bovary's (see Chapter 3). Social and cultural institutions, and ultimately the state itself, therefore sought to influence what 'the people' were doing with what little spare time they had. Bestowing official blessing on folk culture was one such attempt. A folklore movement grew up in the nineteenth century, and particularly in the early decades of the Third Republic (the Société des traditions populaires was created in 1886), which sought to preserve and validate traditional practices that were being eroded by industrialisation and urbanisation. Certeau teases out the ideological motives of this process of assimilation ('castration', as he sees it) in the essay 'La Beauté du mort' (The Beauty of the Dead, 1974). He argues that an anodyne version of folk culture, evolved by scholars in the late nineteenth century, defused and 'museified' the disruptive potential of the new urban lowbrow, recasting the popular as a reassuring shared heritage that demonstrated 'the existence of a unity in the French repertoire in which a *French mindset* is expressed' (Certeau 1974: 53).[7] In parallel, schools, factories, the military and local authorities encouraged amateur choirs and brass bands (see Chapter 2 below) in order to divert the working class from undesirable

leisure occupations and alcoholism and foster social as well as musical harmony.

New forms of censorship too were designed to regulate the culture to which the working class had access. Certeau draws out the significance of the fact that the author of a seminal history of chap-books (*littérature de colportage*) first published in 1854, Charles Nisard, was also in charge of suppressing such literature on behalf of the Ministry of Police under the Second Empire. As Nisard admitted, his aim was to protect gullible urban and rural workers from such subversive material while also making it more readily available to present and future bibliophiles educated enough to appreciate it without damage. Thus, writes Certeau, 'the interest of the collector correlates to a means of repression exorcising the revolutionary danger which the events of June 1848 showed to still be latently present' (Certeau 1974: 52). Also in the wake of 1848, the Ministry of Public Instruction surveyed and collected the largely oral heritage of popular song (see Chapter 2). A decree of November 1849 had already prohibited song performances in cafés without a visa from the Ministry of Education; and another, of March 1852, banned public meetings without police authorisation. On the Republican and Socialist Left as well as the Right, there was also a reluctance to allow free access to whatever reading matter the lower orders chose.

Even so, from the Commune of 1871, the conviction that books, education and culture could exert a civilising and unifying rather than corruptive influence became more widely established. When the Ferry laws of 1881 and 1882 introduced free, compulsory and secular education, the 'republican school' evolved a distinctive academic culture designed to emancipate young minds from the atomising-yet-standardising pleasures of mass culture. It sought simultaneously to save them from this self-absorption and to strip them of their particularist inheritances in order to make them citizens of the Republic, moulded by an improving culture to which all (in theory) had parity of access through learning (Rioux and Sirinelli 2002: 284–7). The Third Republic – *la république des professeurs* (the teachers' republic) – was in fact founded on the conviction that all classes and regions should be subject to identical linguistic and cultural influences. This 'ideology of the standard' (Chapter 6) also characterised the folklore movement's educational aims. While legitimating a people's culture of the past, it sought to eradicate cultural difference by rewriting the collected folk songs in standard grammar and musical notation (Duneton 1998, 2: 904–15). More generally, it was thought that literacy could become a tool of national unity if a national culture could

be generated by devising common History and Geography curricula, teaching standardised French and eradicating *patois*, and uniformising set reading, as in the well-known case of *Le Tour de la France par deux enfants: devoir et patrie* published by Belin in 1877, which by 1900 had sold 6 million copies (Rioux and Sirinelli 2002: 78). Thus, in the rhetoric of educational, intellectual and cultural élites, 'popular culture' acquired an aspirational rather than anthropological sense: it was intended as a unified culture to be generated, rather than a mosaic of pre-existing particularist tastes. In tandem, the ideological divisiveness of the Dreyfus Affair (1894–1906) generated a well-intentioned 'popular culture' movement. Its militants advocated access to education, culture and leisure in order that 'the people' might resist the kind of benighted clericalism, militarism and antisemitism that had led to Dreyfus's persecution.

Over the next thirty years, various energies converged on the notion of popular culture, such as the 'popular universities' (*universités populaires*) that grew out of the Dreyfus Affair. But these energies were especially concentrated in the theatre at the turn of the twentieth century. Certainly, theatre at this time was already a 'popular' entertainment in so far as the commercial theatres of Paris and a few other big cities drew large audiences. But these audiences, like the characters created by the successful dramatists of the time (Feydeau, Scribe, Sardou) and the areas in which the theatres were located, were comfortably middle-class. And when an aesthetic backlash against such sophisticated entertainment finally came, for example in the work of Jacques Copeau and the 'Cartel' of great directors he influenced and who transformed French theatre in the first half of the twentieth century (Dullin, Baty, Jouvet and Pitoëff), their often spare, avant-garde productions still held little appeal for the working class.

The popular-theatre movement, on the other hand, had a firmer socio-political aim. Syndicalist and Socialist initiatives to bring theatre to deprived audiences were common at the start of the century and efforts were even made, unsuccessfully at the time, to persuade government to support the principle (Bradby and McCormick 1978).[8] A Committee for Popular Theatre was created in 1899 for the purpose, and in 1905 a parliamentary commission recommended that four 'people's theatres' be set up around Paris, though to no avail. But one of the committee members, Maurice Pottecher (1867–1960), had already founded an open-air theatre called Le Théâtre du peuple (Theatre of the People) in 1895 at Bussang in the Vosges, still active today; and in 1903, his disciple Romain Rolland published the celebrated essay of the same name. Seventeen years later, the government did finally move to set up the first National Popular

Theatre (TNP) directed by Firmin Gémier, though the initiative did not succeed until revived 27 years later under Jean Vilar.

Although in practice popular-theatre initiatives of this kind were quite diverse (Pottecher, for example, staged folk and morality plays, sometimes in local dialect and performed by amateurs), most of them, even Pottecher's, were republican and universalist insofar as they promoted national union, or a more diffuse 'communion' in the quasi-religious sense that was to inform the work of famous directors from Copeau to Vilar. The report of the 1905 parliamentary commission shared this ambition, maintaining that 'in a secular, non-religious society, the theatre can help to elicit and contribute towards the necessary communion of men [*sic*]' (quoted in Bradby and McCormick 1978: 34). Also shared was the desire to actively *produce* a popular culture. This voluntarism has remained a characteristic of French cultural policies ever since.

There were, however, exceptions to this universalist ideology, at least for a time. A concern on the Left with popular fiction, for example, emerged during this period under the name of 'proletarian literature' (see Chapter 3). Politically more important were those writers and intellectuals close to the revolutionary syndicalists and the newly formed French Communist Party (1920). They developed a particularist discourse on the specificity and 'authenticity' of working-class experience in which high culture's claim to universality was deemed a tactic to occult its class nature. Yet even this particularism was to be abandoned in the 1930s when the PCF joined the other parties of the Left in opposing Fascism. 'Culture' entered the mainstream vocabulary of the Left at this time because, as with the Dreyfus Affair, it was felt that sociocultural engineering was required: the people needed broader intellectual horizons if they were to resist not just foreign totalitarianism but its sinister variants at home, spawned by the anti-Dreyfusards: Action Française and the other right-wing leagues which, so the Left became convinced after the violent right-wing demonstrations of 6 February 1934, had aspired to seize power. Thus, even the PCF came to subscribe for a time to the notion of a single, redemptive national culture.

Out of the fear of a resurgent Right grew the Rassemblement populaire of 1935, bringing together the PCF, SFIO and the moderate Radicals in a political alliance that would lead the following year to the election of the Popular Front coalition. The Front came to power with a cultural ambition, shared by the PCF despite its refusal to join the new government, that drew on the popular-culture and popular-education movements. 'Popularisation' in fact became a central theme. It was the responsibility of the

minister in charge of both Education and Beaux-Arts, Jean Zay, and of his junior minister Léo Lagrange, responsible for youth, popular education and the 'organisation of leisure'. These two precursors of French cultural policy have a virtually mythical status today (both died violently during the Second World War). They shared a capacious conception of popularisation. Widening participation in the traditional arts and creating a comprehensive education system were its cornerstones, but it also extended to encouraging sport and leisure, including outdoor activities such as hiking and youth-hostelling, and even to mass culture, mostly in the form of attempts to regulate radio and cinema, considered to be important means of education. The Front also wanted to associate culture with festivity: 'we believe that the masses should be given great celebrations (*fêtes*) which exalt the popular consciousness at significant dates' (Lagrange quoted in Looseley 1995: 17).[9] Zay and Lagrange thereby laid the foundations of France's post-war cultural, educational and youth-and-sport policies, even though the Front itself scarcely lasted a year in full-blooded form and many of their initiatives could not be implemented in time.

In retrospect, the Popular Front interlude can be characterised as pioneering though ambiguous. It recognised marginalised cultural practices and in the process took a significant step towards legitimating the defining element of pleasure in popular culture. But it also exercised soft power: steering and improving culture for ideological purposes, seeking to intervene in shaping a seamless, national-popular culture in which the arts, learning, leisure and pleasure were indistinguishable. As Lagrange put it in the typically spirited rhetoric of the times, 'Sporting leisure, touristic leisure, cultural leisure, these are the three complementary aspects of a single social necessity: the achievement of dignity, the pursuit of happiness' (quoted in Looseley 1995: 15).[10]

Vichy took up some of the Front's cultural ambitions, though with a quite different ideological agenda. Popular culture was intrinsic to Pétain's call for a 'national revolution', construed as a remoralising antidote to the rootless cosmopolitanism of the Third Republic, and especially of the Front itself. Particular emphasis was placed on the importance for French identity of regional folk cultures (traditional dances, costumes, music). At the Liberation, however, with Vichyism discredited, the Popular Front's original ideology was picked up again by cultural movements which grew out of the Resistance, most notably Joffre Dumazedier's Peuple et Culture, and by Resistance-dominated Left governments between 1944 and 1947. This renewed cultural voluntarism was enshrined in a short-lived department within the Education ministry responsible for youth

and popular education. In tandem, the government introduced measures to protect French cinema from Hollywood imports in 1946, developed library provision and the mobile libraries which had been introduced under the Popular Front, drew up censorship legislation in 1949 to control the mass-cultural artefacts the young had access to like comic strips, and attempted to generate a popular taste for serious theatre by creating regional theatres (*Centres dramatiques nationaux*) from 1946 and commissioning Vilar to revive the TNP in 1951. At both the revived TNP and the Avignon Festival, created in 1947, Vilar shared the ambient belief that the people both needed and could appreciate the highbrow, summarising his convictions in the crisply paternalistic formula 'impose on the public what it obscurely desires' ('imposer au peuple ce qu'il désire obscurément'; Vilar 1963: 43).

Hewitt (1999: 353) describes these years from the mid-1930s to the late 1940s as an era of 'doctrinaire and dogmatic paternalism' about popular culture, on both Left and Right; and Fumaroli (1991) detects much the same reprehensible continuity. But this is a partial view. As we have seen, the Front attempted in fact to embrace the popular on several levels. It was neither crude paternalism nor intellectual snobbery that powered its cultural interventions but a pragmatic desire to improve the lot of workers whose standard of living and working conditions in the 1930s were still low. Embryonically, the arts and leisure were coming to be integral to the wider package of democratic rights, alongside health care, welfare, universal education and so on that a civilised society ought to offer its citizens and that Western-European societies sought to implement from the post-war period to the 1980s. Any policy sets out to improve the status quo in some form, so it is questionable whether paid holidays and opportunities to enjoy fresh air, participatory sports and the arts are merely paternalistic. But it is certainly true that 'improving' popular culture was an ambition during this period and that this was taken to mean resisting what were seen as the harmful effects of mass culture.

It was the 'authenticity' of 'popular' culture that was really at stake here. Both notions were of course problematic; yet neither was taken in the immediate post-war period to refer to Americanised mass culture, about which one senses a profound anguish among the cultural Great and Good that would become a distinctive national psychosis, born of the deeply rooted faith in print culture and the word. As André Chamson, writer, archivist and museum curator, wrote in 1959:

> We have unleashed values of metamorphosis that we can no longer control.
> Our culture was a culture of language. It transmitted, via an inner whisper,

a sound of voices in the depths of silence. But every day we are creating a civilisation of image and clamour. It is not that we should say no to illustrated books, radio, cinema, the record-player and television. But how can we continue to hear that which can only be heard in inner silence? (Quoted in Rioux and Sirinelli 2002: 265)[11]

Cultural authenticity, then, for some, was a matter of national survival. Indeed, the post-war period was marked by a more starkly polarised way of thinking about popular culture than at the time of the Popular Front. On the one hand, a market-driven, incipiently global economy producing lowbrow artefacts that appealed to the populace; on the other, the voluntarist conviction held by governments and by arts professionals like Chamson, Vilar and the popular culture movement, that 'the people' have a right to and a deep-seated need for high culture but are haplessly falling victim to the egregious products of what Adorno and Horkheimer called the 'culture industry': film and television, radio and records, paperback fiction and comic strips. This is the context which saw the creation in 1959, the year of Chamson's statement, of France's first ministry in charge of culture, the 'Ministry of Cultural Affairs' headed by André Malraux.

His newly minted department, patched together to give him a job in the new government, needed to forge a mission from scratch. It did so by dedicating itself to counterbalancing cultural industrialisation with improved access for all to the 'best' of the arts. The normative meaning of 'popular' culture adopted by the Ministry was thus a less comprehensive version of the Popular Front's. As Malraux said before the Constituent Assembly of 1945, 'It seems to me imperative … that French culture cease to be the preserve of people who are lucky enough to reside in Paris or be well-off' (quoted in Looseley 1995: 36).[12] And this was the position he built on as minister, adopting 'popularisation', now called 'democratisation', as his lodestone. 'Culture is popular by virtue of those it reaches, not by its nature', he said to the National Assembly in 1966 (quoted in Urfalino 1996: 53 n.16).[13] Here, Hewitt's accusation of discriminative paternalism carries more weight since, unlike Zay or Lagrange, Malraux was content to leave mere leisure to other ministries. Within that logic, listening to pop music or watching Hollywood movies or TV shows, activities fast becoming dominants of French leisure, were not considered cultural at all but toxic entertainments mass-produced by the 'dream factories' (*usines de rêve*) to which Malraux saw democratisation as the antidote – a position close to Adorno's. Malraux equally believed that creating a popular culture was not a matter of education. An appreciation of true culture cannot be taught; it is a case of love at first sight. As he said at

the inauguration of the Maison de la culture at Amiens in 1966, nobody has ever come to love music or poetry because it was explained to them. It is much more a matter of communion and revelation: 'each time one replaces this revelation by an explanation, one will do something which is eminently useful, but one will create a misunderstanding' (translated in Ahearne 2002: 58–9). Rather, it was a matter of facilitating access, encouraging encounters: the Ministry as matchmaker. Yet as the Maisons de la culture were soon to demonstrate and Bourdieu and Darbel (1969) were to point out, this 'charismatic ideology', reliant on the supposed 'cultural innocence' of the lower orders, was fatally flawed. Workers simply did not make use of Malraux's intimidating 'cathedrals' of culture, preferring the creature comforts offered by the mass media. As with the other fault lines in French society, this discursive clash over popular culture came to a head in May 1968.

Not unlike Malraux, the most radical activists in 1968 had little time for mass culture, which they saw as the Trojan horse of capitalism. Yet they were equally opposed to the 'popular culture' promoted by the Ministry of Cultural Affairs, the decentralised theatre movement, and Vilar's Avignon. The Americanised entertainment industry and the institutionalised *culture populaire* movement were in fact presented as objective accomplices, two faces of a repressive bourgeois culture generating false consciousness. Authentically popular culture, on the other hand, was deemed to spring spontaneously, with a nudge from empathetic *animateurs*, from the people and the street, articulating their oppression. It was therefore ideological and potentially revolutionary.

Throughout the 1970s, these conflicting narratives of popular culture dominated debates about cultural policy, especially at local level: on the one side, cultural democratisation as construed by Malraux's ministry; on the other, 'true' cultural democracy as conceived by arts radicals in the aftermath of May. It was only during Mitterrand's presidency (1981–95) that a different narrative really came to prominence, issuing particularly from a Ministry of Culture led for most of that period by Jack Lang (1981–86 and 1988–93). As Rigby (1991) shows, 'popular' and 'mass' were increasingly conflated during this period, the semantic parameters of the popular widening beyond its class associations to embrace the population as a whole. And this enlarged conception was steadily legitimated. In one sense, this was an inevitable, even belated response to what had incontrovertibly been happening at the grass roots of cultural practice for over 100 years in blithe disregard for the administrative efforts made to guide or shape that practice. All the same, the legitimation of mass

popular culture remained a contested process, generating the 'culture wars' of the late 1980s and 1990s, as postmodernity, postcolonialism and, more generally, the French theorists who were influencing anglophone Cultural Studies challenged the hegemony of republican universalism. But before tracing the relationship between the state and popular culture any further during that period, we need to understand more clearly how this challenge came about.

Popular culture reinvented

In the 1970s, the interrogation of democratisation during May 1968 helped generate a community-arts movement dedicated to the more people-oriented notion of cultural democracy. That interrogation had partly been informed by Bourdieu's writings, coupled with the production from 1973 of official statistics on national cultural practices. In *L'Amour de l'art* (Bourdieu and Darbel 1969; *The Love of Art* 1990) Bourdieu's answer to the failure of cultural democratisation had been that democratisation should be pursued not by a weak and deluded Ministry of Culture but by the transformation of arts education in schools. For only here could at least some progress be made towards counteracting the deleterious effects on the underprivileged of cultural capital and habitus. Persuasive though this was as a sociological riposte to Malraux's humanist idealism, it does reveal Bourdieu's scepticism about popular culture as the authentic voice of the working class. Indeed, the popular is represented in much of his work as a dominated caricature of the highbrow, although there is debate among Bourdieu scholars about how negative he actually is. Yet as late as *Méditations pascaliennes* (1997; *Pascalian Meditations*, 2000), published only five years before his death, it is still apparent. The argument is fairly well known, so I shall only summarise it.

Here as in *Distinction* (1979), Bourdieu critiques Kant's claim that judgements of taste aspire to universality. Bourdieu insists (2000: 74) that this claim merely constitutes 'a particular experience of the work of art (or of the world) as the universal norm of all possible aesthetic experience', tacitly legitimating 'those who have the privilege of access to it' (2000: 75). It ignores the historically determined 'social conditions of the experience of beauty' (2000: 77), the 'economic and social privilege' which makes the 'aesthetic' (that is, high-cultural) viewpoint possible in the first place. The alternative, however, a 'populist aestheticism which leads some to credit the working class with a "popular aesthetic" or a "popular culture"' (2000: 75), fares no better in Bourdieu's analysis, for it

objectively perpetuates the aesthetic viewpoint by still tacitly taking high culture as the universal, classless norm. It is illogical on the one hand to denounce working-class social conditions while on the other claiming that, despite these conditions, the working class manages to fulfil 'human potentialities such as the capacity to adopt the gratuitous, disinterested posture that we tacitly inscribe – because it is socially inscribed there – in notions such as "culture" and "aesthetic"' (2000: 75). Any attempt to 'rehabilitate' popular culture discursively, as in an American study of the 'inventive and colourful language' (2000: 76) of adolescents in Harlem, is senseless so long as society, as enshrined in the education system or in recruitment procedures for the most prized jobs, fails to recognise it:

> The cult of 'popular culture' is often simply a purely verbal and inconse-quential (and therefore pseudo-revolutionary) inversion of the class racism which reduces working class practices to barbarism or vulgarity ... this ultimately very comfortable way of respecting the "people", which, under the guise of exalting the working class, helps to enclose it in what it is by converting privation into a choice or an elective accomplishment, provides all the profits of a show of subversive, paradoxical generosity, while leaving things as they are. (2000: 76)

Inevitably, then, on this view, cultural policy is in a cleft stick. Either it attempts, as Malraux did, to bring 'legitimate' culture to people whom it denies any means of decoding that culture; or it adopts the '"populist illusion"' (quoted in Ahearne 2010: 112), which merely imprisons them in their imposed particularism.

Although as Bourdieu admits this is 'a fairly depressing conclusion' (2000: 76), it carries weight. Yet it is weakened somewhat in its relevance to today because, as Hesmondhalgh argues (2006: 218), 'Bourdieu offers no account of how the most widely consumed cultural products – those disseminated by the media – are produced'. One might take issue with the absolutism of Hesmondhalgh's view, but it does at least highlight a problem with assuming that Bourdieu's overarching thesis regarding the social stratification of tastes is the natural paradigm for making sense of contemporary popular culture – as some do, particularly in France. Anachronistically interpreting *populaire* as meaning working-class, he seems to assume that 'legitimate culture' is still the dominant player. Indeed, in his later critiques of the neo-liberalism of the 1980s and 1990s, he even appears to take up a 'legitimist' position not unlike Malraux's own, championing 'a self-consciously "high" culture against the "dream factories" and moneymakers of transnational corporations' (Ahearne 2010: 121).Yet what have to be addressed are the consequences of the

far-reaching industrial, socio-economic and technological changes that have transformed traditional popular culture into mass popular culture and in the process eroded the symbolic domination exercised by the highbrow, whose legitimating power has diminished yet further in the digital age (Webb, Schirato and Danaher 2000: 148–9). Before we can properly understand these transformations as they have affected France, then, we need to relativise Bourdieu, initially by returning to Certeau, another French thinker who has inflected anglophone Cultural Studies.

For the militants of 1968 drawing on Bourdieu and Passeron's study of culture and higher education in *Les Héritiers* (1964; *The Inheritors* 1979), both the modern state and the cultural industries use symbolic violence to impose a set of cultural values based on the superior class's 'experience of beauty', which brings about the deculturation of the working class. Certeau does not so much deny this miserabilism as identify reasons to be a little more cheerful. Along with the formal, centralised production of objects and images comes 'another kind of production, disguised as consumption, a kind of production that is crafty, dispersed, silent and hidden but which worms its way in everywhere. It does not reveal itself in products of its own but is characterised by its own ways of making use of the products disseminated and imposed by a dominant economic order' (Certeau 1989: 186).[14] In practices of consumption, ordinary people become creative: they invent ways of negotiating imposition, locating interstices within which they can manoeuvre and be cunning, like a poacher living off the landowner's game. Rather than being dominated and decultured, each of the millions of people watching the same TV programme, for example, makes '[his or her] own product, different, incoherent and superb ('son produit à lui, différent, incohérent et superbe'; ibid.: 187).

However, Certeau does also manage to avoid the populist extremes that Bourdieu berates. Ahearne (2010), teasing out the policy implications of this position, points out that Certeau rejects any simplistic binary of individual freedom and institutional constraint. On the contrary, writes Ahearne, 'institutions (language, the family, school, of course, but also the broad sphere of cultural policy institutions) are fundamental to the very self-constitution of the human subject' (2010: 188–9), for it is the very plurality of institutions that opens up the margins of manoeuvre that individuals exploit. The responsibility of cultural policy, therefore, is to 'foster what Certeau calls a "multilocation of culture" maintaining "several types of cultural reference" and developing a "play of different cultural authorities" (*ce jeu d'instances culturelles différentes*)' (Ahearne

2010: 189). What this requires, then, is an institutional mosaic that accommodates the divergent creativities of individuals, and especially, in order to foster cultural diversity, a range of 'experimental micro-institutions' (Ahearne 2010: 191), for example at the local level, that can thereby mediate between cultural democratisation and cultural democracy.

One problem here is that the margins of manoeuvre that Certeau identifies are actually quite small. But this has not prevented his arguments being influential in the development of a creative consumption thesis in anglophone Cultural Studies. The idea associated with Birmingham's Centre for Contemporary Cultural Studies in the 1970s that, within working-class youth subcultures, style and taste act as a form of quasi-political resistance to dominant values is one illustration. More recently, there have been attempts to widen this reading beyond dissident, usually male subcultures such as bikers, Teddy Boys and punks, and to show that mainstream popular practices (pop music, girls' magazines, romantic fiction, television-watching) demonstrate a comparable capacity for creativity and invention, rather than limp passivity.

As pointed out in the Introduction, however, France did not experience the international spread of Cultural Studies in the 1970s and 1980s and it is only in the last few years that the discipline's perspectives and methods have been addressed and, in the case of some younger academics, adopted or adapted. But a concern to reject a miserabilist view of mass popular culture can nevertheless be found, for example in the work of French cultural historians who have begun to question the standard Adornian or Bourdieusian readings. Jean-Yves Mollier (2002: 85), for example, historian of literature and publishing, argues that in nineteenth-century France, with the progress of literacy and the press, the production of the *roman feuilleton*, the detective novel and the comic strip (see Chapter 3), the people's memory of its own cultural universe became as informed and encyclopaedic as that of the habitué of a bourgeois salon. Furthermore, he borrows from Hoggart's *The Uses of Literacy* (1957), albeit in the heavily modified form of its French translatio,[15] the idea that the working class had the capacity to undertake 'an oblique reading' (*une lecture oblique*) of popular fiction, to read dynamically 'with skill, amusement and detachment' (*avec astuce, amusement et détachement*) (ibid.: 86 and 92).

Yet if reading was a vital form of emancipation both socially and creatively, so too were the newer manifestations of the burgeoning mass culture, which provide further evidence that lowbrow culture was not uniformly passive. The *café-concert* involved the public as both consumer (purchasing drinks) and participant (singing along or simply ignoring

the performers while pursuing their own conversations). Dance too became a working-class activity with the *bals musettes*, where the accordion provided simple dance rhythms. Later, in the first decades of the twentieth century, the same argument may be applied to the more industrialised cultural forms that Adorno actually had in mind. Radio, which began in 1922, brought cultural forms into the home and allowed a closer relationship with them than live performance did. When records eventually reached a truly mass audience, which was not until the 1950s with the coming of vinyl, they domesticated music consumption and made possible a relationship with a piece of music that was more intimate than had ever been possible (see Chapter 2). Cinema too, while greatly intensifying the stardom that music hall had produced, also delivered a different, more personal relationship with them, as Morin argues in *Les Stars* (see Chapter 4). Morin in fact produced an early form of Cultural Studies, more subtle in its analysis of mass culture than Hoggart's *The Uses of Literacy* published in the same year. Morin accepts that stars are merchandise and that the star system has produced them for strictly commercial reasons. But he is more interested in their reception by the public. He sees in fans' adoration of their favourite stars, usually American, not an inert dependency but a profound, almost metaphysical need. And he recognises that it is this need that actively produces the star, not the other way round, giving the consumer a more dominant, creative role. He later applied this analysis to a further turning point in the development of French mass culture, namely the teen idol: that is, youth culture, another area which provides evidence that mass popular culture is not always passive or barbarous.

Popular culture as youth culture

Mollier (2002: 90) sees signs of a burgeoning youth culture as early as 1900, arguing that the cartoons of Louis Forton, 'Les Pieds-Nickelés' in *L'Épatant* from 1908 to 1914, by deliberately avoiding traditional or scholastic culture, helped generate 'an imaginary specific to the young' making youth 'a category apart, with its own codes and tastes and its own pleasure in seeing fictional creations subvert the social rules of play' (p. 89).[16] This was not, he insists, an appeal to working-class youth but to all classes, as evidenced by the importance of 'Les Pieds-Nickelés' in the boyhood reading of Sartre.

A next stage came with jazz. When swing was appropriated by French bands in the 1930s, it proved especially popular with the young, who

danced in the jazz clubs that grew up on the Left Bank and elsewhere. During the Occupation, when jazz was discouraged (though not formally banned), listening to it became subversive and was at the root of the youth-cultural movement called the Zazous, who grew their hair long and developed their own style of clothing, attracting disapproval, beatings and even head-shaving by collaborationists. In the immediate postwar period, the be-bop of Charlie Parker or Thelonious Monk appealed to the same constituency. Meanwhile, the proportion of the population under twenty was rising dramatically, from 28.9 per cent in 1936 to 33.1 per cent in 1962 (Guibert 2006: 114). With this rise, rock'n'roll replaced jazz at the end of the 1950s, though for some time in the 1960s comic strips and New-Wave cinema were actually more influential (Sirinelli 2003). But an irresistible succession of new pop styles, especially disco in the 1970s followed by world music, rap and techno in the 1980s and 1990s, has ensured that music has become the preferred 'cultural space' of young people, according to the sociologist of youth Pierre Mayol (1997; see also Looseley 2007b).

Yet paradoxically youth culture today is no longer just about youth. The difficulty in French of naming youth culture (*la culture jeune, la culture des jeunes, la culture juvénile*) testifies to this semantic instability. As the 1960s generation has aged, youth culture has acquired 'a history, aesthetic, rhythmic and sartorial traditions ... As a result, it is reaching more people than just the young, it is getting older, quite considerably in fact ..., it is steadily spreading to all social and professional categories' (Mayol 1998: 6).[17] Youth culture, then, although Mayol himself does not say so, has arguably become *the* popular culture of the early twenty-first century – as illustrated, to cite just one instance, in the 'youth-driven' linguistic levelling observed by Armstrong (Chapter 6).

Morin (1963) had already remarked upon the 'juvenilisation' of French society that mass culture was inducing. And in the 1980s, Alain Finkielkraut (1987) evoked youth culture's deleterious effects in 'de-intellectualising' French society as a whole. Even the more streetwise music journalist Benoit Sabatier, writing in 2007, demonstrates similar disapproval when he traces the evolution of what he calls '*jeunisme*' (literally, youthism), since he clearly regards the baby boomers who retain their pop sensibilities in middle age as responsible for turning youth culture from authentic subculture into fashionable mainstream, 'a normative way of life' ('un mode de vie normatif', Sabatier 2007: 9).

In his analysis, the values of May 1968 – liberation, self-realisation, hedonism, the carnivalesque, the right to difference – were those of

dissident middle-class youth, but as that generation has assumed power, they have ensured that those values have become widely accepted. Sabatier traces the real turning point here to 1984, since, in that one year, independent radio stations (*radios libres*) went commercial by taking advertising, Madonna went global, Canal Plus and its Top 50 were launched, and rap first appeared on French television. But, most importantly, the oldest baby boomers reached forty. Although this made them the older generation for the teenagers of 1984, they refused to grow old, self-consciously striving to look young and be their children's friends. Irrespective of the accuracy of his chronology, Sabatier does make a significant point, alongside Morin and Mayol. Rather than a neutral classification, 'youth' has become a free-floating performance severed from an age range, as evidenced on those Sundays in Paris when the streets are closed and a swarm of skaters of all ages, notably bald but ponytailed men, glide down the boulevards with grimly resolute grace.

A further stage in this transformation can be found in the dance culture that grew up in the 1970s thanks to disco (see Chapter 2). Here once again, we find readings that suggest the presence of agency and creativity in mass culture rather than hapless passivity. And a key vector of that creativity is the notion of carnival, festivity and hedonism. A festive conception of culture was a legacy of May (though it goes back much further), already present in the chaotic occupation of the Sorbonne. A year later, Woodstock prompted enterprising young French to mount similar though not altogether successful festivals in the early 1970s. But more important than the festive delivery of pop music to large audiences was the way that festivity was theorised.

For Certeau, the festive is included in the toolkit with which a dominated culture 'ruses' with the dominant culture. It is also a resurgence of the 'carnival sense of the world' that Bakhtin identifies in the Middle Ages:

> Carnival is a pageant without footlights and without a division into performers and spectators. In carnival, everyone is an active participant, everyone communes in the carnival act. Carnival is not contemplated and, strictly speaking, not even performed; its participants *live* in it, they live by its laws as long as those laws are in effect; that is, they live a *carnivalistic life* ... All distance between people is suspended, and a special carnival category goes into effect: *free and familiar contact among people.* This is a very important aspect of a carnival sense of the world. People who in life are separated by impenetrable hierarchical barriers enter into free familiar contact on the carnival square. (Reproduced in Storey 1998: 250–1)

Indeed, Bakhtin goes on, the arena for carnival 'could only be the square, for by its very idea carnival *belongs to the whole people*, it is *universal, everyone* must participate in its familiar contact' (ibid.: 255). In an analogous way, the post-1968 festival, where pop or alternative theatre abandoned the building for the 'street', or 'square', could be represented as a semi-spontaneous folk event, the kind of Dionysian occasion that, as in the Middle Ages, reverses social hierarchies and abolishes dividing lines between highbrow and lowbrow, power and the people. This kind of subversive reversal appealed to the fuzzy political ambitions of many in 1968.

However, this societal generalisation of a carnivalesque youth culture progressively became indistinguishable from the consumerisation of cultural products and a corresponding softening of intellectual disdain for those products. Eventually, this caused administrative constructions of popular culture to change. The nineteenth-century suspicion of popular culture, and the various forms of remedial intervention that resulted from it, were discursively reversed after 1981. In the process, the epithet 'popular' itself has generally been avoided in official discourse, not so much because of its polysemy but because popular education, the Popular Front, popular culture as Vilar or Malraux meant it, all smacked of a bygone age of prescription and uniformity, of the France of what Lipovetsky (1983: 11) calls 'disciplinary socialisation', rather than postmodern consumer sovereignty or 'personalisation'. Nevertheless, the abandonment of the term has not meant that a culture 'of the people' has ceased to be an aspiration; only that the aspiration has been reconfigured as a politics of pleasure, identified especially with Mitterrand's new Minister of Culture Jack Lang in 1981, one of Sabatier's inveterate *jeunistes*.

Popular culture and policy from the 1980s to the present

The turning point for policy in this regard can probably be identified in the publication of the Ministry's first full survey of public taste in 1973: *Les Pratiques culturelles des Français*. The cultural policies of Mitterrand's Socialist Party arguably evolved in response to the findings of this survey which, reflecting the intellectual evolution I traced in the preceding section, showed that popular-cultural practices were quite different in reality from those which the state had long been endeavouring to foster. Then, just a year after the Socialists came to power, a second edition of the survey appeared (1982), demonstrating the same thing with greater intensity, as indeed have successive editions in 1990, 1998 and 2009.[18]

What the surveys show beyond reasonable doubt is that mass culture has now become *the* culture of the French.

As early as 1978 in a seminal essay, Augustin Girard (1978), head of the Ministry's research unit which had come to function as a think-tank, pointed out that the new cultural technologies were democratising access to culture more successfully than state policies. Soon after Lang's appointment, Girard (1982) drove the point home in *Le Monde* by highlighting how that year's edition of *Pratiques culturelles* revealed the illogic of state policy in that the levels of subsidy for the various arts were inversely proportional to the French public's consumption of them. Lang's Ministry too had got the message and popular-cultural entertainments and artefacts, particularly those of the young, became objects of state approval: pop music and *chanson*, comic strips, circus, fashion and advertising. From 1983, the cultural industries also became a Ministry buzzword, with little of the negative connotation of Ador-no's 'culture industry'. Thus, a new administrative conceptualisation of 'people's culture' was developed that appeared to signify that whatever recreational activity people engage in is cultural: 'le tout-culturel', to borrow the caricature adopted by Lang's conservative detractors. While these changes certainly did not produce a dramatic inversion in the distribution of public spending on the arts, what was important, given that the majority of these outputs functioned in a market economy and did not strictly speaking need state funding to survive as opera did, was the discursive shift towards legitimation.

Some fifteen years before Tony Blair and 'Cool Britannia', the enjoy-ment, recognition and celebration of popular-cultural creativities were rhetorically foregrounded, as they still are to an extent today. This is epito-mised in the Fête de la Musique, launched by Lang's ministry in 1982 in order to signify, some years before it became fashionable, that official culture is ecumenical, festive and fun. The arts should not be seen as lofty and remote but as low, earthy and necessary: 'culture as pleasure, *jouissance*, food, thirst', as Lang memorably put it in an early interview in *Playboy* (quoted in Looseley 1995: 81). Yet if policy finally seemed to be catching up with both theory and practice, this was not a complete reversal of the paternalism identified by Hewitt. Rather, it was a strategy to restore the threatened republican ideal of universalism by giving it a pre-millennial makeover. In Gramscian terms, *fête* thus becomes part of the state's hegemonic project, a way of negotiating people's compliance by – in a nice paradox – voluntaristically regenerating an 'authentic' popular culture.

Yet France's 200-year-old republican universalism could not be made over that easily. With the evolution of a multicultural France, the festive version of the popular is inadequate to address a variety of cultural practices and expectations which classical republicanism was not designed to accommodate. Hence, some recent reflections at para-governmental and European levels on diversity and interculturality, which may be interpreted as attempts to work out a more rationally inclusive version of what popular culture in the twenty-first century should mean. Lang's recognition of popular-cultural forms opened the way for policy actors to address the cultural dimensions of social exclusion, a route also taken by his successors, at least for a while. Limited though it has been, the Ministry's exclusion agenda has produced some new policy thinking, often initially pursued at local level, with regard to 'emergent', 'urban' or 'street' cultures (Looseley: 2005). A related initiative concerns the so-called 'new territories of art', abandoned industrial buildings appropriated by grassroots arts collectives for alternative, multidisciplinary or hybrid cultural activities and in which policymakers began to take an interest in the early 2000s. Policy in these areas has in large part sought to address the troubled multicultural neighbourhoods (*quartiers*) or suburbs (*banlieues*) where the violent street protests of autumn 2005 revealed the extent of the unaddressed plight of residents. From the melting pots of the *banlieues* and the new territories of art, sites of intercultural dialogue, and from the constant injection into this creative spectrum of new technologies, has come a wind of change, an alternative discourse of cultural democracy construed in terms of 'departitioning, pluralism, reappropriation and cross-fertilisation …; a discourse concerned with overturning the traditional power relations between art forms and between artist and public', which amounts to 'an interrogation of established creative forms, practices, methods and institutions which has come about in the postmodern age' (Looseley 2005: 153–4). This interrogation amounts, I believe, to an attempted postcolonial reconfiguration of popular culture.

Malraux's vision of popular culture hinged on the notional existence of a 'non-public',[19] composed of those who did not engage with high culture even though, according to his ministry's 1960s rhetoric, they were perfectly able to do so. Hence the need for democratisation. The problem with this view was that it construed the non-public as singular, its members homogenised by supposedly shared, innate 'cultural needs', an essentialist notion at the heart of Ministry thinking in the 1960s. In contrast, in today's postcolonial optic, the idea of the non-public is both pluralised and up-ended, with the result that there are now identified 'new

publics' (*les nouveaux publics*) who are deemed not to be recipients but agents, despite the unfortunate semantic confusion caused by the retention of the term 'public'. Some of the more advanced French policy thinking since roughly the end of the millennium has emerged from this new optic.

One result is a concerted terminological shift from 'cultural exception' to 'cultural diversity' to 'intercultural dialogue'. At the time of writing, this last notion is still in process of translation into a European policy agenda via a Council of Europe White Paper on the theme published in May 2008, so it is too early to do more than generalise about its significance. But there is already a case for seeing it as the latest avatar of the concern with the popular.

As is now well-documented, the concept of 'cultural exception' became explicit at the GATT negotiations of 1993, where France insisted that 'culture' (most importantly in this context, the cultural industries, particularly TV and cinema) should not be subject to international free-trade agreements, meaning that European countries should be allowed to continue with what the Americans see as protectionism. But it was in fact the logical outcome of the Lang ministry's recognition of commercial popular culture, since the government was now obliged to concern itself with the global economy. The meaning of cultural exceptionalism also expanded somewhat to express the idea that the French have a unique commitment to and faith in culture.

But by the end of the 1990s, the nationalistic undertones of this unstable concept were proving counterproductive. 'Cultural diversity' was thus introduced to replace it, with a broader, more liberal emphasis, informed particularly by the anthropology of Claude Lévi-Strauss, on maintaining the rich variety of local cultures throughout the world in the face of rampant globalisation. The notion spread to the wider Europe and developing countries, becoming an identitarian tool with which to resist the transnational free market. Promoted vigorously by France, this more open notion was adopted by UNESCO in 2005 in its Convention on the Protection and Promotion of the Diversity of Cultural Expressions and ratified by a sufficient number of member states (the US was a conspicuous absentee). The Convention (UNESCO 2005: article 2) defined a 'principle of sovereignty' whereby 'States have, in accordance with the Charter of the United Nations and the principles of international law, the sovereign right to adopt measures and policies to protect and promote the diversity of cultural expressions within their territory'.

Clearly, diversity here is a much more flexible term since it implies both the recognition of multiculturalism at home and the need for an

openness to international cultures. And under these two headings, it inevitably validates the popular, the provisional and the commercial alongside the highbrow and the patrimonial, as is clear from the Convention's article 4, on definitions:

> Cultural diversity is made manifest not only through the varied ways in which the cultural heritage of humanity is expressed, augmented and transmitted through the variety of cultural expressions, but also through diverse modes of artistic creation, production, dissemination, distribution and enjoyment, whatever the means and technologies used ...
>
> 'Cultural activities, goods and services' refers to those activities, goods and services, which at the time they are considered as a specific attribute, use or purpose, embody or convey cultural expressions, irrespective of the commercial value they may have. Cultural activities may be an end in themselves, or they may contribute to the production of cultural goods and services. (UNESCO 2005: article 4)

Even so, the notion of diversity has also had its problems. Whereas 'exception' seemed too defensively nationalist, 'diversity' pointed to a multiculturalism with which some countries, not least France with its constitutional commitment to indivisibility and universalism, had problems. Consequently, 'intercultural dialogue' has been put forward as a third conceptualisation, though it was already present to all intents and purposes in the UNESCO convention.

Intercultural dialogue for the time being tends to be the subject of pious generalities, with the 'cultural' usually taken in its very broad anthropological sense. In its White Paper, the Council of Europe (2008: 10), for example, understands intercultural dialogue as 'an open and respectful exchange of views between individuals, groups with different ethnic, cultural, religious and linguistic backgrounds and heritage on the basis of mutual understanding and respect between individuals and groups belonging to different cultures that leads to a deeper understanding of the other's world perception'. But some attempts to distinguish it more clearly from cultural diversity define it *against* multiculturalism. Whereas multiculturalism implies the harmonious coexistence of separate cultures within the same national community, intercultural dialogue is taken to imply 'co-production': mutual contributions from all sides to a common civic culture. It is this element of commonality that harmonises with the idea of the popular, harking back through Lang and Malraux to the early decades of the twentieth century. It is not just that all forms of cultural activity are deemed to have equal value and rights; it is the additional concern with building bridges and constructing a connected, common

public sphere that seems to characterise intercultural thinking. As the UNESCO convention puts it, '"[i]nterculturality" refers to the existence and equitable interaction of diverse cultures and the possibility of generating shared cultural expressions through dialogue and mutual respect' (UNESCO 2005: article 4.8). Intercultural dialogue, then, seems to update the much older idea of a 'popular' culture that, rather than being a class culture, is a common currency, shared and understood by all. This becomes much clearer when the arts specifically are addressed in the White Paper (Council of Europe 2008: 47):

> Public authorities and non-state actors are encouraged to promote culture, the arts and heritage, which provide particularly important spaces for dialogue. The cultural heritage, 'classical' cultural activities, 'cultural routes', contemporary art forms, popular and street culture, the culture transmitted by the media and the internet naturally cross borders and connect cultures. Art and culture create a space of expression beyond institutions, at the level of the person, and can act as mediators. Wide participation in cultural and artistic activities should be encouraged by all stakeholders. Cultural activities can play a key role in transforming a territory into a shared public space.

Even here, though, conceptual difficulties remain. For Ghislaine Glasson-Deschaumes (2008: 19), the notion of dialogue that has been developed in such intergovernmental forums still tends to see cultures too much in terms of ethnicities and religions, and dialogue as therefore taking place between bounded cultures that are homogeneous, entire unto themselves. For the multicultural to become genuinely intercultural, dialogue must be dynamic, interactive and transformative: not simply reciprocity but hybridisation, eradicating any vestige of a crypto-colonial power relation and, in the process, of the binary of high and low brows.

In the context of the arts, the emergence of a Gallic version (or versions) of hip-hop is one illustration of intercultural dialogue at work. French appropriations of anglophone hip-hop entail dynamic, constitutive 'dialogue' between French and American cultures, black and white, and, most significantly, high and low, a dialogue which invents a new national multiculture, a 'hybrid universalism' as Mireille Rosello puts it (2003: 138). Far from recycling the standard anti-Americanisation rhetoric, this in fact amounts to what has been called aesthetic cosmopolitanism, defined as 'the condition in which the representation and performance of ethno-national cultural uniqueness becomes largely based on contemporary art forms like pop-rock music or film, and whose expressive forms include stylistic elements knowingly drawn from sources exterior to indigenous traditions' (Regev 2007: 319).

In France, hip-hop has been absorbed into contemporary dance just as graffiti has become one of the acknowledged graphic arts. The chore-ographer Kader Attou is a case in point. Attou began as a hip-hop dancer and trained circus acrobat who at the age of sixteen formed the Accrorap company in Lyon, later moving to Besançon where the company flour-ished as a 'legitimate' contemporary dance troupe. This legitimation was then crowned in September 2008 when he was appointed by the then Minister of Culture Christine Albanel to head the prestigious Centre chorégraphique de La Rochelle, in the august steps of Brigitte Lefèvre and Régine Chopinot, with Accrorap as the resident company. There, his aims have been to create an international hip-hop training centre and to work with musicians, singers and others in order to throw the Centre open 'to combinations of cultures' (*aux croisements des cultures*). Originally fusing street dance with acrobatics and music, the company now hybri-dises this already hybrid style with classical and contemporary dance (and dancers), to create what Attou describes as 'auteur dance': 'hip-hop is a dance form that has been enriched by other aesthetics, which has acquired its own tools and which constantly evolves by appropriating other elements' (Attou 2009).[20] One striking instance of this boundary-crossing was on show at the July 2009 Francofolies, where Attou and his dancers joined with DJ Zebra to perform a tribute to Michael Jackson shortly after his death, to a mix of 'Billie Jean' and other pop classics by Jackson and others (Attou and DJ Zebra 2009). As practised by Attou, then, naturalised French hip-hop becomes a form of intercultural dialogue par excellence: not an affirmation of multiculturalism – communitarian expressions of static, bounded particularisms; but a popular, dynamic, evolutionary form dialoguing with other particularisms in such a way as to melt boundaries and make its way towards a universal public space.

Conclusion

The question of popular culture in France has been a leaven for cultural and even political change. Institutional engagement with it did not come about *ex nihilo*. While the pleasures and pastimes of the urban working class were thought of for a long time as dangerous, particularist and mediocre, that very representation made them an irritant and catalyst. It led in the twentieth century to a voluntarist aspiration to democratise high culture in order to elevate working-class life-experience and resist the depredations of the new mass practices generated by the cultural industries. From the 1980s onward, these three semantic dimensions

– working-class culture, democratised culture and mass culture – have become harder to disentangle, like the wires behind a computer. Transformed by mass and then youth culture, the nomenclature of the popular has shifted from the particular to the universal. By its ubiquity and constant rejuvenation, mass culture has also absorbed both high culture and the old organic popular cultures (Crubellier 1974). In the process, the stark cultural divide between classes that characterised nineteenth-century French social relations has weakened and, under Mitterrand and Lang, a change in government policies eventually ensued. The Mitterrand era's tactical recognition of commercial arts can in fact be seen as a catalyst but also as a symptom: of the steady infiltration of an ideology of populism and pleasure into the Republic's deeply rooted cultural ideology of civic improvement.

This change has in turn impacted on politics more generally, for example the way politicians relate to the public and vice versa. Today, the popular as a political preoccupation can be detected in institutional and administrative discourses concerned with recognising the equal dignity of all cultural practices, highbrow and lowbrow, and with finding 'cultural' responses (that is, involving 'the arts' very broadly defined) to immigration, multiculturalism and globalisation in a republican-universalist society. It can also be detected in, ostensibly, more trivial ways. Even in the 1970s, it would have been difficult to imagine Kylie Minogue being decorated by a Minister of Culture, as she was in 2008; and more difficult still to imagine a President of the Republic marrying a pop singer and former model, having a taste for 'bling' and a dislike of Classical literature, or addressing a nearby heckler during a walkabout in the ripest language of the street.[21] Clearly, in twenty-first-century France the politics of the popular is proving more protean than ever.

Notes

1 There is little point here in exploring the debate between political economists and 'creative consumptionists', which I shall return to briefly later. A debate between Nicholas Garnham and Laurence Grossberg on the subject can be found in J. Storey (2006: 614–36).

2 Some of the analysis in this chapter draws on work I have published in Looseley 2011.

3 Richard Hoggart was the founder of the Centre for Contemporary Cultural Studies at the University of Birmingham in 1964 and his earlier book, *The Uses of Literacy* (Harmondsworth: Penguin, 1963, 1st edn 1957) was one of Cultural Studies' founding texts. Passeron co-translated it (with F. and J.-C.

Garcias) into French under the dubious title *La Culture du pauvre: Étude sur le style de vie des classes populaires en Angleterre* (The Culture of the Poor: A Study of the Lifestyle of the Working Classes in England). I am indebted to Professor Vincent Dubois (Strasbourg) for alerting me to the significant differences between Hoggart's original and its translation. Although I have not examined these differences further, Brian Rigby's inaugural lecture at the University of Hull (1994) discusses their linguistic and ideological dimensions with considerable insight.

4 As Rioux and Sirinelli point out, Maurice Crubellier's *Histoire culturelle de la France* (1974) and Paul Gerbod's *L'Europe culturelle et religieuse de 1815 à nos jours* (Paris: PUF, 1977) were certainly forerunners in this regard, but, like a number of other scholars in the following decades, they gave only limited (usually chapter-length) accounts of the history of mass culture in France.

5 Grignon in fact queries any simple distinctions between utility and gratuitous stylisation in traditional popular culture: Grignon and Passeron 1989: 41–3.

6 See for example the chapter entitled 'Résistances' in Rioux and Sirinelli 2002: 259–301.

7 'L'existence d'une unité du répertoire français dans lequel une *mentalité française* s'exprime'. My translation. The essay, 'La Beauté du mort', was written in collaboration with D. Julia and J. Revel.

8 The following comments on turn-of-the-century people's theatre are indebted to this monograph, especially Chapters 1 and 2.

9 'Nous pensons qu'il faut donner aux masses de grandes fêtes qui exaltent la conscience populaire aux dates significatives'.

10 'Loisirs sportifs, loisirs touristiques, loisirs culturels, tels sont les trois aspects complémentaires d'un même besoin social: la conquête de la dignité, la recherche du bonheur'.

11 'Notre culture était une culture du langage. Elle transmettait par un chuchotement intérieur, un bruit de voix au plus profond du silence. Mais nous créons chaque jour une civilisation de l'image et de la vocifération. Il n'est pas question de nous refuser aux livres illustrés, à la radio, au cinéma, au pick-up et à la télévision, mais comment continuer à entendre ce qui ne peut être entendu que dans le silence intérieur?'

12 Il me semble indispensable ... que la culture française cesse d'être l'apanage de gens qui ont la chance d'habiter Paris ou d'être riches'.

13 'La culture est populaire par ceux qu'elle atteint, non du fait de sa nature'.

14 'une autre production dissimulée en consommation, une production rusée, dispersée, silencieuse et cachée, mais s'insinuant partout. Elle ne se marque pas avec des produits propres, mais elle se caractérise par des manières propres d'employer les produits diffusés et imposés par un ordre économique dominant'.

15 See note 3 above.

16 'un imaginaire propre aux jeunes'; 'Une catégorie distincte, avec ses codes, ses goûts et son plaisir de voir des êtres de fiction subvertir les règles du jeu social.'

17 'Une histoire, des traditions esthétiques, rythmiques, vestimentaires ... Du

coup, elle touche plus de monde que les seuls jeunes, elle avance en âge, et même assez haut ..., elle s'étend progressivement à toutes les catégories sociales et professionnelles.'

18 The latest edition is O. Donnat (2009) *Les Pratiques culturelles des Français à l'ère numérique: enquête 2008*. Paris: La Découverte/Ministère de la culture et de la communication.

19 This term was originally coined by Francis Jeanson in May 1968, but it has subsequently become, as Ahearne points out (2010: 166) 'a stock reference in cultural policy debates'. I use it here in this 'stock' sense, as a shorthand, rather than in Jeanson's more nuanced and historically specific sense: see Ahearne 2010: 164–7 and 184–5.

20 'une danse d'auteur': 'Le hip-hop est une danse qui s'est enrichie d'autres esthé-tiques, qui s'est dotée d'outils et qui évolue en permanence, en s'appropriant d'autres éléments'.

21 President Sarkozy expressed an unusually negative view of France's first great novel, *La Princesse de Clèves* by Madame de Lafayette. He was also filmed at the Salon de l'agriculture riposting to a heckler who refused to shake his hand 'casse-toi alors, pauv' con', which can be translated approximately as 'piss off then, you twat'.

2

Authenticity and appropriation: a discursive history of French popular music

David Looseley

Introduction

This chapter is about the meanings of popular music in France.[1] Music fans generally believe they know what they mean by 'popular' and 'pop'; but not all of us can readily say what that is. Here, I shall use 'popular' to refer to what are, today, industrially produced forms of music directed at and appreciated by a very large, or 'mass', audience. Such forms do not usually require any conventional musical competence or erudition; and they are easily available on the market. I will take 'pop (music)' to mean something more specific, namely all forms of broadly speaking youth-oriented music that derive in one way or another from mid-1950s American rock'n'roll; whereas 'popular music' will be used more comprehensively, to include jazz, big-band, variety, and so on, in addition to pop. Further issues to do with the meanings of the French epithet *populaire* in the context of music will be unpicked as the chapter progresses.

But my overarching concern in addressing meanings is how, in France from the late nineteenth century to the present day, both nationally produced popular musics and imported Anglo-American styles have been conceptualised, classified and argued about by critics, intellectuals and the music world generally. Scholarly histories of French popular music during this period are still rare, while the fairly numerous commercial histories tend to be unproblematised journalistic surveys of styles and genres. I will certainly refer from time to time to the aesthetic characteristics and strategies that cause certain styles and genres to be popular. But I will mainly do so in order to identify mutating conceptions of the popular or the 'people' embedded in those styles.[2] Hence my term 'discursive history'.

This approach takes 'popular' music to be a rhetorical artefact rather than a stable aesthetic category, and its history, therefore, to be a narrative.

Explicitly or implicitly, popular music is constructed, 'produced', and these constructions change over time. If, as Foucault contends, discourse is a practice, that both defines and produces objects of knowledge by making them mean something, evolving discursive practices may be viewed as competing for power, struggling to be adopted as the 'natural' narrative and therefore beyond question. This temporal struggle for discursive power is, I believe, especially evident in the familiar but elusive notion of *chanson*.

For years, a view common to both francophone and anglophone accounts of French popular music has been that *la chanson française* is a vernacular and quintessentially French art-form (see Looseley 2003: Chapter 4). French pop, by contrast, was long considered of inferior quality and embarrassingly derivative, a graft that had simply not taken. Music journalist Benoit Sabatier (2007), for example, argues that Johnny Hallyday could never compete qualitatively with his Anglo-American models but became a star only because the industry needed local product. This leads Sabatier to conclude unequivocally that 'French rock is a joke' (2007: 39–40).[3] A better argued version of much the same narrative is developed by the academic Larry Portis (2004) in a chapter confidently entitled 'The Poverty of French Rock'n'Roll', where he maintains that 'the advent of rock and [*sic*] roll in France was not a social phenomenon of great depth or importance as it was in the United States or Britain'. This is evidenced, he goes on, in the fact that the careers of already established French *chanson* performers like Yves Montand, Charles Aznavour or Georges Brassens did not suffer from rock's arrival (Portis 2004: 123). Portis's argument, then, is that the importing of rock'n'roll was primarily a marketing strategy, that 'there was no profound aesthetic or social movement dictating the form the new mode of musical expression would take' (ibid.: 127). This does not mean for Portis that demand for it was artificially created, but that the music was not an organic expression of a preexisting cultural need in the way that *chanson* was: 'what distinguished the inception of rock and roll in France was that the merchandising preceded the modification of popular culture. In France, financial interests did not simply exploit the performer-artists, they created them' (ibid.: 133).

There is some force in these arguments, especially when one examines, as we shall, how the burgeoning French music industry operated in the 1950s and 1960s. Yet they raise other questions, which I shall deal with as the chapter progresses. One of these questions, however, needs to be addressed straightaway. Portis (ibid.: 2) takes for granted the standard view that there is a 'cultural uniqueness' which gives French popular music 'a distinctiveness that seems alien and inaccessible [to

anglophones]'; a distinctiveness epitomised in *chanson* and deriving from 'deep-seated cultural impulses and different combinations of social and political conditions', which he examines. What seems to lurk unheeded beneath such bounded terms as 'cultural uniqueness' and 'deep-seated impulses' is a notion of what might be called national-popular authenticity (Looseley 2003). We need to enquire what exactly this authenticity amounts to. In what sense is French popular music actually 'French' and 'popular'?

Today, sociological analysis and Cultural Studies tend to play down the national dimensions of popular culture in favour of the global and the local. In the French case, a global perspective may seem all the more valid given French music's assimilation of international styles, from rock'n'roll or rap to zouk or raï, and of English-language generic categories, from *le music-hall* and *le jazz* in the 1920s, through *la pop(-musique)*, *le disco*, *le funky* and *le rock* in the 1970s, to *la techno*, or *les boys'* [*sic*] *bands*. Yet the business of borrowing is never as straightforward as it looks. The styles and nomenclatures borrowed seldom duplicate their connotations in English, suggesting a cultural reappropriation of the original terminology. Indeed, as Warnier points out (1999: 93–7), studies of globalisation, by isolating cultural products from their local contexts and privileging convergence over difference, obscure the multiple ways in which those products are domesticated and recoded within local communities, by family, church, school, and other institutions. This process of 'glocalisation' is usually taken to involve sub-territorial divisions such as social groups, 'tribes' or regional communities. But in the French context, where the 'national' imperative of republicanism still holds sway, the glocal community may be national, as the institutions cited by Warnier in fact suggest.

This takes us into the question of naming. Like Foucault, Bourdieu argues in his consideration of language and symbolic power (1991) that naming is crucial to the discursive formations that mediate social reality, shaping perceptions of the object named. On this view, the taxonomy of the music, the discourses surrounding it and the way it is valued all become key issues. These issues are, I suggest, especially apparent to the anglophone observer. Francophone studies of French popular music tend to take the discourse of *chanson* for granted, as if it were a shared assumption that need not be interrogated. But anglophones, who bring to their observations other culture-specific taxonomies gleaned from cultural or popular-music studies, can easily trip over this deceptively simple notion, which quite plainly does not only signify words set to music but connotes, in some usages at least, a latent value system.[4]

To help bring out what that system is, I shall take a lead from Simon Frith (1998: 26), who suggests that 'to understand what's at stake in arguments about musical value, we have to begin with the discourses which give the value terms their meaning'. Combining and extrapolating from Howard Becker's model of 'art worlds' (2008 [1982]) and Bourdieu's concept of cultural capital, Frith identifies three discursive practices through which music is heard and evaluated and which produce the terms in which value judgements are made: art, folk and pop. In art discourse, the ideal is music that is serious, transcendent, 'spiritually pure' and 'never secondary to the performer or to the audience' (29). In folk discourse, by contrast, music is valued in terms of its social, communal, integrative function: as the supposedly natural, informal and spontaneous production of communities, even though in advanced industrial societies these virtues have paradoxically to be laboriously constructed. This construction work stands in explicit opposition to 'pop' or 'commercial' discourse, where music is valued as a commodity which offers the experience of pleasure and fun. Unlike either Becker or Bourdieu, however, Frith does not see these three discourses as separate art worlds or as class-specific: rather, they are shared across the high/low boundary and are constitutive of each other (Frith (2006 [1991]: 591). Furthermore, Frith argues (1998: 26), these interdependent practices are 'the effects of specific historical situations': together they constitute a social mapping of musical taste in Western societies from the nineteenth century. For this reason, he argues, cultural historians have often produced better analyses of popular culture than Cultural Studies has, with its 'cavalierly postmodern attitude to the past'. Hence this chapter's historiographical ambition.

Authenticity and the invention of the middlebrow

Chanson as ideology

The term *musique populaire* has not been used in France in the same sense as 'popular music' until fairly recently. In English, as we saw at the beginning, 'popular music' loosely covers all widely enjoyed styles that do not come under the umbrella 'classical', from (some) jazz and folk to the infinite sub-categories of 'pop'; though, of course, the closer one looks at English usage, the more problematic this convenient highbrow/lowbrow binary becomes. In French, however, the more comprehensive, 'Anglo-Saxon' sense of the popular competes with the traditional 'folk' meaning: the pre-industrial musical tastes and practices of peasant and, later, urban workers. Hence a tendency today to use the plural *musiques populaires* to

indicate that its meanings are multiple. Hence too, no doubt, the long-established preference for the term *chanson*, which appears to avoid the confusion inherent in *musique populaire*. In practice, though, the *chanson* category generates more problems than it avoids, for it is neither cultur-ally nor ideologically neutral.

Chanson has typically been thought of as a popular genre – even, as one source puts it, 'the most popular art there is' ('l'art le plus *populaire* qui soit'; Vernillat and Charpentreau 1977 [1971]: 3). But the epithet *populaire* here connotes more than it denotes. For Vernillat and Charpen-treau, it should not be understood in the 'restricted' and 'slyly pejorative' sense found in dictionaries, for in reality *chanson* 'is not the preserve of any class, social group or period. It is a universal art' (ibid.: 3), yet also one that is 'deeply rooted in the history of our country' (ibid.: 117).[5] *Chanson*, then, for these authors is popular not in the supposedly 'pejorative' folk sense but because it is an ecumenical taste characteristic of the nation. And it is in this sense that the almost tautological expression *la chanson française* must be understood. Even today, this expression remains dominant in public discourse. On the occasion of the 2009 Fête de la musique (National Music Day), which took 'fifty years of *chansons fran-çaises*' (*Culture Communication* 2009: 2) as that year's theme,[6] the music journalist Stéphane Davet explained the 'naturally popular and unifying' power of the theme ('un thème naturellement populaire et fédérateur'). *Chanson*, he maintained, distinguishes itself from English-language song by foregrounding lyrics, but unlike in other countries with a similarly 'literary' song tradition, *chanson* also 'reflects French centralism and the fascination that Paris holds' (Davet 2009: 3).[7]

As such statements reveal, *chanson* is at once an aesthetic and an ideological category: it is structured by an art discourse (Frith) and a discourse of national-cultural memory, neither separable from the other. How, then, did it acquire this dual signification? To answer this, we need to examine more closely *chanson*'s literariness: the myth of the lyric.[8] Adapting Frith's taxonomy, the history of *chanson* involves, I believe, a shift from a folk discourse to a compound of folk, commercial and literary discourses best described perhaps as a discourse of the middle-brow. Extrapolating in the 1970s from statistics dating back to the 1960s, Bourdieu (1984 [1979]: 16) describes a 'middlebrow' art (the standard translation of his term *un art moyen*) as 'the most legitimate of the arts that are still in the process of legitimation', citing as illustrations jazz, cinema, 'and even song'. And he describes middlebrow taste as bringing together 'the minor works of the major arts [he cites *Rhapsody in Blue*]

and the major works of the minor arts, such as Jacques Brel and Gilbert Bécaud' (ibid.: 16). He makes an only too clear distinction here with 'popular' taste, characterised apparently by a preference for 'light music', the popular classics, 'and especially songs totally devoid of artistic ambition or pretension' (ibid.: 16) Although as we shall see Bourdieu's classifications smack of essentialism, look distinctly passé today in their rigidity, and were already problematic by the 1970s, they do serve as a starting point, usefully pointing up the especially complex historical status of *chanson*, which needs to be teased out.

The self-conscious chanson

Historians trace *chanson*'s origins to the French lyric poets of the twelfth and thirteenth centuries: the *troubadours* in the South and their northern counterparts, the *trouvères*. Both were initially of high degree and wrote refined verse for the aristocracy about courtly love or chivalry. But vernacular equivalents, the *jongleurs*, did emerge, many of whose works were anonymous and have been lost. Somewhere between these two categories might be placed the wayward poet and thief François Villon (1431–c.1463), regularly cited by singer-songwriters as a historical point of reference. In France much more than England, a tradition also developed for poetry to be set to music (Hawkins 2000: 27–8). The invention of the printing press then gave greater permanence to vernacular lyrics, which were usually set to existing melodies known as *timbres*. These core features largely remained in place until the mid-nineteenth century, placing *chanson* in a folk tradition until that time.

What transformed its social meaning, I suggest, was self-consciousness, an awareness of *chanson* as a genre, with its own formal properties. This awareness developed incrementally, not only among singers and composers but among those working in or with what was to become the music industry: critics, decision-makers, intellectuals, folklorists and – much later – cultural mediators and institutions. The first glimmers of self-consciousness came with *chanson*'s metamorphosis, in the 1840s and 1850s, from an amateur culture *of* the people to a professionally produced product *for* the people.

Various cultural and institutional changes help account for this metamorphosis. After the Revolution, regional cultures were disdained as repositories of particularism and ignorance. But, as elsewhere in Europe, Romanticism's concern for a mythical rural past, including the oral tradition of folk song, produced a desire in intellectual and literary circles to preserve that past in written form. This was followed in 1845 by the

ministerial creation of the Commission for the Religious and Historical Songs of France (*Commission des chants religieux et historiques de la France*). Shortly after Napoléon III came to power, a decree of September 1852, 'Instructions Relating to the Popular Poetry of France' (*Instructions relatives aux poésies populaires de la France*), took up this concern by commissioning the Minister of Public Instruction, Hippolyte Fortoul, to collect the largely oral heritage of popular song. Although it ignored melodies, the survey helped produce an awareness of the nation's folk heritage from which would emerge a series of publications spanning over a century: Champfleury's *Chants populaires des provinces de la France* (1858), Weckerlin's *La Chanson populaire* (1886), and others. Later, informed by successive ideologies – from the Popular Front's promotion of a hearty outdoor life, through Vichy's attempts to reconnect with France's rural identity, to the period of post-war renewal – the anthologies continued unabated: Chailley's *La Chanson populaire française* (PUF, 1942), Claude Roy's *Trésor de la poésie populaire* (1954), and so on.

From the 1850s well into the post-Liberation period, then, the term *populaire* was applied in much the same sense as the English term 'folk', including both rural and urban musics. However, the anthologising of songs began a process of transforming the oral tradition into a written culture. This took place later in France than in Britain, primarily because of intellectual and political resistance to the popular (see Chapter 1) and the concern since the eighteenth century with eliminating patois and dialects (see Chapter 6) in the name of the 'purity' of the French language (Duneton 1998, II: 906–9). Unlike in the USA where fragmented or segregated community cultures grew largely unhindered (Guibert 2006: 109; Rioux and Sirinelli 2002: 54), for the French state in the era of colonial expansion, the will to preserve was part of a concern to centralise and discipline a divided nation, in which the arts, language and education were all enlisted.

French folk songs thus began appearing as primary-school texts in the first two decades of the Third Republic, with their lyrics 'corrected' so that patois and regional varieties could be removed (Duneton 1998, II: 912) and with their melodies notated and reharmonised to respect formal conventions. It had also become fashionable by the beginning of the twentieth century for 'serious' composers (Debussy, Stravinsky, Bartok) to draw on folk melodies, slicing through their popular roots and recasting them for the delight of élite audiences (Guibert 2006: 56). We may, then, detect in the latter half of the nineteenth century the start of an exponential reflexivity: a learned discourse about *chanson* which

intensified consciousness of its significance for national memory. This is arguably the first stage of its induction into the middlebrow.

The state's policy of excising difference in order to fabricate a national popular taste is identifiable also in establishment attitudes to amateur music-making in the form of the various kinds of brass bands (*harmonies, fanfares, cliques*) that during the July Monarchy grew out of turn-of-the-century choral societies (*orphéons*). Bands were encouraged by both secular and religious authorities in order that they might educate, socialise and moralise the working class, the band serving as a metaphor of social harmony (Dubois, Méon and Pierru 2009: 30). A network of outdoor bandstands (*kiosques*) was also set up from the 1850s with similar ideological intent.

All these initiatives, by intellectuals, writers, musicians and the state, sought to pickle a mythical popular-musical past, in reaction to the topical emergence of an urban song culture which was inexorably ousting folk song. From the eighteenth century, song clubs had been appearing in Paris where songwriters could perform their compositions to like-minded club members. The *caveaux* were their earliest form, made up of educated middle-class writers and artists whose songs were characterised by wit, satire and Epicureanism. The first *chanson* 'star', Pierre-Jean Béranger, emerged from this culture. In the nineteenth century, less sophisticated, working-class and more openly oppositional equivalents emerged called *goguettes*, from which new composers arose, in particular Eugène Pottier, author of *L'Internationale*, and Jean-Baptiste Clément, who wrote *Le Temps des cerises* (Cherry Time), both associated with the Commune of 1871.

In the aftermath of 1848 and the return of empire, the political sedition associated with *caveaux* and *goguettes* led to their being effectively closed down in 1852. But alternative commercial entertainments were already becoming available to cater for the urban public's taste for songs and singing. New issues of ownership raised by these commercial settings led to the formation of the SACEM (Society of Music Authors, Composers and Publishers) in 1851, which gave songwriters formal author rights. This began a process of professionalisation and commercialisation which would transform the culture of amateurism and free exchange that had grown up in the singing clubs.

The *caveaux* and *goguettes* prefigured the more 'literary' song of the Montmartre cabaret, most famously Le Chat Noir where Aristide Bruant's fame began, while a more populist form of musical entertainment appeared with the *café-concert*. Le Chat Noir, a bar opened in 1881,

featured poetry readings and song recitals by Bruant and others, together with some puppetry and other acts. In 1885, Bruant, who had debuted in *goguettes* and *cafés-concerts*, took over the original premises and started his own cabaret, Le Mirliton, decorated by Toulouse-Lautrec. Attracting a literary as well as bourgeois clientele, these venues mixed Bruant's own compositions – usually featuring a stereotypical working class and sung in the appropriate accent – with traditional folk songs, symbolist poetry and other arts. All of these cultural associations enhanced *chanson's* literary identity, as did the intimate cabaret setting which allowed a proximity between the singer-author and his select audience, who came to Montmartre for the thrill of sampling bohemian life.

Cafés-concerts were on an altogether different scale. They began in 1848 when itinerant singers started working outside then inside cafés on the Champs-Elysées, and for the first time musicians were hired and paid (Duneton 1998, II: 924). The formula then snowballed in Paris and other cities until the end of the century. The *cafés-concerts* were bigger, rougher, noisier venues than either *goguettes* or cabarets. Together with the SACEM, they took *chanson* decisively towards massification and commodification. And in both contemporary and more recent accounts of this change, a note of regret creeps in, as if something authentic and organically French had been lost. The Goncourt brothers wrote of such venues in 1864: 'For some years now, France has been suffering from a moronic form of St Vitus's Dance. Quite clearly, the intellectual level of the nation has been going down and the French, excessive by nature, are bent on becoming the most imbecilic and feeble-minded of peoples' (quoted in Duneton II, 929).[9] Much later, Dillaz indignantly saw *cafés-concerts* as having 'devoured' the *goguette* just as they in turn would be devoured by music hall, setting in train 'a monstrous process' of market competition (Dillaz 1973: 25).

Certainly, at the *café-concert* there was little of the intimacy of the singing club or cabaret. But a form of song centred on lyrics as well as performance and personality still flourished there. It was only when the English-style music hall ousted the *café-concert* in the first decade of the twentieth century that the lyric-based song was seriously threatened, since in the halls singing acts were mixed with a spread of more spectacular entertainments. In particular, the revue, shaped round a series of tableaux, extravagant costumes, dancing girls and some nudity, became popular at venues like the Folies-Bergères and Le Moulin Rouge.

The music hall, then, marks the second major turning point in the development of *chanson's* self-consciousness and absorption into the

middlebrow: the beginning of a discursive practice still current today, in which *chanson* is defined by what it is not. And it was not music hall. As in the UK, singers were of course integral to music hall and many were happy to work there. But a way of thinking about *chanson* developed which was concerned to define its aesthetic distinctiveness and integrity against music hall. The halls foregrounded the visual and physical in the new dance rhythms of the 1920s, whereas the *caveaux, goguettes, cabarets* and even *cafés-concerts* had all foregrounded the voice (Guibert 2006: 80) and the lyric. This binary thinking would be exacerbated once the halls began featuring a particular kind of dance music sweeping France: African-American jazz, born in the working-class districts of New Orleans at the turn of the century. At this juncture, the opposition between song and dance becomes overlaid with issues of Americanisation, authenticity and ethnicity; and the concern to delineate a specific *chanson* aesthetic becomes more visibly bound up with the definition of a national popular culture.

The English music hall and American jazz were not the first foreign incursions to raise these issues. The accordion, hackneyed metonym of French popular tradition, had in fact been developed in Austria, Germany and England before being brought to France at the end of the nineteenth century by Italian immigrants who, with Auvergnat musicians in the working-class outskirts of Paris, developed the hybrid style known as *musette*, suited to popular dances (*bals populaires*) where men and women could dance in couples. Indeed, as it spread across France the accordion was greeted with dismay by the Church and politicians; and by folklore purists who saw it as a coarse, mass-produced invader destructive of indigenous traditions.

A more extreme clash of identities came when black jazz musicians who had come to France with the American Expeditionary Force in 1917 began performing in French music halls after the Great War. Jazz was then disseminated and publicised much more widely in 1925 when the Revue nègre featuring the young Josephine Baker appeared at the Théâtre des Champs-Elysées. Through her dance styles, at once comically stylised and erotic, Baker exploited and subverted the perceived otherness of black America, and of black women particularly, both scandalising and arousing the predominantly male critics. In our discursive history, she serves to underscore the racialised as well as gendered dimension of *chanson* discourse, in a culture where the Colonial Exhibition of 1931 could still exhibit Senegalese 'natives' in a human zoo at the Parc de Vincennes. As Terri Gordon argues (2004: 39), the cultural meanings of

this 'Black Venus' were a jumble of primitivism and cubism. For the 1920s critic André Levinson: 'there seemed to emanate from her violently shuddering body, her bold dislocations, her springing movements, a gushing stream of rhythm' (cited in Gordon 2004: 42). Through rhythm, Gordon continues (45), Baker 'represented, in the eyes of the [French] public, the return of the repressed, the black continent of Freud, the triumph of primitive and spontaneous instincts over the intellect'.

These reactions help us understand the evolution of *chanson* at this time. Guibert (2006: 81–2) points out that despite the success of cosmopolitan jazz and revue during the 1920s, songs in the 'national' *café-concert* tradition, where the vocal and verbal were more important than orchestration and rhythm, remained popular. Indeed, by the 1930s, *chanson* had outstripped both jazz and revue: despite the initial popularity of Baker's dancing, she was soon identified much more with two songs, 'J'ai deux amours' and 'La Petite Tonkinoise', the first a waltz, the second a fox-trot (Guibert 2006: 82), which were to form the cornerstone of her long career in France. This helps us identify a further step-change in *chanson*'s self-consciousness by the early 1930s. The polarisation of song and dance, words and music, had mutated into a binary opposition between the national and the cosmopolitan, identity and otherness. French popular music had come to acquire two conflicting dimensions: on the one hand, an appealing modernity, even modernism, founded on the new cosmopolitan, hybrid forms of mass entertainment; on the other, a defensive, exclusionary reaction to modernity not unlike the nineteenth-century folklore movement, a 'purist' determination to cling to an imagined *chanson* – now an urban form but coloured by the folklorist's obsession with 'national' authenticity (Looseley 2003). This ambivalence, which plays on the dual nature of song as both written and oral, text and performance, was to have lasting repercussions for *chanson*'s evolution, as it broke free of music hall. By the early 1930s, the halls were in decline due to competition from cinema, causing a rebalancing of this delicate ecology. Aside from establishments like the Folies Bergères, which continue with a fossilised revue format to this day, those halls that survived or were to reopen, as the famous Olympia did in 1954, focused on recitals (*tours de chant*), abandoning or reducing other forms of variety entertainment.

One alternative to music hall for the *tour de chant* was still the much smaller cabaret. Prefiguring the smoky cellars of the post-war Left Bank, the 1930s cabaret continued the literary tradition of the *caveaux*, with singers like Marianne Oswald and Agnès Capri or Marie Dubas performing poems (by Carco, Brecht, Prévert or Cocteau) set to music,

in some cases by contemporary classical composers like Satie or Poulenc (Vernillat and Charpentreau 1977 [1971]: 86–7). However, more radical technological alternatives still were emerging at this time, which were transforming the very nature of venue and performance. The use of the microphone for live performance began in the mid-1930s. Radio, mostly given over to live music, became established, and to a lesser extent records.[10] Technology, then, was altering the relationship between singer and audience and the nature of listening. The sociologist Antoine Hennion (2001) uses the term 'discomorphosis' to describe how, whereas nineteenth-century listeners might only have heard a particular piece two or three times in their lives, the record permitted an entirely new familiarity unimaginable to previous generations.[11] The microphone and radio produced an equally crucial transformation: the microphone by allowing the singer to introduce a wider range of vocal shades and techniques than the single mode of declamatory delivery of a Bruant; the radio by allowing a more personalised, domesticated relationship with singer and song. This new intimacy was to have a major impact on *chanson* and the way it was thought about. In particular, it made possible a closer, more private engagement with lyrics. To this can be added the impact of sound cinema, which regularly brought *chanson* to the screen in the 1930s, creating a visual as well as sonic relationship with singers and transforming a few into icons.

Emerging from this more complex 1930s landscape, two *chanson* stars were to embody and reconfigure it: Édith Piaf and Charles Trenet. By the 1970s, Bourdieu (1984[1979]: 60) had identified both as middlebrow tastes, by virtue of their longevity and consecration. Indeed, both, in quite different ways, were to advance the self-consciousness of *chanson* and the discourse of the middlebrow that was inseparable from it.

Piaf and Trenet

In Piaf, the defensively exclusionary aspect of national cultural memory is made flesh. As represented by Josephine Baker, popular music becomes an exotic, alien experience, formed of dance, sexuality, jazz and cosmopolitan modernity. Piaf's songs, on the other hand, cling to the more melodic, reflective, lyric-based French tradition of the urban folk song. *Chanson* here is about listening or singing along more than dancing. Baker's is a spectacular music of the body; Piaf's a music of the heart and mind. Certainly, the Piaf body too is iconic on stage; but it has none of the fleshy luxuriance and unashamed eroticism of Baker's: it is a body of skin and bone, of classed and gendered suffering.

Almost half a century after her death in 1963, her life story is well-known and her status as popular-cultural icon is constantly being re-imagined, most recently by Olivier Dahan's biopic of 2007, *La Môme*, which reconstructs her life as a national parable. Yet, as the film's very success indicates, she is just as much a metonym of an internationally imagined France. This unique status derives from the fact that embedded in her life and songs – the songs mythifying the life, the life intensifying the songs – is a conception of the popular, originating in the nineteenth century but forced to evolve by internationalisation, social change and technological innovation. Arguably, then, the pleasure that Piaf engendered in the 1930s was nostalgic and commemorative, for her work reacted to cosmopolitan modernity by largely pretending it was not there. In her, *chanson* self-consciously becomes a *lieu de mémoire* (a realm of memory: Nora 1993), erected on what was by this time a trope of 'the people' in the national imaginary, visible contemporaneously in the crime fiction of Georges Simenon, or the films of René Clair and Julien Duvivier that often feature the craggy working-class persona of Jean Gabin (see Chapters 3 and 4). That trope harks back to Hugo's *Les Misérables* and the naturalism of Zola, the earthy songs of the *goguettes*, the *café-concert* and what became known as the *chanson réaliste*.

The 'realist song' is indebted to the work of Bruant and the somewhat younger Gaston Montéhus but is primarily associated with early twentieth-century female performers. Berthe Sylva (1885–1941), Fréhel (1891–1951) and Damia (1892–1978) launched their careers with songs by Bruant or Montéhus but ended up recasting the male rhetoric of social populism as the weepy fatalism and female dependency of the popular romance.[12] Piaf too (1915–63) is of this tradition but at a remove: in her hands it reached its apogee but became subtly self-referential. The 'people' in the Piafian trope are the mythologised poor, sometimes criminal, sometimes canny working-class men and women of Paris at the turn of the century: the era of the *apaches* (youth gangs), the fallen street girl and the ripe speech of the *faubourgs* or 'zone' (the capital's old working-class perimeter). And while there is certainly a sense of place here and an element of topical social observation, the modernisation of the 1930s was already turning the 'realist' model into a stylised generic convention. Consequently, one may glimpse beneath Piaf's success with this trope a besieged cultural nationalism. Her celebration of anonymous adventurers, sailors, legionnaires and other combatants in the colonial forces, in songs mostly written during this period by her Svengali, the ex-legionnaire Raymond Asso, but appropriated by her through the triumphant narrative

of her contralto, reasserts in the shifting post-war world of the 1930s the masculine vigour and stable gender roles of the French empire. Her heroes are manly, terse, often blond with a winning smile, and good in bed; her women are fatally drawn to fall recklessly into their arms. If the world beyond France is present in any of these songs, it is either in the form of an enigmatic, white 'gars du Nord', as in 'L'Étranger' (1934) or 'Le Contre-bandier' (1936), with a lilting accent that adds to his sex-appeal; or of caricatural 'natives': the '*salopards*' of 'Le Fanion de la Légion' who treach-erously attack the outnumbered legionnaires in their fort; or the parody of the maritime adventurer in the form of a simple-minded, scrawny '*nègre*' in 'Le Grand Voyage du pauvre nègre' – significantly one of the rare Piaf songs of the period to be set to a brassy blues accompaniment reminiscent of Bessie Smith.

Once she became an international star, Piaf's most iconic numbers, 'La Vie en rose' (1946), 'Hymne à l'amour' (1949), and of course 'Non, je ne regrette rien' (1960), largely abandoned this national and sociolog-ical locatedness, floating instead in the mid-Atlantic idiom of the torch song. Inscribed within her work, then, is a historic shift from a nostalgic working-class-French particularism to a modern universalism in which a 'popular' song is one appreciated by a sociologically diverse and increas-ingly international audience. Her early songs embody a conception of the popular redolent of the Popular Front; and, both musically and politi-cally, this conception was finished after the Occupation. This 'belated-ness' as Keith Reader calls it (2003: 208), this Proustian reminiscence of a national past, helps explain the pleasure of Piaf even today.

Another singing star whose early career embodied the spirit of the Popular Front is Charles Trenet, though in some ways his work is the opposite of Piaf's lachrymose populism. Trenet avoids retrenchment by absorbing difference, injecting into *chanson* a more outward-looking modernity and freshness. He began his singing career in 1933 in a duo with Johnny Hess, which broke up in 1936. Both were gifted exponents of white American swing. Portis (2004) underscores the neglected impor-tance of Hess for placing swing at the centre of French youth culture; but it is Trenet's solo career, begun when he signed to Columbia in 1937 and released 'Je chante', which interests us here.

First, he renewed the tradition of the singer-songwriter established by Bruant but sidelined during the visual extravagance of 1920s music hall; and in the process, he reinforced the centrality of the well-turned lyric. Second, he updated that tradition by assimilating jazz. Like Piaf, Trenet developed a star body.[13] The youthful exuberance of his live persona as

'the singing fool' (*le fou chantant*), with his comically popping eyes and turned-up straw hat, together with the weightless quality of his voice, were embodied signifiers of the worldview communicated by his witty, tragi-comic lyrics and upbeat sound, where clever wordplay could acquire a syncopated musicality close to scat singing. Thanks largely to this sound, he too found success in the post-war anglophone world, with compositions such as 'Boum', 'La Mer', and 'Que reste-t-il de nos amours', adapted into English as 'Boom', Beyond the Sea' and 'I Wish You Love' respectively. But at home, his impact was to help the lyric-based *chanson* appropriate rather than reject Americanisation and thereby refresh itself. Whereas the early Piaf looked backward and inward to a disappearing popular France, the conception of the popular embedded in Trenet's songs looked forward, outward and upward.

The stardom of Trenet and Piaf is inseparable from the new media (radio, microphone and record) and both of them helped reconfigure *chanson* for the age of mechanical reproduction, paving the way for a new generation to whom that age was already a way of life. Each star also, in different ways, contributed to that generation's most characteristic achievement: the invention and legitimation of what has become known as the 'text' or 'poetic' song, the next stage in the evolution of the self-conscious *chanson*.

The trope of the singer-songwriter

Young post-war singers learnt from Piaf that *chanson* could be a serious, intense, intimate art when it eschewed the frivolity and spectacle of music hall; and that it could elicit affective identification between artist and audience. From Trenet, they discovered the imaginative possibilities of the lyric and how to adapt it to international rhythms and arrangements. Arguably, both influences combined to produce a new, middle-brow conception of *chanson* with its own, more developed interpretation of authenticity.

The post-war generation began their careers in quite different circumstances from their predecessors, despite an illusion of continuity created by pre-war stars like Chevalier, Tino Rossi, Trenet and Piaf (Dillaz 2005: 31–2). Culturally and economically, the Liberation brought reconstruction; and the music business was looking for new talent. 1920s music hall was moribund and cabaret was now identified with the Left Bank: small, poorly lit cellar bars where a singer would have no room for a band, so that self-accompaniment, on guitar or piano, was a virtue made of necessity (Calvet 1981: 71–2). One advantage of this self-sufficiency

was the intimacy that he (less often, she) could foster with his audience; and from it came a new wave of singers who wrote their own material. This is a crucial change aesthetically and commercially. The restricted performance space, coupled with the intimacy and with self-composition, encouraged auteurism: the self-aware expression of a personal worldview, political position or emotion and a self-referential universe or language. And this Romantic auteurist aesthetic soon generated a public expectation which turned it into a genre. Another benefit of performing one's own material was that one no longer had to trail round music publishers in search of new material and accept only what was left after bigger names had taken their pick. Furthermore, income was maximised via performing rights. In America, as Peterson demonstrates (1990: 111), the rise of the singer-songwriter in the 1950s and 1960s amounted to a major structural change in the record industry, as the creative focus shifted from the jobbing songsmith as functionary of a record company. Something comparable took place in France too, where an alternative creative economy concentrating the hitherto distinct functions of singing, playing, composing and lyric-writing proved similarly pioneering (Lebrun 2009: 6). In the process, the singer-songwriter was transformed into a suggestive new trope which continues in modified form today: that of the middle-brow poet-troubadour who symbolically combines the outsider status of Villon, the topical awareness of Bruant and Montéhus, the literary skills of Trenet, and (in some cases) the emotional, self-fashioning qualities of Piaf. The label *auteur-compositeur-interprète* (literally: author-composer-performer), which seems to come into regular use in the 1950s to designate this figure, was abbreviated to 'ACI' – as much, I would suggest, for symbolic purposes as for convenience.[14] It is the trope of the literary artisan and an updated version of Frith's popular-musical art discourse.

Generalising a good deal, ACIs' songs initially lacked orchestral settings and were less obviously swing-influenced than Trenet's, since one effect of a fairly rudimentary self-accompaniment was that arrangement and even melody were subordinated to lyrics. The canonical figures here are Georges Brassens, Jacques Brel and Léo Ferré, with, some way behind, Francis Lemarque, Jean Ferrat, Guy Béart, Charles Aznavour, a little later Serge Gainsbourg, and others. Although the ACI was at first figured as male, a small number of female performers, most notably Barbara and Anne Sylvestre, came into the category, though they are invariably represented differently (Looseley 2003: 68–9).

Unlike most French popular-music figures, the ACI has of late been the subject of academic study,[15] so there is no need here for more than general

remarks. Speaking rather unconvincingly of a 'Left Bank sound', Portis (2004: 98) sees this as continuing the *chanson réaliste* tradition but mixed with jazz and swing. This connection is hard to sustain for long, when the soap-operatics of realist song are contrasted with the diverse musical settings, performing styles and ethical, social and affective content of the text song, and with the irony or humour in much of Brel's, Brassens's and Ferré's work, absent from the realist tradition. Nevertheless, what does arguably link these three artists is not a 'sound' but a performance of middlebrow authenticity. The performance varies a good deal from singer to singer but is epitomised in Brassens. Accompanying himself on an acoustic guitar with one foot placed uncharismatically on a chair, his square features, peasant moustache and palpable discomfort on stage, his endearingly careless attire and homely pipe off-stage, coupled with his colloquial, often vulgar vocabulary both ancient and modern and the witty, ribald content of his songs, all come together as a composite signifier of French sceptical intelligence and artisanal integrity, to which other singer-songwriters aspire and which, in the rhetoric, has been 'betrayed' by *la chanson spectacle*, the purely commercial, 'illegitimate' song which we saw earlier described by Bourdieu as 'totally devoid of artistic ambition or pretension'. Brassens is thus constructed as the anti-star par excellence, his anarchistic worldview and wicked observational humour seemingly distancing him from vacuous celebrity, and at the same time from his own myth. Duneton (1998, II: 930) portrays him as reawakening an implicitly authentic French tradition put to sleep for 100 years by the *café-concert*.

This pared-down model of middlebrow authenticity certainly had a sonic component, but this component was much more varied than the idea of a 'Left-Bank sound' suggests. Brel, Béart, Ferrat and others began by accompanying themselves on guitar, while Ferré and Barbara were pianists. Brassens himself never departed from this formula, while others did. As his career developed, Brel opted for more emotional orchestration closer to Piaf's post-war style, while Ferré produced his own symphonic arrangements in his later work (Hawkins 2000). Others again, like Claude Nougaro or Gilbert Bécaud (not strictly an ACI since he did not write his own lyrics) took Trenet's route into swing and jazz.

This evolution towards new arrangements and instrumentation was the result of the new resources furnished by commercial success, technology and the media. The post-war ACIs began their recording careers in the era of the 78rpm. But in 1947, CBS brought out the first vinyl 'long player' (LP), which played at 33rpm, followed in 1949 by RCA's 45 rpm, which became the industry standard for the single or EP (Extended Play). Vinyl

records and the Teppaz portable record player went on sale in France in the mid-1950s. Among the many advantages of vinyl were better sound quality and in the 33 rpm a much longer playing time. No longer restricted by the 3-minute format of the 78 rpm, singer-songwriters could be more expansive and experimental in expressing themselves: the LP brought the record closer to being an *œuvre* (Dillaz 2005: 59). When Jacques Canetti offered Guy Béart a record deal, Canetti insisted on an eight-track, 25cm record rather than a 45 rpm, 'because you're a songwriter' (ibid.: 60).[16] By the late 1950s, portable transistor radios were selling fast and the number of radio stations playing records was growing, notably with the launch in 1955 of Europe No. 1, broadcasting from outside France. By 1960, then, France's music industry had been revolutionised, albeit later than America's and Britain's, as records took over from the simple form of sheet music known as the *petit format* as the primary means of disseminating popular songs and measuring success.

As with radio and records in the 1930s, these industrial changes help explain, in tandem with the culture of the word which had dominated education since the Revolution, the popularity of the text song. Advancing the domestication and personalisation of listening, they established a successful national tradition of the commercial art song where artistic integrity was (in theory) guaranteed by a perceived identity between singer and song. This did not automatically disqualify anyone who did not conform to the model. Piaf, identified more with the songs of others than with her own (numerous) compositions, acquired in the public imaginary the same gloss of authenticity by virtue of her repertoire being written, from Asso onward, to reflect her persona and biography. But the ACI trope in this flexible form did enrich French *chanson*'s sense of its own exceptionalism, in defensive opposition to the perceived otherness of 'cosmopolitan' or industrialised musics and dance forms. However, this representation of *chanson* as a 'legitimate', authentically national popular art did not spring up spontaneously when the big three's careers took off. Rather, it was sculpted in the 1960s in response to the formative revolution of American rock'n'roll.

Rock comes to France

When rock'n'roll reached France in the late 1950s, the French music industry was still quite distinctive in comparison to that of the USA. Three related factors may account for this. The first is state voluntarism which, although it had not yet evinced much concern with music specifically (and certainly not popular music), did reinforce and prolong the

prevailing social construction of culture in terms of a high-low binary. The second is that, before the arrival of vinyl, records had been slow to compete with the music-publishing branch of the industry. In the US, a profusion of separate popular-musical cultures had developed organically and independently, as a result of minimal state intervention, 'racial' segregation, and the blossoming of a record industry as early as the 1920s. This had generated a healthy independent record sector sustained from the 1950s by a proliferation of equally independent radio stations which began playing records (Peterson 1990: 105–6). This mosaic of subcultures drove production forward in the 1950s, largely by means of constant hybridisations – most notably the fusion of white country music with black rhythm'n'blues that would produce rock'n'roll. In France, on the other hand, a comparable blossoming of the industry did not begin until the arrival of vinyl. Centralisation in the form of linguistic 'normalisation' (see Chapter 6) and various other interventions to preserve, regulate and improve popular culture, had hampered the growth of a similarly rich humus, reducing the French industry's potential for growth. Even so, the state did not see fit to intervene in live popular music to the extent of altering its commercial status. Indeed, a decree of 1945 made it clear that live performance was unequivocally a for-profit enterprise (Guibert 2006: 102–3), and the creation of a Ministry of Cultural Affairs in 1959 concerned only with high culture did nothing to change this.

This points to the third factor, which was a process of commercial normalisation by the still blinkered French record business. Characteristically, the policies of that industry were defined by the *directeur artistique* (artistic director), a distinctive figure of the French industry whose job was to promote new artists and sign them to a record label. Until the mid-1960s, when *directeurs artistiques* began turning themselves into independent producers as the recording sector evolved (a process which had happened a decade before in the USA: see Peterson 1990), they were usually employed by record companies. While a few – like Jacques Canetti (Polydor, then Philips) or Boris Vian (Philips/Fontana and, briefly, Barclay) – were enlightened, most were driven by the conservative conventions of *la variété française* (French commercial music, purely for entertainment[17]) into which creaking categories even the most ambitious artists like the ACI were squeezed. The spread of television in the 1960s only aggravated matters, as shows like *Discorama* and *L'École des vedettes* (School for Stars, the first TV show to feature Johnny Hallyday, in 1960) began a tradition still dominant today of the TV spectacular modelled on variety (Guibert 2006: 126–7).

As a result of these three factors, the music business in France was less supple than the American and less equipped to respond to youth-oriented rock'n'roll. While the state and the other traditional organs of legitimation (the press, education, the arts) reacted to rock with patronising disapproval or moral panic, the industry, excited by the new market opportunities but convinced it was another short-lived dance craze, lacked the vision to do more than squeeze it as quickly as possible into a recognisable variety niche. All the more so since amplified rock bands were ill-suited to the French music-hall convention of having all live solo singers accompanied by the same, unamplified, house band (Guibert 2006: 125). In this way, early teen stars were deftly separated from their backing groups and steered towards more standard showbiz careers. In the exemplary case of Hallyday, whose recording career began in March 1960, the makeover was already under way by the end of 1961. Certainly, the process echoed what Elvis Presley himself had undergone; but the distinctiveness of the French case came from the speed and hamfistedness with which the machinery of sanitisation – *récupération* in French – was set in motion. It is this that persuades Portis that early French rock'n'roll was a top-down marketing strategy rather than the bottom-up youth-cultural phenomenon it had been in the USA.

He is right to an extent. For much of the 1960s, electric guitars were hard to come by; radio was *chanson*-dominated, with few shows playing Anglo-American records (José Artur's 'Pop Club' was a celebrated exception), and few shops stocking them (Sabatier 2007: 77). There is also a case for saying, as we saw in Chapter 1, that it was New Wave cinema and comic strips (*bandes dessinées*) that were the primary preferences of culturally active French youth at that time (ibid.: 76–8), though the slick mood music featured in Demy's *Les Parapluies de Cherbourg*, Truffaut's *Baisers volés* or Lelouch's *Un homme et une femme* was a far cry from teen pop. Similarly, text song too might be seen as a dominant of youth culture in the 1960s, where better educated young people were concerned.[18] Certainly, Brel, Brassens, Ferré, Ferrat and others continued to be commercially successful in the 1960s. And, as I have argued elsewhere (Looseley 2003), negative reactions to rock and pop were mediated though the combined art and folk discourses at work in representations of *la chanson française*.

From the 1960s, therefore, *chanson* became more explicitly middlebrow. It was palpably segregated from the 'illegitimate' *variétés* by its literate, audible lyrics in the national tongue and by the decorous melodies and rhythms tailored to underscore them. More explicitly than with Piaf,

it came to signify emotion tempered by intelligence, the primacy of the head and heart over the body. This ultimately is the symbolic meaning of the now standard construction of Brel, Brassens and Ferré – three very different artists in fact, who rarely met – as an iconic triumvirate, the one and indivisible republic of song (Looseley 2003: Chapter 4).[19] And if text song was seen as authentically French by cultural gatekeepers, Anglo-American pop could only be viewed as 'other', just as Baker and *la Revue nègre* had been in the 1920s, albeit without the same directly racialised element. Pop was inauthentic and lowbrow: a foreign, manufactured, barely literate product of American industrial capitalism; it was everything that *chanson* was not. Nevertheless, the story of pop in France from the 1960s to the present is in fact one of gradual appropriation and transformation into a more rooted, more organically French popular culture.

Appropriation and the reinvention of the lowbrow

The meanings of yéyé

What I have just examined are primarily adult representations of pop at the time. Equally significant is the reception of the music by those for whom it was intended, the baby-boomers reaching maturity in the late 1950s and 1960s. The social perception of teenagers before pop was as adults in the making, going through the biologically unavoidable but temporary phase of puberty. Hence, the powerful attraction for adolescents of an Anglo-American culture where a teenage identity had already taken root. Assisted by this culture, around the end of the Algerian war (1962), French youth began, without entirely realising it, to develop a social construction of its own.

The historical reasons for the development of youth as a socioeconomic and sociocultural category in France are well-known: the baby-boom, three decades of economic growth (*les Trente Glorieuses*), the rise of a consumer society and the new audiovisual technologies, urbanisation and the establishment of the first suburban housing estates, which had the effect of bringing together hitherto scattered schoolchildren and young workers in an urban crucible. These factors were steadily developing their cultural autonomy; and then, cause and effect of that autonomy, came rock'n'roll.

As the sociologist of youth Pierre Mayol writes of the 1960s (1997: 166), 'in its simple, unanimist rhythm, rock confirmed the shift from a society founded on kinship, in which the dominant role was the father's, to one based on parity where the central figure was the group of mates.'[20]

At first, Mayol continues (ibid.: 166), rock was represented as a deviant, male, working-class, and therefore particularist phenomenon associated with housing estates and suburban garages. But it was swiftly universalised, and anaesthetised, by record companies, whose commercial imperatives turned it into a more consensual pop music known as *le yéyé*. This was rock washed, brushed and feminised, both by new female performers like Sheila, Sylvie Vartan and Françoise Hardy, and by more androgynous male performers like Claude François, whose impish looks contrasted with the proletarian build and rougher-hewn physiognomy of Hallyday or Eddie Mitchell.

Yéyé has been consistently disparaged in France over the decades as lowbrow, inauthentic and Americanised. After all, the lived culture of a French teenager in 1960, male or female, had little in common with the founding myths of American rock'n'roll: individually owned cars or motorbikes, pocket money or a temporary job, greater romantic or even sexual freedom. But *yéyé*, I believe, is more organically important than this might suggest. Certainly, by the mid-1960s, many aficionados of youth music had developed a notion of authenticity founded upon what might be called national purity: a preference either for Anglo-Saxon originals or for *chanson française*. Nevertheless, *yéyé* may be interpreted as a first, modest step towards a different conception of authenticity. Songs originally in English were not translated into French so much as linguistically and culturally transposed, often with some skill. And, as the magazine *Salut les copains* shows,[21] young fans often preferred Anglo-American hits in this mediated form. Furthermore, original songs in French in the pop style began to be recorded. As a result, *yéyé* steadily acquired a more rooted cultural meaning. In an embryonic way, it became a vehicle for appropriation and even *métissage*. Evidence of this can be found in the successful post-*yéyé* careers of Michel Polnareff, Jacques Dutronc and Françoise Hardy, for example; but chiefly, perhaps, in the esteem held today for Serge Gainsbourg, who in the mid-1960s began playfully hybridising the aesthetics of *chanson* and *yéyé*, as in his Eurovision winner of 1965, performed by France Gall, 'Poupée de cire, poupée de son' (Wax Doll, Rag Doll), whose lyric already displays a striking degree of pop self-referentiality.

An element of appropriation is also identified in the famous analysis of *yéyé* by Edgar Morin (1963) written after la Fête de la Nation of 22 June 1963 organised by *Salut les copains*, an outdoor pop concert which became the apogée and swan song of *yéyé*. As in his earlier essay on Hollywood (*Les Stars* 1972 [1957]), Morin is far from blind to the massifi-

cation and fabrication of the new youth culture, but he is more aware than others of its complexity: that it is at once a fabrication and the organic expression of a profound cultural shift. *Yéyé* is not simply the industrially imposed music that Portis sees. On the contrary, the alterity of its sounds, gestures and worldview is a vector of the alterity of youth itself in the eyes of adult society. Thus, while recognising in *yéyé*'s ephemeral wildness a cathartic preparation for the docile life of the adult consumer, Morin also detects a version of what Cultural Studies would later call a 'subculture', though one less marked by class. For him, *yéyé* was a subculture insofar as it was composed of 'the expressive forms and rituals of those subordinate groups' (Hebdige 1979: 2) whose styles and tastes express values that challenge dominant bourgeois culture. But it was the expression of values specific not to a social class but to an age class (*une classe d'âge*); and he calls those values *copinisation*, after the radio programme and magazine (since a *copain* is a 'mate', *copinisation* might be translated with comparable awkwardness as 'matification').

Copains believe in an eternal present and they have learnt to live this belief in a ludic, communitarian mode which, for Morin, carries one loose meaning: '"we, the young, aren't crumblies", as if their youth had an unalterable, inalienable quality, as if the problem it posed were not the very fact of growing old' (Morin 1963: 12).[22] And the live music and dancing specific to this subculture are homologous with this relentless cleaving to a bodily present: 'what frightens [the adult world] is the exaltation without content. For there is indeed a gratuitous frenzy triggered by the rhythmic singing, the "yeah yeahs" of the twist … In the rhythm – this chanted, syncopated music, these cries of yeah yeah – there is a form of participation in something elemental, biological' (Morin 1963).[23] And this desire for the physical and elemental, this 'message of ecstasy without religion, without ideology' has 'come to us via a prodigious injection of black energy, of uprooted negritude, into American civilisation' (Morin 1963: 12).[24]

While today this equation of the African diaspora with primitivism and rhythm sounds dubious to say the least, in *Les Stars* Morin briefly highlights the equally central role in French youth subculture of a white icon: James Dean. And I would argue that Dean is a vital link in the appropriation of American mass culture by French youth. The very first baby boomers were not yet ten when Dean was killed in 1955 (Sirinelli 2003: 190). Yet seven years later, *Salut les copains* published substantial extracts, spread over three issues, from a biography of Dean by Yves Salgues (1957). How can this prolonged interest in a dead movie star be understood? Here too, I believe, it is a question of authenticity.

Of course, Dean's patina of authenticity can be explained first by the tormented young rebels he played and by his dying young and glamorously in a speeding sports car. Coinciding thus with his screen persona, he took his first step towards becoming an icon of youthful integrity. But for him to become fully mythic for French youth, a series of other mediations were arguably needed. One of these was the French title of *Rebel Without A Cause*, translated as *La Fureur de vivre* (roughly, Passion for Living), which conveys a quite different meaning from the original: the desire to live with an intensity that requires the risk of death. A second mediation was Presley, who took up Dean's iconic authenticity but shifted the myth from cinema to music, at the same time associating it with a black-white intercultural hybrid. And a third mediation was Johnny Hallyday who, bearing a physical resemblance to Dean and copying Presley's movements on stage, gallicised this hybrid. And the final mediation was the renewal of the Dean myth by *Salut les copains*'s serialisation of Salgues's book, written in French. With each link in this chain of mediations, the mythification of Dean as authentic because unable to age or compromise, is intensified and, via Hallyday and Salgues, gallicised.

Morin's readings of 1960s youth culture especially alert us to the complexity of its meanings, poised between an adult, pacifying mass culture based on bourgeois individualist pleasure ('le jouir individualiste bourgeois', Morin 1963: 12), and an incipient revolt against the contemporary adult world. Although he does not say as much, this revolt may be read as a less slavish, more appropriative subcultural response to mass culture. While he sees the first of these meanings of *yéyé* as dominant in 1963, he does not exclude the possibility that the second, revolt, might one day seize the time. At one level, the events of May 1968 were the realisation of this possibility.

From 1968 to disco

The fragile balance between subcultural revolt and its 'recuperation' in the form of docile consumption was to become a dominant theme of early French writing on popular music in the 1960s and 1970s. Youth music was not explicitly implicated in the May events, because the most radical student protestors, mostly drawn from the oldest baby-boomers, rejected *yéyé* and its offshoots. As rock journalist Alain Dister comments, the problem such Leftists had with pop was pleasure (Sabatier 2007: 82). Marc Zermati, one of the fashionable urban set known as *minets/minettes*, an approximate equivalent of UK mods, describes how he was unable to persuade Cohn-Bendit and others that 'to get all young people

working together, the best, most explosive medium [was] rock; but they were into their boring bloody theories' (quoted in Sabatier 2007: 80).[25] In paternalist, Gaullist France, he goes on, the young simply did not know how to build their own culture.

Zermati is only partly right. The long-term meanings of May certainly proved not to lie in the extreme leftism of Cohn-Bendit. But they did lie in the revelation of the collective identity and potential power of youth; and in this regard *yéyé* had undoubtedly sown seeds. In the five years following 1968, further ground was cleared for the emergence of a French youth culture which was more in tune with the outside world and of which popular music was the agent. Commercial imitations of Anglo-Saxon pop and rock still prevailed but, from the innocuously dissident Antoine, Michel Polnareff and Jacques Dutronc in the mid-1960s – all outgrowths of *yéyé* – to the *soixante-huitard* Renaud and the professional controversialist Serge Gainsbourg in the mid-1970s, the creative appropriation of Anglo-American pop did steadily help produce a more organic youth culture in France.

Appropriation, however, was not just the work of musicians. More important was the mediation of Anglo-American pop culture by civil society. One key mediation was the more sophisticated youth press that emerged in the mid-1960s, beginning with the monthly *Rock&Folk* (1966), followed by *Best* (1968) and *Actuel* (1970). Of these, *Rock&Folk* had the biggest impact, democratising rock in a way that the new Ministry of Cultural Affairs under Malraux, committed to 'democratisation', declined to do (Sabatier 2007: 129). As rock steadily grew from pop, *Rock&Folk* helped make it a force for cultural change in a France where young people were still devouring *SLC* and the charts were still dominated by Brassens, Hallyday and Mireille Mathieu, not to mention Maurice Chevalier with his version of 'Yellow Submarine' (Sabatier 2007: 123). By 1970, both *chanson* and *yéyé* were dismissed by *Rock&Folk*, and popular music was splitting into a new binary: on the one side, the Anglo-American, avant-garde 'rock' being promoted by the magazine (Sabatier 2007: 122–5); on the other, a quasi-official culture where juvenile and adult tastes (symbolised in Johnny and Brassens respectively, fast becoming 'national treasures' in their own ways) began to be represented together as consensually 'French'.

As Americanised pop and rock became more established in France, what this culturally more ambitious, less teen-oriented press helped produce was an audience with a more literate, reflexive understanding of the music and a more international palette of tastes, as new global forms and French appropriations of them took off from the 1970s to the present.

The history of French popular music over the last 40 years thus becomes a narrative of its appropriation, hybridisation and segmentation into an ever more complex mosaic of genres, sub-genres and tastes.[26] In what became known in the 1970s as *la nouvelle chanson française*, for example, text song encountered pop or folk-rock in the work of a new generation of 1970s ACIs who had been brought up with both: Jean-Jacques Goldman, Renaud, Francis Cabrel and others. Another 1970s illustration was punk which, as understood in the UK or the USA, did not produce many direct disciples in France but did generate an independent, DIY record sector which in turn produced further waves of generic subdivision and *métissage* (cross-fertilisation) in the 1980s and 1990s, ever more remote from punk itself. There was also disco (see pp. 73–4), and home-grown hard rock: *le rock français* (Téléphone, Bijou, Starshooter, etc). In the 1980s and 1990s came indie rock (*le rock alternatif*), rap and world music; and in the 2000s, boy bands (*les boys bands* in French), R'n'B, reality talent shows, and so on.

This process of apparently infinite segmentation makes the development of French popular-musical tastes up to the present impossible to chart any further in a single chapter, other than in the kind of broad sweeps facilitated by the Ministry of Culture's surveys of French cultural practices, the most recent published in 2009 (Donnat 2009). Since the 1970s, the surveys have identified a 'musical boom' and 2009 is no exception. All age groups now listen to more music than they did in 1997, measured in terms of daily listening (Donnat 2009: 120). While the under-55s generally prefer '*le rock*' (no doubt in its broad sense, which comes close to 'pop') to 'classical', even today's oldest age-groups like rock more than their predecessors of 1997 did. This is because of a 'generation dynamic' (Donnat 2009: 121) which the surveys have persistently identified over the decades whereby the musical tastes formed in youth are carried into middle and late-middle age; though one caveat to this is that the taste for songs in English diminishes with age in proportion as the taste for songs in French increases, rising steeply in those over 35.

However, beyond such broad trends, what becomes most evident when the survey asks respondents to name their favourite musical genre without the aid of a pre-established list is the fragmentation of tastes (Donnat 2009: 132). More than sixty genres are cited in 2008, scarcely any of which attract more than 10% of preferences. The exceptions, significantly, are *variétés françaises* and *chansons françaises* which when grouped together come top with 33% of respondents citing them as their favourite genres and 62% listening to them most frequently, and across all

age ranges except the 15–19s (ibid. 132–3). These two French-language categories also have the lowest rejection rate (never listened to/do not like), at 13%. The next category down, *variétés internationales*, comes out much lower on all counts: only 9% cite it as their favourite genre, 34% as most listened to, with 10% rejecting it altogether: fractionally more than those who preferred it. What this mosaic of tastes demonstrates is, first, the extent of generic confusion today. *Variétés internationales*, including R'n'B, are spontaneously cited as a category by some, yet 'rock' and 'pop', 'métal' and 'hard rock', and 'rap' and 'hip hop' are each cited as alternative categories by others, without any indication of whether they were 'international' or not. Two things are clear, however. One is that *chanson* as a distinct generic category still has currency against all other genres, including *variétés françaises*. But the other is that Frenchness, which in fact brings *chanson* and *variétés* back together again, has an even higher profile, a point to which I shall return in my concluding remarks.

The music boom since the 1970s has also entailed an increasingly active, participative, even creative relationship with professionally produced products, especially given the new digital technologies which, Donnat indicates (2009: 189–203), have transformed amateur practice by creating new forms of expression, albeit at the expense of more traditional ones. Disco was an early case in point. The club culture of disco in the mid-1970s embodies Bakhtin's 'carnivalistic life' discussed in Chapter 1. It is a form often neglected in French music histories, or represented as a short-lived, lowbrow descendant of *yéyé*, by which *la chanson française* was threatened but which it survived. The important elements of disco for the history of appropriation are communion and collective participation in the club experience. In Paris, one especially popular venue for carnival culture was Le Palace, significantly a converted theatre and music-hall, where gay and straight cultures mixed and flamboyant dancing and fashion dominated. Here, disco was communal performance par excellence. One of its habitués was Roland Barthes, for whom 'Le Palace is not just a business but a work: those who conceived it can justifiably consider themselves artists' (quoted in Sabatier 2007: 225).[27] Barthes highlights how dancing to disco music translates the ancient notion of carnival into a hedonistic form of popular creativity, where self-performance turns each individual clubber into a postmodern conceptual artist. Gilles Lipovetsky (1983), writing about Le Palace some years after Barthes, arrives at a similar conclusion, but he also makes clear that the 'hypertheatricalisation' which characterises the eccentric dress codes, dance styles and behaviour in the club creates a permanently humorous distance which 'hijacks' (*détourne*)

or reappropriates the traditional cultural meanings of both the former theatre building and the sophisticated night club (1983: 244). Everything and everyone becomes a polysemic spectacle, where extravagant outward appearance is a means not of being noticed but of self-discovery. The discothèque, we may say, strips the festive of its post-68 leftist ideology and brings it round instead to Morin's bourgeois individualist pleasure: a narcissistic, self-justifying celebration of consumption and pleasure.

Also important was the fact that disco, reversing the standard pattern of Americanisation since the late 1950s, had European origins which Anglo-American youth culture had absorbed. This has in fact led to a further complexification of the overlapping *chanson*/pop and song/dance binaries. On the one hand, the disco craze led some established *yéyé* artists – Sheila, Sylvie Vartan, Claude François – to reconfigure themselves as disco stars and produce dance albums in English. On the other, the young *chanson* artists who emerged at the same time (Renaud, Goldman et al.) were intent on embracing pop while producing well-crafted lyrics in French. Indeed, a campaigning movement began to preserve *la chanson française* that would eventually lead to the radio quotas of the 1990s.

To complexify the binaries further, the success of 1970s disco would eventually lead to dance music being represented as a distinctive strength of French popular music, just as *chanson* has been. This discursive formation came to fruition in the late 1990s with techno, disco's progeny, where an even more narcissistic discourse of the hedonistic body than at Le Palace is discernible. This contrasts with rap where, surprisingly perhaps, one finds a more conventional *chanson* discourse. Such contrasts arguably represent the latest vectors in the *chanson*/dance binary today.

Rap and techno

Rap and techno (or *la house*[28]), two major innovations of the 1980s and 1990s, are both forms in which claims for an essential popular Frenchness have been foregrounded. Hip-hop[29] reached France around 1983 and has acquired huge popularity among the young, particularly as the expression of minority-ethnic youths in disadvantaged suburbs. Causing controversy in the cultural and political establishments because of its political or violent content, not to mention its reshaping of the French language, rap music's impact echoed the arrival of rock'n'roll. Yet hip-hop settled in much more quickly and, apparently, naturally. According to Gilroy (2006 [1987]: 58), it 'exported to Europe the idea that black communities in the inner city, particularly the young, could define themselves politically and philosophically as an oppressed "nation" bound together in the

framework of the diaspora by language and history'. There was therefore in hip-hop the potential for a new identity politics for young urban immigrants which helps explain both the speed with which it took off in these communities and the official hostility to it.

Yet rap music was soon assimilated into a more conventional *chanson* discourse and thence into a new cultural establishment. This was partly due to the usual process of 'recuperation', as rap artists signed to major labels. But it was assisted by the trajectory of MC Solaar on the one hand and by the state on the other. The importance of Solaar's work for our purposes lies in its polished, 'literary' qualities, the intertextual referencing of canonical writers, and its engagement with contemporary society. In this way, Solaar has served as a discursive space where contemporary youth culture can be represented as continuing the tradition of the troubadours and Villon, who, as we saw, were the legitimating historical references for *chanson*. The political advantages of this parallel did not escape the Minister of Culture, Jack Lang (see Chapter 1). He had worked from the outset to integrate popular music into the sphere of state aid and was quick to adopt hip-hop as his latest *cause célèbre*. He and his Gaullist successor Jacques Toubon were instrumental in introducing the radio quotas in 1994 which proved particularly helpful to hip-hop, prompting for example the commercial radio station Skyrock to switch to a largely rap playlist. While thus being assimilated commercially, rap was absorbed rhetorically into the national-popular *chanson* by virtue of its emphasis on lyrics.

Although it would probably be premature to describe rap as a new middlebrow, this rhetorical absorption has certainly helped it ride out the kind of scandal caused by the inflammatory lyrics of acts like NTM in the 1990s and Sniper in the 2000s. But, as Sabatier argues (2007: 510), it has simultaneously weakened rap's status as a subversive subculture for young suburban immigrants. Sabatier is right to signal this transformation, though one is struck by the simplistic purism of the conception of 'authenticity' that he implies: with no explanation, he appears to suggest (2007: 512) that a music emerging from a black particularism can only remain authentic if it remains black and particularist. Hence, perhaps, his favourable treatment of techno, which began to challenge rap as *the* subversive music of youth in the late 1990s.

For the celebrated techno DJ Laurent Garnier, techno was 'the last musical revolution of the twentieth century' (quoted in Sabatier 2007: 434).[30] Sabatier too, a journalist on the magazine *Technikart*, sees it as a radical new counterculture which gratifyingly restored the generation

gap of the 1960s and which he links back through punk to situationism. This is certainly true within techno's own self-fashioned myth, but in reality it is only half the story. Techno saw itself as radical musically, philosophically and socially. Like disco and punk, it was a music that sought to break with the commonplaces of *chanson*, pop and rock, with the DJ represented as a new kind of postmodern creator: not necessarily a musician but one who, like Marcel Duchamp or Pop Art, appropriated the ready-made, in this case using computer technology. Even more than with disco culture, in the DJ the line between amateur and professional, creator and consumer, the musician and the 'people', becomes blurred.

Philosophically, techno was, again like disco, founded on person-alised physical pleasure. For Christophe Monier, techno artist and writer, what was at stake was the ambition 'to reconcile the West with the body' ('réconcilier l'Occident avec le corps'; quoted in Sabatier 2007: 428). Socially, techno saw itself as moving beyond the classic socio-economic, gender and ethnic particularisms: 'Dance music has always been subver-sive. It's the only music that isn't ethnic. It advocates the mixing of races, classes, styles, ages, genres and sexes … Liberating the body, liberating spirituality, these are universal causes' (Monier quoted in Sabatier 2007: 432).[31] This universalist narrative is not of course peculiar to techno: the claim has been made for various pop musics as far back as rock'n'roll. But where techno is concerned, it is founded, again without much originality, on dance culture and especially the rave. Here, techno discourse becomes more complex and potentially contradictory since, as I have argued else-where (Looseley 2003: 193), there is a shifting dialectic between narcis-sistic individualism and collective communion. In terms not dissimilar to Morin's, dancing at a rave, especially under the influence of drugs, is depicted as a rediscovery of the body and descent into the self, incar-nated in the rave convention of dancing on one's own, without an iden-tifiable partner. Yet, that dancing is also done alongside others and is to that extent social, close to what Maffesoli (1988) means when he argues that contemporary individualism is being replaced by an 'être-ensemble', a 'being-together'. The rave and the music that underpins it in fact imply a new, ephemeral form of popular-cultural community; or, as Shusterman writes: 'the feeling of a new and ephemeral group identity which can be formed and disappear in the space of one night of music or even a few minutes of dancing' (quoted in Looseley 2003: 195).

This perhaps accounts for the peculiar discursive uses to which techno has been put since its French version became internationally successful through such performers as Garnier, Daft Punk and Air. Supposedly

subversive and anarchic, it has actually proved surprisingly adaptable in its more commercial avatars to various forms of national-popular discourse, and particularly to being cast as somehow distinctively 'French', all the more so when non-French commentators have suggested that 'the French' have proved particularly good at techno. Such external perceptions were of course gleefully internalised via the industry tag 'la French Touch'. The French state too adopted the term, which soon began appearing in the discourse of the Ministries of Culture and of Foreign Affairs and in the activities of the various French Music Bureaux abroad. The Centre-Right government of Jacques Chirac's presidency had done its best to quash rave culture because of its associations with drugs and civil disorder. But when the Socialists were in power between 1997 and 2002 (still under Chirac's presidency), a new Minister of Culture, Catherine Trautmann, seduced by techno's export record, sounded a more positive note by stressing the artistic creativity of the DJ. The rave was similarly seductive insofar as it could be conscripted as the latest expression of a carnivalesque conception of popular culture, reaffirming a new polyvalent oneness in the twenty-first-century postmodern nation.

The introduction of radio quotas from 1994, designed to protect the French language in contemporary music, brought out another ambivalence in techno discourse. The quotas did techno no favours, since it is mostly instrumental. This produced a debate between free-market economics and national protectionism which revealed a bewildering postmodern politics, as this supposedly revolutionary counterculture turned into the mouthpiece of neo-liberalism lambasting market distortion. What this discursive confusion around techno points to is the process of increasing complexification of the *chanson*/pop, lyrics/dance binaries. Just as *chanson* became more self-conscious once threatened by Americanised pop, so techno has defined itself in a binary opposition with other established French popular musics, all lumped together (except disco) as French *variétés*, while techno has presented itself as admirably self-made, global, neo-liberal and in touch with Anglo-Saxon ways (Sabatier 2007: 431). Techno particularly sets itself up in opposition to *chanson* by contrasting the latter's modernist auteurism with the postmodern DJ; and at the same time in opposition to rap, as we have just seen. Despite its best efforts, however, including its progression towards abstraction through repetition via looping, and the rave's drug-related anarchy, it could not for long avoid being discursively legitimated by institutionalised culture and turned, like *chanson* and rap before it, into a French specificity of which the nation could be proud.

French popular music in the twenty-first century
Today, *la chanson française* as expressed in the ACI trope is proving virtually ageless, though much less gender-specific than it was in the 1950s. Despite a spate of deaths in the first decade of the century (Trenet, Bécaud, Ferrat, and others), survivors like Renaud, Cabrel and Goldman form a continuity with younger artists like Bénabar, San-Séverino, Axelle Red or Carla Bruni. There is middle-of-the-road pop (less frequently called *variétés* these days) in the form of boy bands and a succession of girl singers like Lorie, Alizee, Jenifer and Nolwenn Leroy – thrown up in these last two cases by TF1's reality talent show *Star Academy* (see also Chapter 5). Rock, or *musiques amplifiées* as it is now officially known, is alive and well and so too is world music, for which France has a strong international reputation, as it does for rap and techno. There is also, of course, French jazz, equally esteemed internationally though less obviously 'popular' these days because of its often avant-garde nature. And there is folk, or *les musiques traditionnelles*, the latest manifestations of the nineteenth-century movement to preserve France's popular past.

Within all this diversity, *Star Academy* is of special interest for its relationship with standard *chanson* discourse. Faced with the threat of techno, *chanson* in the 2000s has fought back, just as it did in the 1960s with pop and in the 1970s with disco: by stressing its national-popular authenticity. Hence the resurgence of the 1970s label 'la nouvelle chanson française' (sometimes known as the 'new new French *chanson*). But in this latest fightback, *chanson* is also set up in opposition to *Star Academy*. Launched on TF1 in 2001, a talent contest grafted on to a variety show and the keyhole voyeurism of *Big Brother*, *Star Academy* is self-consciously ebullient, colourful and unthreatening, featuring attractive, enthusiastic, multi-ethnic and occasionally talented youngsters trying to break into the business. Despite its huge commercial popularity, especially among children and early adolescents, the show has met with opposition from the music and arts worlds. This, I suggest, is because in its very conception it is at the furthest remove from the auteurist, anti-star narrative that depicts the ACI as the best that has been thought and said in *chanson*, a self-contained, authentic craftsperson and artist who, like poet or painter, produces the art first and thinks about a public afterward. Young *Star Academy* winners like Jenifer and Nolwenn become living embodiments of cultural commodification, a process so unselfconscious that it is the logic of the whole programme. Rather than writing their own material or singing songs adapted to their persona like Piaf, the fledgling stars are required to perform any song that their trainers

give them; indeed, their persona is itself, perfectly visibly, the artefact of those trainers.

The format has been greeted with dismay by traditional *chanson* performers. As Juliette Gréco, herself a singer rather than a songwriter but legitimated by her longevity and associations with the Left Bank of the 1940s, has said of the *Star Academy* contestants: 'You don't become a singer in three months. Barbara, Brel, Ferré or Brassens took years to become what they became' (*Le Monde* 2002: 4).[32] From a quite different musical tradition, Jean-Louis Aubert, former lead singer with the rock band Téléphone, has similarly commented: 'It's all about these young people's freedom. Now what kind of freedom have they got to sell or to offer? "Star Academy" only teaches them stereotypes – and the most worn out ones at that' (*Le Monde* 2002: 5).[33]

In such instances, a middlebrow art discourse is again opposed to a lowbrow commercial one. Genuine musical creativity is deemed a matter of auteurist self-expression and painstaking apprenticeship. The alternative is seen as reprehensibly inauthentic.

Conclusion

What is most noticeable here, and throughout the period examined in this chapter, is the absence of the kind of interpretations of popular music associated with anglophone Cultural Studies and popular-music studies. French narratives (even perhaps Bourdieu's, despite himself) are still ultimately Adornian in that they distinguish between an essentialist notion of high artistic creativity and the processes of manufacture and standardisation that the inappropriate industrialisation of music has introduced. Cultural Studies, on the other hand, influenced by de Certeau among others, has for several decades insisted that alternative forms of interactivity and creativity are at work in the reception of mass-cultural products. Also remarkable is how complex the binary between *chanson* and pop/dance has become. Not only has it ceased to be watertight (Hallyday's and Aubert's cross-benching from rock to *chanson* are cases in point), but it has also broken down into multiple sub-binaries. *Chanson française* today defines itself in opposition to both techno and pop; and techno in opposition to *chanson*, rap, pop and rock. Rap was originally constructed in opposition to the standard white, melodic *chanson* form but has been absorbed into it. The French music scene, then, is eloquent testimony both to the interdependence of Frith's three discourses and to the reflexivity and relativism of culture in the postmodern world.

Yet, despite this blurring of boundaries, binary thinking remains alive and well: for example in an article in *Le Monde* from 2003 (quoted in Sabatier 2007: 566):

> On the one hand, Star Academy. On the other, Carla Bruni or Vincent Delerm: in 2002, the French popular music scene is split in two. [Faced with the highly commercialised *Star Academy*] a spontaneous reaction has come about in the form of music that's non-formulaic, that's acoustic, almost stripped down, and performed by young singer-songwriters.[34]

Here, the familiar system of aesthetic evaluation is still at work. Although in practice *chanson* comfortably absorbed pop, rock and rap long ago, in updated garb the same discourse of opposition between *chanson* and Americanised pop that arose in the 1960s prevails today. A more nuanced but still recognisable version of it appears in Stéphane Davet's attempt to define *chanson* against English-language song. As we saw early on, he makes the standard allusion to the primacy of the poetic lyric and the tradition of Villon. But he does admit of a second *chanson* tradition, that of 'la grande variété française', citing Johnny Hallyday and Patricia Kaas (Davet 2009: 2). He concludes, then, that *chanson française* 'resists all new fashions and styles in music: folk musics, electronic musics and others, which it in fact borrows from and is regenerated by' (Davet 2009: 2).[35] On this view, it would seem, the national *chanson* is admirably protean: big-hearted enough to admit Johnny or Kaas, successfully adapting to new styles from jazz to rock to rap, it has a remarkable ability to shapeshift while remaining fundamentally unaltered.

Yet such binary thinking is not restricted to *chanson*, as we have glimpsed. A different but possibly more austere dialectic is at work in Sabatier's notion of authenticity. The music that in his view stands out in epic resistance to both *Star Academy* and (for him) the barely distinguishable *nouvelle chanson française* includes techno, contemporary R'n'B, and indeed any music that embodies what he sees as the Platonic ideal of youth music, namely the countercultural, non-commercial values that he purports to trace back to early rock, punk and situationism. He never explains why youth music should be ethically summoned never to evolve away from this starting position into something different, more mainstream. But that it should not is clear from his decidedly retro grumpiness about the new technologies of MySpace, iPod, and ringtones (2007: 639–41), sales of which, he laments, now outstrip sales of singles: 'technology erases barriers. It encourages critical regression' (ibid.: 641). Most striking, then, about Sabatier's historical sense of pop is the difficulty he

experiences with the notion of aesthetic and cultural change, since the organic evolution of a musical form and its commercial success appear to be synonymous with compromise and inauthenticity.

Perhaps part of the explanation is that, although Sabatier likes to imagine himself fully in touch with anglophone tastes, his Adornism about industrialised music is, we have seen, characteristic of a dominant French discourse, in sharp contrast with Cultural Studies. It also contrasts with the less Cultural-Studies-oriented work of Simon Frith who argues against the idea that industrialisation is some form of alien incursion that has denatured popular authenticity. As Frith writes (2006 [1988]: 231), 'the industrialization of music cannot be understood as something which happens *to* music, since it describes a process in which music itself is made – a process, that is, which fuses (and confuses) capital, technical and musical arguments'. In a not dissimilar way, I have also argued throughout this chapter that French *chanson* is not a distinct genre in some absolute aesthetic sense, remote from the manufactured inauthenticity of anglicised French pop. Rather, its distinctiveness and 'authenticity', what it has come to see itself and be seen as, have been dynamically self-fashioned in a process of growing consciousness of its national mission. *Chanson* is not a musical genre so much as an ideological narrative.

Probably no firmer conclusions than this can be drawn at present about a phenomenon so organic, metamorphic and contemporary as popular music. But in the light of this discursive history, what we might conceivably be seeing is a process of as yet subterranean, tectonic shifts in the highbrow-lowbrow, legitimate-illegitimate binary that Bourdieu identified almost fifty years ago. That binary is still visible, in the ever-changing series of legitimations of new aspirational forms like rap, or in the endlessly renewed disapproval of more shamelessly commercial ventures like *Star Academy*. But perhaps its complexification, initiated by the slow sedimentation of a self-conscious middlebrow in the form of *chanson*, is having the effect of undermining it, in the end leaving *all* popular-musical forms, even the consecrated *chanson*, floating in a postmodern, evaluative soup of the kind indicated by the 2008 survey of cultural practices. Yet if this is the case, at least one traditional value appears to remain intact, as the survey shows, one which ultimately harks back to the narrative of *la chanson française* that I have traced: an awareness of and preference for the nationally specific, the linguistically authentic; in short for something we might still reasonably call French popular music.

Notes

1 Earlier versions of parts of this chapter appear in Looseley 2010.

2 It should also be said that there are already numerous surveys – mostly journalistic but, increasingly, academic – which provide coverage of French popular-musical styles and genres, for different periods and using different selections and emphases: for example Coulomb and Varrod (1987), Fléouter (1988), Hawkins (2000); Looseley (2003: Part 1), Dauncey and Cannon (2003), Tinker (2005), Lebrun (2009).

3 'Le rock français est une blague'.

4 Lebrun (2009: 5–7) usefully attempts to separate out the meanings of *chanson*, maintaining that recently the word has become a shorthand for *chanson à textes* ('text-based song': a category I shall return to later), and that this specialised sense has 'virtually supplanted' the more commonplace meaning of words set to music. But these senses cannot be so easily separated: rather, they contaminate each other, with the result that *chanson* is a permanently ambiguous, polyvalent term whose constantly deferred meanings both contain and conceal its value system.

5 'n'est l'apanage d'aucune classe, d'aucun groupe social, d'aucune époque. C'est un art universel'. 'Ce prestige de la chanson est la chose du monde la mieux partagée par les Français ... cet art si fortement enraciné dans l'histoire de notre pays.'

6 'un thème naturellement populaire et fédérateur'.

7 'notre chanson est le reflet du centralisme français et de la fascination qu'exerce Paris'.

8 By 'myth' here, I do not mean that the perceived primacy of lyrics in French *chanson* is necessarily false – though there are plenty of *variétés* songs of both past and present to which it does not apply. But I do suggest that it is a socio-cultural construction, as the chapter will argue.

9 'Depuis quelques années, il passe ainsi des danses de Saint-Guy de bêtise sur la France. Évidemment le niveau de l'esprit national baisse et le peuple français, naturellement excessif, est prêt à devenir le plus imbécile et le plus gâteux des peuples.'

10 France had five million radio sets by 1939, though still only 5 per cent of homes owned a gramophone: Rioux and Sirinelli 2002: 233–4.

11 For fuller analysis of Hennion's sociology of listening, see Looseley (2007a).

12 In Chapter 3, Holmes argues that some romantic fiction proved more complex or even subversive than this might suggest.

13 See Chapter 4, where Platten points out the important distinction between pop and film stardom resulting from the bodily presence of the live singing star.

14 I shall continue to use the abbreviation 'ACI', to indicate this specifically French discursive configuration of the singer who performs his or her own compositions.

15 For example, Cordier (2008), Hawkins (2000) and Looseley (2003).

16 'car vous êtes auteur-compositeur'.

17 Like *chanson*, *variété(s)* (singular or plural) has no direct equivalent in English other than the misleadingly similar 'variety'. It originates in French music hall where, as we saw, a variety of different acts appeared on the bill, not simply singers. But in the post-war period, the term acquired a specifically musical sense in opposition to *chanson* (see Looseley 2003: Chapter 4), signifying, as Lebrun (2009: 8) neatly puts it, *chanson*'s 'debased, unsophisticated, newer and mediatized avatar'. See this page of Lebrun for more.

18 Bourdieu's remarks (1984: 14–18 and 60–1) on the socio-educational stratification of *chanson* tastes are worth reading here. See my brief analysis of them in Looseley 2003: 91–3.

19 The complex meanings of this triumvirate have been illuminatingly explored at much greater length in a recent thesis: see Cordier (2008).

20 'Par son rythme simple et unanimiste, le rock a certifié le passage d'une société de parenté où commande la fonction du père, à une société de parité dont la figure centrale est le groupe de copains.'

21 *Salut les copains* was initially a music show for teenagers on the radio station Europe no.1, but it subsequently launched its own magazine, with the same name. See Looseley 2003: 28–9. A rough, twenty-first-century translation of the title might be 'Hey you guys'.

22 '"Nous, les jeunes, nous ne sommes pas croulants", comme s'ils détenaient en la jeunesse une qualité inaltérable et inaliénable, comme si son problème n'était pas précisément le vieillissement'.

23 'Ce qui l'effraie [l'adulte], c'est l'exaltation sans contenu. Effectivement, il y a une frénésie à vide, que déclenche le chant rythmé, le "yé-yé" du twist … à travers le rythme, cette musique scandée, syncopée, ces cris de yé-yé, il y a une participation à quelque chose d'élémentaire, de biologique'.

24 'Qui nous est venu par une prodigieuse injonction de sève noire, de négritude déracinée, dans la civilisation américaine'.

25 'Pour fédérer tous les jeunes, le meilleur media, le plus explosif, c'est le rock, mais ils étaient dans leur théories chiantes'.

26 This was evidenced as early as 1973 in the first Ministry of Culture survey of cultural trends, *Les Pratiques culturelles des Français* and it has become ever more evident in the subsequent editions of 1982, 1990, 1997 and 2009.

27 'Le Palace n'est pas une simple entreprise, mais une œuvre: ceux qui l'ont conçu peuvent se sentir à bon droit des artistes'.

28 As is often the case with French taxonomies of popular music, the use of '*la techno*' may puzzle the Anglophone reader since, rather than referring to a fairly short-lived style of electronic dance music from the early 1990s, it is commonly employed to denote electronic dance music in general.

29 Although the labels 'rap' and 'hip-hop' are sometimes used interchangeably in French, generally 'le hip-hop' denotes the interdisciplinary ensemble of rap music, related dance styles and graffiti art.

30 'La dernière révolution musicale du XXe siecle.'

31 'La dance music a toujours été subversive. C'est la seule musique qui ne soit pas ethnique. Elle prône le mélange des races, des classes, des styles, des âges, des genres, des sexes … Libérer le corps, libérer la spiritualité, ce sont des causes universelles.'

32 'On ne devient pas chanteur en trois mois. Barbara, Brel, Ferré ou Brassens ont mis des années à devenir ce qu'ils sont.'

33 'C'est la liberté de ces jeunes qui est en cause. Or quelle liberté ont-ils à vendre ou à offrir? "Star Academy" ne leur enseigne que des stéréotypes qui, de plus, sont totalement éculés.'

34 'D'un côté, Star Academy. De l'autre, Carla Bruni ou Vincent Delerm: la variété française dessine en 2002 un paysage dichotomique. Une réaction spontanée s'est organisée du côté de la musique non formatée, acoustique, presque dépouillée, interprétée par des jeunes auteurs-compositeurs intimistes.'

35 '[La chanson française] résiste à toutes les modes et courants musicaux nouveaux: les folks, musiques électroniques et autres, auxquels elle emprunte, d'ailleurs, et qui la régénèrent.'

The mimetic prejudice:
the popular novel in France

Diana Holmes

As earlier chapters have pointed out, 'popular' is a capacious and slip-pery word. On the one hand, popular novels are simply the novels read and appreciated by a very large number of readers, as opposed to those that are canonised by critics and by literary histories but actually read by a relatively small élite. On the other hand, the 'popular' novel conjures up – if somewhat vaguely – a particular kind of fiction, raising the question of the aesthetic and philosophical specificity of the popular: do 'popular' novels conform to particular models of narrative? Do they deploy specifically 'popular' strategies? Does the world-view they imply differ from that found in more 'literary' novels? The meanings of the word are also heavily inflected by context, both temporal and spatial, and in particular by different national perspectives and senses of the place of culture in the nation's identity.

In the case of France, the contemporary situation of the novel makes an enquiry into the relationship between the popular and the literary both pertinent and topical. French bestseller lists for the first decade of the twenty-first century demonstrate the popularity of the life-writing genre (from the memoirs of Jacques Chirac to those of reality TV stars) and, within the category of fiction, of *bandes dessinées* or comic books,[1] as well as translated international blockbusters (*The Da Vinci Code*, *Harry Potter*, the *Twilight* vampire series, Stieg Laarson's thrillers). However, they also show the continuing appeal of the indigenous novel. In France, well-publicised annual literary prizes regularly produce the 'cross-over' phenomenon whereby a critically acclaimed 'difficult' text briefly becomes a popular purchase – thus immediately after the award of the 2009 Prix Goncourt Marie N'diaye's *Trois Femmes puissantes* (Three Powerful Women) jostled with comic books and reality-TV memoirs for number one position on the lists. More germane, however, to an enquiry into the textual qualities that make a novel popular is the work of those

authors who achieve repeated commercial success with one novel after another, or whose books sell in huge numbers over an extended period. Marc Levy has consistently achieved massive sales for his romantic tales of love defying mortality, set mainly in a glamorous USA familiar from countless Hollywood romcoms; Guillaume Musso's fictional world – equally American, equally affluent and stylish, equally peopled by character types familiar from US television or film (hell-raising heiresses; brilliant, handsome psychiatrists; adorable children), and with a similar use of the supernatural – rivals Levy's in popularity. Levy's and Musso's writing repeats a formula that clearly provides pleasure for readers, and represents a marginally more respectable version of the internationally bestselling Harlequin brand of popular romance. Meanwhile, other long-term occupants of the bestseller lists offer stories that address, at least obliquely, the contemporary reality of twenty-first-century France, in an accessible prose, the tone, texture and rhythm of which are nonetheless distinctive and form part of the pleasure of reading. Muriel Barbery's surprise (and lasting) bestseller *L'Élégance du hérisson* (Elegance of the Hedgehog, 2006), Claudie Gallay's *Les Déferlantes* (Breaking Waves, 2008), Anna Gavalda's series of 'hits' that began with *Ensemble c'est tout* (2004, inexplicably translated as Hunting and Gathering) have all been rapturously received by readers, as have Fred Vargas's droll, myth-tinged crime stories. The preponderance of women authors among these recent successes may have some connection with the fact that women form the majority readership for fiction, probably about 75 per cent.[2]

What the most popular novels, from Harlequin to Gavalda or Vargas, have in common is first their unabashed embrace of the fictional illusion, the invitation they extend to enter – for the duration of the reading – an absorbing fictional world dynamically structured by plot; secondly, an underlying optimism that, even where the events evoked are grim, makes life appear worth living. Reader responses to Gavalda's *Ensemble c'est tout* are particularly clear on this, emphasising as they collectively do the urgent pleasure of being 'unable to put the book down' and thus 'devouring' it (*dévorer, engloutir*), the corporeal empathy they feel with the characters' sensations and emotions ('My heart beats faster, my senses intensify', as one reader puts it), and the pleasurable sense of being – the word is used repeatedly – 'reconciled' with the world.[3] In this, these popular novels differ sharply from the majority of novels in French that achieve critical attention and acclaim and that, since the 1950s *nouveau roman* at least, have tended to foreground the artificiality of coherent fictional worlds, to abandon or satirise the conventions of plot and character, and to

emphasise the unintelligibility and generally unsatisfactory nature of life. The predilection in French women's writing for an inter-genre that plays on the vexed frontier between autobiography and fiction (auto-fiction) is one sign of this: among the several high-profile 'literary' women writers of the 1990s and 2000s (including Christine Angot, Nina Bouraoui, Annie Ernaux, Camille Laurens, Lorette Nobécourt, Amélie Nothomb), few – Nothomb in some texts, Nancy Huston throughout her fiction– depart from a writing centred on the self and its representation, or from a dark vision suffused with shame, anxiety and loss. Critically fêted author Michel Houellebecq's world is also compellingly and solipsistically dark. One of the striking differences between the francophone and anglophone literary scenes is the relative absence, in France, of what we might term (without its often negative connotations) the 'middlebrow' – writers such as (to take a few random examples from a crowd of possibles) William Boyd, Sebastian Faulks, Barbara Kingsolver, Vikram Seth, Rose Tremain, Ann Tyler, whose work is taken seriously by academics and critics, and also read by a large, varied audience in part for the compelling nature of its plotting and characterisation. In France – with, of course, a number of exceptions, including the 'cross-over' successes of prize-winning texts – critical acclaim accrues more easily to the formally experimental and the philosophically dark, while popular taste leans distinctly towards the unashamedly mimetic and towards optimism.

In recent years, there has been some recognition of the chasm that divides what most people read from what is considered literary. The polemical *Littérature-Monde* manifesto ('For a World-Literature in French') published in *Le Monde* in March 2007, and signed by forty-four writers from across the francophone world, focused mainly on the need to consider French-language writing as a world phenomenon rather than as metropolitan French with its largely ex-colonial 'others' tacked on, but it also called for the return of 'the world', of 'le sujet, le sens, l'histoire, le "référent"' (subject, meaning, story/history, the 'signified') to a French novel that (the manifesto claimed) had become preoccupied only with itself. Unexpectedly, one of the founding voices of structuralist criticism, Tzvetan Todorov, published an essay in 2007 that thundered against what he termed the 'nihilism and solipsism' (Todorov 2007: 37) of the contemporary French novel, and defended the power of all fiction ('from Harry Potter to the Three Musketeers') to produce in its readers a salutary empathy with others and a life-affirming sense of meaning: 'the common reader, who continues to seek in books a meaning for his/her own life, is right, and the teachers, critics and writers who tell him/her that literature

is only about itself, or that it can teach only despair, are wrong'(Todorov 2007: 72).[4] Novelist Nancy Huston wittily debunked the orthodoxy of pessimism in *Professeurs de désespoir* (Teachers of Despair, 2004) and argued for the moral and aesthetic significance of fictional stories in *L'Espèce fabulatrice* (The Story-telling Species, 2008). This shared diagnosis of a French literature, and particularly a French novel, more radically divided than elsewhere between 'high' and 'low' brows, is borne out by the somewhat puzzled and patronising reaction of literary critics from the serious press to the warm popular reception of writers like Barbery and Gavalda. Critics know how to deal with a Levy or a Musso, and the formulaic nature of these authors' style, characterisation and plotting is indeed easy to demolish (even if the sources of their readers' pleasure deserve to be taken more seriously). But writers who already had some literary credentials before becoming popular, like Gavalda and Barbery, and yet who invite a page-turning, empathising, tears-and-laughter reaction rather than a critically appreciative one, pose more of a problem: 'Reading it is like gliding down a gentle snowy slope, easy and painless',[5] objected *Libération*'s critic to Gavalda's *Ensemble c'est tout* (Lançon 2004), finding highly suspect a novel that was both easy to read and 'painless'.

The contemporary gap between majority reading practices and critical definitions of the literary is the starting point for this chapter, which will trace a brief, necessarily elliptical history of popular reading since the mid-nineteenth century in order to pose the following questions. How did the chasm between popular and highbrow reading come about, in a nation that in the nineteenth century could produce Balzac, Sand and Zola, whose fiction gripped the ordinary reader while stretching the form and scope of the genre? How have the French conceptualised, discussed and attempted to shape the nature of the 'popular' in the context of literature? How has this changed – and remained consistent – since the gradual development of mass literacy in the nineteenth century? What are the textual and narrative strategies that appeal to and provide pleasure for the majority of readers? What is the relationship between reader and 'popular' text?

If the time frame here is relatively long, this is because it is with the rise of mass publishing – which implies the existence of a mass readership – that popular literature can really be said to start, and that both its artistic strategies and its construction as the 'other' of 'high' literature begin. The development of the French popular novel can best be understood by taking as our starting point the fiery public debate over the serialised novel or *roman-feuilleton*, which took place in the 1840s. Thereafter, the

constraints of space will demand considerable selectivity. The chapter will be divided into three parts, determined less by neat symmetry than by coherence of argument: from the mid-nineteenth century to 1914; from the First World War to the end and immediate aftermath of the Second World War; from the 1950s to the present. In each section a brief account of the genres,[6] series and individual novels that dominated popular reading will underpin an exploration of the ways in which the popular was viewed, shaped and 'constructed' within the dominant culture of the day, and of what makes novels popular.

From the beginnings of mass-readership to the First World War

The democratisation of reading

In 1836 Émile de Girardin halved the subscription price of his new daily paper, *La Presse*, the lost income replaced by selling advertising space. Advertisers were best persuaded by high sales: the era of the mass-market press had begun,[7] and other newspapers soon followed suit. One aspect of de Girardin's strategy to attract readers was a regular 'chatty' column on social events, trends and fashions, written by his wife Delphine Gay under the pseudonym Charles de Launay, printed at the bottom of the page, and designated a *feuilleton* (diminutive form of *feuillet,* a leaf or page). By the 1840s, the gossip column had been replaced by a serialised novel, for the need to know what happened next was a sure way of hooking readers. The *feuilleton* rapidly came to mean serialised fiction, and was adopted by virtually all French dailies. At a period when the typical print run for a novel was 1,500, serialisation suddenly gave literary fiction the potential to reach a much vaster readership (Coward 2002: 289). The profession of novelist became a viable financial proposition,[8] and over the following decades the most successful (for example Alexandre Dumas, Paul Féval, Eugène Sue, Ponson du Terrail) made fortunes and became household names by providing their public with colourful, suspenseful tales of adventure, crime, love and the long and pleasurably deferred triumph of good over evil. Between June 1842 and October 1843, the nation held its collective breath between episodes of Sue's *Les Mystères de Paris,* and the poet Théóphile Gautier joked that the mortally ill clung on to life until they had finally learned the story's *dénouement* (Nathan 1990: 14).

The press provided accessible text; the available readership was also steadily growing as literacy increased through education until, under the Third Republic's policy of universal primary schooling (introduced in 1881/82), France became a whole nation of potential readers.

Technological advances (cheaper paper, the Marinoni cylinder press
from 1863) continued to reduce the costs of mass production (Leroy
and Bertrand-Sabatini 1998: 16). In the 1860s, the first really cheap daily
paper, sold by the copy and not by subscription, was the *Petit Journal*,
sales of which reached a million by 1891 (Migozzi 2005: 73). It was soon
followed by the equally successful *Le Petit Parisien* (1876), *Le Matin*
(1883) and *Le Journal* (1892). Each of these carried one – and often more
than one – *roman-feuilleton*. Serialised novels were generally reprinted
in book form, in library editions for the *cabinets de lecture* (privately-run
libraries), and then in cheaper reprints for sale in bookshops or, from
the 1840s, railway station kiosks. From the 1840s on, many novels were
also published in collectible parts or *livraisons*, spreading the cost for the
poorest readers. The publishing trade was a significant element of the
French economy by the final decades of the century, with several enter-
prising publishers (among them Jules Rouff, Arthème Fayard, Joseph
Ferenczi, Jules Tallandier) making their names and fortunes through the
mass publication of books, the majority of these novels. The price of a
book in relation to average earnings dropped steadily from the mid-nine-
teenth to the mid-twentieth century, falling by two-thirds between 1840
and 1870 (Todd 1994: 12) and continuing its downward trend between
1890 and 1938 (Leroy and Bertrand-Sabini 1998: 17).

 In 1904–5, Fayard launched a low-cost book series, the *Modern biblio-
thèque* (0.95 francs per volume, compared to the average book price of
3,50) followed by the still cheaper *Livre populaire* (0.65fr). Their success
led to rapid imitation by other publishers, and low-priced popular series
soon joined and surpassed the *feuilleton* as the principal mode of delivery
of fiction. These series or collections included both reprints of bestselling
popular 'classics' (Dumas, Hugo, Zola and, for example, Charles Merouv-
el's huge 1889 success *Chaste et flétrie* [Chaste and Sullied]) and new work
that introduced new types of hero, such as Gaston Leroux's journalist-
detective *Rouletabille* (first encountered in *Le Mystère de la chambre jaune*
[The Mystery of the Yellow Room], serialised in *L'Illustration* 1907 then
published in book form 1908), and in 1911 Marcel Allain and Pierre
Souvestre's arch-villain *Fantômas* and his would-be nemesis, the jour-
nalist Jérôme Fandor. Classics and adventure/detective stories (generally
spiced with a whiff of romance) could appeal to both sexes, but other
series implied a more gender-segregated readership, with the German-
based publisher Eichler introducing ten-centime romances (with titles
such as *Entre l'amour et le devoir* [Between Love and Duty]; *Coeur féroce,
coeur tendre* [Fierce Heart, Tender Heart] [Nathan 1990: 19]) alongside

series translated or adapted from American 'dime-novels' and aimed rather at a male audience (*Nick Carter, Buffalo Bill*). Tallandier's *Le Livre national* (1900) packaged its adventure collection in blue covers, and romance in red.

The appearance of specialised, low-priced collections, each volume's promise of reading pleasure guaranteed by the series' brand rather than by the author's name, heralded a stronger division of the popular market into what may be termed 'middlebrow' and 'lowbrow'. The category of the popular, defined by high sales, remained separate from that of the élite literary or 'highbrow' novel, which subscribed increasingly to the primacy of form over content, and to a deep suspicion of any desire to please audiences. In terms of what people actually read, however, for most of the period up to 1914, the frontiers between novels read by the working classes and those read by the more educated and leisured middle classes were not sharply defined. The huge number of novelists who supplied the daily papers' insatiable appetite for fiction may have employed the emphatic narrative techniques and roller-coaster plots that make for easy, absorbing reading, but their language was syntactically complex, and their plots extended across the social classes and depended for their narrative tension on issues of broad social relevance: the function of marriage as socio-financial transaction or as expression of love, the social consequences of illegitimate births or of the legalisation of divorce (in 1884, Loi Naquet), the nature of and proper retribution for crime. Dumas, Sue, Ponson du Terrail, Hugo, Émile Richebourg, Xavier de Montépin, Daniel Lesueur, Georges Ohnet – the list could fill a page – were read (their sales figures and longevity on the market strongly suggest) by both upper and lower middle-class readers as well as by those who would qualify as 'proletarian', their popularity signifying widespread acclaim rather than limitation to an audience of 'the people'.

Alexandre Dumas (1802–1870), one of the first *feuilletonnistes*, thrilled a socially diverse readership from the 1840s on with the intertwined romance, adventure and gripping suspense of his lengthy tales. The *Voyages Extraordinaires* of Jules Verne (1828–1905) were never accepted as fully 'literary' by the cultural gatekeepers of his own era, but the massive popular response to his adventures in space and time extended across social classes, and included 'élite' voices such as those of Théophile Gautier and the critics of the prestigious magazine *Revue des Deux Mondes*. Émile Richebourg (1833–1898), whose melodramatic tales of financial and romantic intrigue made him both 'the shopgirls' favourite storyteller'[9] (Olivier-Martin 1980: 184) and a millionaire, shared settings,

plot devices and even narrative techniques with the novelist most favoured
by the high society of the Belle Époque, Paul Bourget (1855–1935).[10]
Gaston Leroux's racy crime novels thrilled many a well-educated reader;
Sartre, brought up in an eminently 'high culture' household, recalls in
his autobiographical *Les Mots* (The Words) the joy of childhood read-
ings of the cheap adventure series published for children (Migozzi 2005:
12; Sartre 1995: 64–7), and Colette's *Claudine* novels (their author still
officially Willy), thrilled and scandalised across the class spectrum, with
their peculiarly modern use of marketing through branded merchan-
dise.[11] The period from the mid-nineteenth century to the end of the Belle
Époque was one of an increasingly compulsive appetite for fiction across
a broad spectrum of tastes and levels of education. If, at the 'high' end
of the market, the novel moved gradually away from plot and mimesis
towards a self-reflexive modernism (from Flaubert to the Symbolists and
Decadents and on to Gide and Proust), the majority of readers – from
those who reclined with a leather-bound volume to those who sewed the
snipped-out *feuilleton* into a book – took delight in stories that simulta-
neously represented their own material and emotional world and offered,
through satisfyingly coherent plots, escape from the contingency, banality
and general inconclusiveness of the everyday.

Despite the wide spectrum covered by the most popular novels of this
period, from the swashbuckling dramas of Dumas or du Terrail to the
detective-style mysteries of Allain and Sylvestre, from Bourget's world-
weary tales of adulterous liaisons among the upper classes to the pious
romances of Maryan, it is possible to draw some general conclusions
about the kinds of narrative that drew large readerships. If 'high' literature
is characterised by a self-conscious will to seek new forms, to question
and reinvent the relationship between language and experience, popular
literature seeks to provide reliable pleasures, both cognitive and affective,
and thus observes the norms established by previous successes even as it
plays new variations on existing themes and narrative chords. As Franco
Moretti suggests, the history of popular literature is closer to Braudel's
'histoire immobile' (slow, motionless history) than to the 'histoire *événe-
mentielle*' (events-based, narrative history) that tends to structure canon-
ical accounts of the literary past (Moretti 1998: 150).[12] Continuities can
thus be traced across a broad range of the period's bestsellers.

What connects these very different texts is a mode of storytelling that,
through specific narrative techniques – including in most cases omni-
scient narration[13] – facilitates absorption in the fictional world and makes
this intensely pleasurable. Novels plebiscited by a huge readership offer,

on the whole, an experience akin to being taken on an exciting journey from which, moreover, one can safely return at any moment. Rapid and pleasurable immersion in the story is made possible by the fact that the fictional world is both familiar – referring or 'hooking on' (Prendergast 1986: 61) to the reader's own experience – and agreeably different in its heightened coherence and density of event.

All of the popular fiction of this period functions mimetically, that is, it assumes the unproblematic relationship of word to referent and 'negotiat[es] and nam[es] the world in terms of familiar, shared images and representations' (ibid.: 7), inviting a reading that registers but does not examine the words themselves (or that assumes the transparency of the signifier). The mimetic text 'knits the order of "fiction" into the order of "fact", and thus ensures that process of recognition whereby the reader connects the world produced by the text with the world of which he himself [*sic*] has direct or indirect knowledge.'(ibid.: 61). The plausibility and legibility of the fictional world thus depend on the reader's 'internalised probability-system' (Kermode 1975: 119; Prendergast 1986: 43), itself the product of both lived experience, and familiarity with the generic conventions of similar fictional texts. Thus when, in the opening pages of Daniel Lesueur's *feuilleton*-novel *Calvaire de femme* (A Woman's Ordeal, 1907, *Le Petit Parisien*), the heroine alights by night at a small suburban railway station and sets off towards the anticipated pleasure of a meeting with her lover, the sound of a car behind her on the road immediately signifies fear and danger: women (especially adulterous ones) are indeed at risk in the extra-textual world, and in the melodramatic world of the *feuilleton*, to be followed in the night immediately connotes the threat of violence. The reader is drawn into Solange's state of mingled excitement and (it will transpire, well-founded) dread, and into the fictional space that is also the real, contemporary city of Paris. The pleasure of such mimetic readings is threefold: near-effortless imaginary travel to an absorbing 'elsewhere' (or what is sometimes pejoratively termed escapism); the successful exercise of interpretative competence; a sense of sharing in and engaging with a communal system of knowledge, or a social world.

Where the popular-fictional world diverges most acutely from that of everyday experience is in its ultimate coherence. The narrative dynamic is teleological, driven by and interpreted in the light of the reader's apprehension of a final resolution, the deferral of which produces suspense. Each event, element of behaviour, place, object will reveal its meaning by the time we reach the *dénouement*, not only in the case of mystery or detective plots, where resolution takes the form of the revelation of truth,

but also in the romance, where all will prove to have led to the final union or dis-union of lovers, or the multifaceted sagas of Dumas or Ponson du Terrail where each detail of plot will contribute to the final restoration of moral order. The end, as Frank Kermode puts it, confers organisation and meaning on the 'merely successive character of events' (Kermode 1967: 56) or in Paul Ricoeur's words 'draws configuration out of a succession' (Ricoeur 1991: 22). Provisional absorption in a wholly meaningful and coherent world itself provides a type of pleasure: secure in the promise of their reliable satisfaction, the reader can enjoy suspense and anticipation, and the process of detection and interpretation. Both a viable sense of identity and a bearable way of being in the world seem to depend on some transcendence of mere chronicity: 'in order to make sense of [our] span, [we] need fictive concords with origins and ends, such as give meaning to our lives' (Kermode 1967: 7). Fictions that address and appeal to a wide readership generously provide this sense of time as meaningfully shaped, at the deliberate expense of a more demanding realism. In the great corpus of bestselling fictions that pleased huge publics in the later nineteenth and early twentieth centuries, endings were not always happy (though they mostly were) but they did always confer coherent meaning on the entire narrative, and in this sense provide an optimistic sense of life's meaningful shape and comprehensible causality.

Narrative pleasure does not only depend on the reliable closure of the ending. The reader's desire to know (cognitive desire) is granted repeated partial fulfilment as clues to the truth are uncovered, but affective desire is also brought into play in the reading process. Identification with fictional characters produces the vicarious experience of loss, need, lack or anxiety to which a happy ending will supply fulfilment, and even an unhappy ending will supply resolution. And here too, the process of arousal and satisfaction of desire is played out repeatedly within the broader narrative, in minor episodes that dramatise the characters' fears, longings or apprehensions of danger in order then to calm, satisfy or relieve them. In romance, which forms at least one strand of the majority of the novels, desire for the other will be briefly satisfied by a moment of intimacy or sign of reciprocity. Episodes of hunger, exhaustion, fear punctuate adventure and mystery plots but are followed by the pleasure of relief: Jérôme Fandor, pursuing the trail of the evil Fantômas, is kicked into the Seine or imprisoned in a trunk, but soon (to the reader's relief) regains dry land or fresh air (Allain and Souvestre 1932: 90–2).[14] Lesueur's Solange is left alone and traumatised by the horror of her lover's murder and her own narrow escape, but then reaches the relative, temporary security of home,

warmth and sleep (Lesueur 1907: 52). Freud's description of the infant's *fort/da* (gone/there) game (Freud 1966: 14–15) where the child's fear of loss is played out pleasurably in the safe knowledge that the object can be restored, provides a nice metaphor for the narrative pleasures of the teleological plot and its intermediary *mises en abîme*.

The moment of the '*fort*', however, is crucial to this game: fictions do not work so well if they fail to confront danger, horror, loss, the desire for total and ruthless self-fulfilment as well as that for social acceptance. The reader takes as much pleasure in the ingenious criminality of Fantômas or Arsène Lupin, and their endless evasion of justice, as in their honest pursuers' attempts to save the innocent and restore moral order. No *feuilleton* gripped its readers without the looked-for dose of villainy, transgression of social and moral laws, confrontation of awful danger. A Delly romance does not 'work' without the presence of some wanton, aggressive female rival who acts as a foil to the heroine's virtuous purity and as the signifier of all that this represses. The restoration of some form of harmony at the narrative's closure does not simply negate the vivid experience of lack or disorder: popular fictions also articulate the appeal of excess, violence, resistance to the social laws that regulate class and gender. Apprehension of this oppositional element in popular reading fuelled reactions to the expansion of the literary market.

The *roman-feuilleton* controversy and the construction of the popular

From the 1840s on, then, the novel became a profitable commodity: fiction that could transport its readers to a compelling imaginary world attracted a mass readership that extended across class boundaries and meant material reward for authors and publishers. As Lise Dumasy's edited anthology shows (Dumasy 1999), the French parliament and press identified this emerging phenomenon and quarrelled eloquently over its aesthetic and political implications. The impassioned debates around the *roman-feuilleton* established the terms of a dispute that frames much discourse on popular fiction to this day. If Sainte-Beuve fired the opening salvo, with his influential 1839 article 'On industrial literature',[15] parliamentary and related press debates provided some of the most colourful articulations of the opposing arguments, with the Baron Chapuys-Montlaville, a left-wing *député*, leading the attack, and Louis Desnoyers, journalist, editor and author, defending with particular eloquence the qualities and virtues of the *feuilleton*. What concerns us here is not the detail of the debate, but the major arguments it produced, and their lasting relevance.

In casting literature that aimed at a wide readership as 'industrial', Sainte-Beuve was expressing his condemnation of any subjection of personal expression in art to the requirements of the market. Opposition to the *roman-feuilleton* frequently focused on its debased origins not in the creative urge of its author, but rather in the imperatives of a capitalist economy: the speed of composition, the work's length and structure, were determined not by any aesthetic imperative, but by the need to keep readers hooked and maximise profits. As Bourdieu has comprehensively shown, the defence of the values of 'high' art frequently conceals a defence of class interests, and in refusing cultural value to any work motivated by the author's need to make a living, the privileged classes were protecting their control of the cultural domain. The assumption that whatever pleased the masses must, by definition, be of poor artistic quality served a similar purpose. Yet when Chapuys-Montlaville uses the public forum of the National Assembly to berate the 'mercenary greed' of the producers of serialised novels (Dumasy 1999: 81), he is not only protecting the authority of a patrician élite. His suspicion of a market-driven culture also presages twentieth-century critiques grounded in democratic left-wing values: capitalism's aim is assumed to be the deliberate corruption of mentalities to produce a passive market of avid consumers, and it is the job of enlightened politicians and intellectuals to defend the common man and woman against this cynical exploitation of their real needs and desires.

The mass consumption of fiction was seen by its opponents not only as a malign extension of the power of the market, but also as a threat to French national identity. As a man of the democratic, republican – and still firmly patriarchal – left, Chapuys-Montlaville aligned authentic Frenchness with a rational, emancipatory and virile politics, at risk of corruption by exposure to the sprawling, self-indulgent and by implication feminine *roman-feuilleton*.[16] 'Everything effeminate and imaginary is contrary to liberty: everything strict and based on reflection favours political progress and the emancipation of men' (quoted in Dumasy 1999: 100).[17] The Catholic Church, despite espousing a rather different ideal of French identity, also saw in the consumption of beguiling fictions a serious danger to the nation's moral character, insisting in particular on the danger to French womanhood posed by tales that glorified passion and the secular pursuit of happiness.

There would have been no debate on the *roman-feuilleton* if no one had sprung publicly to its defence and, led by the editor and political journalist Louis Desnoyers, a democratic, Republican case was also made

for the virtues of the popular novel. Eloquent and humorous, Desnoyers used his own paper *Le Siècle* to demolish the arguments of Chapuys-Montlaville point by point, and to situate the *roman-feuilleton* firmly on the side of progress, modernity, and national unity. Desnoyers presented the aesthetics of the popular novel not as determined by the profit motive, but as expressive of a new age of life-enhancing technologies, increased mobility, and social equality:

> The age of miniatures has passed: we are now in the age of frescos. The artist no longer works for an élite public, but for all … people who have a political tribune, a free press, steam ships and railways, need fast-moving stories, energetic compositions, powerful themes and even robust entertainment …
>
> The Revolution was a great leveller … there is now only one class of reader: all the French are equal before literature as before the law. (quoted in Dumasy 1999: 145–6)[18]

For Desnoyers, the sheer scale and broad-brush energy of the *feuilleton* connotes the dynamism of modernity. Democratic equality demands not the effete miniaturisation dear to the élite, but a more robust, passionate, affirmative and (in a neat reversal of his opponents' use of the gender binary) *virile* culture that can unite a cross-class readership. Desnoyers' defence of the popular novel proposes an interesting and rarely asserted alignment of absorbing, story-driven fiction with democracy and progress.

A little later in the century, the Catholic Church, despite its sustained characterisation of the *feuilleton* as a site of licentious fantasy, also opted pragmatically to appropriate popular fiction in the service of its own values. In the early days of the Third Republic, beleaguered by the new regime's anti-clerical policies, the Church in a spirit of 'if you can't beat them, join them' encouraged the production of a popular fiction that provided all the pleasures of immersion in a compelling imaginary world while endorsing a Catholic and conservative worldview. It was a Catholic group that in 1877 founded the highly popular magazine *Les Veillées des Chaumières* (Evenings by the Cottage Fireside), in which the reality of most women's domestic lives was acknowledged by the provision of articles on cookery and dressmaking alongside serialised stories representing the ineluctable centrality of marriage and family, pleasurably idealised through romances that were at once chastely proper and well provided with narrative thrills. Pious romantic fiction thereafter came to form a significant strand of French popular culture that lasted till the mid-twentieth century. Conservative romantic novelists, of whom the

most famous and widely read was Delly,[19] often began their publishing careers in the pages of *Les Veillées*, and went on to write for series such as Firmin-Didot's *Bibliothèque des Mères de Famille* (The Mothers' Family Library), aimed in particular at unmarried girls who might thus be saved from the temptation of more subversive, secular reading matter. Beneath their overt conservatism, however, it is possible to discern a utopian and mildly subversive re-writing of the patriarchal script that governed their readers' lives: their pious yet quietly assertive heroines transform tyrannical (though devastatingly desirable) heroes into sensitive, devoted partners; it is the woman's refusal to compromise her own values that wins her social approval, personal and – so the reader may easily surmise – sexual fulfilment. As with any form of fiction, popular reading is an active process that may find pleasure in meanings the author never consciously intended.

The decades between the *roman-feuilleton* quarrel and the First World War thus saw the development of popular reading on a grand scale, and to some extent justified Louis Desnoyers' assertion that in post-revolutionary France one could 'find everywhere, in the hands of a banker or a workman, under the eyes of a learned or a common man, the same stories and the same novels' (Dumasy 1999: 146). Readerships, themes and narrative techniques overlapped between 'high' and 'low' categories of the genre. Even its detractors could be found making use of the mass-appeal novel, and thus developing its influence. The importance of novel-reading in national culture was at once recognised and amplified by the establishment of annual national prizes for the 'best' novel – the Prix Goncourt in 1903, the Prix Femina, with its all-female jury, in 1904 – which generally produced a sharp rise in sales and widened readership. Public defence of popular fiction identified it firmly with democratic and robustly *modern* values, casting its much derided narrative forms as aesthetically progressive and even, in the word's original meaning, as modernist.

Nonetheless, as the market grew, the majority of those who held cultural power in the nation evinced contempt for the type of literature aimed at a mass readership, attacking or dismissing it, from both right- and left-wing standpoints, as aesthetically irrelevant and morally harmful. If in practice the frontiers between the 'popular' novel and the 'literary' novel remained porous, at a discursive level *popular* fiction was widely relegated to a domain of its own, somewhere outside literature proper.

From one war to another: 1914–1945

Topical bestsellers and genre fiction

The 1914–18 war disrupted all aspects of life in the nations involved, including publishing. Nonetheless, the underlying long-term trend for books to become more affordable continued (Leroy and Bertrand-Sabiani 1998: 17). As a leisure activity and a form of storytelling, reading was potentially rivalled by the new medium of cinema, already popular by 1914. But cinema, unlike reading, meant an organised outing, and the cultural media most threatened by the 'seventh art' were theatre, music-hall, and the now declining *café-concert* (see Chapter 2), rather than the book. Popular literature and cinema soon developed a mutually beneficial relationship, with commercially successful novels rapidly adapted for the screen, and the film in turn promoting sales of the book. Fantômas, the elusive criminal hero of 32 books between 1911 and 1913, rapidly made the leap to the silver screen, with the series directed by Feuillade first appearing in 1913. In 1916, the first *ciné-roman* series appeared, with film scripts presented in easy-read comic-book form. Radio also developed as a possible competitor during this period, with the first private radio station appearing in 1922, rapidly followed by many more in both commercial and public sectors. Despite some attempts at fiction, however, radio delivered music rather than stories. Across the spectrum from highbrow to lowbrow, the consumption of fiction through the written word remained a vibrant element of cultural life during and between the wars. Several new national literary prizes were established including the Prix Renaudot (1925) and Prix Interallié (1930). Prizes did not guarantee huge commercial success, but they did provide intense publicity that in some instances could turn a literary triumph into a best-seller.

Moretti's characterisation of the history of what most people read as relatively 'immobile' remains relevant to the twentieth century (Moretti 1998: 150). Dumas, Verne, Zola, and many of the *feuilletonnistes* continued to be very widely read in the low-price series inaugurated by Fayard in 1904–5, then rapidly emulated by competitors, as did the popular tales of *Rouletabille* and *Fantômas*. The compelling nature of popular classics was well established, and the fact that their once contemporary settings had receded into history did not appear to detract from their charm. Indeed, imaginary escape to the past may have become an element of their appeal, particularly during the harsh war years and the grimness of the 1930s Depression.

However, durability is only one aspect of the popular: immediate, contemporary relevance was also a major factor in the mass appeal of many

of the era's best-selling novels and series. In this period that opens with
the first planetary-scale war and closes with the second, war itself was
recounted, imagined, reflected on in some of the most widely read fictions.
The 1914–18 war produced Henri Barbusse's *Le Feu* (Under Fire, 1916,
Prix Goncourt) and Roland Dorgelès's *Les Croix de bois* (Wooden Crosses,
1919, Prix Femina), each of which sold in massive numbers on publica-
tion and on into the 1920s (Todd 1994: 41). Both novels depict with brutal
frankness the material and emotional horrors of trench warfare, from the
first-person perspective of the ordinary soldier. Although they conform
to the narrative codes of the popular novel in many senses – they are
intensely mimetic, knitting the fictional world closely into the order of
fact, and punctuate diegetic bleakness with the provision of brief vicarious
pleasures – both texts withhold that sense of resolution that hitherto had
largely characterised popular fiction. Indeed, the terrible incoherence of
the world they describe is central to each novel's power. The popularity
of these books arose not only from effective narration and dramatic plot-
ting, but also from the revelation and validation of traumatic experi-
ences shared, no doubt, by many of their readers, but silenced by official
discourse during the war and rarely spoken of by survivors.

The war years of 1914–18 brought intense experiences of separation,
bereavement and social upheaval to millions, and many of the fictions
that resonated most with a wide public deployed and modified familiar
narrative strategies to address these new realities. Popular romances
of the 1920s regularly featured stories in which war fulfilled the narra-
tive need for obstacles to delay the concluding union between hero and
heroine; in some instances (particularly in the pious Catholic romances
of series like the Collection Stella) the hero's death at the Front meant that
this union could never be realised in the earthly sense. If the 20-year-old
Raymond Radiguet's *Le Diable au corps* (The Devil in the Flesh, 1923)
became one of the decade's best-selling *succès de scandale*, this was no
doubt in part because the plot concerned a passionate wartime infidelity
that struck a chord with many after the (for most, new) experience of
couple separation and (for women) of unheralded independence that the
war years had brought.

The specific event of war demonstrated that one source of literary
popularity is a novel's ability to articulate collective experience in imme-
diate dramatic form. Some of the major best-sellers of the 1920s also
owed their success to their ability to capture a mood or moment of social
tension and transform it into a page-turning plot. Victor Margueritte's
1922 *La Garçonne* (The Bachelor Girl) certainly came into this category:

if the novel sold over 100,000 copies within months of its publication and went through multiple reprintings throughout the decade, this was largely because it provided a technicolour take on a question that felt very real and urgent to a considerable part of the population: had female identity and relations between the sexes changed fundamentally, due to women's brief experience of non-traditional employment and relative independence during the war? Margueritte poses this question through the story of Monique Lerbier, aged 20 and on the eve of a fine bourgeois marriage, who rebels against the sexual double standard exemplified by her fiancé's infidelity and departs the family home to embark on her own promiscuous bachelor lifestyle. Monique's revolt is both treated sympathetically, as a legitimate response to oppressive inequality, and wildly sensationalised as the heroine's emancipation takes chiefly erotic forms – a move which cost the author his Légion d'Honneur (he was stripped of the honour for offence to public morals) but certainly increased sales. Margueritte also extended the constituency to which the novel appealed by his final redirection of the plot towards traditional values: Monique's experiments with sex, drugs and a 'masculine' lifestyle come to an end when she meets a good, feminist-inclined hero and finds herself 'a woman again, and weak, faced with the splendour of true love' (Margueritte 1922: 296). The rebellious heroine is returned to her proper place, defined by love and motherhood. Nonetheless the novel's appeal – as its author and publishers cannily emphasised in their publicity – owed much to its identification of a phenomenon nonetheless real for the rapid post-war backlash that returned most wartime '*garçonnes*' to the home. Tangible everyday changes in clothing and body style (short, uncorseted garments that favoured mobility, cropped hair), as well as mores (even respectable middle-class girls now went unchaperoned) appeared to threaten the sharp binary divide between the sexes, and (for some) exacerbated fears about the nation's low birth rate. On the very day that Margueritte's novel went on sale, the Senate had rejected, for the umpteenth time, a bill proposing female suffrage.

Along with Margueritte (and among others Colette, Paul Morand, Raymond Radiguet), Maurice Dekobra was accused by the conservative press of corrupting French youth through the immorality of his immensely popular stories. Like that of his fellow accused, his appeal owed much to a generalised post-war restlessness and anxiety that responded to tales of cosmopolitan travel (Morand, Dekobra) and moral disorientation (a theme common to all).[20] *La Madone des Sleepings* (The Madonna of the Sleeping Cars, 1925) sold over half a million in two years, and

like *La Garçonne* was widely translated, selling over fifteen million copies worldwide. Dekobra's best-seller carried readers away to a sophisticated, cosmopolitan, dispassionately amoral world that blithely ignored the material and moral constraints of the everyday. The absence of an omniscient narrator is telling: the novel's unity depends not on a reassuringly authoritative source of factual and moral knowledge, but on the amused, complicit perspective of an intra-diegetic narrator, Prince Séliman, who is very much part of the frenetic 'roaring Twenties' society he observes. Featuring a heroine (Lady Diana Wyndham) as sexually adventurous as '*la garçonne*' but far more assured and urbane, a dense, racy plot anticipating James Bond with its ruthless and seductive Russian spies and cliff-hanging suspense, and a resolute emphasis on modernity (including a language full of jazz-age neologisms), *La Madone* evokes a glamorous, exotic world anchored nonetheless in contemporary news stories, films, and popular music. No romantic union ends this novel: Lady Diana sets off again on the Orient-Express, ready for new adventures.

Readers of both sexes probably enjoyed *La Garçonne* and *La Madone*'s narrative thrills, erotic daring and evocation of a bold new post-war world, though we can speculate that women in particular may have been drawn to heroines who are the very antithesis of the chaste, home-loving, contentedly subordinate female ideal still held up for emulation by a conservative, pro-natalist majority. Both heroines are resourceful, sophisticated modern women for whom sexuality is quite separable from procreation, although Margueritte's conservative closure differs acutely from Dekobra's provocatively open ending.

Topical best-sellers stand out against the increasing number of popular series sold by subscription or in bookshops, corner shops and train stations. Though the narrative of crime and detection was already well established both as a component of many *feuilletons* and through the stories of journalist-investigators Rouletabille and Fandor (in the *Fantômas* books), it was in the 1920s and 1930s that crime series became an established part of popular reading in France. Albert Pigasse launched the first of these, *Le Masque*, in 1927; by 1939 there were some 60 series on sale, emanating from all the major publishing houses. Georges Simenon (1903–1989) served a solid apprenticeship as an 'artisan' of the popular novel, writing pseudonymously in any and every genre, before concentrating primarily on the crime stories that were to make him famous, with the first Maigret novel (*Pietr-le-Letton*) appearing in 1931. Simenon's short novels use what he termed 'palpable, material'[21] language to plunge the reader into a world at once everyday and suffused with menace, in which

a central enigma (who committed the murder? why? who else will die?) is posed, investigated and resolved. His narratives form satisfying puzzles while powerfully evoking a sense of place (often grim Parisian suburbs or northern ports enshrouded in fog), and communicating a worldview that is (like that of his most famous character, Maigret) wryly humane and iconoclastic. The resolution of Simenon's plots often reveals the guilt of the socially privileged and their willingness to exploit the poor; by opposing Maigret's intuitive tactics and keen sense of justice to the bureaucratic methods and pomposity of his superiors, Simenon ridicules authority; his respect for the human being within the criminal determines both the novels' nuanced characterisation of evil and Maigret's own patient, curious treatment of his suspects. Simenon's crime fiction exemplifies the capacity of transparently referential, easy-to-read literature to carry the reader, through pleasurable absorption, onto quietly 'serious' territory.

While detective fiction staged the still predominantly masculine, public dramas of crime and legal punishment, the love-story plots of the burgeoning romance series acknowledged the reality of most women's lives, circumscribed by limited education and employment prospects, and shaped by the hegemonic belief (Margueritte and Dekobra notwith-standing) in marriage and maternity as a girl's only proper destiny. Out of this more or less ineluctable life-course the popular romance made an enjoyable narrative, dramatising the brief period of adolescent freedom through heroines who (more often than not) set out on lonely journeys far from home and survived difficult ordeals, before discovering to their joy and the reader's real if incredulous satisfaction that the hero's harshness concealed true love, and thus that personal fulfilment could be recon-ciled with obedience to social law. Delly, publishing one or two novels per year between 1903 and the late 1940s and endlessly reprinted right up to the 1980s, dominated the market, but Max du Veuzit (pen-name of Alphonsine Vasseur), and later Magali (Jeanne Philbert) were also hugely popular, as were the proliferating series fed by a host of more or less anonymous writers. All conformed to the established narrative conven-tions of popular fiction through the perfect coherence and semiological intensity of their plots, the density of dramatic event, the melodramatic use of coincidence and the selective omniscience of the narrative voice.

As readers consumed crime, romance, cosmopolitan adventures and one-off novels that captured an issue or mood of the moment, many serious 'literary' novelists in the wake of Flaubert, Proust and Gide began to 'reject both story as the main business of fiction and the realism which expressed it', jettisoning the legacy of 'plot, psychology, heroes and

mainstream standards of judging right from wrong' (Coward 2002: 385), so that the distinction between 'literature' and 'popular literature' in some ways sharpened. Nonetheless, this is still a period that sees considerable overlap between the various levels of 'brow', with best-sellers appealing across a wide spectrum of readership, crime fiction appealing as much to the surrealist poets as to the modern equivalent of the *feuilleton* reader, and romance as a narrative trope stretching across the hierarchy and straddling the literary/popular divide.

The construction of the popular: good and bad reading

The *roman-feuilleton* debate had pitted the opponents of literature as mass entertainment against those for whom crowd-pleasing novels embodied a new cultural democracy and a new modernist aesthetic. The defenders of popular fiction, however, left a weaker legacy in France than did its enemies, and in terms of how best-selling novels were seen and judged it was suspicion of 'industrial literature' that prevailed in mainstream critical judgement and implicitly in state policy. Literature that sold well to a mass audience was generally cast as dangerously indulgent of escapist dreams, and failing in art's mission to uplift and improve.

In pastoral letters, sermons and publications, the Catholic Church continued to condemn novels of adventure, crime and romance as likely to foster inflated dreams and aspirations, and to undermine a proper acceptance of the reader's God-given station in life (Chartier and Hébrard 1986: **531-3**). For most of the period, the discourse of the secular Republican state also implied that the pleasures of popular fiction were dangerous, and dangerous in a peculiarly gendered way. A 1920 school textbook for teenage girls, *La Jeune Française*, typically quoted a passage from Fénelon on the danger of reading 'fantastical stories of adventure mingled with profane love', and went on to comment that 'the moral failings indicated by Fénelon remain common among women: vain, indiscreet curiosity, over-fertile imagination, a romantic turn of mind' (Chartier and Hébrard 1986: 529).[22] Fiction was likely to encourage a female tendency to oppose idealised dreams to the more banal reality that was women's lot, and for boys too an individualist tendency to get lost in fictional worlds was often negatively compared to a proper spirit of realism and practical, virile camaraderie.

Good reading was encouraged: if for the Church this meant the consumption only of novels conforming to a devoutly Christian world-view, for the state educational system it meant the choice of canonical (and rarely contemporary) reading matter and the critical practice of *explication de*

texte, which assumes both the maintenance of cerebral detachment from the object of reading, and the existence of a primary 'correct' meaning to be discovered in each and every text (Chartier and Hébrard 1986: 535–6). Public libraries too tended to favour serious, improving reading governed by the national canon rather than to encourage reading in all its forms. Municipal lending libraries for all did not really take off in France until after the Second World War; state-run libraries in the inter-war period were largely connected to schools and universities and catered for an academic rather than a general readership. In neither education nor library policy was there any perception of virtue or vitality in simple reading for pleasure.

It was logical that such defence of popular reading as did surface should come from the Left, and in the small, only moderately successful moves to promote a 'proletarian' or 'populist' literature in the 1920s and 1930s, there were some vestiges of Louis Desnoyers' vigorous defence of 'equality before literature as before the law'. Henri Barbusse, best-selling author of *Le Feu* and Communist intellectual, promoted the model of 'proletarian literature' as the 'living, contemporary, intensified form of what used to be called popular literature' (Flower 1983: 75). Barbusse and Henry Poulaille's concept of a *'littérature prolétarienne'* and Léon Lemonnier's *'littérature populiste'* shared the ambition to develop a new, authentically proletarian literature that would privilege working-class settings and characters, giving narrative shape to ordinary lives which the novels would show (implicitly, rather than explicitly) to be shaped and limited by political inequalities. But although Barbusse had succeeded in combining mass appeal with political seriousness in the exceptional circumstances of war, this proved very hard to achieve in more ordinary times. Poulaille's own semi-autobiographical saga (four volumes beginning with *Le Pain quotidien* [Daily Bread] in 1931) suffered from a lack of narrative verve and a moralising tone that discouraged the reader in search of a page-turning read. If Louis Guilloux's *La Maison du peuple* (The House of the People, 1927) and Eugène Dabit's *Hôtel du nord* (1931, Prix Populiste) achieved wider readerships, the movement as a whole fell short of its own ambition to heighten political consciousness through compelling storytelling, to instruct through entertainment, and to entertain through relevant, politically meaningful stories.

The 'populists' were one element of a broader movement for cultural democracy in France that fed into the victory of the socialist Front populaire in 1936, and its ensuing emphasis on cultural policy, and in particular on the promotion of reading as an important leisure activity.

The *Association pour le développement de la lecture publique* (ADLP – Association for the Development of Public Reading) was set up by the incoming government soon after the Front's electoral triumph, to build on a variety of preceding initiatives on reading including the French Communist Party's 'proletarian libraries' (*bibliothèques prolétariennes*). Thanks to the Front's commitment to and funding of its projects, the ADLP had some effect, developing municipal libraries, sending out mobile libraries or 'bibliobus' to promote reading across France. But the life of the Front populaire was short – Léon Blum's government fell in June 1937 – and its promotion of popular reading was in any case foundering on the difficulty of reconciling the hegemonic view of 'good' reading as serious and instructive with the largely mistrusted but crucial issue of reading pleasure. Unlike Desnoyers, who had seen in the literature read by the majority an energy and aspiration that (however obliquely) bespoke democracy, the Front Populaire continued to see the primary aim of their policy as the elevation of the ordinary reader to an apprecia-tion of 'good' literature.

As in so many other domains, the continuity of cultural policy between the Front populaire, Vichy and the post-war Fourth Republic is more apparent than their differences. If under Vichy there was little new move-ment on reading policy, in 1945 the new Republic set out its commit-ment to encouraging reading in terms very akin to those of the Front. The aim was to 'give to the mass of French people a taste for the book and for reading …, help them to become aware of the need to read, not only for pleasure, but also for their education, information, culture and social advancement' (Mollier 2005: 45). The vigour of the publishing trade through the inter-war years suggests that 'the mass of French people' already had a taste for books – but what they read simply did not count as true reading.

From the Liberation to the new century

Reading for pleasure: generic consistency and cultural change
The German occupation of France in the Second World War disrupted publishing more radically than had the previous war, due to an increas-ingly acute shortage of paper as well as to Nazi and Vichyite censorship. In the heady days of the post-Liberation, with the nation anxious to iden-tify itself with Resistance, those pro-Resistance texts that had reached tiny audiences through the underground circuit gained huge readerships. Vercors' *Le Silence de la mer* (The Silence of the Sea) notably became the

bestselling novel of the decade (Todd 1994: 94), while Elsa Triolet's *Le Premier Accroc coûte 200 francs* (A Fine of 200 francs, 1944, and the first Prix Goncourt to be awarded to a woman writer), sold 110,000 copies in two months. J.-F. Curtis's fast-paced Resistance novel *Les Forêts de la nuit* won the 1947 Goncourt. The Occupation period – at once a traumatic national memory and a rich setting for dramas of passion and adventure – would be re-imagined in a number of bestselling novels in the following decades, including Joseph Joffo's 1973 *Un Sac de billes*, the highest-selling novel of the 1970s, Régine Deforges's *La Bicyclette bleue*, overall bestseller for the 1980s, and Marc Levy's foray into history, *Les Enfants de la liberté* (2007).

A national programme of material and economic reconstruction swiftly followed the end of the war, supported by Marshall Aid from the USA. The 1950s and 1960s, in France as elsewhere in Western Europe, were characterised by rapid modernisation, economic growth, and an intense commodification of culture that went hand in hand with changes in social values. These were the years of the birth of youth culture, the erosion of class and generational deference, of anti-colonialist struggles at home as well as in the colonies themselves, of steps in women's emancipation that presaged the second-wave women's movement of the 1970s. Literary production responded to and was itself a part of the economic boom and the rapid ideological shifts of the post-war decades. The 'petites collections' that had facilitated and fuelled popular reading in the inter-war years led on in 1953 to the 'Livre de poche', neat, portable paperbacks published by an Hachette/Gallimard consortium to whom most of the major publishers contracted the rights to both classics and recent successes. Costing only one-third the price of a standard edition of a novel, the Livre de poche was an immediate success: by the early 1960s, 55 per cent of book purchases by 20–27-year-olds were 'poche' (Dumazedier and Hassenforder, 1962: 19), and Flammarion imitated the model with the *J'ai lu* collection in 1958, while Gallimard set up their own *Folio* in 1971.

One publisher in particular saw the possibilities for the novel to be part of a developing commodity culture that emphasised youth, newness and the appeal of cultural objects whose purchase gave the sense of 'buying in' to a seductively modern identity. René Julliard had set up his publishing house in 1942, under the Vichy régime, but moved to Paris at the Liberation and rapidly gauged the mood of the age. Julliard published all three of the Goncourt winners for the years 1946–48, and continued to prioritise new fiction. The bestselling war novel *Le Pont de*

la Rivière Kwai (Bridge over the River Kwai, Pierre Boulle, 1952) was a Julliard publication, and he also had a string of successes in the 1950s with young, female, first-time novelists, each of them attracting publicity through the unusual degree of sexual frankness in their writing and through the interest in the personal lives of young celebrities manifested by new, self-consciously modern magazines such as *Elle* (launched in 1945) and *Paris Match* (1949). Françoise Mallet's *Le Rempart des Béguines* (The Illusionist, 1951), and later Michèle Perrein's *La Sensitive* (The Sensitive Woman, 1956), both attracted considerable publicity and sales, but Julliard's major discovery was Françoise Sagan whose first novel *Bonjour Tristesse*, published in 1954 when she was just 18, won her the *Prix des critiques* and instant stardom. Sagan's heroine, like the rapidly mediatised version of the author herself, leads a pleasure-loving, morally disaffected existence reminiscent in its narrative impunity of Dekobra's Lady Diana, but with the added scandal of Cécile/Sagan's extreme youth and single status. The novel's depiction of a sun-drenched, affluent, leisured lifestyle (soon to be further glamorised by Brigitte Bardot's much publicised holidays in St-Tropez), together with its dispassionate yet poignant narrative voice, made it one of the most widely read (and lastingly popular) books of the 1950s. Sagan's slim, spare tales of attempted and failed relationships, mainly set thereafter in a contemporary Paris peopled by a restless, bohemian middle class, had huge appeal throughout the 1950s and 1960s and beyond. At a period of internal conflict over the brutal war in Algeria, and of a developing tension between traditional and 'youth' cultures, they captured a mood of unfocused but widely shared disaffection from the values of family, duty and nation.

Paperbacks, sold in bookshops but also in newsagents and later supermarkets, took popular fiction into the new consumer age. Book clubs, begun in 1946 with the *Club français des livres*, catered for a slightly different, older audience, providing through the subscription model a sort of bookshop adviser by correspondence, and in some cases accounting for the majority of a book's sales.[23] If fiction reading overall decreased in France under the competitive influence of television (the percentage of the French population owning a TV set rose from 6 to 70 between 1958 and 1968 [Gaffney and Holmes 2007: 14]), the new medium also offered opportunities for mutually beneficial collaboration, with both classic and contemporary novels being adapted to the small screen, and this in turn generating new sales of the original book.

Some of the highest-selling French authors of the past six decades have gone virtually unnoticed outside France and owe their appeal to

a classically realist narration of stories that situate the individual within broad sweeps of twentieth-century history. The multi-volumed sagas of Bernard Clavel (*La Grande Patience* [The Great Patience], 1962–68; *Le Royaume du nord* [The Northern Kingdom], 1983–89), like those of Henri Troyat (*La Lumière des justes* [The Light of the Just], 1959–62; *Les Héritiers de l'avenir* [The Heirs of the Future], 1968–70) were constantly in the French best-seller lists, as were the right-wing spy novels (*SAS*) of Gérard de Villiers, their popularity unaffected by the social upheavals that began in May '68, as by the rejection of plot, character and story that accompanied the New Novel movement and continued to underpin academic and critical discourse on literature in France up to and beyond the end of the twentieth century. But if twentieth-century best-sellerdom demonstrates the enduring appeal of certain genres, it also reveals how popularity may depend on topicality, or the ability to provide narrative form for a historically situated 'structure of feeling' (Williams 1961: 56).

Guy des Cars (1911–1993) authored sixty novels which sold in their millions in France between the Liberation and the 1980s,[24] as well as being widely translated, but which then quickly disappeared from the popular canon. Des Cars is an interesting figure here because he engaged in open warfare with the critics who contemptuously nicknamed him 'Guy des Gares' (the 'roman de gare' or 'station novel' being one synonym in French for the potboiler). Des Cars and his publishers used the opposition between the popular and 'literary' novel to market his books.

> READ FOR PLEASURE, NOT OUT OF DUTY. There are authors and books that must be read – even if they are intensely boring – out of duty … as an intellectual or social obligation! And then – fortunately – there are those novels that one devours and savours purely for pleasure, because they are unputdownable. (Nathan 1990: 208)[25]

The pleasure of des Cars's novels was provided by sensational plots generously spiced with eroticism and crime, their narrative techniques a now familiar combination of mimesis and melodrama, allied with what were, at least superficially, daringly 'modern' topics: sexually emancipated women (in many novels), artificial insemination (*Le Donneur* [The Donor], 1973), surrogate motherhood (*La Mère-porteuse* [The Surrogate Mother], 1986). However, like Victor Margueritte before him, des Cars's appeal for so wide a readership depended on combining a pruriently sensationalist topicality with the reassuring endorsement of a conservative doxa. When the critics reviled des Cars's unabashed use of cliché ('in a des Cars novel all Englishmen are phlegmatic, all redheads are alluring and all circles are vicious', as *L'Express* put it [Demeron 1980]),

this was not simply an élitist putdown of accessible, transparent narrative style, but also an indication of the connection, in des Cars's work, between the linguistic commonplace and the comfortable confirmation of reactionary – and in the period of his success increasingly challenged – assumptions. The novels' logic depends on the unquestioned and unexplored assumption of a vaguely Christian deity who dispenses rewards and punishments in this life or the next, making illness or the violence of others a punishment for (usually the heroine's) dissolute living. In several novels, the heroine redeems her life as a well-paid prostitute or mistress by becoming, in the closing pages, a nun or 'bride of Christ' (Des Cars 1959: 254). Despite the majority of women among his readers (Nathan 1990: 214), des Cars always depicts women as 'other', attributing to the female sex a familiar set of essentialised characteristics for which men – as simply default human beings – have no equivalent: thus heroines display 'that amazing sensitivity that only women possess' (Des Cars 1946: 160), and suffer from a peculiarly feminine inability to 'resist the call of the senses' (Des Cars 1959: 79). The racial superiority of white Western peoples, in novels most popular in the years of anti-colonialist struggles, is another unquestioned assumption: the 'natives' of the more exotic locations are collectively characterised as childlike, irrational and potentially brutal (in, for example, *L'Impure* [Impurity], 19).The pleasures of des Cars novels reside in their efficient working of well-tried narrative formula to transport the reader to the exotic (for most) worlds of crime, high fashion, and global travel – but also, for many readers in later twentieth-century France, in their comforting validation of a beleaguered sense of racial and gendered order.

It is easier, from an early twenty-first-century standpoint, to understand empathetically the appeal of that trio of picaresque heroines, each of whom romped her way through French history, and thence to the top of the best-seller lists, in different post-war decades. Jacques Laurent (1919–2000), already known as a 'serious' author, created *Caroline Chérie* in 1948 under the pseudonym Cécil Saint-Laurent, and thus became the highest-selling author of the decade. Anne (1921–) and Serge (1903–1972) Golon invented *Angélique, Marquise des Anges* (Angélique, Marquise of the Angels) in 1956, inaugurating a 13-volume series of Angélique's adventures which achieved huge sales in France and internationally. Régine Deforges (1935–) also began a lengthy series (10 volumes to date) with her heroine Léa in *La Bicyclette bleue* (The Blue Bicycle, 1981), the first three volumes of which topped the best-seller lists for the 1980s.

All three novels certainly owe some debt to Margaret Mitchell's international blockbuster *Gone With the Wind* (1937), which was as successful in France as elsewhere.[26] Like Mitchell's iconic story, set during the American Civil War, each of them depicts a well-known and particularly dramatic period of national history – the 1789 Revolution for *Caroline*, the reign of Louis XIV for *Angélique*, the Occupation for *Bicyclette bleue*. Like Mitchell's Scarlett O'Hara, each young heroine is from a privileged but (from early in the novel) impoverished background, is of a passionate, robustly selfish disposition, finds her aspirations to adventure and self-fulfilment rudely interrupted by a major national crisis, and pursues her desires through a series of brave, foolhardy and occasionally patriotic exploits in a fictional world firmly anchored in historical reality. Like Scarlett, Caroline, Angélique and Léa are each marked out from their siblings not only by their physical beauty but by the intensity of their appetites – for adventure, sex, food, and life in general – and by their courage in the face of physical danger: genteelly raised, the girls all respond to new circumstances by throwing themselves into the fray. The novels thus follow a picaresque structure as their heroines confront dangers, journey across and beyond France to escape or pursue enemies, and repeatedly find brief moments of solace or romance before resuming their exploits. In a manner reminiscent of the *feuilleton*, this structure allows for the pleasure of reading to be prolonged not only into lengthy novels (*Caroline Chérie* is the longest single volume, at almost 1,000 pages), but into potentially endless sagas. In each case, the heroine's extreme youth and naivety at the story's opening allows the narrator to instruct the reader in the (well-researched) events and politics of the era through the protagonist's own learning process.

The pleasure of these texts is not hard to find: they appeal to readers' curiosity about famous moments in history, transporting us to the smells, sounds and intrigues of seventeenth-century Paris or (as Caroline cowers in one of the palace's attics) to the moment in 1789 where the mob besieged Versailles; they offer an interestingly ambivalent relationship with a feisty, brave yet often egotistical heroine, composed of identification and a half-guilty admiration for her sheer ruthlessness, and they deploy the romance script by introducing, in each case, a prototypal hero whose love for the heroine is eventually revealed, but who can never quite be won – so that the full closure of traditional romance is always avoided. Each heroine finds plenty of compensatory casual sex and romance as she continues her quest for her own well-being, that of those she loves, and ultimately the constantly deferred ideal of an absolute romantic union.

These novels deploy the classic resources of the popular with a jubilant energy that remains appealing, and certainly appealed to a huge readership of whom the female component at least clearly warmed to heroines who play an irrepressibly active role in their own history and story, and enjoy the pleasures of romance without making it the only matter at stake in a female destiny.

The love story in its elemental form – meeting, desire, the struggle against obstacles to love, union (or separation) – lost little of its appeal in the second half of the twentieth century, despite feminism and resulting changes in – and heightened awareness of – gender roles. Though Delly remained the market leader for a surprisingly long time, the indigenous popular romance eventually fell prey to that cultural colonisation the French so dreaded, and resisted, from the 1950s on. In 1978, the international romance publishers Harlequin extended their empire to France, setting up their local subsidiary Harlequin-France to perform the functions of overseeing translation of selected Harlequin texts (all authored in English), marketing the product and managing (through focus groups, correspondence, subscriptions and other loyalty incentives) the all-important relationship with readers. Harlequin developed and diversified the genre, increasingly combining the romance plot with elements of other popular genres such as the historical saga, sci-fi or – in the twenty-first century – chick-lit, but the brand remained (and remains) true to the fundamental narrative and utopian ethic of romance: self-realisation is achieved through passionate reciprocal love; the apparently insuperable alterity of the masculine hero conceals elements of 'sameness' that make understanding and tenderness possible; personal freedom and emotional commitment are reconciled as the heroine wins the man now capable of fulfilling her needs. Harlequin operates largely outside the normal circuits of literature, selling mainly through subscription, in supermarkets and nowadays on-line. Its world, as its critics deplore, is mainly that of a vaguely evoked, anglophone modernity, but in this its difference from Delly romance is slight: the most popular romances have always maintained a fairytale imprecision of setting that focuses attention solely on the metaphorical functions of place, and universalises the dream.

The love story has also remained a vital component of individual best-sellers. After *Bonjour tristesse*, most of Françoise Sagan's unsentimental, laconic novels turned on the glimpsed happiness and final impossibility of a good (and lasting) heterosexual relationship. Sagan's literary stardom in the 1950s and 1960s pre-dated the second wave of feminism, and owed much to her novels' articulation of the tension between young women's

continuing quest for reciprocal love and their desire for some larger, as yet undefined form of self-realisation.[27] Beauvoir's *The Second Sex*, published in 1949 to a chorus of publicity and outrage, had provided a magisterial analysis of this very tension, but had not yet permeated attitudes to gender roles and identities. Until the resurgence of feminism in the 1970s, women's sense of inchoate dissatisfaction found expression in a taste for ambivalent fictions, like Bardot's on- and off-screen persona composed equally of rebellion and submission, Sagan's coolly modern but disconsolate heroines, and Beauvoir's own Goncourt-winning 1954 best-seller *Les Mandarins* (The Mandarins), at once a political and intellectual *roman à clé* and a passionate, autobiographically based romance in which the intensity of sexual love is vividly evoked before being painfully sacrificed to the heroine's need to pursue the relationships and causes to which she has already committed her life.

The popular success of *Les Mandarins* was thus in part due to its topicality, of which the passionate but failed romance plot was a significant part, but the unexpected (if brief) border-crossing of a 'difficult' feminist intellectual to the domain of popular fiction was echoed thirty years later when Marguerite Duras's 1984 Goncourt winner *L'Amant* (The Lover) achieved a similar feat, rapidly selling two million copies and climbing to the top of the best-seller lists. *L'Amant* reworks the author's own girlhood love affair with a rich Chinese man in French colonial Indo-China, capturing, perhaps, a national desire to explore troubled memories of a lost Empire, and evoking the intricate web of emotion and desire that connects sexual and family relationships. The autobiographical resonance of both these novels by famous, well mediatised women writers, in an increasingly star-struck age, undoubtedly contributed to their success; so too did the quality of the writing (Beauvoir's densely, effectively mimetic and realist, Duras's lyrical and spare), and the centrality to each narrative of a relationship fuelled and finally destroyed by the 'otherness' of the beloved. Annie Ernaux's elliptical *Passion simple* (Simple Passion) would owe its 1994 success (it topped the best-seller lists for three months) to similar qualities.

In the 2000s the most consistently best-selling novelists also rework the structures and themes of romance, with Marc Levy and Guillaume Musso echoing Harlequin's desertion of national settings for a globalised North American 'anywhere', as well as their separation of the love story from any specific social context, while Anna Gavalda interestingly addresses contemporary fears of loneliness in an atomised, post-family world by doubling her couple romance plots with collective romances in

which several disparate individuals, adrift in post-modernity, manage to achieve the happy ending of chosen communal living, or a recomposed, non-biological family. In both *Ensemble c'est tout* (literally 'Together means everything') and *La Consolante*, the happy conclusion of an edgy, awkward romantic attraction is inseparable from the establishment of a collective, inter-generational social unit. Gavalda's knowingly omniscient narrative voice, extensive use of free indirect style to individualise her characters, affectionate evocation of contemporary French language and lifestyles and neatly woven plots delight her readers by providing the experience of total immersion in the fictional world, and of sharing vicariously in the imaginary resolution of real anxieties.

The ubiquity and versatility of the romance script in contemporary fiction are rarely acknowledged, whereas in the 1990s and 2000s crime fiction has visibly straddled the frontier between high and popular, allying the serious themes, highly crafted language and self-reflexivity of the fully 'literary' with compelling plots and engaging characters (Platten 2004), and thus coming closest in France to what we are terming, in a positive sense, the middlebrow. Daniel Pennac's humorous, humanist and thoroughly immersive stories of the Malaussène tribe were first published in a specialised crime series (the Série noire), but crossed over in 1990 to Gallimard's 'literary' Folio collection. A writer like Didier Daeninckx uses fast-paced murder mysteries to tackle politically resonant issues of national memory. Fred Vargas, one of the most original and widely read of contemporary crime writers, combines erudition (she is an archeologist) with narrative skill, and a richly allusive style laced with humour (one of her characters speaks almost entirely in Racinian alexandrines) with a warm humanism: to solve a murder mystery always demands recognition of human complexity, unpredictability and precious individuality: 'the peculiarities of all these people – their talents, their interests, their unpredictable actions'[28] (Vargas 2008: 389). The cross-class popularity of the 'polar' (detective novel) with its narrative coherence and (largely) humanist values throughout post-war decades dominated by epistemological scepticism, formalism and pessimism in literature may be seen as evidence of resistance to the anti-mimetic doxa – as indeed may the apparently immutable appeal of romance.

Elite and popular reading: the great divide

In French academic, intellectual and state discourse, the second half of the twentieth century saw a sharpening divergence between popular culture – characterised as facile, morally and aesthetically impoverished

and (in some instances) Americanised – and high culture, represented as demanding, educative, appealing to the highest human faculties. While in anglophone intellectual circles a Cultural Studies approach[29] defined 'popular' culture as what most people like, and sought to understand the reasons for these choices and their effects, the universalist tradition of French republican thought, combined with fear of 'coca-colonisation', meant that in France the ideal of a unifying national 'high' culture, to which all citizens would have access through education, remained dominant. The term 'popular' continued to be associated primarily with folk culture, and products that satisfied the taste of the majority were defined rather as 'mass', with all the word's implications of commercialism, commodification, and appealing to the lowest common denominator (see Chapter 1).[30] From a right-wing perspective, the democracy of taste was inherently suspicious and cultural guidance was needed to lead the majority to a proper sense of aesthetic value; from a left-wing point of view, including that of the May 68ers, part of whose project was a radical re-thinking of cultural forms, the central role of the market made mass-appeal culture deeply suspicious.

State policy in both Fourth and Fifth Republics showed a strong degree of continuity with previous régimes, pursuing – in relation to literature – the Chapuys-Montlaville line on the political and moral value of 'good' literature and the corrupting effect of 'bad', rather than any Desnoyers-style equation of popular taste with democratic self-assertion. Literature and the promotion of reading have formed one element of cultural policy in France since the Second World War, but the major emphasis has been on raising the majority to an appreciation of 'high' literature rather than exploring or promoting popular genres. The highly publicised system of annual literary prizes, the active and visible *Conseil national du livre* (National Book Council), with its sponsorship of the annual *Salon du livre*, all promote the book – and especially the novel – as a vital element of French identity. But it is the 'literary' novel that is proudly identified with the specificity of Frenchness, and the public's fondness for the upbeat, romantic, traditionally told stories of the highest-selling novelists is treated with mild embarrassment.

More pervasively influential on social attitudes to literature than state policy was the outright attack on the mainstream novel made by the 'new novelists' of the 1950s. Although Nathalie Sarraute, Alain Robbe-Grillet, Michel Butor and the other theorists and practitioners of this literary trend probably had little influence on the reading habits of the majority, they did provide a powerful articulation of the anti-realist tendency

that had been gradually deepening the divide between the 'literary' and popular novel since the late nineteenth century. For the *nouveaux romanciers*, the mimetic realism of the mainstream novel had little to do with any authentic representation of the 'real', but meant rather the lazy reproduction of a prefabricated version of reality plausible to the reader only because of familiarity with the genre's codes and conventions. To read the traditionally plotted novel with its invitation to become absorbed in an imaginary world was to indulge oneself in the banal delusion of a coherently meaningful reality: 'all the technical elements of the narrative ... aimed to impose the image of a stable, coherent, continuous, univocal, and wholly decodable universe' (Robbe-Grillet 1963: 31).[31] Barthes's striking distinction (in *The Pleasure of the Text*) between the 'readable' and the 'writable' text, the former offering conventional, merely comfortable pleasures, the latter (experimental or avant-garde writing) engaging the reader in rewardingly active co-creation (Barthes 1973: 25–6), further underlined the distinction between an inferior literature read by the many, and an enriching, progressive literature read by the few. What condemned the merely 'readable' novel to mind-numbing banality was precisely the set of narrative techniques that facilitated immersion in the fictional world, and motivated most readers to buy and read novels. A novel's value was in inverse proportion to the transparency of its language, its mimetic representation of space and time, its use of plot and character to 'hook' the reader: authentic literature was linguistically opaque, formally experimental, demanding. This literary ethos has remained powerful in French intellectual life, and filtered through to criticism in the mainstream press as well as to the teaching of literature. As I showed briefly at the start of this chapter, it motivates current polemics against what Todorov calls the 'abyss that separates mass or popular literature, which has some direct relevance to its readers' lives, from élite literature read by professionals' (Todorov 2007: 63).

The belief that true art must always be formally demanding, allied with a deep suspicion of the market, also informs academic constructions of the popular novel in France, and explains the widespread resistance to a Cultural Studies approach premised on the idea that cultural forms preferred by the majority deserve to be taken seriously. In France, as Dominique Pasquier put it in 2005, 'popular culture is not studied so much as deplored' (Pasquier 2005: 62).[32] The last three decades have nonetheless seen the gradual development of a minority academic interest in popular fiction, and of a rich and distinctively French seam of writing on the history and theory of the popular novel. The first conference on

what was then termed 'paralittérature' took place at the famous Cerisy Centre in 1967; further Cerisy events followed on the crime novel (1982) and the *roman-feuilleton* (1986). Since then, scholarship in this field has developed through a small number of university research centres and the work of some brilliant scholars[33] who still, however, often feel themselves beleaguered within a *habitus* that remains largely committed to the canonical and/or the Barthesian 'permanent revolution in language'[34] model of literature.

Conclusion

The attack on the mimetic illusion in the novel has been particularly sustained and impassioned in France: from (at least) Flaubert to the present, the French avant-garde has consistently and bracingly challenged the ideological implications of provisional belief in a fictional world characterised by diegetic coherence, univocal narration and occultation of the mediating function of language. This has led to generalised critical suspicion of novels that reach a large audience, and to a sharper divide than elsewhere between the 'literary' and the popular. For despite the eloquence and intellectual authority of the literary avant-garde in France, what Christopher Prendergast terms 'the sheer tenacity of the mimetic prejudice' (Prendergast 1986: 13) is as evident there as anywhere else: diverse as they are, what connects the most popular novels of the past century and a half remains their capacity to conjure up a plausible world, anchored in lived experience yet excitingly different, and to enable the reader's temporary immersion in this parallel universe. A set of complex, if familiar, narrative techniques 'coax the imagination into simulating sensory perception' (Ryan 2001: 122): the embodied reader 'devours' the text, enjoying full imaginary presence within a coherent fictional geography of space and time. Precise techniques vary and evolve, with the confidently omniscient narrator of the nineteenth century still operative in the twenty-first, but often now deploying, in a world more sceptical of absolute truths, an extensive system of intradiegetic focalisation, or (as in the case of Gavalda or Vargas) a self-aware irony about omniscience. But certain fundamental pleasures of popular reading remain constant. Cognitive desire, or 'the reader's desire for the knowledge that awaits her at the end of narrative time' (Ryan 2001: 140) is aroused and satisfied by effective plotting, and often interestingly survives second and third readings. Affective desire also fuels the wish to turn the pages, as the vicarious experience of negative sensation and emotion is answered by that of (at

least provisional) resolution and fulfilment. The novels that attract large readerships tend, in some sense, to affirm the value and interest of being alive, to demonstrate the possibility of making sense of experience, and to enact transcendence of the solipsism of individual consciousness.

Certain genres traverse the history of popular reading, connecting the 'immobile history' of serials and series addressed to a mass audience to the individual best-sellers that, often unforeseeably, strike a chord with the public. Romance and crime, in particular, have proved both durable and adaptable, providing at once the deep resonance of myth or fairytale and a capacity to address topical issues or states of feeling. It is this simultaneous appeal to fundamental human narratives and immediate, contemporary anxieties and aspirations that characterises, perhaps, the most popular of popular fictions: the great *roman-feuilletons* of Dumas and the rest, the mid-twentieth-century 'heroine sagas', many novels of the crime genre, all succeed in combining mythical narrative structures with topicality.

The implication of the 'discourse of deploration' (Pasquier 2005: 62) that still surrounds popular fiction in France is that to read easy page-turners is to indulge in a form of self-mystification that is both aesthetically and ideologically reactionary. This negative view deserves to be taken seriously: it is true that the imperative to provide easy pleasures can lead to moral and political blandness, to a complacent insistence on the comfortable coherence of reality, to sanitising pain, poverty and suffering by representing them only in the glamorous terms of the wholly soluble personal dilemma. But the idea that the fiction most people read is bad for you, and its resulting exclusion from the history, critical theory and teaching of literature, can be challenged on many fronts. First, it assumes a model of the reader as passive consumer, wholly absorbed by the mimetic illusion to the point of identifying the fictional world with lived reality. In fact the process of reading fiction is, as Marie-Laure Ryan nicely puts it, at once immersive and interactive, the source of 'amphibian' pleasures as entrancement 'takes oxygen from reality' (Ryan 2001: 97). Michel de Certeau's image of the reader as 'poacher' (Certeau 1980: xxxvi) similarly emphasises the complex psycho-emotional process involved in reading even the simplest of stories, and the active agency and selectivity of s/he who performs this act. Secondly, even a rapid and selective analysis of the most popular fictions of the past 170 years shows their diversity, and demonstrates that blandness is not all: in the great *feuilleton* novels of the nineteenth century, in the crime fictions that have captivated readers throughout the period, in those best-sellers that become so by reso-

nating with the collective traumas of an age, and even in the most critically reviled genre of all, the romance, darker emotions and desires are acknowledged and, in various senses, addressed. Moreover, a defence of popular fiction has no need to renounce discrimination: the nature of the pleasure that readers find in Guy des Cars or Guillaume Musso is worthy of study, but there is no imperative to claim their equality with a Dumas or even a Gavalda. Thirdly, the capacity of novels to provide pleasure to a mass readership is important because – it can be argued – reading fiction mimetically is in and of itself a humanising, enriching activity. To transform written signs into an imaginary universe is a process that requires a particular kind of creative imagination, different from that required by the visual story-telling of film or comic book. To see the world from the perspective of another consciousness – be it the narrator or a protagonist – demands the practice of empathy, in every case; it means, in Nancy Huston's words, 'the self put to the test by another' (Huston 2008: 30).

The physical form of the book and its place relative to other media has always changed, and is in the process of changing more radically as e-books offer an alternative to paper and print, and the primacy of the visual intensifies. But if written narrative fiction maintains its place as a popular cultural form, supported rather than diminished by new media, and if French fiction can optimistically envisage its twenty-first-century expansion into a *world* rather than national literature, this is thanks largely to those publications that continue to respond to the deeply rooted mimetic prejudice, and to readers' desire to both lose and find themselves in a story.

Notes

1 For example in the Livres-Hebdo list of 25/11/2009. 'BD' as they are known in France are, for reasons of length, outside the remit of this chapter, but form an important strand of popular fiction in France since early in the twentieth century.

2 The feminisation of reading since the mid-1970s has been well documented by Olivier Donnat in *Les Pratiques culturelles des Français* (Paris: La Documentation française, Donnat and Cogneau 1990 and Donnat 1998). By 2008, women made up an estimated 75 per cent of novel readers, accounting for 52 per cent of readers even for the traditionally masculine genre of crime fiction: http://www.ambafrance-cn.org/L-edition-un-secteur-en-mutation.html (accessed 25/11/2009).

3 Website http://www.evene.fr/livres/livre/anna-gavalda-ensemble-c-est-tout-10582.php, Avis des lecteurs.

4 'Le lecteur ordinaire, qui continue de chercher dans les œuvres qu'il lit de quoi donner sens à sa vie, a raison contre les professeurs, critiques et écrivains qui lui disent que la littérature ne parle que d'elle-même, ou qu'elle n'enseigne que le désespoir.'

5 'On le lit comme on descend une piste blanche, en pente douce et sans douleur.'

6 Given the constraints on length, I have paid more attention to what emerge from my research as the most popular genres of all, namely crime and romance, than to, for example, science-fiction or fantasy.

7 In Britain, the reduction in newspaper duty following campaigns in the 1830s was also opening up a new era of the popular daily.

8 The professionalisation of songwriting occurred at approximately the same time. See Chapter 2, p. 54.

9 'le conteur préféré des midinettes' (Yves Olivier-Martin, 184).

10 Despite Richebourg's denser and more colourful plotting, his *Une haine de femme* (A Woman's Hatred, 1899), for example, shares many features with Bourget's *Un cœur de femme* (A Woman's Heart, 1890): an upper-class Parisian setting, a binary typology of male character (the libertine opposed to the worthy but less seductive husband), marriage, money and consumption as central themes, and a knowing, authoritative narrative voice.

11 *Claudine à l'école* (*Claudine at School*), published in 1900, went into its 80th reprint by 1903. The *Claudine* brand of products included ashtrays, collars, cigarette holders, postcards.

12 Fernand Braudel's concept of 'l'histoire immobile' runs throughout his work and that of the Annales school.

13 Despite a few exceptions to the rule – the appeal of Colette's bestselling *Claudine* series (1900–3), for example, arising in part from the exuberantly irreverent tone of their eponymous first-person narrator – an omniscient narrative voice tempered by shifting focalisation remained the popular norm for this period.

14 The 32 Fantômas volumes first appeared between 1911 and 1913. The many subsequent reprintings omit the original date of publication.

15 In the *Revue des deux mondes*, 1 September 1839.

16 'French souls will grow flabby', he declared in 1843, under the influence of 'works of excessive, formless imagination' (Dumasy 1999: 81).

17 'Tout ce qui est efféminé et d'imagination est contraire à la liberté; tout ce qui est sévère et de réflexion est favorable au progrès politique et à l'émancipation des hommes.'

18 'Le temps des miniatures est passé: nous sommes au temps des fresques. On ne travaille plus pour un public d'élite, on travaille maintenant pour tout le monde ... À un peuple qui possède une tribune politique, une presse libre, des bâteaux à vapeur et des chemins de fer, il faut des rapides récits, d'énergiques compositions, de puissants intérêts, et même de vigoureux amusements ... La Révolution a tout nivelé; ... il n'y a plus qu'une seule classe de lecteurs: tous les Français sont égaux devant la littérature comme devant la loi.'

19 The pen-name of a brother and sister writing team, Marie (1875–1946) and Frédéric (1876–1949) Petitjean de la Rosière.

20 Colette's *Chéri* (1920) and its sequel *La Fin de Chéri* (The Last of Chéri, 1926) – among her most widely read novels – captured this sense of social and emotional alienation. Cosmopolitanism was at the heart of Paul Morand's many successes in the 1920s and 1930s, including *Ouvert la nuit* (Open at Night, 1922) and *New York* (1930).

21 Simenon's article 'L'Âge du roman', first published in 1943, refers to his learned capacity to write with 'des mots qui seraient palpables, des mots matière' ('words that are tangible, material words', Simenon 1988: 28). Colette was one of Simenon's first editors, when he wrote for *Le Matin* in the 1920s; he also acknowledges the benefit of her advice to systematically delete adjectives and avoid anything 'too literary' (ibid.: 47).

22 'Les défauts signalés par Fénelon demeurent fréquents parmi les femmes: curiosité vaine et indiscrète, imagination errante, esprit romanesque.'

23 For example Christine de Rivoyre's 1973 *Boy*, which sold 100,000 in paperback and 332,500 through the Book club edition.

24 According to his publishers, between 1979 and 1986 des Cars's novels sold 37 million in the paperback *J'ai lu* collection.

25 LISEZ PAR PLAISIR, PAS PAR DEVOIR. Il y a des auteurs et des livres qu'il faut lire – même s'ils sont mortellement ennuyeux – par devoir ... intellectuel ou mondain! Et puis il y a – heureusement – ces romans qu'on dévore ou savoure par pur plaisir, parce qu'ils sont passionnants (1976 publicity for *L'Impure* and *La Brute*).

26 Régine Deforges followed the model so closely that in 1987 she was prosecuted for plagiarism by the heirs of Margaret Mitchell.

27 In the same years that millions of French women were reading Sagan, Betty Friedan in the USA was identifying a similar tension – the 'problem that had no name' – in *The Feminine Mystique* (1963).

28 'ce saugrenu de chacun des êtres, leur éclat individuel, leurs originalités aux effets incalculables' (Vargas 2006:). The word 'saugrenu' is richer than 'peculiarities', though hard to translate. It implies the unexpected, the bizarre, the (agreeably) ludicrous.

29 The influential Centre for Contemporary Cultural Studies was set up at the University of Birmingham, UK, in 1964. Drawing on earlier work by British theorists including Richard Hoggart and Raymond Williams, it revolutionised anglophone approaches to popular culture by taking popular texts and audiences seriously.

30 Brian Rigby quotes a 1979 text by academic Geneviève Poujol: 'It seems impossible that a French academic could confuse mass culture with popular culture, as is still often the case with certain Anglo-Saxon academics' (Rigby 1991: 159).

31 'tous les éléments techniques du récit ... tout visait à imposer l'image d'un univers stable, cohérent, continu, univoque, entièrement déchiffrable'.

32 'les cultures populaires ne sont pas étudiées, elles sont prises dans un discours de déploration'.
33 These include Marc Angenot, Ellen Constans, Daniel Couegnas, Marc Lits, Michel Nathan, and the network of scholars linked through the Limoges-based Centre de Recherches en Littératures Populaires et Cultures Média-tiques, directed by Jacques Migozzi.
34 For Barthes, literature represented a 'révolution permanente du langage' (Barthes 1978 [1977]: 11).

Why popular films are popular: identification, imitation and critical mortification

David Platten

Projections of reality

To the intrepid film critic the term 'popular French cinema' might suggest an awkward taxonomy; in the bars and restaurants around town it would strike many as an oxymoron. Conventionally, France (and Paris especially) is seen as a hub of art-house cinema, a treasure trove of films of aesthetic and ethical superiority and a protected, national industry that epitomises the 'European way'. The stereotype may obscure a diverse body of film, but outside the halls of the academy such diversities are rapidly homogenised; sophisticated cinema-goers mildly contemptuous of the feral free-marketeers of the American film industry happily juxtapose Eric Röhmer with Claude Berri, and Jean-Luc Godard with Léos Carax. In their eyes very few French directors would have bathed long in the dead waters of Hollywood. Luc Besson and Jean-Jacques Annaud may have transgressed by using their talents to direct blockbusters rather than building monuments to the seventh art; otherwise the 'Frenchness' of popular French cinema tends to eclipse the 'popular'. This prevailing view has been nourished by a long-standing critical bent in France towards auteurism, according to which the film is evaluated as first and foremost an artistic creation, with the director assumed to be playing the role of the artist. The notion of the cinema as the ideal medium for shaping perspectives on the world, rather than simply reflecting it, has, in incremental stages, come to signify a national filmic identity. At the 1993 GATT talks, which focused on the removal of barriers to international trade, the subsidies allocated to the cinema industry in France proved to be a durable sticking-point. In the world of international politics French cinema was portrayed as the last bastion of European protectionism, a position that fitted neatly with the views of those who regarded it, then as now, as the

epitome of the cultural exception and a source of national pride.

Arguably the most important phase of this artistic consecration of the cinema in France occurred in the 1950s, with the foundation of the influential film journal the *Cahiers du cinéma* and the subsequent films made by the young critics who wrote for it. This new wave of French cinema, or 'Nouvelle Vague', associated with the work of among others Jean-Luc Godard, François Truffaut, Claude Chabrol, Jacques Rivette, Alain Resnais and Agnès Varda, was consequential in a number of respects. Seeking to liberate the process of film production from the perceived tyranny of the studios, it attempted to democratise the process of making films. Godard in particular advocated a punk ethos, an 'anyone-can-do-it' attitude to film-making. However, as they were breaking down the walls of the cinematic establishment in France, so the Nouvelle Vague radicals were also erecting their own barriers, by practising a form of cultural revisionism. The critics working for the *Cahiers du cinéma* promoted a cinematic hegemony, a snakes-and-ladders perspective on French film history in which vaguely defined aesthetic values are paramount. On their recommendations some directors like Jean Renoir and Jean Vigo climbed ladders, whereas others, such as Claude Autant-Lara and Henri-Georges Clouzot, slithered down snakes.

Key concepts associated with the Nouvelle Vague generation such as auteurism, 'cinéma-vérité' (defined as 'authentic' rather than 'realist' cinema), formal experimentation and non-linear narration have not only influenced many subsequent film productions in France and elsewhere, but also laid the basis for the theoretical swerve away from the notion of film as a popular spectacle, a deviation which is especially prevalent in academic film studies. The Nouvelle Vague *auteurs* did show an interest in box-office receipts but only to the extent that any profits could be ploughed into their next projects, and they professed indifference to the habits and tastes of the mass cinema audience. It is an attitude that has been overwhelmingly reciprocated. Over the past fifty years the French people have been happy to support the national film industry, but the kind of films they tend to watch on the big screen do not feature prominently in the many available study guides to French cinema. In contrast to the world of fine art, where spectators flock to exhibitions of abstract paintings and wonder at all manner of artistic 'installations', the public has left the cinematic avant-garde to its own devices, preferring instead to spend its money on comedy and light entertainment.

Today, in relation to French and European cinema, critical opinion skirts nervously around definitions of the 'popular'. It is described, in

the Introduction to a path-breaking collection of essays, as 'notoriously slippery or, alternatively, rich' (Dyer and Vincendeau 1992: 2). Within a few sentences this equation is absorbed into a well-grooved formulation, according to which a contemporary mass culture driven by consumerism is distinguished from a traditional popular culture concerned with local, grass-roots activities emanating from that mythical entity termed 'the people'. However, the dialectic is not sustained through the discussion: is mass culture slippery, rich or both? And, as Dyer and Vincendeau continue to interrogate notions of the popular with regard to the cinema, they encounter more slipperiness before alighting on the 'common specificity to the material situation within which popular cinema has to be produced in Europe' (Dyer and Vincendeau 1992: 13). The implication here is that critical interest in popular cinema should centre primarily on the industrial process of production and the commercial facts of the film's reception rather than on the product itself. Two recent studies are equally reticent when it comes to defining their terms. Both fasten their respective collections of essays to the 'alternatively, rich' mast of Dyer and Vincendeau's initial description, insofar as they propose an openness and diversity of approach that is understood in terms both of an explicit broadening of the choice of film subjects and also of the critical methodology used to analyse these films, thus acknowledging, albeit tacitly, the disjunction between 'lowbrow' and 'serious' cinema that has been operative in France for the past fifty years (Mazdon 2001a; Vanderschelden and Waldron 2007).

The absence of reliable statistics for box-office receipts of individual films in France before the creation in 1946 of the *Centre national de cinématographie* has further exacerbated attempts to understand exactly what a 'popular French cinema' might entail. However, two lists included as appendices to a dictionary of popular French cinema, recently published in its second edition, do help to define a canon (Dehé and Bosséno 2009). One gives the top 100 most popular films shown in French cinemas since 1945, and the other, in ranking order, those most frequently broadcast on French television. The first list is dominated by comedy and (to a far lesser extent) adaptations of classic adventure stories. The nine most popular films since the War are all straight comedies. The first non-comic film, Jean-Paul Le Chanois's 1957 adaptation of *Les Misérables* with a venerable Jean Gabin in a starring role, is in tenth position, with Luc Besson's *Le Grand Bleu* (The Big Blue, 1988), Jean-Jacques Annaud's *L'Ours* (The Bear, 1988) and Just Jaeckin's *Emmanuelle* (1974) in thirteenth, fourteenth and fifteenth positions respectively. Of the pantheon of critically acclaimed

French directors, only Jacques Tati and Henri-Georges Clouzot have made films that feature in the top one hundred at the box-office. Given the history of French television (see Chapter 5) which has evolved from a nationalised industry to a predominantly commercial concern, and the significant variability in the pricing of film screenings on television, the second list does present a more nuanced picture, with a wider historical sweep. More of the big names – Jean Cocteau, Jean Renoir and Jean-Pierre Melville – feature here, with Marcel Carné's *Les Enfants du Paradis* (Children of Paradise, 1944) heading the list of films most frequently shown on television. Interestingly, early, pre-war cinema is also represented, with French television audiences showing appreciation for Louis Feuillade's adaptations of the *Fantômas* stories (see Chapter 3).

Such empirical evidence of commercial success helps to demarcate the field of popular cinema, emphasising among other factors the mass appeal of comedy on the big screen. However, it cannot speak to the broader, and arguably more important, question of the impact of the cinema on modern life, a subject which is of interest to historians and sociologists, as well as to cultural critics. For the assumption underlying research into such aspects as the nature of spectatorship – on how we view film, or indeed how we are primed to view film – or cinema-going as social ritual is that, like Renaissance theatre or the nineteenth-century serialised novel before it, the cinema is, quintessentially, a popular medium. The part played by audience figures in dictating the course of film history ought not to be discounted, but equally the impact of the cinema as a cultural phenomenon, and the extent to which it has recalibrated visually the relationship of the subject with the external world, should not be downplayed. Recent scholarship on the reception of the cinema in the first decades of its existence has illuminated precisely this anthropological dimension.

On 28 December 1895, before an audience of thirty people assembled in the Salon Indien at the Grand Café, Boulevard des Capucines, Paris, the Lumière brothers demonstrated their new *cinématographe*. The show consisted of ten brief sequences of animated pictures, each lasting no longer than one minute, showing aspects of daily life. Accounts of the spectators' reactions to these moving images differ, but it would appear that on this occasion, as at other early showings, their shock was palpable. Reports of viewings of the brothers' *L'Arrivée d'un train* (The Arrival of a Train) describe how, as the locomotive on screen appeared to grind in their direction, spectators stiffened in their seats, screamed or fled the auditorium. However, in the opinion of many film and cultural

historians the shocks and tremors experienced by these first cinema audiences have been exaggerated; they did not in and of themselves amount to an ontological earthquake. Rather the Lumières' unveiling of their *cinématographe* has since been interpreted as a significant event in a well-documented history of scientific experimentation, 'a particularly ingenious synthesis of research into motion-picture technology carried out by several generations of scientists and amateur inventors' (Temple and Witt 2004: 9). For some, particularly those inspired by the work of André Bazin, for whom the cinema belongs to the order of mimesis, the invention of photography some sixty-five years prior to the Lumières' showing, which proved that it was possible to create exact visual reproductions of the material world, marked the beginning of this story. For others, the pre-history of the cinema stretches back further into the past, and it embraces a range of cultural practices such as magic-lantern shows, slide shows and various optical devices designed to create illusions of the world in motion (Mannoni 2000).

A similar teleology operates with the construction of a history of spectatorship. Reading Walter Benjamin's concept of *flânerie* as 'shorthand for describing the new, mobilized gaze of the precinematic spectator' (Williams 1997: 88), Vanessa R. Schwartz casts light on three privileged sites of public entertainment in late nineteenth-century Paris: the Morgue; the waxworks of the Musée Grévin; and the 'reality machines' known as 'panoramas' and 'dioramas'. She argues that the popularity of these attractions derives from an appetite for 'real life' experiences and simulations that, in time, would be fully satisfied with the advent of the cinema. The Parisian Morgue was a particularly striking example of what Schwartz terms 'spectacularized Parisian life' (Williams 1997: 93). Crowds flocked to see the gruesome exhibits, which were often placed in a sitting position behind a curtain in the *salle d'exposition*. The appeal of this theatre of death may be understood, paradoxically, as a deep-seated yearning for contact with the reality of life, for a greater understanding of the material conditions of life accessed through direct experience. As such the Morgue, which closed to the public in 1907, may be regarded as a temporary milestone, marking the spectator's journey from the still-life figures of the Musée Grévin to the motion pictures of human life in two-dimensional plenitude projected onto the big screen.

More telling still was the renewed vogue for 'panoramas' that gripped Paris in the final decades of the nineteenth century. These were circular paintings that enclosed the spectator, cutting visual contact with the outside world. The late nineteenth-century versions, in contrast with

earlier models, enhanced the verisimilitude of the images depicted through the deployment of photographic effects. They also featured pictorial references to topical stories, which included images of celebrities. The more elaborate the illusions of reality they were able to convey, the more popular the panoramas became. One commentator records that Charles Castellani's 'Le Tout Paris' was displayed throughout the Exposition universelle of 1889, which attracted over 300,000 visitors (Williams 1997: 107). Such a mass resurgence of interest in this form of compartmentalised visual experience at this time has prompted scholars like Jonathan Crary and Anne Friedberg to identify the 'panorama' as a clear antecedent of the cinema in France, precisely because it identifies the spectator as an active participant in the viewing process.

The historical trajectories that inform much work on the early cinema, including for example studies on the importance of the pioneering French entrepreneurs Léon Gaumont and Charles Pathé in creating the film industry as we know it today, inevitably palliate the impact of the early showings given by the Lumière brothers. However, the analyses of pre-cinematic nineteenth-century cultural practices in Paris function like an ultrasound scan, revealing the embryo of the future film spectator who is depicted as a hungry consumer waiting in anticipation of that first shot, that first stream of moving images that he or she will experience as a gush or jet of unmediated visual reality hitting the retina. Even Georges Méliès, master illusionist and director of the Robert-Houdin Theatre of Magic and an interested spectator at the Grand Café, was flabbergasted when the moment finally came, as the pictures began to move on the screen.

It is clear that with the birth of cinema something fundamental in the realm of human experience occurred, akin to the discovery of a new dimension of being or of a new primary colour. Many theorists have taken a lead from the cultural critic Walter Benjamin, who, in a seminal essay, describes how the cinema performed a radical transformation in the scope of human perceptual experience:

> Our taverns and our metropolitan streets, our offices and furnished rooms, our railroad stations and our factories appeared to have us locked up hopelessly. Then came the film and burst this prison-world asunder by the dynamite of the tenth of a second, so that now, in the midst of its far-flung ruins and debris, we calmly and adventurously go travelling. (Benjamin 1973: 238)

Film, particularly with the advent of synchronised sound, is thus understood as a projection of realities that exist beyond, and conceivably at a great distance from, the spectator's habitual field of perceptions.

However, the extant question arising from Benjamin's ruminations concerns the capacity of film to flick a new cognitive switch in the human mind, to penetrate deeply and in unprecedented fashion into what he terms with astonishing prescience the 'web' of reality.

Georges Méliès saw an economic value in using the new technology to challenge habitual perceptions of reality. Within months of the Lumières' first showings he had bought his first projector (from an English supplier), designed a camera, and begun producing so-called 'trick' films, the first being *Escamotage d'une dame chez Robert-Houdin* (The Vanishing Lady, 1896). In 1897 he built a glass-house studio at Montreuil, south of Paris, and made a series of 'shorts' followed by longer 'fantasy' films, including an adaptation of Jules Verne's *Le Voyage dans la lune* (A Trip to the Moon, 1902). The new medium of the cinema allowed Méliès to create a more fluent presentation of the effects previously generated during his theatre shows by ingenious combinations of trapdoors, mobile sets and stage machinery. In order to create this new film magic, he developed the techniques of stop-motion and multiple exposure. Méliès realised that by stopping the camera and adding or subtracting elements to the scene before shooting resumed he could convey 'magical' transformations, and by superimposing layers of images on the same roll of film he could populate scenes with ghostly figures.

Méliès was an important influence over the course of film history in two regards. First, his demonstration of how to manipulate the moving image at such an early stage dispelled questions of credulity and verisimilitude and transported the motion picture into the realms of fiction and entertainment. Méliès' eager mastery of the new technology supports the view of Tom Gunning, who challenges the received view that the first spectators mistook the moving image on screen for reality. Instead, Gunning advances the idea that these first films were viewed and experienced as extensions of the kind of *trompe l'œil* effects common in baroque art, ensuring the rapid transmutation of the spectators' initial astonishment into a 'conscious delectation of shocks and thrills' (Williams 1997: 120). Each one-minute film of the Lumières brothers would have delivered what Gunning terms 'a brief dose of scopic pleasure' (Williams 1997: 121). Moreover, he argues that the future of the cinema as a medium of entertainment is predicated on our attraction to such 'scopic' pleasures, previously manifested by the public taste for spectacle in nineteenth-century Paris, which may be conceptually framed by Augustine's dialectic of the *voluptas* (meaning 'the visually beautiful') and the *curiositas* (meaning the impulse to view unbeautiful sights) elaborated in the fifth century.

Secondly, Méliès' experimentation with cutting and editing film has led him to be characterised as the progenitor of formal innovation in film-making, and as such a precursor to Sergei Eisenstein, whose theory and use of montage in the 1920s, most famously in his film the *Battleship Potemkin*, is normally regarded as the most significant landmark in the history of the cinema as art. Here we bump against the fundamental division that has orchestrated much film theory and criticism over the twentieth century, between on the one hand realism, exemplified by the work of André Bazin and the privileging of *mise en scène* and the depth-of-field shots associated with, for example, the films of Orson Welles, and on the other hand formalism, according to which film is a priori a creative form, there to be shaped by artists like Eisenstein and Godard. However, in relation to the study of popular cinema this is, if not a false dichotomy, then hardly a useful one. In an essay on the apparatus of the cinema, Jean-Louis Baudry develops an analogy between film spectators and the chained, immobile prisoners of Plato's Cave; in both situations we may divine a picture of spectatorship as pure absorption into the projected, illusory world of image and sound. Baudry describes the images on the screen/wall of the cave as 'representations experienced as perceptions' (Rosen 1986: 314). In both instances the projections constitute a singular cultural experience, and likewise both sets of spectators, those led into the cave and those in the Grand Café, find themselves in new philosophical territory, where the previous rules of engagement no longer apply. As Jean Mitry explains, in contrast to other representational media the cinema holds up a genuine two-way mirror to human experience:

> Whereas the classical arts propose to signify movement with the immobile, life with the inanimate, the duty of the cinema is to the expression of life with life itself. Its journey starts where the others' finish, thus their rules and principles cannot apply to it. (Mitry 1965: 453–4)[1]

This unprecedented insight into the lives of others provided by the cinema appears to absolve it, in some cases, from the normative standards of critical judgement applied to other fictional forms. It is as if Mitry's perspective on the medium as the 'expression of life by life itself' precludes the intervention of the independent human mind, to the extent that philosopher Jacques Derrida was later to consider going to the cinema as a guilty pleasure, as a form of pure leisure that absented him from the work of thought. Derrida speaks of 'a hypnotic passion for the cinema stemming from childhood … One is there glued to the screen, an invisible watcher, authorised to view and identify with whatever is

projected, without any sanction at all and without having to work at it'
(Dehée and Bosséno 2009: 9).[2]

The Lumière brothers' demonstration of their *cinématographe* at
the Grand Café in December 1895 thus encapsulates an extraordinary
moment of historical and cultural synthesis. Within the 'tenth of a second'
estimated by Benjamin the spectator would have been transported to a
different world and the cultural distinctions that might have formerly
separated him or her from his or her neighbour would have been obliter-
ated. The surrealists, with their customary bent for the importance of the
quotidian, saw this transportation as an activation of our dream-world,
taking the subject to that point at which, in the words of André Breton,
'life and death, the real and the imagined, past and future, the commu-
nicable and the incommunicable, high and low, cease to be perceived as
contradictions' (Breton 1972: 123).[3] However, the key point in relation
to this essay is that the cinema ushered in a new potential for obtaining
knowledge that would be available to all, irrespective of education and
social standing, in equal measure. In this sense it may be considered
as quintessentially popular, as the medium which is *sui generis* 'of the
people' and was to inspire the vision of André Bazin, one of its greatest
critics, who saw in it the possibility of an integral realism, 'a recreation
of the world in its own image' (Bazin 1969 [1958]: 25, 'une recréation du
monde à son image').

The research that has been conducted on the early cinema and on
pre-cinematic cultural practices in Paris is invaluable to this study, since
it helps to set theoretical parameters for the discussion of popular film,
which we might now envisage as proceeding along an axis, with the
notion of the cinema as perception, connoting the limitless mobility of
the gaze and the potential for 'scopic pleasure' at one end of the spectrum,
and the cinema as representation, offering complete renditions of alter-
native realities, at the other. Such a theorisation of film, which has the
viewing experience of the spectator at its locus, offers a change from the
standard dialectic that has governed much film criticism, which opposes
the mimetic aspect of film as enacted through the *mise en scène* to its
creative potential concentrated in the director and his or her capacity to
change perceptions through shot selection and *montage*. Alternatively, it
could be argued that, in the contemporary era of 3D movies and digital
imaging, that raw connection between the projection of moving images
and the spectator that once gave rise to what Tom Gunning describes as
an 'aesthetic of astonishment' (Williams 1997: 114–33) has lost some of its
magnetic power. It is true that the clever promotion of the big Hollywood

franchises, such as the *The Lord of the Rings* or the *Harry Potter* series, can still mobilise a mass cinema-going public and create a collective, 'cinematic' event, but as individuals we are not easily shocked these days by what we see on film. Instead the drama of the Lumière brothers' first showing is now played out over a different medium, the television, and generally through documentary or 'live' news broadcasting. In 1985 BBC news audiences froze as they watched the first pictures of the Ethiopian famine, and sixteen years on the images of 9/11 were embossed on the collective memory of a global audience, many of whom thought, having inadvertently switched on their sets, that they were watching a disaster movie.

The theoretical premise to this chapter is that film conceived as the representation of another (usually fictional) existence triggers instincts or desires within the spectator who is compelled to align him or herself, through processes of identification or imitation, with this screen world. This is the *tabula rasa* of the cinema, the fundamental viewing conditions of the motion picture. However, whereas the film *auteur* will use all manner of means to elevate the spectator to a position whence he or she is supremely conscious of the artifice of the medium, the popular director will seek to activate the spectator's overwhelming urge to find his or her place in the world of the film. Some of the most skilled practitioners operate at the juncture between these two apparently irreconcilable motives. A good example would be David Lynch, whose visual tapestries of modern life are enticing but also suffused with dream and hallucination such that they can never correspond entirely with the real-world view of the spectator.

The next two sections of this chapter will explore distinct aspects of popular cinema. First, appropriating an established area of film theory, the analysis focuses on ways in which the spectator is encouraged to model him- or herself on the star. Secondly, it addresses the theme of laughter and various modes of comic imitation. In the last section it returns to the preoccupation in critical discourse on contemporary French cinema with the authenticity of the image and the impact this arguably narrow focus has had on common perceptions of popular film. At each stage the argument is illustrated with detailed reference to specific films, all of which have enjoyed marked commercial success.

Stars in their eyes

In 1919 a group of film performers including Charlie Chaplin, Mary Pickford and Douglas Fairbanks, whose wage demands could no longer be met by the Hollywood studios, joined forces with director D. W. Griffith to form their own production and distribution company, United Artists. This initiative was predicated upon a common understanding of the economic value of the on-screen performer, which in turn derived from the intuitive perception that drove the Hollywood film industry, namely that the motion pictures offered a legal means of trespass. This notion of the commercial film as a roving eye, granting the spectator comprehensive access to different geographical locations, and also to different social classes, approximates to the position of Benjamin and others who saw in the invention of the cinema a new kind of omniscience. In the first decades it rapidly became clear that durable economic growth in the film industry would be achieved neither through technology – which spans Méliès' early trickery and the computer-generated images of contemporary disaster movies – nor through the creation of compelling narrative fictions, important though both these aspects have been and continue to be to its history, but by the cultivation of the charismatic film star. What for more than a century has driven people in great numbers to return again and again to the cinema, indeed to attend ritually, is the thrill of being able to see themselves as other human beings, perceived to be more attractive than they and living infinitely more exciting lives.

The nature of this communal urge is significant. French sociologist Edgar Morin argues that the Hollywood film star generated a form of collective worship: 'When we speak of the *myth* of the star, we mean first of all the process of divinisation that the movie actor undergoes, a process that makes him the idol of crowds' (Morin 2005: 30 [1972: 39]).[4] Morin wrote here about the influence of Hollywood over the lives of ordinary citizens at a time when the cinema was the sole form of mass entertainment. However, in the late 1950s the popular music star materialised, and by the mid-1960s, with the teenage female hysteria that greeted public appearances of The Beatles, it could be argued that, as the primary focus for mass adulation, the film star had been usurped by the pop star.

The emergence of the pop music star helps sharpen our understanding of film stardom, since the relationship of star to spectator/audience is specific to each medium. Here a key distinction lies with the bodily presence of the pop singer, which contrasts with the ethereal nature of the screen actor. Even a relatively minor pop star appearing live within the confines of a concert venue may generate feelings of quasi-religious

fervour, of the sort that, in Morin's view, crystallised the myth of the Hollywood star. However, this type of idolatry is contingent on the possibility of the physical manifestation of the star, which occurs much more frequently in the world of popular music than in the cinema industry (see Chapter 2). The occasions on which the film star appears in person – at premieres or festivals and on television chat shows – tend to form part of a promotional campaign. They retain some aspects of performance though by and large are pre-scripted and dull; the film star comes alive on the big screen.

This screen presence occupies an intermediary zone. It is easier for the spectator to imagine that he or she is the film star, because the material reality of this other is, in nearly all circumstances, absent. An analogous relationship pertains between the twenty-first-century television or gossip-magazine celebrity and the consumer. In these cases the distance between image and reality would imply that the relationship of spectator to star is aspirational rather than idolatrous. For whatever reason, we want to be like them. The chronicling of the life of the former glamour model Katie Price by the UK media, through its endlessly contrived reiterations, offers the purest illustration of such aspirations. As an unapologetic recipient of cosmetic surgery, a caring, though fun-loving mother discarding weak-kneed husbands, astute business woman and 'author' of 'self-help' autobiographies, Price offers exaggerated, multifarious projections of what many women at different stages of their lives aspire to be. Each new chapter in her star or celebrity life carries an emotional charge transmitted through the British tabloid press, pain as well as exhilaration, a discourse intended to authenticate the 'reality' of this illusory existence.

Academic interest in film stars and the nature of stardom was awakened by Morin, to whose work I shall return below, and explored further by Richard Dyer. In his books *Stars* and *Heavenly Bodies*, as well as in numerous subsequent papers, Dyer investigates the hitherto 'invisible' ideological praxis that informs the construction of the Hollywood film star by showing how standard procedures for the lighting of film sets tend to enhance the white face while at the same time subduing the profile of the black, to the extent that, as he puts it, 'photographing non-white people is typically construed as a problem' (Turner 2002: 95). One example he cites concerns a symmetrical shot from a 1993 film, *Rising Sun*, in which Harvey Keitel is flanked by Sean Connery and the mainstream black actor Wesley Snipes. Whereas Connery's facial features are clearly demarcated, we see little of Snipes's, other than the whites of his eyes. (Turner 2002: 103). Elsewhere he suggests, referring to the back-

lighting of Marilyn Monroe and Robert Redford, such 'problems' reflect Hollywood's veneration of blondeness.

Over the last two decades the rise to global prominence of Bollywood and other world cinemas, as well as the success of recent international hits such as *Slumdog Millionaire* and *The Kite Runner* that primarily feature brown-skinned actors, suggest that the covert ideology dictating the production of movies identified by Dyer has become less visible, more obscure, perhaps more subtle. Yet his analyses of film stardom remain instructive, as they remind us that the shooting of any film will never be entirely innocent; the medium of film will always seek to present the constructed and the artificial as natural. Moreover, in the final paragraph of his seminal contribution he acknowledges that, although his method will capture this ideological dimension to the star, it cannot embrace the totality of the phenomenon:

> I feel I should mention beauty, pleasure, delight ... When I see Marilyn Monroe I catch my breath; when I see Montgomery Clift I sigh over how beautiful he is; when I see Barbara Stanwyck, I know that women are strong. I don't want to privilege these responses over analysis, but equally I don't want, in the rush to analysis, to forget what it is that I am analysing. And I must add that, while I accept that beauty and pleasure are culturally and historically specific, and in no way escape ideology, none the less they are beauty and pleasure and I want to hang on to them in some form or another. (Dyer 1998: 162)

Dyer's honesty in confessing to the existence of an unresolved essentialism manifest in the pleasure he experiences in watching films, which, like Derrida, he thinks of as antipathetic to serious thought, alerts us to another potential flaw in his argument. One assumption informing Dyer's approach, which underpins other critiques of popular culture, notably those associated with the Frankfurt School, positions the viewer of commercial films as a passive consumer of images and thus potentially blind to the ways in which what he or she sees has been manipulated by the film moguls. Contrastingly, for Morin the extent to which the star is ideologically constructed or the degree of passivity of the spectator as recipient of this visual information are of a secondary importance; he is more interested in what the spectator registers and how these impressions might change his or her view of the self. It is this 'affective relation between spectator and hero' (Morin 2005: 11 [1972: 23])[5] that, in Morin's eyes, fuels the Hollywood star system, a relationship which, he argues in a key passage, is anchored in the profound human impulse to see oneself as other, to project one's own desires and fears onto external images:

In the last analysis it is neither talent nor lack of talent, neither the cine-
matic industry nor its advertising, but the need for her that creates a star. It
is the misery of need, the mean and anonymous life that wants to enlarge
itself to the dimensions of life in the movies' (Morin 2005: 81 [1972: 91]).[6]

Playing different roles in different films, the star accumulates a visual
density, which is both recognisably unique and sufficiently malleable to
allow a significant fraction of the cinema-going public to project their
own identities onto him or her. These relationships are forged at critical
moments. For example, Morin highlights the importance of cinematic
make-up (in contrast with theatrical make-up) in consecrating the image
of a particular star in the mind's eye of the spectator, and the electrifying
effect of the screen kiss, especially for the rapt, pre-1960s, adolescent
spectator. The potency of the relationship is vouchsafed by its continua-
tion beyond the confines of the cinema auditorium, which is documented
in the outpourings of fan mail and the responses elicited from the repre-
sentatives of the star, a correspondence forming what Morin calls 'the
stellar liturgy'.

Morin does concede that the connection between spectator and star is
in part historically determined. The third edition of *Les Stars*, published in
1972, is embellished with a supplementary section in which Morin traces
an evolution of the star system. Competing for public attention with tele-
vision, the car, home improvements and the new 1960s leisure concept
of 'the weekend', the cinema is no longer 'the keystone of mass culture'
('la clé de voûte de la culture de masse', Morin 1972 [1957]: 148).[7] With
the mediatisation of Western society in the 1960s, charted in the work of
McLuhan, Leroi-Gourhan and later Régis Debray, came a new type of star
that seemed to bridge the gulf between the silver screen and humdrum
realities. The matinee idol of Hollywood's Golden Age had been replaced
by a new breed of film actor who tackles problems, is permitted to be
unhappy, and may suffer from neuroses and depression. He or she takes
his or her place in a 'new cultural constellation', in which the influence of
the star over modern and contemporary society is extended. The film star
may no longer exist as an unattainable entity on a pedestal, but we still
crave the stardust that only he or she has the power to sprinkle; not only
are we interested in the lives of the stars, we also aspire to the lifestyles
they promote. And the most efficient vehicle for this type of promotion
is the feature film. Let us take two examples of French films that are each
emblematic of the cultural values of their time: *Un homme et une femme*
(A Man and a Woman, 1966) directed by Claude Lelouch; and *37° 2 le
matin* (Betty Blue, 1986) directed by Jean-Jacques Beineix.

For Morin the precursor to the modern film star is James Dean, the first teen idol and ultimate symbol of a world with no tomorrows. The French title of his signature film *Rebel Without A Cause, La Fureur de vivre* (Passion for Living), accurately defines the legendary status of this star in terms of his hunger for different experiences – 'James Dean wanted to do everything, to try everything, to experience everything' (Morin 2005: 99 [1972: 137])[8] – the purest expression of which is a yearning for speed, whether it be at the wheel of the dragster his character races in *Rebel Without a Cause* or of the Porsche in which he died. Morin astutely points out that James Dean's approach to life (and death) reaches beyond the horizons of the teenager; it also articulates a (predominantly masculine) urge to pit the self against the world, to conquer territory by travelling over it, at great speed. Paradoxically the car, as oft-cited representation of modernity, offers the prospect of renewing contact with a more primitive world, one where quick reflexes and motor skills defined what it was to be male: 'Motorised *speed* is not only one of the modern signs of the quest for the absolute but corresponds to the need for risk and self-affirmation in everyday life' (Morin 2005: 107 [1972: 143]).[9] It is also, as many commentators have observed, a model of design, and therefore a fetish-object par excellence, something to look at, a sumptuous, visual artefact and signifier of a dynamic, instantaneous presence.

The male character in *Un homme et une femme* is a racing driver played by Jean-Louis Trintignant, his female counterpart a 'script-girl' in the film industry played by Anouk Aimée. Over the prolonged title credits, the film cuts on four separate occasions to shots of the male lead, also called Jean-Louis, either in the passenger seat of his convertible, leaning across to help his young son steer a straight course, or at the wheel himself, weaving patterns in the sand of the beach at Deauville to the sound of the boy's laughter. The first words of the film, uttered by Jean-Louis to his son are 'Come on, let's take the hood down' ('Décapotons, je t'en prie'). Weekend driving for fun is juxtaposed with the world of the professional driver, as the spectator is treated to dramatic shots of Jean-Louis's racing car in practice, speeding along a steeply banked track framed by a line of trees. The lighting of this scene is exquisite, with shafts of orange sunlight occasionally penetrating the misty whiteness and illuminating the bodywork of the car. Later, the tension and excitement of the start to the Monte Carlo Rally is rendered, as close-up shots of Jean-Louis are skilfully woven into documentary footage of the event.

There is not much to the story of *Un homme et une femme*. It purports to explore the early stages of a potential romance that risks being derailed by

the woman's memories of a past tragedy. Dialogue is sparse and, echoing the influence of the Nouvelle Vague, often improvised, so as to convey the awkwardness of two strangers who find themselves together during a long car journey. From the outset the focus on the couple's relationship is literally and metaphorically framed by the car. They are depicted during their first journey from Deauville to Paris in front profile, conversing unsuccessfully as the rain lashes the windscreen, with the camera magnetised in long, silent close-ups of Anne's face. Jean-Louis trades on the glamour of his profession, though Anne, on the basis of the preliminary information given to her, imagines him, in what is intended to be an amusing aside, as a pimp.

Much of the action in the film occurs inside cars. Anne's apprehensiveness over falling in love for a second time in her life is mirrored in the spectator's nagging concern that the romance will be curtailed by a car accident. Previously, Jean-Louis incurred serious injuries while competing in the Monte Carlo rally, which prompted the suicide of his wife who thought he was dying. Anne's former husband, a stuntman, whose profession, like that of Jean-Louis, brings danger and human mortality into the realm of daily existence, was killed on a film set before her eyes. Car journeys in the film are frequently punctuated by bulletins on the radio warning of inclement weather conditions, including, on one occasion, news of a fatal road accident, involving 'un homme, et une femme'. Thus when, having just completed an arduous Monte Carlo rally and received a congratulatory telegram from Anne, Jean-Louis decides to drive through the night to join her at Deauville, the spectator fully expects that romance will be thwarted by tragedy. Instead, it remains partially obstructed by Anne's continuing grief over the loss of her husband, which is conveyed visually through arresting images, embellished by an evocative soundtrack.

In the early 1960s Claude Lelouch served his apprenticeship as a film director by shooting 'scopitones', short filmic sequences designed to accompany songs played through a kind of audiovisual juke box. The 'scopitones' were in effect the first pop music videos. However, by dint of concentrating on filming sequences intended first and foremost to illustrate music rather than drive a narrative, Lelouch was to develop an aesthetic dimension to film-making that was demonstrated for the first time in *Un homme et une femme*. Composed by Francis Lai, the music in the film is essentially non-diegetic, with the mostly instrumental pieces in the first half giving way later to more traditional *chansons* performed by Pierre Barouh, who plays Anne's dead husband in the film. In the absence of meaningful dialogue between the characters, the words of the

songs express the mixed emotions of Anne. Lai's melodies complement an audacious mix of filmic styles, such that the auditory and the visual combine in a sensory lushness, which is both a powerful aesthetic statement and a strong selling-point of the film. In the years since, the sound track has become associated with the iconography of Europe in the 1960s, and especially with a certain style and glamour, exemplified by Michael Caine in *The Italian Job*, Bardot at Cannes, Gainsbourg on the Left Bank, and the Rolling Stones in Saint-Tropez.

Although it was awarded the Grand Prix at the 1966 Cannes Film Festival, which is traditionally a mark of cinematic quality, *Un homme et une femme* is an explicitly commercial endeavour. One of very few European films to be given an international release, it contrives to promote a number of French tourist attractions. Anne's flashbacks to happy times with her husband show them riding white horses in the Camargue and rolling in the snow on Alpine slopes, and the footage of Jean-Louis competing in the Monte Carlo Rally is intercut with scenes of Anne shopping in the boulevards of Paris. Moreover, it is one of the first films to indulge in what is now known as product placement. Pall Mall cigarettes, the *Le Nouvel Observateur* weekly newspaper and of course Jean-Louis' Ford Mustang car all feature prominently within the first few frames. Its two stars, Jean-Louis Trintignant and Anouk Aimée, are equally commodified, in that they are presented as potential role models at a time when opportunities formerly restricted to social élites appeared to be more available to a wider public. Lelouch's conceit is to present these well-known actors as somehow on the same level as the average film spectator, even though they live lives, as stars and fictional characters in the film, that are not and are never likely to be his or hers. Still, the dream is that if they, like us, can have such difficulties with their relationship, then perhaps we, like them, might one day be able to start our weekends by driving to Deauville in a Ford Mustang.

The film ends inconclusively. Jean-Louis negates the sorrowful departure at the railway station by racing Anne's train in his car and appearing on the platform as she changes at Rouen. However, as they embrace in a final freeze-frame, the expression on Anne's face betrays the same ambiguous blend of passion, doubt and anxiety as it did when they made love the previous evening in the hotel room. The problem is still there, but it is a very attractive problem, nestled in an exciting, luxurious, stellar existence.

A striking aspect of the film is its cinematography. Lelouch apparently ran out of colour film stock, so was obliged to shoot some of the scenes in black-and-white. The flashbacks of Anne's life with Pierre are bathed in

warm, colourful tones, whereas the scenes that take place between Anne and Jean-Louis are either at night in the car, and therefore shot in black-and-white, or in a wintry, bleak light on the front at Deauville. Thus, the spectator might assume that Lelouch is operating by simple binary prin-ciples, displaying a happy, romantic past in colour, and a troubled present in either black-and-white or muted sepia tones. However, as Anne's rela-tionship with Jean-Louis gains some traction, so the colour begins to return. Of particular significance are the scenes on the beach at Deauville, where a hazy natural light allows for subtle reflections of oranges and reds, presumably obtained by filming as the dawn sun is just rising, or alternatively at twilight. Swept along by a seminal sound track, the film thus gradually reveals its true colours. Ostensibly a serious treatise on love, mourning, and the dilemma of the single parent, *Un homme et une femme* bottles and sells the optimism of the 1960s, an optimism which is encapsulated in the timeless image of the perfect family, silhouetted in the iridescent whiteness of the beach at Deauville.

If *Un homme et une femme* is (almost literally) a still life of 1960s France, Jean-Jacques Beineix's ode to an alternative lifestyle in the 1980s is a more prescient film. Beineix's message – that it is better to opt out of consumerist society – is plain, but the film is quite messy. *37°2 le matin* is a festival of colours, with Beineix producing images from a Matisse-like palette. At the coast and in the southern countryside deep blues contrast with sunshine yellows; conventional urban environments are splashed with reds and greens. And even as the story of Betty and Zorg tilts towards tragedy, the colours refuse to fade, grist to the mill for the many critics of the 'cinéma du look' who argue that Beineix's 'esthétique du beau' (art of the beautiful) is too crude to convey storylines of shifting moods.[10] Yet it is precisely this dumb combat between form and content which makes *37°2 le matin* the quintessential French film of the 1980s. The film documents the mental disintegration of a young woman, culmi-nating in her mercy killing. At the same time it lies at the fulcrum of a cinematic movement that brought the guile and seduction of the adver-tiser to the big screen. The extent to which the big names of the 'cinéma du look' – Beineix, Luc Besson and Léos Carax – spent their early careers working in television advertising has been exaggerated; prior to directing his first film *Diva* in 1980, Beineix served an orthodox apprenticeship in the film industry and had never worked in advertising. However, he and the others made films that were, like Mitterrand's 'Grand Projects' for new Parisian architecture, emblematic of a cultural extravagance in the 1980s, which mirrored the growing economic aspirations of the people.

The bliss of the opening scenes of *37° 2 le matin* is short-lived. Betty is unlikely to be satisfied for long with these crumbs of sensory happiness. Young and dynamic, she wants to move on. She identifies the notebooks containing a draft of Zorg's unpublished novel, which he has squirreled away, as a key to unlock the door to a new existence, the shape of which she is unable to articulate. As we see in these first, iconic twenty minutes of the film, Betty embodies an entrepreneurial force for change. What she lacks, of course, is familiarity with concepts of risk. If the homeless Betty, who has left her waitressing job, is to live rent-free with Zorg, then the couple must paint the façades of the sea-front bungalows owned by the latter's grubby boss. This is a gargantuan task, one that Zorg expresses imploringly, in conversation with his boss, in terms of its labour costs: '500 bungalows, 1500 façades'. The truth of the deal is concealed from Betty, and the pair embark on decorating an old couple's bungalow in candy-pink. These few days of constructive happiness are explicitly commemorated with a number of still, postcard-style shots of the natural environment, accompanied by the lilting theme music of the film. Zorg's old workmate Georges implausibly metamorphoses into a blues saxophonist, leaning gently against the fairground dodgems and serenading the couple at twilight. Moreover, their first completed candy-pink bungalow is celebrated, as Betty and Zorg pose for photographs, smiling in front of the façade, paint rollers held aloft.

This fleeting transformation of Zorg's drab existence into candy-pink seems to be a fitting comment on the empty promise of the consumer boom of the 1980s. The wiser, older Zorg knows that it is illusory, just as he seems to understand the limitations of genuine happiness. Once Betty discovers the truth, however, she uses what remains of the supply of paint to 'decorate' the boss's car before setting fire to Zorg's dwelling. Perhaps *37° 2 le matin* was intended as a serious exploration of this destructive energy, as a manifestation of mental illness. But it is also tempting to see in Betty's fate an analogy of what happened to many people who fell prey to the 'get rich quick' ethos of the era. The couple's last moment of real happiness occurs as they are leaving the coast, with Zorg in the back of a pick-up truck looking up at the sky, as Betty shouts 'Je t'aime!' out of the passenger window. This reference to a 1960s zeitgeist is cruel, for the world has changed; twenty years on, the pursuit of individual gain eclipses the longing for a better society. In Léos Carax's *Les Amants du Pont-Neuf* (The Lovers on the Bridge, 1991), the film which is seen as the high water mark of the 'cinéma du look', fireworks arching over the banks of the Seine reprise the opulence of the 1989 bicentenary celebrations in Paris,

when the French government put on a spectacular display of cultural and economic strength. Yet the fanfare that accompanied Jean-Paul Goude's grandiose designs, as they processed down the Champs Élysées, would soon fade to the distant crash of the world's stock markets. By the time that Carax's film was released, France, along with most other European countries, was in the grip of recession.

If *Un homme et une femme* interrogates notions of film stardom, *37° 2 le matin* exhibits starry behaviour. Still, these are both popular articulations. They each capture the mood of their respective eras, quintessentially one might add, and yet in each case affirmative representations are undermined by the forms they assume. In the first instance film stars are presented as no different from ordinary people, and in the second ordinary life is presented as if it is a film.

Game for laughs: Hulot, de Funès and Dany Boon

As Voltaire observed (Naves 1956: 125), to explain a joke is to kill it stone dead, which is why writing on comedy that explores the mechanics of laughter and analyses its relation to social and cultural practices poses an intellectual challenge. A favoured approach is to discuss the notion of comedy outside of the canonical traditions exemplified by Shakespeare, Molière and Pirandello as a culturally inferior form, otherwise known as a 'body' genre. In common with sexual arousal, weeping and the various physical reactions triggered by fear, laughter is categorised as an innately physical response, in Mack Sennett's words 'a contraction of the zygomatic muscles' (Paulus and King 2010: 129) that lies, fleetingly, beyond the control of the conscious mind. This idea of comedy as essentially corporeal is associated with popular drama, where it has a long history, stretching from the *commedia dell'arte*, to vaudeville theatre, to the French *café-théâtre*. However, immediately prior to and during the first years of the cinema this dimension of the comic as involuntary and unthinking was further underscored by developments in two different fields of human endeavour.

The first is the more tendentious. During the 1870s and 1880s the pioneering neurologist Jean-Martin Charcot held public events at the Salpêtrière Hospital in Paris, at which he demonstrated the virtues of hypnosis as a means of becalming his hysterical patients. However, public attention was captured not so much by the prowess of the neurologist as by the spasms, twitches and contorted expressions of the patients themselves, which provoked laughter. According to Rae Beth Gordon,

Charcot's experiments inadvertently confirm that the stock human response to what she terms 'epileptic performers' (Gordon 2001: 4), whether they be psychiatric patients, clowns or contortionists, is one of laughter. Gordon goes on to argue that all physical comedy stems from a perceived disconnection on the part of the spectator between body and mind. This manifestation of a 'corporeal unconscious' is, however, only one aspect to the parade of Charcot's patients. Another concerns the social relation of laughter to mental health, for the abdication of reason and the rational mind expressed through fits of hysterical laughter is what the upstanding bourgeois citizen was deemed to fear most, more even than sexual exhibitionism. Laughter manifests an incipient violence. Just as in English we 'roar' with laughter, so in French we are apt to 'mourir de rire' (die laughing), and in both languages we burst out laughing, crease up, roll around on the floor and so on. Laughter banishes hierarchies and, as Antonin Artaud recognised, is potentially disruptive of the social order. The avant-garde dramatist and latterly psychiatric patient, whose Theatre of Cruelty sought to dismantle the false barriers between mind and body that in his view protected the social attitudes and hypocrisies of the bourgeoisie, lauded the finale to the Marx Brothers' film *Monkey Business* as 'a hymn to anarchy and total rebellion'.[11] This sense of comedy as a means of breaking with the dominant ideology resonates, albeit in attenuated fashion, in Bakhtin's notion of the carnivalesque as a vital, liberating force from social constraints, a prerequisite for a healthy society which, in Europe, was progressively squeezed by the moral strictures of the nineteenth-century bourgeoisie.

The second trigger for laughter is the advent of the machine, or to be precise the possibilities created by the multiple technological advances that were achieved at the end of the nineteenth century. Motor cars, skyscrapers and all manner of giant cogs and wheels were the stock-in-trade of the Keystone comedies, which, in the first decades of the twentieth century attracted the American people to cinema auditoriums in large numbers. The prevailing culture was thus favourable to the universal theory of comedy presented by philosopher Henri Bergson, which presumed that laughter occurs when external circumstances compel the human body to function as if it were automated.[12] Such mechanical chaos was embodied in the movements of the silent comic, no more so than in the famous sequence of Harold Lloyd dangling from the clock-tower in *Safety Last* (1923). Although Lloyd's uncontrolled jerking can be seen to contrast with the programmatic behaviour of the masses below driving the wheels of modernity, others have sought to attenuate the contrast

between human and machine. Tom Gunning, for example, analyses the construction and delivery of gags in slapstick comedy, which he likens to 'crazy machines', physical arrangements designed to self-destruct. This more involved relationship of human to machine highlights what has been described as the 'operational aesthetic' (Paulus and King 2010: 121) of slapstick comedy, an emphasis on the process of making film, which, in the eyes of many critics, came at the expense of narrative or thematic complexity.[13] Indeed it is commonly accepted that the greatness of Charlie Chaplin lay precisely in his ability to invert the Bergsonian model by taking on the power of the machine, striving against the notion that man is a slave to the machine or indeed to any other enslaving power, and thus restoring meaningful, sometimes political content to the slapstick scenario.

The example of Chaplin points to the fallacy of thinking about comedy primarily in terms of involuntary human actions provoking laughter. As a stage actor, the comic is and has always been a mimic, a character who displays an idiosyncratic imitation of normative behaviour. Such propensity for mimicry is less culturally distinct; rather it has a timeless, universal value. Moreover, mimicry, in which the subject deliberately imitates an identifiable other, resonates with the theories of cinematic perception – as representations of reality understood as perceptions – advanced by Baudry, Mitry and Benjamin. The difference with the latter is the presupposition that the spectator's identification with the moving image is, at least in part, subliminal, whereas the comic actor consciously draws attention to the artifice of the medium. With comedy the film audience is encouraged not to believe in the reality of what they see but rather to recognise the imitation as imitation. Consequently comedy operates at a distance from the spectator, whose intellectual scepticism towards the images increases as his or her emotional attachment wilts. Gerald Mast borrows the term *katastasis* to describe this phenomenon, arguing that the greatest comic films season their staple dishes with what he terms *sprezzatura*, or 'the art that conceals art' (Mast 1979: 26), so that the conspicuous staging of a scene may convey a mysterious spontaneity. Often this impression is reinforced by the comic actor's gift for improvisation. Still, my contention will be that the overwhelming appeal of comedy to cinematic audiences in France may be gauged by the reactions of the spectator, who is freed from stellar transfixion and can exult in the presence of a superior consciousness, which is embodied in the comic actor who exposes the filmic image as the representation of reality rather than its actuality.

In *Les Vacances de Monsieur Hulot* (Mr Hulot's Holiday, 1953), the film that established Jacques Tati's reputation as the finest comic director in the history of French cinema, the sound and vision of everyday life provides material for a stream of anti-mimetic gags. Over the title credits the sound of roaring waves persists in drowning the music. The famous, Lowry-like distance shots of passengers scurrying along the platforms of the railway station are punctuated by unintelligible barkings emitted by the loudspeaker. Initially these noises may induce sympathetic smiles among the audience, but Tati further distorts the voice by speeding it up, so that memories of railway station frustrations deepen into a more unpleasant sensation, suggestive of bewilderment and alienation.

The virtual absence of dialogue in the film coupled with Tati's predilection for intrusive, non-verbal sound marks a clear aesthetic position, which betrays the director's reverence for movies of the silent era and concomitant disdain for the view that with the synchronisation of sound and image the cinema could offer an exact replication of real life. However, the strong scent of nostalgia in itself installs a historical framework that, in the case of *Les Vacances de Monsieur Hulot*, would risk transforming an exquisite, universal comedy of manners into a period piece. One clear historical reference is made when Hulot lights a match in a dark shed and provokes an accidental firework show, parodying the aerial bombardment of French beaches during the Second World War.[14] Otherwise, Tati ensures that the eruptions of non-verbal sound in *Les Vacances* have precise functions. Thus, the dull twang each time the door to the Hôtel de la Plage opens and closes would be irritating no matter who was arriving or leaving, but in the spectator's mind it becomes associated with the comings and goings of Monsieur Hulot. The jazz music from an adjoining room that shocks the diners into silence emphasises both the joylessness of the guests and the profound solitude of Hulot, who is shot from behind on a stool crouched over the gramophone. Interestingly the scene is reprised later in the film with a young boy in the role of Hulot; the response of the proprietor is to cut the electricity supply.

Bellos argues that the gags in *Les Vacances* are situational, since the humour tends to derive from the situation in which the hapless Hulot finds himself rather than from the intent of the main comic character. Consequently these events are 'quirks of a world that is *just like that*' (Bellos 1999: 175) and Hulot himself remains a 'light-footed, evanescent and apologetic enigma', a foil for social observation. However, the idea that Tati offers a neutral world-view is wide of the mark. Bellos points out that the guests assembled in the hotel form 'a realistic cross-section

of international, middle-class life' (Bellos 1999: 186), yet collectively they reject this mildest of eccentrics; with his stooping gait Hulot is a much less exaggerated comic type than the classic Hollywood figure. One evening at dinner he reaches across the person sitting next to him to retrieve the salt pot for another diner. This minor infringement of table manners triggers a farcical situation, whereby the salt pot is passed back and forth across the table, with Hulot, out of misguided politeness, desperate to return it to its original position and his neighbour equally determined to reposition it in front of Hulot. This repeated gesture of the neighbour's, which is intended to confirm the magnitude of Hulot's initial gaffe, betrays instead the inculcation of social attitudes.

Les Vacances de Monsieur Hulot has proved itself to be an enduringly popular film among different sections of society, including children, who are immune to its misanthropy. The pattern of humour is one of dislocation, whether centred on Hulot himself, bowing and waving goodbye to the wireless as the broadcaster concludes his programme, or on the handyman trying to paint a name on the hull of a boat, as the winch unwinds and the boat rolls towards the sea. Although there is no real plot, the film does precipitate a movement, as the spectator's sympathies gravitate towards Hulot. This progression may be gauged by two switch gags that rely on visual metaphors. The first does not involve Hulot at all. A man has just retrieved his hat from a coat-hanger. He pauses to look at a picture on the wall with his walking stick in an elevated position, so that it looks from the camera's point of view as if it is one of the curved prongs of the coat-hanger. Another man enters and places his hat casually on the curved handle of the elevated walking stick. The first man then departs without realising that another man's hat is perched on the end of his walking-stick.

The second gag is another example of situational comedy, but this time it does involve Hulot, who parks his old car with his passenger Fred at the gates to a cemetery, where a funeral is taking place. They have stopped in order to retract the canvas roof of the car, but as he extricates the necessary tools from the boot, Hulot takes out the spare inner-tube and lays it on the damp ground. Wet leaves on the ground stick to the surface of the inner-tube, covering it so well that a passing funeral director, mistaking the inner-tube for a wreath, picks it up and hangs it on the memorial plaque. Hulot himself is also mistaken for a fellow mourner and, to the accompaniment of a loud raspberry noise as the inner-tube abruptly deflates, he is warmly greeted by the funeral party. Whereas the coat-hanger/walking stick analogy that underpins the first gag prompts comic

displacement, the inner-tube/wreath analogy of the second bridges an apparently unbridgeable gulf, in that it provides Hulot with the social contact that in nearly all other circumstances is denied him.

Hulot's delight at the friendly gestures of the mourners adds poignancy to the comic irony; he is welcomed as a complete stranger by a group of people who mistakenly assume that he, like they, is bereft and shares their sadness. A further irony occurs at the end of the film when, as the guests depart the hotel, he finally succeeds in introducing himself to one of the ladies staying at the Hôtel de la Plage, who remarks that she has had a wonderful time and will be back next year. By now the comedy is so thin, and the sense of melancholy so pervasive, that Hulot's social paralysis can only prompt more profound reflection on what it is to be human. It is a question that Tati addresses on numerous occasions during the film, not least with a startling crane shot of swimmers in the sea, which is taken from such a height that they look more like amoeba wriggling under a microscope than human beings.

Tati's refined comedy could not be more different from the exuberant farce of *La Grande Vadrouille* (Don't Look Now – We're Being Shot At, Gérard Oury, 1966), which was for four decades the most commercially successful film in the history of the French cinema. A large part of the film's appeal derives from the fact that it is a joyous reclamation of the German Occupation of France, which banks on being able to unite the nation in laughter at a common enemy. Within its first twenty minutes the immaculate uniform of the most menacing Nazi officer is, in separate incidents, drenched with paint then covered with floury dust. With its high production values typical of the cinematic epic popular in the 1950s and 1960s, *La Grande Vadrouille* is also a pastiche of the war adventure film. Two of France's best known comic film actors, Bourvil and Louis de Funès, inadvertently rescue three English airmen who have bailed out over Paris and, with the assistance of sundry others, guide them to the border. Once there, they make a dramatic escape in two gliders. Their route to this rather spectacular climax, which involves much dressing up, sometimes in drag, hiding in wardrobes and popping up in the wrong beds, is the standard fare of theatrical farce. It is also symptomatic of the relaxation of social mores that Bakhtin associates with the carnival, recalling in simplistic terms the euphoria of the liberation of the country at a time, in the late 1960s, when a rather more nuanced picture of this period of French history was beginning to take shape.

The funniest sketch takes place at the Turkish baths in Paris, where the two-man crew of the stricken bomber has been instructed to reconvene

at a time and date pre-arranged by their squadron leader, Sir Reginald, played by the incomparable English actor Terry Thomas. However, Stanislas (De Funès) the conductor at the Opéra and the decorator Augustin (Bourvil), who, in parallel storylines, are each hiding an English airman, both deem that their charges are too conspicuously English and therefore should not risk venturing to the baths. Begrudgingly, the two comic actors agree to go in their stead, in order to make contact with 'Big Moustache'.

In an anteroom at the baths Sir Reginald is radically pruning his extravagant moustache, since he has been warned, by a friendly zookeeper, that his prized whiskers too readily denote his Englishness. The film cuts to the communal sauna, where plumes of steam billow around groups of bare-chested men wearing white towels fastened at the waist. We are treated to the spectacle of first Augustin then Stanislas circling a pot-bellied Stalin lookalike who sports an impressive moustache. As the latter stares uncomprehendingly back, they look beseechingly into his eyes while singing or (in the case of Stanislas) whistling 'Tea for Two', which is the simplest of courtship ditties, and suggestively pouting and stroking their upper lips. Though rejected by the Stalin lookalike, they are alerted by the 'Tea for Two' signal and, with each taking the other for an airman, embark on a conversation in English spoken with heavy French accents, which is truncated only when Augustin curses (in French) the poverty of his English vocabulary. Having also been alerted by the strains of 'Tea for Two', Sir Reginald pops his head out of the mists and, in spite of evidence to the contrary, identifies himself as 'Big Moustache'.

The dynamics of this scene correspond to elements of Freud's thinking on mimicry, which is itself rooted in his concept of 'ideational mimetics' (Freud 1960: 240). Expressed in prosaic terms, Freud believes that concepts or ideas emerge from our spatial relation to objects. By extension we then try to reach a greater understanding of our environment by imitating other human beings, and we may take this imitative process so far, through what Freud describes as a 'lifting of inhibitions' (Freud 1960: 244), as to inhabit, in the realm of our imaginations, the position of the other. When the behaviour of the other is so far removed from our habitual framework of understanding as to appear incongruous, we are liable to give up trying to understand him or her, and our unused psychic energy will be discharged in the form of laughter. The incongruity of the 'Turkish baths' scene in *La Grande Vadrouille* is compounded by layers of representations. Two stock comic actors, already known to many spectators as the 'dim-witted one' and the 'irascible one', are obliged to parade their torsos in the sauna and act as if they are trying to seduce

an unprepossessing middle-aged man, before speaking to each other in pidgin English. For an anglophone audience, the sound of Terry Thomas, who is of course the epitome of caricatured, upper-class Englishness, bending his tonsils proficiently around some French vowels is the cherry on the cake.

Much of the humour in *La Grande Vadrouille* stems from the implausibility of disguises and other forms of role-play, though few of the scenes are as well crafted as the 'Turkish baths' episode. In *Bienvenue chez les Chtis* (Welcome to the Sticks, Dany Boon, 2008), which succeeded *La Grande Vadrouille* as the most commercially successful French film of all time, it derives from an extensive at times subtle exploration of the different modes of comic imitation.

Bienvenue chez les Chtis challenges middle-class assumptions regarding the benefits associated with escaping colder climates to live under the Mediterranean sun. This north-south divide is illustrated by the opening scene when, in order to please his wife Julie, the mid-ranking post-office manager Philippe Abram poses as a disabled wheelchair user in order to secure a plum posting to the Côte d'Azur. The comedy in the film springs from the misguided notion that the division between the gloomy, miserable primitive north and the luminous south is absolute. This attitude is personified by Philippe's wife Julie, who views his failure to impersonate a disabled person and consequent assignation to a job in the town of Bergues, Picardy, as catastrophic. What follows is a complex interplay between expectations and reality, which is, in the classical tradition of Molière, both amusing and instructive.

The film adopts a loosely parallel structure, which contrasts life before and after Philippe's first stay in Bergues. So, for example, on his first journey north Philippe is stopped by police for driving too slowly on the motorway, and as he passes the 'Pas de Calais' sign, torrential rain immediately lashes the windscreen. On a later trip, he is again stopped by the self-same policeman, though this time the sun is shimmering on the tarmac and he has been driving too fast. Cultural differences are primarily expressed through language. The success of Philippe's attempts to integrate into 'Chti' society depends on his ability to imitate a happily caricatured northern patois. Consequently, the generosity of his hosts is threatened by linguistic misunderstandings, since the furniture in his rented flat is his ('les siens') and not the dogs' ('les chiens'). While dining in a restaurant with his new colleagues, Philippe attempts to master the 'Chti' croak, an eagle-like, interrogative screech, which has a similar function to the affectation found in some variants of spoken English whereby

the speaker raises the pitch of his or her voice on the last syllables of a question. Philippe tests his newly practiced phonetic skill on the waiter, only to discover that the latter is also a stranger to 'Chti' culture.

Significantly, from an early point in the film the spectator is likely to be drawn towards the northern characters by the presence of television comic Dany Boon, the one famous star in the film, who plays Antoine, the young postman on the staff at Bergues. Dany Boon is a throwback to the old music hall comedian. His rubbery face, expressive gestures and general physicality are reminiscent of the British comic film actor Norman Wisdom. Antoine smiles less often than the cheery Philippe; rather he exudes a certain melancholy which points to the main sub-plot in the film, concerning a domineering mother and a broken love tryst. This ethereal quality to Antoine is enhanced by his role as bell-ringer at the belfry. The peeling chimes recall the loneliness of the phantom of the opera, or Harpo Marx, embellishing the knockabout farce of his brothers with the gentle tinkling of his harp. Throughout the film Antoine acts as a gentle reminder to the spectator, to look beyond the stereotype.

Philippe enjoys life with the Chtis but on his first weekend visit home is obliged to feign misery, because he perceives that to enjoy life in the north would be inconceivable to his wife. As time passes, his role-playing is exacerbated by increasingly effusive (and clichéd) manifestations of the pleasures of home life, which, on the occasion of a 'surprise party', incorporates his old friends alongside his smiling wife and children. On such occasions the myth of the north and its hardships is reaffirmed. Not that Julie needs much encouragement. To prepare her husband properly for his expedition back to the land of the Chtis after his first weekend at home, she insists that he wear a large, arctic, puffed red jacket with an absurd, fur-lined hat with ear flaps.

Underlying social attitudes bubble to the surface in a scene where Philippe and Antoine deliver parcels and are repeatedly invited into people's homes for tipples. Between houses, the spectator is treated to beautifully sequenced stunts of two drunken men riding bicycles through a French town. The round reaches a natural finale when an unwitting citizen of Bergues opens his front door to be greeted by a swaying Philippe, who announces merrily, 'you have no post today' ('vous n'avez pas de courrier aujourd'hui'). Both men are arrested. Philippe calls Julie from the police station, and she inevitably misinterprets the reason for his drunkenness. Assuming that he has turned to drink in order to cope with the barbarity of 'Chti' life, on his next visit home she accuses him of drinking her Givenchy perfume. In this instance Julie's failings have a

poignant aspect, as the spectator knows that it is Antoine and not Philippe who is struggling with a drink problem.

The pivotal moment in the film occurs when Julie, in characteristic mock-epic mode, decides to support her husband and takes the decision to brave 'Chti' culture herself. In a last-ditch attempt to sustain the myth of the grim north, Philippe rents a place in the old mining settlement of Bergues, a few kilometres away from the main town. Effectively he introduces Julie to an artificial village, a reconstruction of Bergues in which the people in the street are dressed and act like museum characters, recreating a stereotypical, industrial scene from the mid-nineteenth century. She is, the audience is led to believe, deceived by this charade until one day she goes out and asks a car driver for a lift back to Bergues.

The museum village distances the reality of 'Chti' life and culture from the popular myth. Moreover the melodramatic storylines, including Antoine's proposal to his colleague at the belfry and Philippe's reconciliation with his wife, stress the universal nature of communal bonds rather than the specificity of a regional culture. This universal appeal of the film is carefully sustained throughout the story. As we know, the spectator is naturally drawn towards the familiar figure of Antoine, irrespective of his regional identity. Philippe's distancing from his wife may be in the first instance an effect of cultural distancing but it is also a universal problem that all married couples confront, when career aspirations mean that one partner has to spend a long period of time away from the family home. So it is that the iconic image of the banner, unfurling from the top of the belfry in Bergues, symbolises something more than regional pride. It signifies also a renewed faith in the value of community, a re-emergence in French society and – through the success of *Bienvenue chez les Chtis* – in the French cinema of the people. Ultimately, the *Chtis* defies the contemporary fashion for neo-liberalism by defining the essence of the human as social, and by portraying a society which is almost unrecognisable from the one so fiercely lampooned by Tati.

Popular aesthetics

In this final section I shall explore further critical attitudes to contemporary commercial film, which, I contend, are riddled with anxieties over the authenticity of the image. I shall then argue that what makes a popular genre like the action thriller successful is the skill with which a director entices the spectator into the film. Here I will not devote much attention to 3D films, which tend paradoxically to expose the artificiality

of the medium, or to the undeniably massive impact on contemporary popular cinema of computer-generated images (CGI); what interests me is the evolution in our understanding of how traditional cinematic techniques, such as the use of montage and point of view, usher the spectator into the imaginary world of the film.

Irrespective of its academic quality, recent criticism of popular French cinema has been almost always disparaging of its subject. Consider two intellectually strong examples.

In a book chapter on Jean-Pierre Jeunet's 'aesthetic of advertising', Michelle Scatton-Tessier demonstrates the methods and techniques used by the film-maker in *Le Fabuleux Destin d'Amélie Poulain* (Amélie, 2001) and *Un long dimanche de fiançailles* (A Very Long Engagement, 2004) to reach the fictional spectator she describes as the 'minimum viewer … the one who will make the smallest effort to follow the film's narrative, the most passive and least patient viewer imaginable, the ultimate zapper'. (Vanderschelden and Waldron 2007: 104). In order to retain the attention of the 'ultimate zapper', the director must endow his or her images with intention and meaning, and Jeunet does this, according to Scatton-Tessier, through the use of tautology and proverb. Tautology frequently occurs in the opening sequences of films, where images are explained by a voice-over, or dialogue. For example, in *Un long dimanche de fiançailles* the veteran soldiers are pictured talking about their war experiences, before the film cuts to dramatic flashbacks of fighting in the trenches. Once the spectator has been inducted into the film, his or her position is secured by the deployment of another item from the advertiser's toolbox, notably the use of proverb or popular idiom, which confers a sense of shared knowledge, collective identity, and relief from the prospect of too much independent, critical thinking.

A different presumption of the taste and intellectual status of the spectator informs Maria Esposito's essay on Claude Berri's 1986 remake of Pagnol's *Jean de Florette*. Berri's film, she argues, with its lavish sets and high production costs, capitalises on a widespread yearning within French society to escape from the challenging social and political realities facing the country in the 1980s into an idealised past. As such it amounts to a sustained attempt to authenticate a myth, to legitimise via what becomes a serial adaptation of a family saga the tourist brochure's image of Provence. The spectator is expected to feast on a beautifully shot though heavily codified landscape and, undeterred by Jean's bathetic experience, contemplate the attractions of a rural idyll. Like Scatton-Tessier, Esposito offers a compelling analysis in support of her argument,

which concentrates on the configuration of space within the film and on subtle derogations from Pagnol's original literary and cinematic œuvres. She remarks on a dramatic structure that seems to belie the egalitarianism with which the original texts are imbued since, in highlighting the three male leads – Ugolin, Papet and Jean – it blends the rest of Pagnol's 'gallery' of characters into a stereotypical backdrop of French village life. This manoeuvre is an example of what Esposito calls 'heritage encoding' (Mazdon 2001a: 16); what might appear at first glance to indicate the influence of a director keen to direct attention to the narrative kernel of the film is in reality a commercially driven decision, masquerading as an artistic choice.

Both commentators strike critical attitudes in respect of the popular which echo Fredric Jameson's view on postmodernist art in general, that it consists of 'the imitation of dead styles, speech through all the masks and voices stored up in the imaginary museum of a now global culture' (Jameson 1991: 18). The theory holds that our perception of the world is now so encrusted with previous interpretations that any new representation can only inflect a pre-existing one. In popular fiction this will often seem as if it is a return to some commonly recognised aspect, or stereotype. With its increasing reliance on popular franchises, such as the 'Taxi' films and the 'Astérix' series, the cinema industry in France today would appear to offer a perfect illustration of popular culture as a finite, endlessly repeated set of paradigms, mined to exhaustion, to which the critical response can only be to talk in terms of pastiche, which Jameson qualifies as 'blank parody' (Jameson 1991: 17). The examples of writing on popular film discussed above appear to vindicate the suspiciously tautological assertion that 'there can be no understanding of popular film without reference to the market, because popular cinema has only existed in a market economy' (Dyer and Vincendeau 1992: 4). But this is a truism. Theories of popular forms will always be to some extent underwritten by the economics of their respective industries. Which is why attention tends to be focused on the exceptions, on the less formulaic, unpredictable successes such as *Bienvenue chez les Chtis* and, more broadly, on different aspects of the cinematic experience, on attempting to understand how we process moving images, and on the feelings they generate within us. Therefore, as Scatton-Tessier implies (Vanderschelden and Waldron 2007: 108), the use of tautology and repeated labelling in a film like *Un long dimanche de fiançailles* may also be explained by the difficulties in adapting to the screen Sébastien Japrisot's psychologically complex novel of the same name. Two decades earlier Jean Becker,

directing the adaptation of another Japrisot novel, *L'Eté meurtrier* (One Deadly Summer, 1983), also struggled to bring to life a multilayered narrative meandering towards a buried past.

More tellingly, Claude Berri's decision to concentrate on the male triptych in *Jean de Florette* – which was augmented by Emmanuelle Béart's Manon in the sequel – might conceivably have been motivated by a drive for authenticity and a rejection of sentimentality, in order precisely to emphasise the contrast between the earthly fate of the characters and the bucolic, paradisiacal setting in which their dramas are played out. Taken together, *Jean de Florette* and *Manon des sources* (Manon of the Spring, 1986) tell an elemental story of blood, water and land, a story with universal appeal that should transcend generations and speak not only to the past and the present, but also to the future. However, there is little action and the plot burns slowly, which suggests that a large part of the films' success must be due to the contributions Berri was able to elicit from his stellar cast. These were of course the roles that established Daniel Auteuil and Emmanuelle Béart as stars of the coming generation, but the credibility of the film ultimately hinges on the performances of Gérard Depardieu as Jean and Yves Montand as Papet. At the peak of his screen acting career, Depardieu drew on his own aspirations to become a winegrower and thus transcend his own difficult, urban upbringing, playing Jean as a gentle-voiced evangelist striving to conquer the land. As the older man nearer to closing the circle on his own life, Montand saw much of his own father in the character of Papet, whose scheming in *Jean de Florette* hardens in *Manon des sources*, as he faces escalating recrimination with a fish-eyed obstinacy. Esposito rightly suggests that the film would have granted the spectator a temporary escape from his or her own hardships, but nostalgia for a past mythical age is but one part of the whole. Essentially, the Pagnol films are about money and power. As Papet intones to his nephew in *Jean de Florette*, repeating the first phrase so as to ensure the point is not lost on the audience, 'I'm strong, I'm strong because I've got money' ('Je suis fort, je suis fort, parce que j'ai des sous'). He lends Jean the money for his mortgage, knowing the enterprise to be doomed and that he will be unable to pay it back, and thus hedges his own investment in Ugolin's carnations in a very twenty-first-century manner. However, as many a good fairytale warns, money does not necessarily bring happiness. The shot from behind of Papet in the churchyard towards the end of *Manon des sources*, limping towards then past Manon's wedding party to place his bouquet on Ugolin's gravestone, is one of the more memorable scenes in modern French cinema.

Notwithstanding the pleasure that Berri's Pagnol adaptations afforded to millions of cinema-goers, critical opinion has held stubbornly to the view that the films lack gravitas and authenticity. As theorists of the early cinema like Gunning and the example of practitioners like Méliès have shown, the very notion that the filmic image can be faithful to the reality of the experience it depicts is, at the very least, questionable. However, in the history of French film criticism the lineage traced by Bazin from the photograph to the moving image has been generalised into a set of assumptions that coalesce around the artistic integrity of the director. Any film appearing to exhibit too much visual trickery or Méliès-type magic is regarded with suspicion and too readily classed as non-serious entertainment. This culturally embedded critical stance explains why, in the 1980s, the dazzling visuals of the 'cinéma du look' were derided as an assault on the essence of cinema. What irked many was the extravagance of the enterprises coupled with the directors' seriousness of intent; thus Carax's decision to have a full-scale replica of central Paris built in the vicinity of Montpellier in order to shoot *Les Amants du Pont-Neuf* (1989) induced apoplexy in parts of the cultural establishment.

A particularly interesting case of critical repulsion is Jean-Michel Frodon's assessment of Jean-Jacques Annaud's *L'Ours*. Frodon is incensed at the way in which Annaud mistreats a family of bears, by converting natural history footage into a sentimentalised drama:

> *The Bear* transforms living beings, which are supposed to embody the wildness of nature, into special effects, into machines. This result is achieved by all manner of mechanical, optical, chemical and electronic trickery, but also, more significantly, through the editing of the film. It is the cutting of images and sound into fine strips and their subsequent reconstitution in sequences far removed from the original conditions of the filming that creates such powerful effects, notably the way that animals are manipulated like marionettes, and this occurs not so much on the film-set itself but in the editing suite. The work on the sound track, giving rise to even more extreme manipulations due to the music being put through synthesisers, follows the same pattern, which continues into the third stage of the process, the editing, where the sound is added to the images. (Frodon 1995: 686)[15]

Frodon's position is described here in some detail, in order to show how his technically proficient critique carries a moral stricture. However, whether or not one agrees with his verdict on Annaud's film – and he presents a strong case – in the contemporary era the ubiquity of CGI and other means of creating and manipulating film images undermines,

perhaps fatally, the theoretical premises of an approach which takes as a given the existence of the authentic filmic image. Frodon (and those who think like him) adopt a critical stance, which, at its crudest, assumes that the great film directors are those able to graft slices of reality onto celluloid. This is an outmoded view. In the cinema the digital revolution has diverted attention from the source of the image to the way in which it is apprehended by the spectator, which is why philosophers of aesthetics such as Noël Carroll and Daniel Dennett concentrate their attention on processes of cognition and reception rather than on the creation of the film image.

In *Image and Mind: Film, Philosophy, and Cognitive Science*, Gregory Currie argues that cinematic images are 'temporary, response-dependent and extrinsic' (Currie 1995: 47), by which he means that they are fleeting, their meaning can only be elicited by the impression they register with the spectator, and that they are sustained by factors external to the medium such as the film strip, projector and light source. The contrast here is with the images on a painting which are intrinsic, since they are dependent on the quality of the canvas. In contrast with the photograph, the film image is not only animate but capable, especially in the era of CGI, of bringing to the forefront of the spectator's imagination phenomena that do not exist in reality, such as a unicorn. For Currie the nature of the spectator's engagement with the moving image depends on our propensity for imagining the self as other, or as he puts it, for running our desires and belief systems 'off-line'. So, if when we see a lion on the screen rushing towards us and our imaginations are sufficiently vivid, we may tense up and want to run. However, we don't run, as the sensation is not real fear but part of a mental process that we have allowed to run off-line. Such feelings and emotions, he conjectures, are 'disconnected from their normal sensory inputs and behavioural outputs' (Currie 1995, 144).

There are moments when the distinction drawn by Currie between the real and the off-line seems rather fine. Strong visual images of violence, such as the close-up of the razor bisecting the human eyeball at the beginning of Bunuel's *Un chien andalou* (An Andalusian Dog, 1929) or of sexual activity, may stimulate real disgust or arousal. However, Currie does provide a useful insight into the art of filming an action thriller.

We have seen how Frodon strongly criticises Jean-Jacques Annaud's use of montage in *L'Ours* because in his (Frodon's) opinion it creates a misleading impression on the spectator. However, some of the finest directors of thriller and horror films, including Alfred Hitchcock and Henri-Georges Clouzot, also use montage, not purposefully to make

artistic statements but to connive with their spectators' emotional well-being. The famous montage sequence of the shower scene in *Psycho* (1960) cunningly veils some aspects, such as the nudity of the actress, while enhancing others. The frenetic cutting between scenes conveys, in part literally, the stabbing motions, but it also simulates the frenzy of the attack. We are terrified by the violence and complicit with it, as, of course, we share the point of view of the assailant. The techniques are brilliantly refined in *The Birds*, where Hitchcock combines images of birds' lidless eyes with the naturally jerky movements of a flock scattering, interspersed with shots of the pecking bird and increasingly scarred victim, to create a deeply disturbing impression on the spectator of a familiar world horribly defamiliarised.

Extreme montage sequences are used more often in contemporary action thrillers to convey excitement and suspense, possibly because the modern spectator accustomed to living in densely visual environments is more able to process visual data at a greater speed. A prime example would be the opening scene of *The Bourne Ultimatum* (2007), where Jason Bourne is trying to prevent FBI agents from assassinating a newspaper reporter in Waterloo Station. Over a twenty-minute sequence the director Paul Greengrass maximises the level of tension by stitching together an astonishing number of different point-of-view and angled shots. The Holy Grail for the director of contemporary thrillers is to facilitate the near-total immersion of the spectator in the action of the film, so that the moving image on the big screen fulfils the prophecy made by Marshall McLuhan that all technologies become extensions of the self. This type of graphic simulation is a key feature of *Banlieue 13* (District 13, Pierre Morel, 2004), a film which was produced by Luc Besson, a notorious figure in the industry and the most commercially successful French director of this or any generation.

The *banlieue*, or district, in question is indeed an imagined place, a walled-off, lawless ghetto in Paris run by drug barons. For the presidential advisors in the Élysée and the left-bank intellectuals alike, it conjures up images of what might occur if ever France were to adopt the model of Anglo-Saxon multiculturalism; the worst of Los Angeles sprouting in the French capital. For those living literally on the margins of many towns and cities in France, however, this antithesis of French republicanism, albeit a nightmarish, fantastical vision, comes somewhat closer to the reality of their daily lives. Here the values of liberty, equality and fraternity have long since fallen into abeyance; as Leito, the renegade gangster in the film, opines, a more suitable set of demands for the people of the ghetto would

be water, gas, electricity ('l'eau, le gaz, l'électricité'). The flimsy storyline doubles back interestingly on itself, raising the possibility of a Western government aping the modern terrorist organisation through the deployment of suicide bombers. Damien, an undercover policeman, penetrates the district seeking to defuse a powerful bomb primed to devastate the well-heeled areas of Paris. At the eleventh hour he realises that the bomb is intended to remove not the iconic Paris of the tourist brochures but the blemish that is District 13, and that he has been unwittingly sent on a suicidal mission. Described by the corrupt minister as 'la racaille', meaning 'scum' – a word that would be used a year later by the then Minister of the Interior, Nicolas Sarkozy, to vilify rioting youth in the suburbs of Paris – the residents of District 13 are expendable.

Notwithstanding this modicum of political comment, it would be a mistake to align *Banlieue 13* with other films depicting urban crisis in France such as *La Haine* (Hate, Mathieu Kassovitz, 1995), *Le Thé au Harem d'Archi Ahmed* (Tea in the Harem, Mehdi Charef, 1985) or *L.627* (Bertrand Tavernier, 1992). Rather it asks to be viewed differently, as a cinematic spectacle foregrounding a new form of cultural expression. 'Le parkour', or 'free running' is an activity undertaken and promoted by groups of young people, who, conceiving of the city landscape as a kind of giant adventure playground, move across it at speed and with extraordinary agility. Requiring a capacity for improvisation and fearlessness in the face of obvious danger, the free runner combines the attributes of the circus acrobat and the downhill skier. Related to other street cultures, such as break dancing, skateboarding and tagging, *le parkour* is on the fringes of legality. As such, it attracts a certain type of young person and has developed its own dress code and exclusive social formations.

Banlieue 13 brought *le parkour* to mainstream film audiences, and in so doing it displayed a marked degree of aesthetic innovation, particularly with regard to the direction of the film, which, through technically accomplished montage sequences, goes some way to simulating the experience of free running. Its two male stars, David Belle and Cyril Raffaelli, are exceptional exponents of the art. The first sequence begins with Belle playing the part of Leito, who is trapped in a room as his pursuers are breaking the door down. As the door falls towards him, he runs up it, using it as a seesaw to spring over the heads of his assailants, before skirting close to the ceiling, Spiderman-style, around the rest of the posse milling in the corridor, and making his escape. One admiring critic (Austin 2008: 162) praises the authenticity of the performances, given that in other fantasy films physical stunts have largely been eclipsed by

CGI, though I remain to be convinced that leaping cleanly through the open front window of a standard hatchback does not contravene the laws of physics. Still, Pierre Morel presents *le parkour* both as a performance art and a new mode of action thriller. Extreme slow-motion takes, borrowed from the vocabulary of Chinese martial arts films, showcase the physique and grace of the actors, who, like male ballet dancers, perform bare-chested. Alternatively, the camera occupies the perspective of the runner in motion, as he navigates a course through unusual, unexpected openings and apertures. At any moment the following camera will cut away and the runner will plunge side-profile into a shot taken from a second, stationary camera that will have been, as it were, lying in wait for him. In such ways the watching of the film simulates the interactive experience of the video-game player who will normally control the perspective of the chief protagonist and guide him through the hitherto unknown world of a virtual universe.

Conclusions

More perhaps than any other film featured in this chapter, *Banlieue 13* demands not to be evaluated in accordance with the orthodox criteria that govern film criticism. Instead the spectator might admire the screen version of a performance art more akin to contemporary dance than a film narrative; he or she might experience vicariously the thrill of the video-gamer, or grapple with a bizarre fusion of these two distinct modes. This chapter argues that any discussion of popular cinema must indeed focus on the experience of the spectator. It also suggests that analysis should be predicated on an attempt to understand the ways in which the spectator registers the cinematic image, the process of cognition. It makes two assertions. First, this process of cognition requires the supposedly passive spectator to perform various types of imitation and identification, what Edgar Morin (2005: 6) terms 'the projection-identification of every spectator' ('la projection-identification du spectateur', Morin 1972 [1957]: 18). Secondly, the popular genres allow us to measure the distance between the spectator and the film-object.

The film star beckons to the spectator, asking him or her to come closer. However, although the star may invade our fantasy worlds, he or she will remain in a physical sense remote, an unassailable entity. The popular director will endeavour to close this gap by sequencing images in ways that could stimulate a physical reaction in the spectator. With pornography the distance between screen and viewer is virtually

abolished; the arrangement of the images is designed solely to produce sexual arousal in the viewer. Violence in the slasher movie – or the expectation of violence in the thriller – is situated a little further away; the spectator may sweat but he or she won't bleed. Kant argued that laughter arises when the 'bubble of expectation' (Paulus and King 2010: 139) is reduced to nothing. Overtly or covertly, the comic actor always winks at his or her audience, revealing his identity and breaking the illusion of reality, thereby restoring the distance between the screen and the spectator. Watching any type of film is an intensely personal activity, but we normally gaze at the big screen in the company of others. And this may be why the most popular form of cinema in France, and correspondingly the least discussed, is the one that provokes the most socially acceptable, physical response: laughter.

Notes

1 'Tandis que les arts classiques se proposent de signifier le mouvement avec de l'immobile, la vie avec du non-vivant, le cinéma, lui, se doit d'exprimer la vie avec la vie elle-même. Il commence là où les autres finissent. Il échappe donc à toutes leurs règles comme à tous leurs principes.'

2 'une passion hypnotique venue de l'enfance pour le cinéma ... On est là devant l'écran, invisible voyeur, autorisé à toutes les projections possibles, à toutes les identifications, sans la moindre sanction et sans le moindre travail'.

3 'la vie et la mort, le réel et l'imaginaire, le passé et le futur, le communicable et l'incommunicable, le haut et le bas cessent d'être perçus contradictoirement' (Breton 1930: 10). For a detailed discussion of Breton's ideas on the cinema, see Kyrou 1963.

4 'Quand on parle du mythe de la star, il s'agit donc en premier lieu du processus de divinisation que subit l'acteur de cinéma et qui fait de lui l'idole des foules' (Morin 2005: 30 [1972: 39]).

5 '... lien affectif entre spectateur et héros' (Morin 2005: 11 [1972: 23]).

6 'En dernière analyse, ce n'est ni le talent ni l'absence de talent, ni même l'industrie cinématographique ou la publicité, c'est le besoin qu'on a d'elle qui crée la star. C'est la misère du besoin, c'est la vie morne et anonyme qui voudrait s'élargir aux dimensions de la vie de cinéma' (Morin 2005: 81 [1972: 91]).

7 The supplementary section does not appear in the 2005 translation of Morin's book. The translations from it, therefore, are my own.

8 'James Dean voulait tout faire, tout essayer, tout éprouver' (Morin 2005: 99 [1972: 137]).

9 'La *vitesse motorisée* est non seulement un des signes modernes de la quête de l'absolu, mais répond au besoin de risque et d'affirmation de soi dans la vie quotidienne' (Morin 2005: 107 [1972: 143]).

10 The term 'cinéma du look' was coined by Raphaël Bassan. See Bassan 1989. For a balanced discussion of the phenomenon, see Austin 2008: 144–54. For a more polemical view see Hayward 1993: 292, 'In the 1980s, film follows media hype'.

11 '…un hymne à l'anarchie et à la révolte intégrale' (Artaud 1978: 135).

12 Bergson was very much aware that his formula of 'du mécanique plaqué sur du vivant' would be decisive in helping future theorists understand the nature of laughter. See Bergson 1940: 29, '… voilà une croix où il faut s'arrêter, image centrale d'où l'imagination rayonne dans des directions divergentes' ('this is the juncture at which we must stop, the pivotal image from which the imagination radiates out in divergent directions').

13 This position is most persuasively articulated by Theodor Adorno. See Adorno 'The Schema of Mass Culture', in Bernstein 1991.

14 David Bellos points out the irony of this scene, during the filming of which Tati suffered minor burns, given that the amenities on the beach at Saint-Marc sur Mer that had been destroyed by wartime bombing had left sufficient space for the cheap erection of a film set. See Bellos 1999: 181.

15 '*L'Ours* transforme des êtres vivants, et supposés incarner la nature à l'état sauvage, en effets spéciaux, en machines. Ce résultat est obtenu grâce à des trucages mécaniques, optiques, chimiques et électroniques, mais aussi, et de manière plus significative, par le montage. C'est le découpage en «fines lamelles» d'images, et de son, puis leur recomposition sans égard à leur origine réelle, qui permet les effets extrêmement puissants obtenus par le film, notamment la manipulation des animaux comme des marionnettes, moins sur le tournage lui-même que sur la table de montage. Le travail sur la bande-son, faisant appel à des manipulations encore plus poussées, grâce au traitement en synthétiseur, relève de la même démarche, de même que la troisième étape, le montage, assemble les images et le son.'

French television:
negotiating the national popular

Lucy Mazdon

Introduction

As has been argued in previous chapters, discourses relating to what constitutes popular culture in France have experienced a sweeping paradigm shift in the last fifty or so years. This has been witnessed across a range of cultural practices and philosophical and political debates. This period of change and negotiation coincides to a great extent with the development and gradual entrenchment of television in French cultural life, from its early days as a little-watched curiosity to its current incarnation as an ever-present and highly influential medium. To attempt to analyse the construction of the popular without addressing the role of television, arguably the late twentieth century's dominant popular cultural platform, would be foolhardy indeed. This chapter will, then, trace the history of French television, attempting to define the ways in which it has contributed to the negotiation of the popular which is this book's central theme and the various ways in which the struggle over culture has been played out across its schedules. However, before turning my attention to French television I will say a few words about television in the UK which will serve to highlight some of the key issues currently facing broadcasters in both countries.

The future of television

In June 2009 Lord Carter published his long-awaited report on Britain's digital future. The report advocated a number of measures including a commitment to universal broadband provision, a clampdown on illegal file sharing and other forms of media piracy, and a switch off of analogue radio by the end of 2015. Arguably most controversial among Lord Carter's various proposals was his suggestion that the government should use part of the BBC licence fee to fund both universal broadband access and

ITV regional news services. Sir Michael Lyons, chair of the BBC Trust, was quick to respond, stating 'The licence fee must not become a slush fund to be dipped into at will, leading to spiralling demand on licence fee payers to help fund the political or commercial concerns of the day. This would lead to the licence fee being seen as another form of general taxation. The trust will not sit quietly by and watch this happen' (*Guardian* 2009). The proposals stoked controversy because of course they touched upon the vexed question of the BBC, public service broadcasting more widely, and their place in the multi-channel, multi-platform environment of 'digital Britain'. In this new, fragmented, and highly competitive environment the remit and identity of public service television and of the BBC in particular became increasingly unclear. How should it be funded? Who was its audience? What was its future? It is within this ongoing and highly politicised controversy that Lord Carter's proposals take their own contentious place.

To begin a study of French television with a discussion of the United Kingdom may seem surprising but British broadcasting, in particular the BBC, served as a model for France in the post-war period as it set out to establish its own audiovisual industry. Similarly, these contemporary anxieties about the future of public service broadcasting are not unique to the United Kingdom and indeed are echoed to a great extent across the channel. Cable, satellite and digital television were slower to take off in France than in Britain. According to statistics provided by the *Centre national de la cinématographie* (*CNC*, 2009) spending on cable, satellite and digital subscriptions rose from 2.9 million euros in the United Kingdom in 1998 to 6.8 million euros in 2007. In France the spend was significantly lower, growing from 2.5 million euros in 1998 to 4.8 million in 2007. Nevertheless, these figures do of course represent an increase and it is worth noting that finance from the *redevance*, the French equivalent of the licence fee, has not grown during the same period, remaining unchanged at 1.9 million euros. In Britain the licence fee has risen from 3.2 million euros in 1998 to 4.9 million in 2007 although it is debatable how much increase that represents in real terms. All the main French terrestrial channels[1] have seen a drop in viewers over the last ten years and although the commercial channel TF1 remains dominant with around 30 per cent of the audience it has suffered the most spectacular fall in viewers, losing 3.5 per cent from 2007 to 2008 compared to 0.6 percent for France 2 and 0.8 percent for France 3 (*CNC*, 2009).

Where growth has been perceived is in audiences for *TNT* (*Télévision numérique terrestre*), the new terrestrial digital channels provided without

additional charge by digi-box or free sat. Combined audience total for
these channels stood at 4.3 per cent in 1998 but had reached 23.7 per cent
by 2008, representing an overall gain of 6.2 per cent (*CNC*, 2009). This
growth clearly responds to an increase in digital provision and acquisi-
tion of digi-boxes and digital television sets and to a great extent mirrors
similar shifts in the British context. However the increasing prominence
of the *TNT* must be set alongside the concomitant growth in satel-
lite take-up to reveal a diversification and fragmentation of the French
audiovisual landscape in which the role of television, particularly public
television, becomes increasingly precarious. Moreover, in both France
and Britain television of all forms must now compete with the myriad
possibilities of the Internet. TF1's eight o'clock evening news programme,
which for so long has marked the start of French prime-time viewing
and united up to 9 million viewers in this so-called '*grand messe*' ('high
mass'), is arguably now just one element of the continuous and multi-
farious news provision available on-line and via satellite. The image of
French families gathered around their television set in the privacy of the
home is increasingly being replaced by the mobile internaut accessing
regular news updates via portable computer and mobile phone. Broad-
casters in Britain and France have responded to this new environment
via rapid development of their own Internet provision, notably the BBC's
'watch it again' tool the i-Player, first launched in 2005 but significantly
extended and improved in 2008. While such innovations are of course
vital in the face of Internet competition and linked websites do play a
crucial role in publicising output and raising channels' profile, tools
such as the i-Player may paradoxically hasten the demise of the publicly
funded broadcasting model which as we have seen has been so fiercely
debated in recent years. If programmes are available on-line without
paying a licence fee only an hour after original transmission, who will
continue to pay that fee? Without the licence fee what will happen to the
BBC? Similar concerns are echoed in France where channels are continu-
ously increasing their on-line provision and programmes such as Zattoo
enable real-time viewing of current television output:

> the industrial era of television, with us since the early 1950s, is fast changing
> under pressure from the disaggregation of content from media platforms
> characteristic of today's cross-media industries, and as a response to
> bottom-up appropriations of the affordances of networked computers and
> various mobile devices. This doesn't pose a threat to the concept of 'seeing at
> a distance' that has long characterised television so much as the institutional
> logics that have held it in a vice grip over the past few decades. (Uricchio
> 2009: 36)

Television, it would seem, then, is not what it used to be. Indeed the changes described above represent a seismic shift from the early years of both French and British television broadcasting and it is to those early years in France that I will now turn my attention.

French television, the early years

In order to understand the complex relationship between contemporary French television and definitions of popular culture, it is crucial to first trace the history of that relationship and the various ways in which it has constructed and informed the present. Crucially the fragmentation of the French broadcasting landscape has rendered any attempt to define the 'cultural' role of television highly problematic. Television can no longer be reduced to a limited number of channels, the programming they offer and the audiences who consume these programmes. Rather its proliferation demands that those earlier, already complex definitions must be extended to include the innumerable satellite channels, their plural and diversified audiences and the Internet dissemination and 'mash-ups' which extend 'the box' well beyond the channels of discourse once used to describe its social and cultural roles.

Television was relatively slow to take off in France as a truly popular medium and this becomes particularly apparent when we compare the French case to that of the United Kingdom. Television was first established in France in 1935 and began regular transmissions after the Second World War. However it was not until the late 1950s that a significant audience began to emerge. In Britain television ownership grew from around 35,000 households in 1947 to around 3.25 million in 1954 following the coronation of Elizabeth II. As late as 1957 only 650,000 French homes owned a television set and only five major urban areas could receive television programmes (Michel 1995: 25). Throughout the 1950s television viewing was limited geographically (due to restrictive transmission range) and socially. Unlike in Britain, where the relatively high cost of a television set did not prevent purchase across a broad range of social classes due largely to the popularity of the coronation, television ownership in France was essentially confined to the middle classes. Its infiltration within the family home was minimal, indeed many of those who did watch television did so in cafés and *télé-clubs* (Kuhn 1995: 109) and as such its broader cultural impact was still relatively restrained. This began to change in the 1960s. In 1958 just under 10 per cent of French households owned a television set, this increased to 40.3 per cent by 1964 and 69.7 per cent by 1969 (Kuhn, 1995: 109). As television ownership – and by

extension television consumption – grew, so the need for increased provision was acknowledged and in 1964 a second channel was introduced, and programme schedules were increased so that by the end of the 1960s the total programming offer had doubled (Kuhn 1995: 110), confirming television's role as a central cultural form and a true 'mass' medium.

An article published in the British film journal *Sight and Sound* in Winter 1958/59 provides a very interesting cross-channel perspective on this early period in French television history. Charles Hildesley begins his article by stating:

> Television in France is at once more adult and more amateurish than in Britain or some other countries. A relatively high intellectual level in programmes goes hand in hand with clumsy technical blunders of presentation, due to lack of discipline or preparation; in the general atmosphere of experiment and improvisation, many producers still tend to expect from their viewers a friendly indulgence towards an exciting new toy they have not yet mastered. French television sometimes resembles highbrow amateur theatricals in which a good time is had by all and no matter if the lights fail. (Hildesley 1958/59: 41)

He goes on to stress the 'amazingly high' percentage of 'serious, educative programmes' (41) and admires the fact that an increasing number of people engaged in television in France are 'prepared to regard it as an artistic medium as important as the cinema or theatre, and devote long magazine articles to philosophising about its artistic future in the best French manner' (41). He admires the 'unhurried, creative haphazardness' which typifies French production as it tries to 'find its feet and work out a policy', yet interestingly sees the absence of the 'spur of competition which has done so much for the BBC since the birth of ITA' as a lack (41). While praising the innovation of some of the French output, Hildesley regrets the 'looseness and lack of discipline that ... runs through much of the RTF's [*Radiodiffusion-télévision-française*] work' (42). He explains that RTF devotes about eight hours a week to 'regular documentary programmes of a magazine type' (43), claiming that 'these are generally appreciated by viewers far more avid than their British counterparts for informative documentary' (43). However he does point out that a fifty-minute weekly programme of literary criticism in which authors are brought to the microphone to discuss their new books is 'often very interesting' but 'less widely popular' (43). Hildesley concludes his article by deciding that:

> the French are such an individualistic race that it is hard to pin down their likes and dislikes. They want, above all, to be distracted; but they also want

to be informed ... They do not like parlour games, considering them a boring form of distraction best left to the more Americanised television of Britain and Italy. The snobbish prejudice amongst intellectuals and professional people against owning a television set is quite as strong as ever it used to be in Britain (43).

Hildesley's article is worth quoting at length for the light it sheds on French television of the late 1950s and the ways in which it was perceived by the much more televisually advanced British. Hildesley paints a picture of a television industry still very much in its infancy, subject to the political censorship of its state controllers, *Radiodiffusion-télévision-française* (Hildesley notes RTF's lack of a charter equivalent to that of the BBC) but intent on creative innovation, keenly aware of its cultural remit yet sharply criticised by those who despise its populism, and faced with audience demand for lighter entertainment. Indubitably Hildesley's account is bound up with an ongoing British tendency to perceive French cultural production as 'highbrow', 'artistic' and 'intellectual', a tendency which was of course finding particular expression in British accounts of French cinema at this juncture (see Anderson 1954, Durgnat 1962, Houston 1963). It is striking that Hildesley spends some time discussing the productive relations between French television and cinema (television was still not sufficiently widespread in France to cause the negative impact on cinema-going that it had provoked in the UK) and his closing remark that 'it would be surprising if the French genius, which has already given so much to the cinema, did not bring forth a television Renoir or Cocteau before long' (43) is highly revealing. It is worth contrasting Hildesley's apparent admiration for French cultural life, which to a great extent outweighs his criticism of amateurish technique and poor organisation, with an account of British cinematic culture published in the same year. In 'L'Impossible Cinéma anglais' critic and film-maker Alain Tanner laments British philistinism and anti-intellectualism:

The Englishman, who according to George Orwell openly thanks God for not making him an intellectual, is not a rhetorical construct. We can see the *Daily Mail* congratulating itself on the fact that the English people have had, as it puts it, the good sense to reject the 'culture' which was trying to find its way onto the airwaves of commercial television. Another day, after the theatrical success of John Osborne's plays, the same newspaper published an editorial declaring that theatre should be nothing more than a means of digesting a good dinner ... (Tanner 1958: 31)[2]

While Tanner and Hildesley's respective accounts of British and French cultural life are highly suggestive, one must of course guard against the

attempt to over-simplify attitudes towards 'art' and 'culture' on either side of the Channel. Nevertheless it is telling that while Tanner reveals a *Daily Mail* anxious to prevent the spread of 'culture' on Britain's recently established commercial second channel, in France, which had no equivalent at that stage, anxieties seemed to run in quite a different direction – evidenced by those 'snobbish' intellectuals so opposed to television described by Hildesley.

Early French television and *la culture populaire*

One of the key differences in British and French definitions of popular culture is that while in Britain popular culture has long been seen to include the 'mass' cultural forms of cinema, radio and television, in France *la culture populaire* was far more typically used to describe the culture of or for the people, entirely distinct from the debased mass production of the audiovisual industries (see Chapter 1). With this in mind it is striking that these cross-channel accounts of French and British film and television culture should appear to paint what is essentially a reverse reflection: while Britain by the late 1950s had established commercial television and was finding prominent voices such as that of the *Daily Mail* vociferously rejecting the place of 'culture' on television, France was faced with intellectual antipathy to the very idea of television and was still negotiating a balancing act between élitist calls for 'more culture' and audience desire for entertainment. Of course I am not claiming that such tensions did not exist in the United Kingdom – the Reithian belief in television's duty to entertain, educate and inform did after all still hold sway and both the BBC and ITV were subject to strict rules about the nature of their programming. However, at this juncture it was in France that the very idea of what kind of culture television should provide and of its own place within cultural hierarchies and definitions was most evidently up for grabs.

The very fact that television took so much longer to find its feet in France than in the United Kingdom extended these debates, as there was still a sense that television could be pushed in particular directions or indeed abandoned altogether. Moreover it could be claimed that the protracted nature of the implantation of television in France was to some extent a result of the fierce debates about the role of culture in national life that raged throughout the 1950s. Indeed it is striking that television in France emerges at a time when the very question of what constituted *la culture* was such a hotly contested issue. As Brian Rigby remarks, 'it is

important to stress that a universalist, humanist notion of 'Culture' with a capital C still survives strongly in French society, despite many vigorous attacks upon it' (Rigby 1991: 4). This is a conception of culture enshrined in the *Académie française* and of course in the education system. Laurent Cantet's recent film *Entre les murs* (The Class, 2007) provides a revealing example of the ways in which French schools perpetuate 'traditional, elitist notions of Culture' and serve 'that small minority who have access to Culture and the competence to talk about it' (Rigby 1991: 5). The film is set in a large *lycée* in Paris's socially deprived and highly multi-cultural Belleville. Teacher François attempts to instruct his pupils in the nuances of French grammar, notably the imperfect subjunctive, and is met with blank incomprehension and hostility as the students claim this is not 'their language', that it has no relevance to their daily lives. Tensions reach boiling point when François insults one of his pupils, calling her a '*pétasse*' (a slang word meaning roughly 'tart' or 'slag'). This is very much part of *her language* and it is he who fails to understand the full impact of a term he has used angrily but casually. Thus the film encapsulates the breakdown in communication between teacher and pupils and the failure of the secular education system to move beyond a highly divisive language of culture and power. In so doing it provides a suggestive representation of the continuing impact on French society of 'Culture with a capital C'.

As we shall see, the question of what constitutes culture in France, in particular popular culture, is far from resolved today. However, it became a source of particular intellectual contestation from the 1930s and throughout the 1950s, thus sitting alongside the ongoing development of television. Both the Popular Front of 1936 and the immediate post-war Liberation period were key moments in the development of this questioning of culture which was taken up and developed by the so-called popular culture movement (Rigby 1991). Members of the movement believed that a true '*culture populaire*' and linked popular education should interpolate the individual on a purely personal level 'contributing to their moral, spiritual and cultural development within a broader social context that was defined by cultural dispossession, massification and alienation' (Rigby 1991: 42). Rigby goes on:

> Given such views, it is hardly surprising that the popular culture movement was highly critical of mass culture and the mass media (called 'les moyens de masse' or 'les arts de masse' at this period). At the same time, it tried hard to be resolutely modern and claimed to take full account of the technological realities of the modern cultural world. It solved this apparent

dilemma by adopting a thoroughly educational approach to the mass media. A very characteristic initiative of the popular culture movement was the creation of 'ciné-clubs' and later 'télé-clubs'. These were seen as ways of introducing people to the best examples of cinema and television as well as of helping people to understand and analyse these new media. They were also, of course, seen as ways of criticising, controlling and even eliminating the undesirable aspects of the new media. (Rigby 1991: 42)

Rigby's reference to *télé-clubs* underlines the extent to which early French television was then bound up with the debates about the role and the nature of culture, the impact of mass culture (and by extension Americanisation) and the need to promote the national culture, figured as the 'capital C' high culture discussed above. The beginning of de Gaulle's presidency in 1959, and in particular the appointment of André Malraux as head of the Ministry of Cultural Affairs, marks an explicit implementation of the policy of 'cultural democratisation', largely understood as a governmental responsibility to bring high-cultural practices and forms into direct contact with the public (see Chapter 1). Ideas which had been developed by the popular culture movement among others became an affair of state as de Gaulle envisaged culture as a vital tool in the development of a modernised and powerful France. As Tamara Chaplin notes, 'to many of its early proponents, television's unprecedented ability to provide widespread access to works of high culture (and in the unintimidating setting of one's own living room, no less!) was a critical part of its attraction' (Chaplin 2007: 9). Others were less convinced – Malraux himself loathed the mass culture he saw embodied in commercial cinema and television (Rigby 1991: 133). Nevertheless, and in line with the Gaullist belief in the national benefits of technological advancement, television was seized upon as a central element in the process of cultural democratisation. In other words, television both epitomised Malraux's misgivings about mass culture and the debasing impact of popular education yet simultaneously offered an irresistible platform for the improving agendas of his Ministry:

As a direct descendant of the popular education ambitions of the 1930s, television offered not only the possibilities of a new art form but also a means of 'raising the cultural standard of the nation' through 'a policy of encouraging new creative work'. This pedagogical project along with a desire to promote television as a legitimate art form would guide the work of programme makers and executives until the end of the 1960s. (Lecomte 1999: 40)[3]

The *télé-clubs* mentioned above provide a revealing illustration of this top-down cultural policy but also, I think, suggest that de Gaulle's decision

to mobilise television as a tool in the service of cultural education was nothing new but had in fact been set in place more or less from the start of French broadcasting. In other words, French television from the outset was made to serve the dissemination of 'taste culture' (Chaplin 2007: 9). Its identity as part of the mass media (*moyens de masse*) was acknowledged and, in many cases, feared and thus it became imperative that the culture television provided should be rigorously controlled. The *télé-club* movement began in 1950. At this stage there were only two transmitters in service, serving Paris and Lille. Only 3,974 households owned television sets and programming amounted to around twenty-four hours per week (Lévy 1999: 525). The clubs were the descendants of the *ciné-clubs* founded in the 1940s and which had attempted to mobilise cinema in the service of various forms of education. By the early 1950s the rural *ciné-club* movement was experiencing financial difficulties and a severe drop in attendance and the *télé-clubs*, which of course replaced cinematic film with the intriguing new products of television, thus found a ready audience (Lévy 1999: 525). A line can be traced from the *télé-clubs* to the popular education movements and advocates of the 1930s:

> The rural tele-clubs were bound up with the practices which came from the educational leisure activities and adult education developed by the popular education movements which emerged in France after the Second World War (in particular People and Culture and The French Teaching League). Television was thus considered as 'a new means for popular rural education' (*Unesco*, 1952). (Lévy 1999: 526)[4]

It should of course be stressed that although what was meant by *populaire* here was 'of and/or for the people', the culture that was to be *given* to 'the people', that was to be made 'their own', was to a great extent the culture of the social élites. Television at this juncture was positioned as a means of providing a valuable and improving cultural education to the masses and as such its potential to serve as a 'mass' cultural form providing debased and popularist entertainment had to be curtailed. In other words, there was some confusion about its cultural role and a real tension between these two competing imperatives. With this in mind, it is perhaps ironic that the *télé-clubs* also provoked much interest among set-makers hoping that the clubs would extend the market for their creations and thus the *commercial* strength of the industry; and that RTF paid close attention to monthly reports of club members' reactions to programming, using them almost as an early form of opinion poll, a strategy which in many ways anticipates the decidedly popularising imperatives of the *médiamat*.[5]

By 1952 the *Fédération nationale de television éducative et culturelle*, led by Roger Louis, numbered forty-three clubs. Largely due to the success of the movement, a decision was taken to make a series of programmes aimed specifically at, and in some cases involving, the members of the *télé-clubs*. Roger Louis produced a first series, *La Vie à la campagne* (Life in the Country, October 1952–June 1953) and followed this with *Etat d'urgence* (State of Emergency) directed by Marcel Bluwal and shown between 7 January and 31 March 1954 (Lévy 1999: 526). The latter series is of particular note as it involved collaboration between Jean d'Arcy, then director of programming at RTF, and activists involved in the various movements for 'popular' education. The third in this series of programmes was *D'hier à demain* (From Yesterday to Tomorrow, 1955/56). All three series dealt explicitly with the rural way of life and the impact of new technologies and other forms of modernisation on the working lives of agricultural workers. In other words they spoke directly to and for their viewers – members of the rural *télé-clubs* – and set out to increase these viewers' awareness and understanding of their own living and working conditions while simultaneously engendering a sense of community around this shared recognition and viewing experience. These programmes moved away from the 'élite' culture of other forms of programming (championed of course by Malraux) while retaining a distinctly educational remit. The movement continued to develop throughout the 1950s with the *Ligue française de l'enseignement* (French League for Education) grouping together those clubs which had emerged from the movements for *éducation populaire*. In December 1954 these clubs joined forces with one of these movements, *Peuple et culture* (People and Culture), to host a training course for club leaders (Lévy 1999: 526). While there existed other types of club with a somewhat different remit – the Catholic *Fédération des télé-clubs familiaux et des téléspectateurs* (Federation of Family Tele-clubs and Spectators) formed by Père Richard in 1951 for example – all shared a commitment to the improving and pedagogical potential of television. In these early years of television broadcasting the association between the medium and *la culture populaire* was essentially a question of the then powerful call for education and the transmission of culture to the people and not the 'popular culture as mass culture' with which we far more readily associate television in France today. Moreover, as debates about culture developed, this new cultural form became a vital tool in the struggle for what culture should be and how it should be made available to 'the people'. Television, whose identity and impact was at this stage very far from clear, thus played a crucial role in the democratisation of French

culture which was to prove such a central tenet of the early years of the Fifth Republic.

Politics and pioneers

Of course de Gaulle's interest in television's cultural role was closely bound up in his growing understanding of its political impact. The Gaullists' vociferous and unwavering support for the state monopoly of broadcasting was symptomatic of the administration's commitment to the central role of the state in unifying French society in the interests of domestic harmony and international *grandeur*. RTF remained in place until 1964 when it was replaced by the ORTF (*Office de radiodiffusion-télévision française*) which, like the BBC, was tasked with educating, informing and entertaining the public – the public service ethos of broadcasting was reaffirmed and the state monopoly remained in place. While the government presented the establishment of the ORTF as a move towards increased autonomy for television and radio – truly a French BBC – the reality was somewhat different (Kuhn 1995: 125). The Director General of the ORTF was appointed by the government and half of the board of governors established to ensure accuracy and objectivity in news programmes was also appointed by the state (125). For de Gaulle state control of broadcasting was both a crucial tool in the implementation and dissemination of his political agenda and his personal right:

> Banned from broadcasting by the IVth Republic following the foundation of his hostile *Rassemblement du peuple français* (Rally of the French People) he saw it as his right, upon his return to power, to take tight control of radio and television. He described them 'a magnificent means of support for the public spirit' which of course should be translated as that of the government. (Jeanneney 1999: 378)[6]

De Gaulle's mobilisation of television and radio to serve his ambitions and those of his government has been widely documented. Jean-Noël Jeanneney describes a striking example of this early audiovisual sophistication when he remarks upon de Gaulle's decision to use the radio to address the nation after his return from Baden-Baden on 30 May 1968. In other circumstances, television would perhaps by then have been his favoured medium. However by choosing radio, the media-savvy president avoided revealing the tiredness of his face. Moreover he chose the broadcasting medium of the Free French, thus recalling his glorious past at this hour of greatest need (380).

This heavy-handed approach towards television has tended to domi-
nate accounts of French broadcasting of the period to some extent
disguising or reducing the highly significant roles played by programme-
makers and other personnel and their output. While television of the
1950s was clearly mobilised as a tool in the service of the Fifth Republic, a
number of individuals were working with and between the state-imposed
constraints to produce innovative television programmes. A particularly
notable figure was Jean d'Arcy, director of programmes for RTF from
1954 to 1959, who played a central role in developing television from its
limited and somewhat amateur experiments in the early 1950s to a much
more expert and increasingly popular medium by the end of the decade.
D'Arcy saw three key elements to television's future success: the creation
of original programming; live broadcast of political, sporting and cultural
events; and broad cooperation with international broadcasting organisa-
tions. As Jeanneney points out, d'Arcy saw the director as the 'the master
craftsman ... the creator, the social leader, the head of a team and the
technician' ('*maître d'oeuvre* ... le créateur, le responsable social, le chef
d'une équipe et le technicien') (Jeanneney 1999: 283). In other words he
believed firmly in the creative power of the televisual *auteur* and saw the
nurturing of this talent as vital to the development of the medium. Yet
he was also keenly aware of the social and cultural role television could
and should play and was anxious to nurture talent in the service of this
broader responsibility, 'his particular strength was to have combined
such diverse energies and talents in the service of the social mission of
the new medium' ('la force de son action est d'avoir su rassembler les
énergies et les talents les plus divers au service des missions sociales
du media nouveau') (283). D'Arcy was a great supporter of live drama,
particularly the work of the so-called 'école des Buttes Chaumont' which
from 1956 began a weekly broadcast from the Buttes Chaumont studios
in Paris of live enactments of classic works of French theatre and litera-
ture. As we have seen in Charles Hildesley's account of French television
of the period cited above, these early dramas exhibited a combination
of exciting aesthetic innovation and technical incompetence. However,
what is particularly striking is that, in their dual attempt to explore and
exploit the technical and aesthetic possibilities of television while simul-
taneously providing an improving dose of high culture to the viewing
audience, they provide a snapshot of the mission envisaged for television
by d'Arcy and many others with an interest in the medium at that time.
In other words, these early dramas were a prime example of the attempts
to 'democratise' high culture described above.

Other programmes were somewhat less 'highbrow' than the dramas of the Buttes Chaumont. Series such as *Si c'était vous* (If It Were You, Marcel Moussy and Marcel Bluwal, 1957–1958), *Les Enigmes de l'histoire/La caméra explore le temps* (The Enigmas of History/The Camera Explores Time, Alain Decaux, André Castelot and Stellio Lorenzi, 1956–65) and *A la découverte des Français* (In Search of the French, Jacques Krier and Jean-Claude Bergeret, 1957–60) explored a variety of genres (fiction, documentary and so on) to create programming that was both entertaining and accessible to the expanding television audience and yet they still retained a clear pedagogical emphasis. An episode of *A la découverte des Français* broadcast on 4 December 1958 for example presents a film depicting the lives of the Gaye family in Boulogne Billancourt. André and Gilberte Gaye are teachers and live in an *appartement de service* (service flat) above the school with their five children and two nieces. The film's depiction of a typical day in the life of this average family would have been recognisable to many viewers at the time, part of everyday working culture rather than part of an élitist culture (the literary play of the Buttes Chaumont) largely unfamiliar except through television. Yet even in this more accessible programming, the medium's paternalistic and improving ambitions to some extent remain in place. The film insert depicting the life of the Gaye family is framed by an introduction and discussion led by Etienne Lalou and Paul Chombard de Lauwe and broadcast three days later. Audience responses are thus directed towards a relatively intellectualised examination of the education system and the lives of those who work within it. It is perhaps worth noting that *A la découverte des Français* is one of the programmes singled out by Charles Hildesley as an example of French television's ability to negotiate state intervention – 'The producers claim that although the RTF is state-controlled they are able to criticise the government in their programmes, provided that they do not move too close to current party politics' (Hildesley 1958/59: 42) – and of its aesthetic potential:

> The result, as can be imagined, is sometimes a little naive; but the idea of such debates is a promising one, and is a good example of the RTF's policy of making television a medium of fireside discussion and so of bridging the gap between screen and reality in a way that the more make-believe world of the cinema cannot easily do (42).

Television of the period was clearly not, then, a simple mouthpiece of the state and yet it had to demonstrate a certain amount of ingenuity in its attempts to criticise government policy. It was often engaging, if

sometimes clumsy, and its ability to provoke discussion (another means of educating, of course) was primordial.

In October 1959 Albert Ollivier replaced Jean d'Arcy as RTF's director of programmes. He was an advocate of 'great television for a wide audience' ('une grande télévision pour le grand public') (Bourdon 1999: 319). Less enthusiastic about the possibilities of live transmission than d'Arcy and also much less interested in populist genres such as games and *variétés* (variety shows), Ollivier re-emphasised television's cultural mission. He was keen to recruit directors from the cinema, particularly those of the fledgling *Nouvelle Vague*, in an attempt to extend and enhance the dramatic and aesthetic qualities of television fiction. He also pioneered the use of filmed inserts (such as that described above in *A la découverte des Français*) and increasingly the use of film or video for entire programmes. His passion for television drama, over and above the live transmissions, games and so on also fostered by d'Arcy, played a key role in ensuring that drama remained a prominent televisual genre throughout the 1960s. It received the largest budgets and the most attention, from both programme-makers and Gaullist politicians:

> The directors, many of them left-wing, wanted to make national culture available to those who would not normally have access, or present subversive ideas by dressing them up as culture. The politicians were men rooted in traditional culture, alert to the didactic potential of television and keen to offer prestigious programming based on historical and literary fiction. Overall television tried to convey the tenets of popular education which emerged at the Liberation in a spirit akin to that of the Avignon theatre festival, the recently established National Popular Theatre and the new Cultural Centres. (Favre 1999a: 409)[7]

In summary, this brief overview of French television broadcasting from the late 1940s until the 1960s suggests a television firmly committed to an idea of culture based on the paternalistic desire to educate the public at large through carefully chosen and improving programming. Of course this does not mean that entertainment was ignored entirely. Games, sport and *variétés* were broadcast and crucially played a vital role in attracting and expanding the viewing audience. However, it was the urge to educate and improve which lay at the heart of the state-run broadcasting of the period, partly thanks to those directly involved in the industry, notably those pioneering 'fathers' Jean d'Arcy and Albert Ollivier, but also of course due to that far more powerful 'father', Charles de Gaulle, and his belief in the state's duty to share the cultural *patrimoine* (heritage). Early French television culture was then largely a top-down affair. Improving

programmes were broadcast to an audience who, it was hoped, would be receptive to the values and virtues they set out to share. Their attention was rewarded with the spoonfuls of light entertainment (*La Tête et les jambes* [Head and Legs], 1960, *Intervilles* [Intercities], 1961) which helped this high-cultural, pedagogical medicine go down.

Towards television as mass culture

The development of French television from a minor, arguably élitist cultural form to a true mass medium by the mid-1960s goes hand in hand with the establishment of the Fifth Republic and, perhaps more importantly, extensive discussions about the democratisation of culture. Thus television became an essential tool in this state-led process of top-down cultural dissemination and yet simultaneously revealed the great paradox that lies at the heart of so many French debates about the nature of 'culture'. While the cultural élites called for the sharing of 'taste culture' and attempted to prevent television becoming a debased, Americanised mass medium, the vast majority of viewers desired and enjoyed exactly those 'debased' forms. As television sets became more affordable and programming more easily available, so the audience grew among the lower middle and working classes. To a great many of these viewers the didactic tone of much early programming was emblematic of an élitist culture set up in opposition to a *culture populaire* understood as being *desired by* the people, a culture that they could recognise and enjoy. This gap between élitist cultural forms and popular tastes has an enduring history in France: witness the popularity of French *rocker national* Johnny Hallyday and the widespread apathy towards Jack Lang's crusade against American culture, notably Hollywood, in the 1980s. What is significant here is that the increasing visibility of this gap as television developed in France played a vital role in strengthening the hand of those in favour of the dismantling of state control and moving towards an increasing commercialisation and popularisation of the television landscape.

The election of Valéry Giscard d'Estaing in 1974 represented a break with the Gaullist domination of French politics. The new president's decision to set about reorganising the ORTF and thus prove his liberal media credentials was a key feature of this ideological shift. The ORTF was abolished and replaced by a new broadcasting system consisting of seven companies which would be run independently of one another: *Télédiffusion de France; Société française de production; Institut national de l'audiovisuel; Radio France; Télévision française 1; Antenne 2; France*

Régions 3. The government argued that it would rid television and radio of the political interference which had typified the Gaullist years, and the decision to simultaneously abolish the Ministry of Information underlined this apparent attempt to usher in a new age of media independence (Kuhn 1995: 151). However, as Raymond Kuhn demonstrates, this new relationship between state and broadcasting did not represent the break from the past that was claimed, as the government continued to exercise significant influence on radio and television via the appointment of the director generals of the television and radio companies and various other measures (151).

Nevertheless, and despite their limitations, these reforms did signal a move away from Gaullist heavy-handedness and, perhaps more importantly here, a shift from the perception of television as improving, pedagogical tool towards a growing acceptance of its commercial potential and entertainment value. Of course, while Malraux and de Gaulle's cultural project was to all intents and purposes abandoned, the State did continue to impose via the *cahiers des charges* a series of 'cultural obligations', the need to inform, educate and share national values alongside the desire to entertain. A series of quotas were established, determining the number of 'serious' programmes across a range of genres which should be broadcast. The channels were also obliged to make broadcasting slots available to the Ministry of Education for school or university programming. Moreover statistics gathered by the *Centre d'étude d'opinion* which were used to aid in sharing the licence fee funding among channels were obliged to include an assessment of programme quality rather than relying on audience figures alone (Lecomte 1999: 45). It is perhaps worth noting that one of French television's best-known and long-running 'serious' cultural shows, Bernard Pivot's book show *Apostrophes* (1975–1989), began broadcasting on Antenne 2 a year after the break-up of the ORTF. Television's role as a transmitter of high culture, a means of 'spreading the (literary) word' and encouraging viewers to read certainly did not disappear entirely and continues, albeit in the teeth of much competition, in various forms today (Chaplin 2007: 52).

Despite this continuation of *la télévision culturelle* there was a marked shift in programming policy and identity from the mid-1970s. Although television advertising had been introduced in 1968 and was permitted on TF1 and Antenne 2, there was a significant squeeze on funding following the break-up of the ORTF and, with producers faced with hard financial choices, priority was increasingly given to more populist programmes – games, *variétés* and sport. Series and mini-series which seemed to offer a

more certain return on initial investments grew from 1.3 per cent of total transmission time in 1958 to 23.5 per cent in 1992 (Favre 1999b: 414). While many of these were French programmes, bolstered in 1990 by the introduction of quotas for domestic production, a significant number were of course American and series such as *Starsky et Hutch* (1978, broadcast on TF1), *Dallas* (1981, TF1) and *Deux flics à Miami* (*Miami Vice*, 1986, Antenne 2) proved a huge hit with audiences. Just as the development of television throughout the 1950s and 1960s had echoed and instrumentalised the discourses of cultural democratisation emanating from the Gaullist administration and a number of other prominent cultural commentators, so the shifts in television from the mid-1970s went hand in hand with a shift in élite attitudes towards mass culture. Whereas the proponents of the earlier popular culture movements had refused to see mass culture as part of *la culture populaire* and had thus either disregarded television or attempted to mobilise it clearly within the services of the dissemination of 'Culture with a capital C', post-1968 intellectuals were increasingly willing to describe mass culture as a central part of popular culture, as valid and valuable rather than debased and debasing. Central to the changes in television which sat alongside these shifting conceptions of *la culture populaire* was a growing call for the commercialisation of broadcasting and a definitive break with the public service imperatives that had dominated television since its inception.

The end of the state monopoly

The state monopoly finally came to an end via the broadcasting bill introduced in Parliament in summer 1982. Just as developments in the early French televisual landscape emerged from the broader social and political context (de Gaulle's top-down cultural policy and state control, Giscard d'Estaing's relative liberalism), so the transformations of the 1980s were closely bound up with cultural and technological changes and were of course a central tenet of the ideology and identity of the newly elected Socialist administration and of Mitterrand's presidency. Central to their agenda was cultural policy, including the vexed issue of broadcasting. Mitterrand had been a vocal critic of political interference in television and radio and he was determined to create a more open broadcasting landscape which would make way for those who had previously found themselves marginalised. As I have noted elsewhere (Mazdon 1999b: 330), in many ways the Socialists' plans for broadcasting were symptomatic of their broader ambitions for social change. Through decentralisation and

a renegotiation of citizenship the government began to unpack the long-standing concept of nation constructed by and through the Jacobin state, moving instead, albeit only ever very partially, towards a more plural sense of 'national' identity and 'national' culture. Similarly, developments in broadcasting discarded the relative homogeneity of the state monopoly in favour of a far more diverse media landscape.

A key innovation following the abolition of the state monopoly in 1982 was the establishment of a new regulatory body, the *Haute Autorité de la communication audiovisuelle* (HACA), which was designed to prevent state interference in the public service broadcasting companies (Kuhn 1995: 175). Among other activities it was also tasked with ensuring that the broadcasters continued to respect the requirements of public service broadcasting. This was significant. As change through commercialisation gathered momentum with the advent of the encoded pay channel Canal Plus in 1984, of the commercial La Cinq and TV6 in 1986 and the privatisation of TF1 in 1987, the traditions of public service did not disappear. Indeed, and as Raymond Kuhn has argued, Mitterrand's apparent passion for the liberalisation of the media landscape was in reality the result of political expediency: 'The creation of private television channels ... was a clear signal to the electorate that the Socialist pact of the mid 1980s was a forward-looking, pragmatic force which could give realization to consumer demand for greater choice' (Kuhn 1995: 183). The coming to power of Chirac's conservative administration in 1986 thus saw to a great extent a continuation of this commercialising trajectory while ensuring that those sympathetic to their political agenda occupied key positions in a restructured regulatory authority (the *Commission nationale de la communication et des libertés* or *CNCL*) and television management.

It is not my intention to rehearse here the myriad developments in the French broadcasting landscape of the last twenty or so years. While an account of the years of the state monopoly lends itself to a relatively straightforward mapping, the baroque nature of the discourses and decisions that have transformed television since the 1980s is far more difficult to summarise. Suffice it to say that French television has become something radically different from its predecessors of the 1960s and 1970s. As discussed at the opening of this chapter, it is now identified by a combination of public and private television, of terrestrial, cable and satellite broadcasting, of 'national' production and foreign imports, of public service programming and commercial entertainment. Indeed, French television seems to have undergone what Umberto Eco describes as a shift from *paléo-télévision* to *néo-télévision*, from the clearly defined

schedules, the 'national' address and the spectator-citizen of public television to the multiple choices, niche programming and spectator-consumer of post-privatisation (Eco 1986). These changes have been far from straightforward for the public channels. Much criticism was levelled at both A2 and FR3 following the privatisation of TF1 as many claimed that they had become little more than mimics of the increasingly powerful first channel. In an attempt to remedy this situation, the *Conseil supérieur de l'audiovisuel* or CSA (which had replaced the CNCL in 1989) appointed a chairman responsible for both channels in 1989. The first such chairman was Philippe Guilhaume who was forced to resign in 1990 to be replaced by Hervé Bourges. Bourges was relatively successful in streamlining the output of A2 and FR3, redefining the identity of each channel so as to enable them to work together rather than in overt competition, which would only allow TF1 to increase its market share. This process was taken to its logical conclusion on 7 September 1992 when *France Télévisions* was launched and the two channels were renamed France 2 and France 3. This restructuring, and Bourges' forceful leadership, were successful in enabling the channels to attain creditable audiences in the new broadcasting landscape. However, this in turn led to much criticism of the perceived demise of public service television and the advent of '*une télévision commerciale d'État*' (Bourdon 1994: 282–92). Competition for audiences and advertising revenue orchestrated by the findings of *médiamat* has without doubt seen an increase in popular entertainment, particularly on the second channel and some would now argue that the Franco-German Arte (founded in 1992 and going on to effectively replace La Sept[8]), with its combination of documentaries, cultural programmes and 'art' films, is the only true public service channel to exist in France. The very nature of the new televisual landscape with its insistence on advertising revenue and the concomitant race for audiences means that France 2 in particular is obliged to compete with TF1 with both channels showing programmes capable of achieving large audiences; programming Dominique Mehl describes this as 'la programmation fédérative' (Mehl 1992: 198).

Back to the future

The identity and future of contemporary French television and its cultural role are very far from clear. Just as its early adoption of the public service model was not peculiar to France, so this current ambiguity is mirrored in audiovisual industries across the globe. As relationships

between broadcasters and consumers are gradually changing, as the implications for moving-image content and categories of analysis engendered by the 'digital turn' have yet to be fully grasped and as vast media industries increasingly disseminate their product across a wide variety of platforms, so the question of what television *is* and *will* be becomes ever more difficult to answer (Uricchio 2009: 29). It is striking, not to say surprising, that into this context of change and uncertainty has emerged a so-called '*Téléprésident*', Nicolas Sarkozy, who like de Gaulle pays huge attention to his numerous television appearances, carefully studying his own ratings and the representations of his image and discourse. In 2008 Sarkozy announced a plan to overhaul French state television, arguing that a government appointment of the head of *France Télévisions* would be more 'democratic'. He also announced that he would scrap advertising from state television: since 5 January 2009 there has been no advertising on the five French public channels between eight p.m. (the start of prime time in terms of advertising revenues) and six a.m. A total ban was initially planned for 2011, although this has since been put on hold due to the significant revenue shortfall created by the initial ban. Sarkozy has presented these changes as a move towards the delivery of better televisual fare, with more cultural programming and less commercially driven content. However, the ban on adverts meant the immediate loss of between 200 million and 380 million euros in advertising revenue in the key prime-time slot. As the global economic crisis continues to eat into the advertisers' spending power and as competition for this funding from digital and satellite broadcasters among others grows apace, this clearly represents a very significant loss. TF1, which already commands almost 60 per cent of all of French television's advertising revenues, naturally stands to gain from this restructuring of the market, leading to fears that commercial television's dominance of the broadcasting landscape will be significantly strengthened at the expense of public television. Sarkozy played down these concerns, pointing out that the public broadcasters would be compensated with 450 million euros in state aid, some of it to be gained from a tax imposed on mobile phones and the Internet. As TF1 itself faces declining audiences and a drop in advertising revenue, Sarkozy has presented this shift in funding and the additional state finance as clear evidence of government support for, and belief in, a public television free from commercial constraints.

Perhaps not surprisingly the plans have provoked fierce criticism from media commentators, many in the industry and politicians across the political spectrum. A member of Sarkozy's own government, the Europe

Minister Jean-Pierre Jouyet, stated that the move towards governmental nomination of the director of *France Télévisions* 'has a whiff of the early Fifth Republic which it would be better to avoid' ('a un parfum Ve république du début qu'il vaudrait peut-être mieux éviter') (Nouvelobs.com 2008). Socialist MP Claude Bartelone claimed, 'We're re-establishing the direct telephone line which ran between the Minister of Information and television at the time of the ORTF' ('On rétablit la ligne de téléphone directe qui existait entre le ministre de l'information et la télévision du temps de l'ORTF') (Nouvelobs.com, 2008).Hervé Bourges, a former president of *France Télévisions*, TF1 and the CSA, similarly deplored this 'return to the past'. On 2 June 2009 at the *Théâtre des Folies-Bergère*, a group of industry professionals, artists and other concerned parties gathered to present their 'Appel du 2 juin' which denounced the measures which they claimed were currently threatening French cultural life, notably public television. The paper stated:

> The public audiovisual service is today the victim of a dramatic reduction in programming ... The production and transmission obligations which have defined the French system have ensured the survival of strong and original French programme making ... Public television is an emblem of culture, of diversity and of choice which belongs to us all. (Nouvelobs.com 2009)[9]

This 'call to arms' from artists, intellectuals and industry professionals has a long history in French audiovisual culture: consider *les Etats généraux du cinéma* of May 1968 and *les Etats généraux de la culture* at the time of the GATT negotiations of 1993. What is striking here, however, are the various paradoxes displayed by this call and the policy changes which had prompted it. On the one hand the signatories are calling for the retention of a long-standing notion of public service television, on the other they decry a return to the past, to the period when this quality public television thrived but was subject to the heavy hand of the state. The public television they defend is one firmly rooted in the deeply paternalistic history of French broadcasting and yet interestingly they describe it as a democratic television 'belonging to us all' ('qui appartient à tous'). Sarkozy described the policy changes as evidence of a commitment to quality broadcasting and to the reinforcement of state commitment to public service television, a surprising move from a President who came to power on a platform of economic liberalisation and who until recently had shown apparent disdain for French taste culture and an unfettered admiration for the symbols of American mass culture embodied in his

Rayban sunglasses and morning 'jogging' à la George Bush. These various paradoxes say a great deal about current confusion as to the nature and future of television broadcasting. A simultaneous clinging to and rejection of the traditions of the past speaks volumes about anxieties over the developments of the future. What is television in France today, especially public television? How can it survive in the multi-channel, multi-media, fragmented landscape of the future? In the words of William Uricchio:

> In a certain sense, we have come full circle: from the broadcast era where large publics were the norm, through a period of deregulation at which point cable, satellite and VCR helped audiences to sliver into ever smaller niches. While not yet individualized (our webcams have shouldered that burden), we inhabit a moment where the steady erosion of the mass viewing public has created anxiety in political terms regarding the future of television as a collective mode of address. (Uricchio 2009: 33–4)

More specifically, what is the cultural role of television in France today? How, in this new technological and cultural landscape, does it negotiate that complex relationship with the popular which has identified its history so far?

From democratisation to democracy?

The description of television as 'belonging to us all' is I think significant here. Perhaps one of the most important changes in television broadcasting of the last thirty years has been the shift from the top-down approach to culture described earlier in this chapter to a bottom-up approach which gave the masses greater means to express their own popular culture. Bernard Stiegler sees the video, and more recently YouTube, as an ongoing extension of this shift towards viewer activity and autonomy:

> Until the appearance of the home video, it was more or less impossible for a cineaste to see a work that was not chosen by a film distributor or a television programmer. Thus, the immense popular success of the video recorder relied on choice at an *individual* level. Twenty years later, the appearance of YouTube, Dailymotion and video servers has ended the hegemony of the 'hertzian broadcast' and represents an irreversible break with the model of the cultural industries whose domination marked the 20th century. It is again primarily the organization of broadcasting that transforms video servers today – but on a collective level. 'Broadcast yourself': such is the slogan of YouTube. Video servers and databases have replaced the television transmitter, and there is also an industrial revolution taking place in the domain of what one should no longer call the cultural *industries*, but rather the cultural *technologies*. (Stiegler 2009: 40–1)

While Stiegler is correct to pinpoint the undermining of the dominance of the television transmitter, television does of course continue to transmit and the type of activity he perceives in YouTube, 'broadcasting yourself', is to some extent echoed in much contemporary television programming. The cultural democratisation of the 1950s and 1960s has been replaced by an apparent cultural democracy, the creation of televisual spaces and identities for an increasingly fragmented audience. Since the privatisations and proliferation of television broadcasting of the 1980s a clear shift can be perceived from the pedagogical tones of much early programming to the earthy, seemingly open, participatory and decidedly populist nature of many recent shows.

This shift in tone is clearly illustrated by the explosion in French reality shows since the early 1990s (Mehl 1996). Early examples included *Psyshow* (Antenne 2, 26 October 1983–27 November 1985), *L'Amour en danger* (Love in Danger, TF1, 28 October 1991– 6 May 1993) and *Bas les masques* (Off with the masks, France 2, 29 September 1992–12 June 1996). In many ways these programmes combined the educational ambitions of early television with the moves towards diversity and inclusion which typified the new media landscape. Thus an edition of Mireille Dumas's *Bas les Masques*, broadcast on 24 May 1994, is entitled 'Familles nombreuses: quand on aime on ne compte pas' ('Large Families: love means not counting'). Dumas's interrogation of *les familles nombreuses* contains a series of personal testimonies and short films showing the homes and everyday lives of the programme's participants. The financial implications of having numerous children are only briefly mentioned and broader social and political issues are not raised at all. The programme focuses on individual experience and emotive and affective relationships, an emphasis reinforced by the programme's *mise en scène* which is dominated by close-ups and shot/counter-shot structures between Dumas and her guests 'thus suggesting the intimacy of confession and mimicking the close one to one relationship of the therapy session' (Mazdon 2001b: 343). This contrasts strikingly with earlier explorations of the *famille nombreuse*. An episode of influential news magazine *Cinq Colonnes à la une* (15 January 1960), a flagship programme of state television of the period, reports on the *prix Cognac-Jay* awarded each year to a handful of *familles nombreuses* (Lévy 1995:183). Three families are interviewed by Pierre Dumayet in their home and 'the programme moves, albeit subtly, from its initial celebration of these large families to a revelation of the problems they create and an implied advocation of birth control' (Mazdon, 2001b: 343). In other words, this programme, like

the aforementioned *A la découverte des Français*, draws upon individual experience for the education of the viewing audience and the exploration of social issues which could be assumed to concern many viewers thus creating a clear sense of audience community or shared viewing experience. Dumas' show in contrast focuses almost entirely on personal experience and makes no attempt to address broader social concerns. In this it can be seen to emerge from and echo a television landscape in which the aims of education and national address have to a great extent been replaced by populist entertainment and the articulation and interpolation of a variety of individual experiences.

While these early 'reality shows' did, then, mark a break with many of their audiovisual predecessors, the break was not entirely clean. As François Jost has noted, radio listeners were confiding their personal problems to Ménie Grégoire from the late 1960s (Jost 2002: 339). Moreover, shows such as those cited above did retain a serious address through their recourse to the tropes of psychoanalysis for example, and in this we can perceive a continuation of the educative tone of earlier television. However, where they differed from the vast majority of earlier programmes featuring the lived experience of viewers-turned-participants was in their focus on that experience over and above all other considerations. The programmes were not about a particular issue, its social impact or possible solutions available within the public sphere; they were about the specific sexual/emotional/psychological experience of individual members of the public who by virtue of their willingness to participate in the *mise en spectacle* or performance of their private lives had laid claim to the space within French television opened up by the discourses of democratisation. More recent examples of reality television have continued this logic to produce programmes which arguably do mark a clear rupture with the past. Series such as *Loft Story* (first aired in 2001 on M6), *KohLanta* (TF1, 2001–present), *Star Academy* (TF1, 2001–present) and *Secret Story* (a successor to *Loft Story*, TF1, 2007–present) invite their participants to put themselves and their particular identities on show for the pure entertainment of the television audience. Participants may be asked to sing (*Star Academy*), adventure (*KohLanta*) or hide a secret (*Secret Story*) but essentially they are there to be themselves, not to educate, improve or inform but to amuse and to underline the fluidity and apparent 'democracy' of the new relationship between television and its audience. Like the myriad French talk-shows which emerged from the late 1980s (see Mazdon 1999a) the reality shows can be argued to speak to a viewer-consumer distinct from the viewer-citizen of earlier decades.

By seeing on screen participants who in many ways are a simulacrum of viewers (these are 'normal' people, anyone can apply to participate in these programmes) the viewer at home has a sense of being part of the programme and the broader televisual landscape. The ability to control the shows through voting, on-line feedback and so on increases this sense of identification and participation and furthers the process of democratisation of the audiovisual sphere described above. The shows, such a prominent feature of contemporary French broadcasting, suggest that television and the ways in which it envisages its cultural role has moved a long way from the paternalistic offerings of the early years.

And yet. In order to launch the first series of *Loft Story*, M6 and producers Endemol exploited a variety of methods. On the web and in television trailers they emphasised the controversial and confrontational nature of this new type of programme, while in newspapers and magazines they used a far more nuanced and serious discourse which underlined that this *French* version of the *Big Brother* franchise would show a respect for quality and cultural values not seen in other national productions (Biltereyst 2004: 102). In May 2001 Patrick le Lay, then chief executive of TF1, denounced *Loft Story* as 'that trash television [based] on locking up a group of men and women for twenty-four hours a day while the camera films them, making a mockery of any form of privacy' ('cette télé-poubelle [fondée] sur l'enfermement pendant une longue période d'hommes et de femmes vivant 24 heures sur 24 sous l'oeil de la caméra faisant fi de toute intimité') (*Le Monde* 2001). A month after this diatribe TF1 signed a deal with Endemol for the production of a series of reality shows (Biltereyst 2004: 102) and as some of the examples cited above suggest, this type of programming has now become a staple of the channel.

These two anecdotes about the launch of *Loft Story* say much about the complex and unfinished nature of the shifts in French television as popular culture that I have been describing. Le Lay's hypocritical volteface reveals the extent to which these programmes are bound up with commercial battles between the various French channels. Le Lay of course claimed that TF1's reality programming would be of a far superior quality to that broadcast on M6. This is debatable and is almost certainly a red herring. What is certain is that TF1's programming was marketed hard to reach as wide an audience as possible and thus ensure advertising income. So while the participatory nature of the reality shows may suggest a new form of televisual democracy they are simultaneously, and almost certainly more importantly, a commercial enterprise

which transforms viewers not into active participants but highly lucrative sources of revenue. The dual narratives in the publicising of *Loft Story* are also very revealing. While the focus on the programme's controversy and novelty clearly plays into the commercial logic described above, the underlining of its uniquely *French* virtues suggests a somewhat surprising continuation of the improving cultural discourses and dissemination of *le patrimoine* of an earlier television age.

French television and globalisation

So it would seem that French television of the early twenty-first century is to a great extent Janus-faced, looking forward to the new audiences and new formats enabled by ongoing technological developments while simultaneously looking back to the values and traditions of the past. In her recent study of the presence and representation of philosophy and philosophers on French television since the 1950s, Tamara Chaplin confirms that while programme formats may have altered and approaches differed, the televising of philosophy is still going strong (Chaplin, 2007). She concludes:

> To this day – despite the multiplication of channels, the fragmentation of consumption practices, the rise of the Internet, and other changes in the audiovisual environment that have weighed on the form, the content, and above all the scheduling of programs – French television persistently attempts to indoctrinate (or 'discipline' in the Foucauldian sense) an increasingly diverse public into recognising philosophy and those who practice it as valuable cultural commodities. The conflicts over education, integration, tradition, and technology that have permeated the postwar period have all orbited around one central question: What does it mean in a modern, multi-cultural world, to be French? The persistent presence of philosophy on television in France makes clear that this question has yet to be resolved. (Chaplin 2007: 239)

Chaplin's point here is absolutely crucial. As discussed earlier in this chapter, the development of television in France went hand in hand with the Gaullist ambitions of the early Fifth Republic, their focus on French *grandeur* and the reinforcement and dissemination of the national cultural heritage. Despite the numerous and significant changes in both the broadcasting landscape and successive political administrations since that period, a belief in the importance of a specifically French cultural identity has continued to lie at the heart of cultural discourse, particularly in the realm of the audiovisual, ever since. Even as moves towards a

less centralised, more diverse concept of French national identity began to gain ground in the 1980s (see Chapter 1), so the need to protect an indigenous culture from external (read Anglo-American) threat remained undiminished: witness the aforementioned crusade to ensure *l'exception culturelle* in the GATT rounds of 1993. And yet, as I have already noted, this state-led discourse of national protectionism was not echoed among the consumers of the mass-cultural forms which increasingly lay at the heart of French cultural life. Audiences flocked to see Hollywood films, danced to the sounds of British and American rock and pop and were transfixed by the labyrinthine melodramas of *Dallas* and a whole host of similar American series.

Even the most cursory glance at today's French television schedules suggests that cultural exception and French 'difference' seem to have been eclipsed by a welter of popular and populist television which to all intents and purposes is more or less identical to its international counterparts. Recent successes on TF1 for example have included *Le Maillon faible* and *Qui veut gagner des millions?*, versions of *The Weakest Link* and *Who Wants to be a Millionaire* franchises. With sets, music and even presenters bearing a striking resemblance to their British counterparts, questions about Johnny Hallyday apart, it is no easy task to find a uniquely French element to these programmes. Perhaps surprisingly in the spiritual home of gastronomy, a recent success on France 2 is *A vos marques, prêts, cuisinez*, a version of the light-hearted culinary game-show *Ready Steady Cook*. All this suggests that French television is no longer clearly distinct and that the old enemy, American 'cultural imperialism', may not be the culprit. A significant number of these programme formats have European sources and in some cases they are French in origin but very quickly lose their specificity through international sales and syndication.

This is then the conundrum that bedevils all those with a vested interest in the future of French television and its cultural role. A medium whose form, output and cultural role have long been predicated on particular constructions of national identity and national address, is now indisputably part of a global media industry network. This transformation is embodied in the international distribution of programming and the transnational repetition of franchising and is hastened by the new technologies described at the start of this chapter. In this multifarious media landscape the ability of national policy- and programme-makers to define 'French' television becomes increasingly limited and its popular-cultural role ever harder to define. French television has, since the early days of transmission, attempted to construct, define and share with the

viewing public particular notions of culture. As we have seen, these have ranged from the top-down cultural democratisation of the Gaullist years to the bottom-up televisual 'democracy' of the 1990s. Yet underlying these shifting definitions I would echo Tamara Chaplin and argue that there has been a continuing, if increasingly fraught, negotiation of the 'Frenchness' of French television, of its role in disseminating a national popular culture and of the need (and indeed desire) to protect that role and that identity. This is revealed in the aforementioned policy changes of the Sarkozy administration (presented as an attempt to protect the traditions of *French* public television) and the heated responses they provoked (decrying the government's initiative as an attack on the very same). However, just as television itself becomes increasingly hard to define as it is fragmented across multiple media platforms, so the attempt to pinpoint *French* television and its role in the construction of a national culture becomes ever more problematic.

At the start of this chapter I referred to TF1's nightly eight o'clock news broadcast, described as '*la grand messe*' ('the high mass') for its role in uniting French audiences in front of their television sets. I suggested that this 'national' viewing experience was now under threat from the numerous other news sources now available on specialised news channels, the Internet and so on. This threat is I think undeniable and yet the power and the popularity of the '*messe*' have perhaps not been diminished quite as much as one might suspect. In June 2008 TF1 announced that it was to replace Patrick Poivre d'Arvor, fondly known by his initials as PPDA and news anchor since 1987, with Laurence Ferrari. The replacement caused uproar in the French media and among viewers. Some claimed that this was a political move – Sarkozy was reputed to be furious with PPDA after he compared him to a small boy during his first interview as President at the Elysée Palace and he was said to have put pressure on his close friend, Martin Bouygues, to appoint Ferrari. So yet again we see a repetition of the fears of political pressure which plagued television of the 1950s and 1960s. Yet the outcry also seemed to emerge from a public affection for Poivre d'Arvor and a reluctance to see a change to a news broadcast that had attracted up to nine million viewers a night for nearly twenty years. In other words audiences and cultural commentators alike demonstrated a desire for continuity, for a television which is firmly rooted in the history of French broadcasting. Of course many of the responses to PPDA's departure were posted on-line suggesting that this looking back goes hand in hand with an enthusiasm for new technologies and the new relationship with television and modes of viewing

they enable. In other words, they reveal a desire for continuity *and* change which reflects recent government policy changes, cultural commentary and programming decisions. French television is most certainly 'not what it used to be' and its role in defining the national cultural must now be positioned within the competing discourses and agendas of global technologies and entertainment formats. Yet it remains central to national cultural life and the recognition of its ability to form cultural knowledge and opinions (witness frequent fears about 'dumbing down') has not been diminished. Whether or not contemporary television is able to produce an indigenous popular culture, distinct from the products of the global industry, is debatable and the value of those programmes which could be seen to be firmly anchored in specifically French programming traditions is often fiercely contested. It is perhaps fitting then to finish with a recent programme which in many ways encapsulates the tension engendered by a desire for a distinctly French television which provides an authentic popular culture within the context of a globalised audiovisual culture. The programme in question is France 3's nightly series *Plus belle la vie* (A Better Life, 2004–present), set in a fictitious but very recognisable *quartier* of Marseilles, which has proved a huge hit in France, attracting up to 6 million viewers a night. In the words of Lizzie Davies writing in the *Observer* in November 2008:

> Newspaper front pages have declared it a 'social phenomenon', critics proclaimed it modern life's answer to Balzac, and sociologists deemed it capable of confronting prejudice, desensitising taboos and single-handedly changing the face of France with its populist touch and high-minded ideals. It may sound like an intellectual theory, political treatise or religious movement – but it is not, although it inspires a similarly cultish devotion among its followers. It is a minute and unflinching observation of everyday psychology which explores reality through the fictional lens of a television camera. In other words, it's a soap opera. (Davies 2008)

Here it would seem we have a programme which is distinctly French, which is popular in the sense of both attracting wide audiences and being located in everyday, lived experience, and which continues the 'high-minded ideals' to which so much early French television was expected to aspire. And yet this is a programme whose 'national' identity is firmly rooted in the regional (an imaginary *quartier* of Marseilles) and whose genre and format, the nightly soap-opera, is far more typical of British and American television than French. Contemporary French television and the culture it constructs are, then, it would seem, a complex and ongoing negotiation of past and future, domestic and global and in this

they can, I suspect, be seen to mirror broader debates about the nature of culture just as France's early experiments in broadcasting mirrored those of their day.

Notes

1 France 2, France 3, France 5, Arte, TF1, M6, Canal Plus.

2 L'Anglais qui, selon Georges Orwell, remercie publiquement Dieu de ne pas être un intellectuel, n'est pas une figure de rhétorique. On verra le Daily Mail se féliciter de ce que le peuple anglais a eu, comme il dit, le bon sens de repousser «la culture» qui tentait de s'immiscer sur les ondes de la Télévision commerciale. Un autre jour, après le succès des pièces de John Osborne, le même journal publie un éditorial de première page pour déclarer que le théâtre ne doit pas être autre chose qu'une façon de digérer après un bon repas ...

3 Directe héritière des ambitions de l'éducation populaire des années trente, la télévision ouvre non seulement la possibilité d'un art nouveau mais également un moyen 'd'élever le niveau culturel de la nation' par une 'politique de création'. Ainsi le projet pédagogique et le souci de promouvoir la télévision comme art culturel légitime guident-ils les réalisateurs et la direction des programmes jusqu'à la fin des années soixante.

4 Les télé-clubs ruraux s'inscrivent dans les pratiques héritées du loisir éducatif et d'éducation des adultes développées par les mouvements d'éducation populaire nés en France au lendemain de la Seconde Guerre mondiale (notamment Peuple et Culture et La Ligue française de l'enseignement). La télévision est alors considérée comme 'un nouvel instrument d'éducation populaire rurale' (*Cahiers de l'Unesco*, 1952).

5 The public *Centre d'études des opinions* became a private audience measurement company *Médiamétrie* in 1985.

6 Interdit de micro par la IVe République dès la fondation du Rassemblement du peuple français dirigé contre elle, il s'estime le droit, quand il revient au pouvoir, de faire peser à son tour une main lourde sur la radio et sur la télévision. Il cherche en celles-ci, selon sa propre expression, un 'magnifique soutien de l'esprit public' ce qui, évidemment, s'entend comme celui du gouvernement.

7 Les premiers, souvent de gauche, veulent mettre à la portée des téléspectateurs qui n'y ont pas accès habituellement les œuvres du patrimoine, voire diffuser – sous couleur de culture – certaines idées subversives. Les seconds sont des hommes de culture traditionnelle sensibles aux vertus didactiques de la télévision et soucieux de proposer un programme prestigieux fondé sur la fiction historique et littéraire. Dans l'ensemble, la télévision s'efforce de réaliser les idéaux d'éducation populaire issues de la Libération dans un esprit proche de celui du festival d'Avignon, du Théâtre national populaire ou des maisons de la culture.

8 La Sept (Société d'édition de programmes de télévision) was a French television

broadcaster and production company created on 23 February 1986 to develop cultural and educational programming.

9 Le service public audiovisuel est, dès aujourd'hui, victime d'une diminution drastique de l'offre de programme … Le système français fondé sur des obligations de production des diffuseurs a permis jusque-là d'assurer une création française forte et originale … La télévision publique, vecteur de culture, de diversité et de richesse appartient à tous.

Social and linguistic change in French: does popular culture mean popular language?

Nigel Armstrong

Introduction: scope and aim of the chapter

The phenomenon of what might be called 'social convergence'– the nexus of attitudes that in the last four decades or so has tended to erode hierarchical structures, emphasise the worth of the individual, promote the values of youth and working-class culture and accelerate the 'decline of deference'– tends to be assumed as a given in the study of popular culture. Social convergence or levelling has had important effects on language in this period. In language, social convergence can be seen as standing in opposition to the 'ideology of the standard', a term in sociolinguistics used to refer to the attitude shared by all speakers that sees the standard as the only true language, and its varieties as imperfect approximations to it. This is of course reflected in the terms 'language', opposed to and inclusive of 'varieties' or 'dialects', and there is a parallel here with the various terms used to refer to culture – the bare term 'culture' remains available to denote 'high' culture and every other form, while marked terms like 'popular culture' or 'low(brow) culture' are needed for reference to the hyponyms in the set.

In the light of these considerations, this chapter will examine how, in the standardised French context, popular language is evolving in response to the process of social levelling described above. This is the linguistic aspect of the problem; the social aspect concerns whether France provides an exception to the social levelling at work in comparable countries (Western liberal post-industrial democracies). The first section discusses the general direction of cultural change, referring for the most part to some aspects of the UK situation, because it offers a sharp contrast to what is happening in France, and because the linguistic examples it provides will be familiar to many readers. The second section

explores the distinctiveness of the French language, especially in pronunciation, in its response to the popular and indeed populist social mutations referred to above.

Terms like standard, non-standard and supralocal are used here to refer to the language varieties of interest, simply because the phrase 'popular language' is not current in sociolinguistics. We shall see below that *le fran-çais populaire* is a problematic term in French.

Theorising cultural and linguistic change

Language and social identity

Since the emergence of sociolinguistics in the early 1960s, the direction of linguistic change that has been observed with overwhelming frequency is 'from below', which in the jargon means the adoption by middle-class speakers of working-class forms, to accept for convenience a binary opposition. This is one manifestation of a general cultural phenomenon, including of course popular culture, if language is viewed, in one of its manifestations, as a form of social behaviour. A basic assumption of sociolinguistics is that language variation reflects social variation, the so-called 'speaker-based' approach to change. This view has been clearly stated by a prominent sociolinguist:

> Obviously, languages without speakers do not change. Linguists, however, have not always drawn the correct conclusion from this truism, namely that it is speakers who change languages. A language changes as a result of what its speakers do to it as they use it to speak to one another in everyday face-to-face interactions. (Trudgill 1992: iv)

This seems to be true in a negative direction, since dead languages do not change. Change stems from variation, in language as in other forms of popular culture, but to say that a language varies and changes through the agency of its speakers is too wide-ranging for most purposes. Speakers change languages for different reasons: to economise effort, to enhance vividness, to express their social identity. These three motivations, chosen at random, are not exhaustive. They are all 'speaker-based', but each stems from a quite distinct psychosocial motivation. In this chapter the focus is on how mutations in social structure relate to language variation and change. In this connexion the great French historical linguist Meillet made some time ago the following general remarks. They remain hard to argue with:

The only variable element available to account for linguistic change is social change ... and it is changes in social structure alone which can modify the conditions governing the existence of language. We need to determine which social structure corresponds to a given linguistic structure and how, in general, changes in social structure find expression in linguistic structure. (Meillet 1921: 17–18)[1]

A common way of theorising the link between variable language and social structure, from the viewpoint of the individual, is to look at the link through the prism of social identity, as analysed by examining the elements that relate to the individual: class, gender, age, region and ethnicity are the most frequently evoked in sociology. The concept of social identity is nevertheless hard to theorise or even describe with much rigour, perhaps most obviously because it is experienced subjectively, is multifaceted and dynamic, is perhaps rarely the object of conscious reflection, and is composed of elements which are in any event recalcitrant to precise measurement or even definition, like those listed above. Gender and age are of course capable of being analysed as discrete categories, but are as susceptible to social conditioning as the others.

Region or locality is perhaps one of the least abstract of these, although even the ongoing 'construction' of one's regional identity is influenced by a process that is also complex and dynamic, because subject to continuing socio-geographical developments as well as personal trajectory. As Trudgill points out (1990: 1), a positive sense of regional identity is nevertheless likely to be imprinted in an individual at an early and hence impressionable age, and so continue to make its force felt. This is simply because many if not most people have happy memories of childhood and youth, and these are likely to be associated with a locality or region that is distinctive.

Thus, to take the example of the broad north–south linguistic split in the UK, northern speakers may feel quite strongly that their social identity is bound up in an intimate way with their pronunciation of the 'a' vowel in the lexical set that comprises words like *glass* and *bath*. To pronounce *bath* with a southern long back 'a' might be construed as showing disloyalty to that element of one's social identity which might be labelled 'Northerner', while to reconstruct that component of one's accent so as to abandon northern front 'a' may be to acknowledge diminished allegiance to one's Northerner status.

Attempting to theorise or even describe the interplay between the various elements of social structure and social identity is a formidable task indeed, at least on any large scale. It has been assumed until fairly recently

that social class is generally the major element driving changes in social structure. The more recent development in Cultural Studies known as the 'cultural turn' lays stress on the difficulty of disentangling the various social and economic elements in any cultural phenomenon under examination – the phrase is calqued on the earlier 'linguistic turn' applied to positivist philosophy, and refers to a turn to, or emphasis on, the study of culture in disciplines that attempt to theorise social and cultural history. The cultural turn is in contrast, say, to a Marxist approach that lays stress on the economic as underlying the social and on an 'objective' view of any given situation, as against the 'false consciousness' that may be held to afflict a social class. Clearly, however, economic, social and cultural elements and effects can scarcely be separated out in a hierarchical way, for instance in the rather crude Marxist 'base–superstructure' model according to which the cultural and social merely express the economic. This view cannot be supported in any strong sense, since the perspective of an individual or community on their socio-cultural experience forms an integral part of that experience, and cannot be overridden by any 'objective' viewpoint, as no cogent argument supports the theorist's claim to the privilege.

As Cannadine puts it, historians have more recently 'become increasingly aware of the associational richness and diversity of people's lives: as men and women, husbands and wives, parents and children …' (Cannadine 1998: 16). The list continues for some time, and Cannadine's conclusion is that 'with so many fluctuating and sometimes contradictory senses of identity, which constantly cut across each other, there no longer seems any justification for privileging class identity …' He then goes on to argue what was put forward in the previous paragraph, that while class remains important, the subjective is as important as its external correlate. The remarks apply as much to the sociologist as to the historian, and to any component of social identity as much as to class.

It would be wearisome to labour the point further. The point at issue for our argument is that what have been referred to as the 'elements' of social structure and social identity are the only ones that appear to be available as a way in to any analysis, however deeply fraught with difficulty it may be. Below some connections between changes in social structure and language change will be suggested. The limitations sketched here need to be borne in mind.

Concerning the motivations propelling linguistic and other social change, it is worth citing the position of Labov on the relation between language and society as it affects linguistic change:

The orientation to the relations of language and society that is closest to my own point of view is that of Sturtevant (1947). He viewed the process of linguistic change as the association of particular forms of speaking with the social traits of opposing social groups. Those who adopt a particular group as a reference group, and wish to acquire the social attributes of that group, adopt the form of speaking characteristic of that group. The opposition between the two forms of speaking continues as long as the social opposition endures, and terminates in one way or another when the social distinction is no longer relevant. (Labov 2001: 24)

Labov uses the term 'reference group' in the sense defined by Merton: 'any of the groups of which one is a member, and these are comparatively few, as well as groups of which one is not a member, and these are, of course, legion, [which] can become reference points for shaping one's attitudes, evaluations and behavior' (Merton 1968: 287). The position then is essentially that speakers may adopt new linguistic or other social practices, the property of a given reference group, because they seek thereby to gain social advantage. In this theory the concepts of reference group, social structure and social identity are related because 'the opposition between the two forms of speaking' referred to in the quotation above will stem from an element of social structure and social identity like age, sex or class.

The direction of cultural change

One source of data used below stems from the sociolinguistic sub-discipline often referred to as 'variationist', which studies linguistic variation or diversity in language, considered often in relation to change and using quantitative methods based on the concept of the 'sociolinguistic variable'. A familiar UK English variable, and one currently involved in change, is the glottal stop, which alternates with 't' in speech. The glottal stop has until fairly recently been considered as non-standard or lacking in prestige, but its recent adoption into middle-class speech makes it likely that the 'social capital' associated with the variant will mutate sooner rather than later. Both variants (the glottal stop and 't') occur often enough to make possible the quantification of speech, such that for example a speaker can be recorded as using the non-standard variant as a certain percentage of all possible occurrences. The figures can be correlated against the demographic categories distinguished by sociologists (age, sex, class, ethnicity, etc.) so as to obtain results which are statistically robust and which, as well as avoiding the shortfalls of impressionistic observation, may reveal recurring regularities or indications of change, especially if compared with earlier results: the 'real-time' method. Percentages of this kind will

now and then be referred to below. Sociolinguists commonly attempt to correlate elements of social structure like class and gender with linguistic features undergoing variation and possible change, with a view to identifying regularities or even universals of variation and change.

Although this sociolinguistic enterprise dates only from the 1960s, linguistic change from below is hardly new, nor are impressionistic comments made in earlier times far to seek. An example from English, in 'Born in Exile', a novel by George Gissing (1857–1903) published in 1892, is as follows: 'one hears men and women of gentle birth using phrases which originate with shopboys'. One can assume that Gissing's views would have found an echo in many of his readers, since he had a wide readership and was not known particularly as a controversialist. Anti-democratic views were in any event common at the time. Elsewhere in the novel he sets out the threefold distinction, commonly then used, between acceptable and unacceptable language varieties: upper-class speech and rural dialects are in the former category; in the latter, urban working-class speech, frequently referred to by such labels as 'vile' and 'debased'. This categorisation expresses the social judgements that always underlie folk-linguistic judgements: in this case the upper classes and yeomanry are admirable, but the urban proletariat emphatically is not. This is reflected in the quite common statements of the type heard to this day: 'I think the Yorkshire accent is sloppy', for example. Impressionistic linguistic judgements are often expressed in terms like 'sloppy', 'flat', etc. An accent cannot be sloppy or flat, since these terms have no verifiable phonetic reference, so that judgements on language of this type are really social judgements, in this case perhaps the expression of disapproval of uneducated speakers. We cite some comparable French data below, pp. 214–18. The counterpart is the belief that forms of language like urban dialects are not valid, which has persisted widely until recently and is no doubt still current in some quarters. The linguistic expression of this view was stated in striking form some forty years after Gissing by the historian of English, H. C. Wyld, as follows (1936):

> If it were possible to compare systematically every vowel sound in Received Standard [RP] with the corresponding sound in a number of provincial and other dialects, ... I believe no unbiased listener would hesitate in preferring Received Standard as the most pleasing and sonorous form, and the best suited to be the medium of poetry and oratory.

It is an axiom of perceptual dialectology, the sub-discipline that studies the reactions of non-linguists to dialects other than their own, that listeners

unacquainted with a dialect system are incapable of making 'aesthetic' judgements of this kind. Wyld's view is an expression in no uncertain terms of the ideology of the standard referred to previously. As Milroy and Milroy point out (1991: 14–15), arguments aimed at demonstrating the superiority of the standard are nowadays articulated more subtly, in general using a functionalist discourse which is specious, but make no claims regarding the superiority of the standard in aesthetic terms, let alone as the property of superior persons. The standard is, however, still generally presented as the most suitable vehicle for literary and intellectual expression.

It is only relatively recently that it has become unacceptable to give direct expression to directly anti-democratic sentiments like those cited above in the arena of public debate, although, as Chomsky points out (2003: 396), such views continue to find free expression outside of highly visible contexts. Wyld's view can be regarded as anti-democratic at one remove. The anti-democratic view widespread in the nineteenth century, so repugnant in a contemporary perspective, must in any event be seen in an intellectual context (at least among some thinkers) that saw the possibility of progress through education. As Mills states, 'if looking about them, nineteenth-century thinkers still saw irrationality and ignorance and apathy, all that was merely an intellectual lag, to which the spread of education would soon put an end' (Mills 1956: 301). These optimists felt free therefore to point out 'irrationality and ignorance and apathy' among the masses; the 'swinish multitude', in Burke's somewhat earlier phrase. One may add that among a wider public, beyond the optimistic nineteenth-century thinkers, the free expression of anti-democratic views possible at the time represented also a kind of intellectual lag, from a time when rigid social hierarchies were much more widely accepted (or imposed) and people of all classes were expected to be content with their place in the 'seamless web' of social organisation that is the earliest of the 'three basic and enduring models' of social class or organisation proposed by Cannadine as prevailing since at least the eighteenth century. The other two are 'the triadic version with upper, middle and lower collective groups; and the dichotomous, adversarial picture, where society is sundered between "us" and "them"'(Cannadine 1998: 19–20). These will be discussed further below (see p. 202).

We have devoted some space to a discussion of this issue because the connection between political democracy and what one might call cultural democracy, or perhaps egalitarianism, seems fairly straightforward. The contrast between what has just been described and the present situation

is very great; in fact, the situation now is more or less a mirror image of the previous state of affairs. Put another way, cultural hegemony is largely inverted compared to the previous state of affairs. As Seabrook remarks (2000: 24): 'hegemony ... is the idea that power becomes embedded in cultural distinctions as common sense'. The anti-elitist view cannot, however, yet be regarded as hegemonic, if one accepts what is implicit in Seabrook's definition, namely that hegemony is powerful because unspoken. Perkin has a complementary interpretation of the significance of the new kind of entertainment élite, opposed to more traditional élites now stigmatised as 'élitist':

> Meritocracy has been transmogrified, as merit has come to be defined in non-traditional ways, to include talents no longer dependent on higher education: pop music, fashion modelling, sport, Britart, television presenting, soap operas, and other celebrity vehicles now yield huge incomes and greater wealth than ever. [Celebrities of this kind] are the exceptional beneficiaries of 'jackpot' professions in which many are called but few are chosen, but have the unlooked-for effect of giving hope to those who have missed out in the orthodox educational stakes. (Perkin 2002: xiv–xvi)

The corresponding unlooked-for effect is the disprizing of social mobility through education, and hence of the canon. Popular admiration of 'non-traditional' merit is of course by no means wholly new, although its current scale seems unprecedented, as witnessed by the plethora of popular magazines and TV shows exploiting the cult of celebrity and transitory fame. Perkin cites celebrities like David Beckham and Tracy Emin as representative of this trend.

The date from which one begins to track the process of what one might call symbolic egalitarianism or 'ultra-democracy' (Walden 2000) is a matter of the theoretical and practical optics adopted. Most immediately, one looks to changes consequent principally on the social upheavals of the 1960s and 1970s, typified most spectacularly by the events of May 1968 in France and elsewhere. Earlier significant dates are 1945, 1918 and, further back, the influence of Romanticism with its prizing of the individual, and of the French Revolution. In a practical perspective, accountable linguistic data have become available only relatively recently, as mentioned immediately above, about the beginning of the 1960s when unobtrusive recording equipment began to be available to sociolinguistic enquiry. This starting point is convenient because it coincides more or less with the social revolution of the 1960s and 1970s, which is generally agreed to have produced greater relaxation in many directions.

Social levelling

The nature of the social change of interest here can be referred to in various terms, perhaps the least problematic of which are 'convergence' or, better, 'levelling'. The term levelling is more suitable as it seems to describe more accurately a symbolic diminution of social distance in certain respects, but without necessarily implying, as the term 'convergence' may, a concomitant increase in social cohesion or solidarity. This is because the anti-élitist *zeitgeist* now prevalent seems closer to Cannadine's 'dichotomous, adversarial picture, where society is sundered between "us" and "them"', than to the other models he evokes (consensual seamless hierarchy and triadic).

Levelling in this sense seems more intuitively applicable to what can be called 'vertical' levelling, in a distinction between regional (horizontal) and social (vertical) levelling, although as will be seen the two can hardly be separated in principle. The term 'social', as well as being a hyponym in this categorisation, is also the superordinate since the term covers both the regional and (for example) social-class dimensions. Regional origin can most obviously be thought of in spatial or horizontal terms, as represented in Trudgill's pyramid (1995: 30) that relates the social (class) and regional components of UK accent variation. According to this model, regional variation in accent decreases progressively as one ascends the social hierarchy. At the same time, the regional axis is 'social' in the sense that regional origin is an ascribed attribute possessed by virtually all speakers and capable of influencing social behaviour.

In a more or less everyday phrase like 'social levelling', or more explicitly 'levelling down', the implication or outright sense is of convergence towards a majority social practice, one that before the mutation occurred enjoyed little prestige, or perhaps 'covert' or unacknowledged prestige. Non-linguistic signs of levelling in this sense are not far to seek, and are perhaps easier to conceptualise than linguistic change. Clothing is an obvious example; as Adonis and Pollard point out, items of working and sports wear like t-shirts, jeans and trainers are now increasingly acceptable in more formal contexts. The authors speculate, following Perkin (2002: 431–2), whether trends like these reverse:

> the sociologists' 'principle of stratified diffusion' (the theory that trends in dress, music, entertainment, and lifestyle always begin at the top and work their way down through society). If it had ever been wholly true – and the past history of the upward trajectory of trousers, the lounge suit, and casual wear generally ... suggest otherwise – the 1960s turned it upside down, with the young of the upper and middle classes emulating the denizens of Liverpool and the East End of London. (Adonis and Pollard 1997: 242–3)

Social levelling, the nexus of attitudes and types of behaviour referred to at the beginning of the chapter, when not assumed as a given tends to attract disapproving comments to the effect that hegemonic populism is undemocratic, since it works against the capacity of citizens to participate in the democratic political process in a mature way. It will be seen that an analogous argument has been put forward by some French thinkers, although in the French context the opposition is expressed as between 'republic' and 'democracy', rather than between 'democracy' and 'ultra-democracy'. Our concern here is therefore with the rather paradoxical phenomenon of top-down initiatives aimed at the opposite of standardisation, or anti-élitist views promoted by a socio-political élite. In this argument, political and social inequalities underlie cultural populism, and the latter reinforces the former.

Social convergence or levelling has had important effects on language in this period. Linguistic levelling processes can be seen as running in opposition to the ideology of the standard. Examples familiar to speakers of UK English are certain consonantal features of 'Estuary English' that are spreading nationwide: glottal replacement, referred to above; so-called '(th)-fronting', as in 'earf' for 'earth'; and '/l/-vocalisation', giving the effect of 'miwk' for 'milk'. Some of these changes can be called dialect levelling, since they involve the replacement of localised features by supra-regional variants; others fall into the category, distinguished initially by Labov in the 1960s and referred to above, of 'change from below'. A broad distinction between regional and social levelling can be suggested, although these elements are hard to separate out in English; the French situation in this regard is examined in some detail below. Social levelling, the linguistic expression of the diminution of distinction between middle- and working-class social practices, to adopt again the over-simplified binary opposition, is of most interest here because regional levelling is in France very far advanced, as will become apparent, so that we need to seek other factors at work in the French situation.

A parallel was drawn above with the informalisation of clothing. Parallels between popular language and other types of culture are, however, inadequate in the measure that we are all producers as well as consumers of language, and that as a consequence our social identity is perhaps bound up with language, including variable language, in a more intimate way than obtains for other cultural products. This may be truer of pronunciation than the other 'levels of analysis' distinguished in linguistics, namely vocabulary and grammar. As Coveney puts it (2001: 1): 'Pronunciation is particularly closely linked to identity, more so on the whole than lexis

and grammar …', on account of its concrete character, which is allied to other physical aspects of behaviour like gesture and dress. Further (ibid.): 'The connection [between pronunciation and identity] is also due to the fact that speakers use relatively minor differences in pronunciation to signal aspects of their identity, while generally maintaining intelligibility with speakers of the same language.' Social identity is linked to relatively minor differences in pronunciation which distinguish dialects in subtle ways, measured in millimetres where consonant and vowel variants are concerned. A social dialect is generally acquired in childhood and later adjustments, gifted mimics apart, are difficult for the reason just stated.

One implication is that the considerable effort required to make some-times subtle phonological adjustments is offset by the social advantage gained by alignment to the desired reference group. Coveney's suggestion is discussed below from the viewpoint that the French situation seems unusual, since the required adjustments are largely unavailable in pronunciation and are made at the more abstract levels of grammar and vocabulary.

The French situation

Introduction: some French examples of linguistic change
Although it appears plausible on a superficial view that recent social and linguistic changes have proceeded in essentially similar ways in Western post-industrial liberal democracies with standardised languages, simi-larities are very broad and closer examination reveals the unsurprising fact that each situation is unique. Notable differences in social organisa-tion in France are of course the *dirigisme* and sense of cultural unique-ness characteristic of the country, reflected quite vividly in the example of relatively recent (1994) legislation designed to prohibit the use in official documents of Anglicisms by French state employees; and the republican attitude widespread in France that sees democracy in the light of upward rather than downward levelling. Against this, it certainly makes sense to assume that the youth-driven changes mentioned previously are at work in France; for example, the 'events' of May 1968 are above all associated with their French manifestation.

To anticipate somewhat, several processes of linguistic change now apparent from real-time studies illustrate a shift in the direction of interest here: diminishing use of the negative particle *ne* and variable liaison, for example. Studies routinely show use of *ne* in everyday speech at levels below 10 per cent. The present author has never heard any French speaker

say *je ne sais pas*, at least in unplanned speech; *je sais pas* now seems 'standard' while the forms represented in popular literature by *ch'ais pas* are normal in colloquial speech. Variable non-use of liaison has now reached *quand*, which may shock some readers imbued in the prescriptive tradition. Similarly, it is worth pointing out the mutation in the *tu–vous* system in French: while the system has remained intact as a structured system (unlike in English), its social distribution has changed in response to less rigidly hierarchical conditions. Non-reciprocal *tu–vous* usage has now largely disappeared; for example, while formerly the relations between master and servant, army officer and private, customer and waiter would find expression in non-reciprocal *tu–vous* exchanges, these will now be characterised by reciprocal *vous*; the major exception remaining is the adult–child relationship. At the same time, some groups having a 'shared fate', such as students and teachers, now largely use reciprocal *tu*. The social relations expressed by the opposition now articulate principally social intimacy versus distance rather than 'power and solidarity', in Brown and Gilman's well-known phrase (1960). This is somewhat of a simplification, but it suffices for the present broad discussion and is in line with the levelling hypothesis adopted here. It illustrates the fact of language reflecting society in a fairly clear way. Non-reciprocal *tu–vous* reflects hierarchy quite straightforwardly, while any erosion of reciprocal *vous* can be thought of in terms of Brown and Levinson's analysis (1987: 198–9), which suggests that use of the *vous* form, which is of course also the second-person plural, allows the hearer the interpretation of being addressed as a representative of his or her social group. The obvious corollary is that *tu* individualises the hearer.

A further shift in the pronoun system apparently in process is towards greater use of *tu* or *vous* in preference to *on* as indefinite pronouns, i.e. with reference to people in general, as in Coveney's example and translation (2003: 165): *parfois tu tombes sur des gens qui ont le même âge et qui ont une plus grande maturité.*[2] In this example variation is possible between *tu tombes* and *on tombe*, both variants having indefinite reference. Coveney cites Ball's suggestion that '*on* is now closely associated with formality, and *tu* is used as an informal equivalent' (Ball 2000: 67). The issue is complex because *on* is now very largely used as an informal equivalent to *nous*, with definite first-person plural reference, with or without subject doubling, as in [*nous*] *on va sortir*. A further possible factor motivating the shift from indefinite *on* to *tu* is therefore an 'overload' in the referential function of *on* (Ball 2000, cited in Coveney 2003: 165). Nevertheless, if the shift from reciprocal *vous* to *tu* is interpreted similarly to the

on > *tu* mutation, that is in terms of an impersonal–personal opposition which can be argued to be one aspect of a formal–informal polarity, then both of these shifts are in line with what has been described so far. Other examples of language change like those cited above, *ne* and variable liaison, involve loss of linguistic material and are harder to analyse in this perspective. They are discussed more fully below.

Social levelling in France

A large descriptive-analytical literature on social levelling in France seems to be lacking, although the more interpretive, hermeneutic or non-empirical tradition found in French sociology and other disciplines has seen some French scholars approaching the subject, often in a committed way, either criticising the phenomenon (Finkielkraut 1987) or celebrating it (Maffesoli 1988). The nexus of attitudes of interest here, that tends to erode hierarchical structures and to deplore 'élites' and 'élitism', to emphasise emotion at the expense of reason, etc., has been described by Maffesoli (1988; and in several other works), who stresses what he sees as the positive aspects of the situation. His 1988 work *Le Temps des tribus* (translated 1996 as 'The Time of the Tribes'), lays stress on a social organisation that is mosaicised in a non-hierarchical way. The full title of Maffesoli's book in translation is 'The Time of the Tribes: the Decline of Individualism in Mass Society' and its thesis is similar to that of Seabrook examined above: the expression of social identity through adherence to what Maffesoli calls 'micro-groups', reminiscent of the 'landscape of niches and categories' that Seabrook (2000: 27) suggests as characteristic of the US situation. The subtitle of Maffesoli's book, referring to the 'decline of individualism', might seem at odds with what has been one thread of our argument so far. Whether individualism is in decline in mass society is of course a matter of individual interpretation, and all researchers are confronted with the problem of 'objectivity' that has dogged Marxian analysts especially. Maffesoli is perhaps particularly vulnerable to this charge, since as already mentioned his approach is non-empirical; indeed, he claims at one point to have an 'artistic' viewpoint on his subject. Maffesoli's analysis can perhaps best be summarised, and synthesised with Seabrook's, by suggesting that a social organisation into self-selecting 'micro-groups' may confer on the members of those groups a greater impression of individuality than hitherto, irrespective of the researcher's analysis.

What is especially notable, however, is an attitude of social or cultural conservatism in several French commentators whose stance is on the political left. This is in contrast to the UK situation, where, as Wheatcroft

suggests: 'Both in academic discourse and in practical politics, class conflict has been superseded by "culture wars"; and the other great truth of the age is that the right has won politically while the left has won culturally' (Wheatcroft 2005: 271). This state of affairs was discussed at some length above, by reference to concepts like populism and anti-élitism, which were suggested to be in the process of promotion, at least in part, by the political-cultural élite. The obvious socio-historical explanation of the political victory of the right is to be found in the economic history of the past thirty or so years, which saw monetarism mobilised in response to the oil shocks of the 1970s. The doctrine has not been successfully challenged since, and it is a commonplace that politico-economic discourse in the UK and most other comparable countries is now located in the centre-right. That the left has 'won culturally' can perhaps be interpreted simply as the irreversibility of the post-war socio-cultural developments discussed above, which have proceeded independently of the rightward economic and political restructuring of recent times. Bell's formulation, framed in much more general terms, suggests that: 'A post-industrial society reshapes the class structure of society by creating technical elites. The populist reaction, which [began] in the 1970s, raises the demand for greater "equality" as a defense against being excluded from society. Thus the issue of meritocracy versus equality' (Bell 1999: 410). The argument is therefore that social mobility proceeds through education in the knowledge-based post-industrial society. Access to education is, however, unequal in a meritocracy, since 'merit' in this sense is unequally distributed. The unfairness comes to be widely perceived and a reaction sets in. The unfairness is more keenly felt because it is not 'ascriptive' – i.e., ordained by God or some other non-human agency.

The foregoing remarks appear justified so long as one assumes that they have some wider psychological reality, as opposed to being confined to a narrow section of the academic community. The French situation shows in any event the obvious fact that the political terms 'left' and 'right' discussed above are in large measure nation-specific. Almost the entire political landscape in France tilts 'left', if by this is meant, in a democratic context, 'characteristic of greater state intervention', in all matters: political, economic, social, cultural. Thus the former French President Jacques Chirac, while commonly described by the British media as centre-right, could certainly be seen as left-leaning in his opposition to free-market reforms; when in office he went on record by stating, in *Le Monde* of 23 April 2004: '*Je ne suis pas un libéral*' where *libéral*, a misleading cognate, refers to economic liberalism: free-market economics or 'neo-liberalism'

as it is sometimes currently termed. The 'Nolan chart', reproduced below, is designed to plot personal freedom against economic. (Greater economic freedom is interpreted as operating through lower taxation, while personal freedom relates to issues like sexual orientation, abortion and drug use, which both liberals and libertarians see as a matter for individual choice.) The chart would situate most French political discourse in one of the left quadrants, the notable exception being that propounded by the *Front National*. One element not captured by the Nolan chart (or perhaps captured in a nebulous way along the 'personal freedom' dimension) is the cultural élitism characteristic of France; as will be seen below, this élitism is 'republican' in the sense of being designed to include all citizens, and the French government is an active agent in its implementation.

A further element that the Nolan chart neglects is nationalism, usually in modern times associated with the political right. What one might call the cultural nationalism that cuts across the French political spectrum is discussed below.

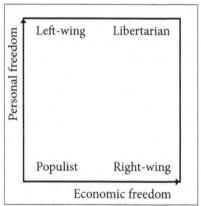

Figure 1 The Nolan chart, designed to situate left–right
political orientation

Perhaps the most striking example of a French intellectual who situates himself on the political left but who has attacked cultural democracy is Alain Finkielkraut; the title of his book, *La Défaite de la pensée* (literally, the Defeat of Thought, 1987), speaks for itself. He is very vocal in his opposition to cultural levelling of the kind that, for example, refuses to distinguish between the quality of Mozart and rap music (his examples). The well-known left-wing writer Régis Debray (1992: 18) has an analogous approach, as shown by the following quotation:

The Republic is liberty *plus* reason, the rule of law *plus* justice, tolerance *plus* will. We may say that democracy is what remains of a republic when the lights have been switched off.[3]

This line of thought shows clearly the element of the republican tradition that lays stress on the republic as a rational enterprise, informed by the Enlightenment ('les Lumières', in the untranslatable pun), and on duties as well as rights, including the citizen's duty of participation in the polity. The sub-title of Debray's book is *Eloge des idéaux perdus* ('In Praise of Lost Ideals'). While other national contexts do not lack discussion of 'dumbing down', notably of institutions like the BBC, which in the Reithian tradition has or has had an educational and even morally improving role, the idea of upward rather than downward levelling, with the aim of full and responsible participation by the citizen in the democratic process, seems more central to the French republican concept. Thus, for example, *civisme* (citizenship or civics) has long been taught in French secondary schools, while the French republican ideal disprizes ethnic identity by refusing to recognise any national identity other than 'Frenchness'. One result of this among many, admittedly a perverse one, is that social data (for example, rates of educational underachievement) are not gathered together with demographic correlates such as ethnic group or origin, since these latter are not officially recorded in exercises like the census. The French ideal is therefore in intention an inclusive and uplifting one, and in practice coercive.

It is of course desirable to show how French centralism finds expression in concrete actions, especially in language planning. The student of French and France soon becomes acquainted with the notion of French *étatisme* or statism: interference by the State in the lives of individual citizens. The tradition goes back a long way, although the Revolution was a catalyst that intensified the process and increased its efficiency through the apparatus set up by Napoleon. A key date in the history of French government intervention in language is 1635, when Richelieu, chief minister of Louis XIII, established *l'Académie française*, the body that was later given the task of creating an official dictionary and grammar. The general point here is obviously that France has a long history of State initiatives to regulate what have been referred to here as social practices, including of course language, and parallels elsewhere are notably absent. The French tradition of laying down the law about language is true not only figuratively, but also literally. As mentioned above, a recent hostile official response to the perceived flood of Anglicisms into French was the Toubon Law of 1994, which obliged French state employees to use, when

composing State documents, officially approved alternatives to UK and US English terms. Once one has got used to the idea of the French State using the law to regulate language in this way, this does not seem too odd, but an earlier version of the law was rejected by the Constitutional Council. The first version of the Toubon Law sought to ban the use of all Anglicisms in the public sphere. The Constitutional Council ruled that this first draft of the law limited the freedom of expression enshrined in the Constitution, since it concerned private citizens as well as State employees. It is worth pointing out, however, that French is defined in the Constitution as the language of the Republic.

Clearly, in France and in all countries having a highly developed sense of being a nation-state, where political and cultural boundaries are expected to coincide, much stress is laid on the relationship that citizens have to the centralising State as well as to their fellow-citizens. This dual relationship is in turn connected with the outward- and inward-looking aspects of nationhood; in its outward-looking aspect, a nation defines itself in contradistinction to other nations, and this can call for a patriotic or nationalistic response from its citizens. The inward-looking aspect implies a concern with internal cohesion and the diminution of difference, the counterpart of external distinction. In times of crisis, external distinction can turn into external threat: a state of war is the most obvious example. At these times internal cohesion is also of paramount importance, and anyone who dissents from this cohesion is likely to be thought of as an 'enemy within'. A recent and striking example is cited by Coveney (2005: 98), of one French writer (Renaud Camus) castigating another's speech:

> Repetition of the subject, repetition of the complement, inability to pronounce accurately a single vowel, pronunciation totally thuggish and uneducated: these are the hands, the lips, holding the fate of French culture. These are the 'intellectuals' who will save us.[4]

The quotation contains the essence of the language-crisis mentality characteristic of any contribution to the standardisation debate, with its mention of the need to save the language. What seems typical often of the French debate, however, is the continuing contemporary virulence of tone, recalling some English prescriptivists, but of a much earlier period. To call someone's pronunciation 'thuggish' or 'Mafia-like' (*pégreuse*, seemingly a unique usage) seems a disproportion. Other contemporary examples could easily be multiplied. The striking aspect of France is therefore that in linguistic matters the State, or at least some of its representatives,

as well as laypersons quite often show a siege mentality, as if hostile outsiders and insiders were threatening the very existence of the French language. This is curious because France is a mature, autonomous, prestigious nation-state, and French is a language with a rich literature. One obvious explanation for this attitude is the French sense of having been relegated to the second rank of nations in the course of the twentieth century. But this is true of the UK also, and this sense does not in Britain find expression in alarm among officials and others about an Apocalypse threatening to engulf the language through external threat and internal perfidy. The real issue here is of course not linguistic, but socio-cultural and political, and one element that is reflected in this debate is the sense of cultural uniqueness that is prevalent in France at the political level and elsewhere, and is summed up in the phrase 'cultural exception' (l'exception culturelle) (see Chapter 1). The French response can also be explained in part by the nation's sense of itself as a beacon of culture and civilisation – phrases like 'the world-wide influence of French culture'[5] are still common. The counterpart to this is that some French people regard as humiliating the perceived invasion of France by Anglo-American popular culture, including of course language. This invasion is summed up in the phrase *la coca-colonisation*.

As Thody points out (1995: 82), '"la querelle du franglais" can sometimes be seen as an example of what the French themselves call "les guerres franco-françaises", quarrels among themselves about what kind of society they ought to have'. Thody remarks that what is distinctive in the French situation is the ferocious and polarised nature of these quarrels, with battle-lines drawn up along predictable ideological lines. In contrast to the political centre, which seemed fairly indifferent to the *franglais* issue and which no doubt includes most French people, the reactionary Right and the *étatiste* Left expressed strongly favourable views when the *Loi Toubon* was being debated in parliament. One Gaullist senator expressed his opinion in the following terms: 'when I see all these American words on the walls of Paris, I want to join the resistance'.

This issue is relevant to our discussion, not only because it illustrates broad differences in institutional attitudes to language change between France and comparable countries, but also because the first version of the Toubon Law, if adopted, would have banned the use of all Anglicisms in advertising, the media and business, and this would have affected radio stations broadcasting to young people, for example, with implications for the diffusion of non-standard lexis. The adoption of Anglicisms is one component of the rapid turnover of non-standard lexis, in its turn an

aspect of the unusual linguistic situation in France. Clearly, legislation can be applied relatively easily to the superficial lexical level, but French pronunciation is subject to the same standardising pressures, at least in intention.

Examples of the statism characteristic of France can be multiplied. One striking difference between the UK and France in this regard is the wider 'republican' attitude to schooling in the latter country. Highly normative, 'teacher-centred' methods continue to be concentrated quite largely in the private education sector in Britain, where some 7 per cent of pupils are taught, in contrast to 'pupil-centred' methods that, at least in caricature, are associated, or have been until recently, with the promotion of empathy and self-expression and correspondingly the disprizing of rote learning and the acquisition of canonical knowledge. The private–public divide characteristic of UK schools is largely absent from France, where private schools exist but are mostly denominational and enjoy no particular prestige. The most highly regarded secondary schools are in the state sector. An obvious conclusion is that the French governing class has a vested interest in maintaining in state schools teaching methods that emphasise the transmission of the canon, including its linguistic element, since their children will benefit along with the rest. Public debate in France about a crisis in educational standards is more or less permanent. Normative teaching methods are applied, at least in principle, to the greater majority of French school pupils, including primary. A telling anecdote concerns Jean-Pierre Chevènement, admittedly a contrarian but who when Minister for Education in a Socialist government spoke out in 1981 against innovative teaching methods, of the type just described. His language from our point of view was instructive: he called for a policy of *élitisme républicain*, perhaps translatable as 'élitism for all'. The formulation summarises a great deal of what has been discussed so far.

The foregoing remarks need of course to be hedged very considerably. Hostility to Anglo-American culture or *coca-colonisation* is less likely to be found among the general population than among its leaders, and a representation of the French school system that suggests the universal transmission of the canon is a sanguine one, to say the least. The social malaise that is rife in the *banlieues* is now common knowledge outside France. Nor do the French show any reluctance to participate in recent technical innovations like texting and blogging, which show in a feedback loop the influence of speech on a lightly edited genre of writing. This in its turn can be seen as weakening the highly normative influence of writing on speech, hitherto especially prevalent in French.

Linguistic levelling as against standardisation in French

The reverence of the French towards their standard language on the one hand, and on the other their deviance from it, have been much commented upon. Le Page's formulation is worth quoting at length:

> French seems to be among the most reified, totemized and institutionalized of all languages. [It has been suggested that] the stereotype of a standard unifying language perform[s] the same function for France as the monarchy for Britain. It was decreed as the symbol of national unity in 1539, and again after the Revolution. By the end of the 17th century the written language of the intellectuals among the bourgeois of the Île de France, which was seen as having reached a stage of near perfection, was held up as a model for speech. It has been held up as a model ever since. (Le Page 1989: 12)

Le Page goes on to describe the idealised view of French as follows: 'a rule-system for a highly focussed approved written language, from which people deviate to the extent that they are not properly educated'. This definition coincides closely with that of any standard language, although the association between writing and formal speaking is perhaps closer in French than in comparable languages. As has often been pointed out, a standard language is the expression of an ideology rather than a reality, and French speakers do of course deviate considerably from the norm in lexis and grammar.

It seems nonetheless uncontroversial to state that French is standardised to an exceptionally high degree, both in its formal writing and in its pronunciation. The language is standardised in two related senses: in its relative lack of variation, and in the internalisation by its speakers of an exceptionally normative reflex of the ideology of the standard. This is an idiosyncratic result of the standardisation process in France if one accepts that language standardisation largely proceeds through the promotion of literacy. According to this view, societies with a literate tradition appear to eliminate non-standard grammar from writing, since writing has the standard grammar more or less by definition. In contrast, the standard pronunciation will not be particularly favoured unless orthography maps on to pronunciation in a very transparent way, which is not true of French.

We sketched above some institutional characteristics that promote in France the ideology of the standard. More concrete factors that have contributed to the unusual standardisation of the pronunciation stem in part from the normative intent of the French school system. In particular, the French system incorporates exercises like dictation, recitation and reading aloud that explicitly relate the spelling to a standardised

pronunciation and that 'have surely had a standardising effect on children's pronunciation' (Coveney 2001: 5).

A further contributing factor was universal military service, dating from the Revolution and the subsequent wars of intervention. In this connection it is worth mentioning that conscription operated by lottery and in the nineteenth century lasted for up to seven years; Coveney (2001: 4–5) mentions further that 'during their military service, young men were deliberately mixed with others from different regions, and intensive face-to-face communication over a period of up to four years (during the 1914–18 war) certainly brought about a levelling of regional differences in speech'. It seems plausible, however, that this communication would have exposed the majority to a generalised vernacular French or *français populaire* which would nonetheless have contributed to the erosion of highly localised speech habits. A further influencing factor in this levelling–standardising process is mentioned by Coveney (2001: 4–5); 'even in Picardy, just to the north of the Paris region, many adults report that their grandparents were monolingual in Picard dialect'. Thus if the 'transition from dialect (or regional language) to French took place quite recently – and abruptly – in many parts of France' (ibid.), then it may be that the model of French provided by the school played a more important role in children's acquisition than is customary in a monolingual society.

The northern French standard naturally admits of regional variation, but the peculiarity of the French case is that regional and social variation do not appear to be very closely tied, so that regional French pronunciation is not automatically viewed as lower-class. Clearly, however, social-class variation expressed in pronunciation is observable: for example, French-speakers do refer to the *accent des banlieues* (roughly equivalent to 'inner-city language'), and this is of course a social-class judgement, but, once again, not a regional judgement.

The perceptual evidence reported in Armstrong and Boughton (1998) gives preliminary, if indirect, confirmation of the dislocation in pronunciation between regional and social variation. On the basis of a comparative study of Rennes and Nancy, they concluded that the majority of a sample of French-speakers in one northern city (Rennes) were unable to identify the regional origin of French-speakers of another (Nancy). The study showed that regional forms either passed unnoticed or could not be identified regionally. On the other hand, working-class speakers from Nancy were for the most part accurately identified as such by the Rennes informants.

The 40 Rennes informants were asked to listen to eight randomly ordered one-minute extracts of spontaneous speech from Nancy interviews, each taken from a different cell of the original sample, thus one younger working-class male, one older middle-class female, etc. The Nancy speakers were thus sampled by age, class and sex. After each extract, the Rennes respondents answered several questions; those of interest here are the following:

A Is the person more likely to be working-class or middle-class?
B Can you identify the person's region of origin?

From the sociolinguistic literature one would expect working-class males to rank highest on this test, and middle-class females lowest, and this was broadly the case, with the notable exception of the older middle-class female, who was of working-class origin and who had retained several linguistic features localised to Nancy. The older middle-class female's regional origin was also correctly identified by eight of the 40 informants, although it should be noted that the answers counted as correct were subject to a liberal interpretation: thus 'correct' answers were those that mentioned northern or north-eastern France. If only those responses were counted which mentioned Nancy or Lorraine, the percentages of correct responses would be negligible. It is worth pointing out too that the older middle-class female speaker's regional origin was identified by several Rennes informants through a feature of intonation rather than of accent ordinarily understood.

Against this finding, even for those Nancy speakers who were perceived to have a strongly marked accent, rather few Rennes respondents were able to say where they might be from with any precision. The case of the young working-class male speaker in the Nancy sample illustrates most clearly the disjunction between the Rennes informants' perception of social class as against regional origin. His perceived working-class-accent score was 92.5% (i.e., 37 out of the 40 Rennes informants perceived his speech as working-class) while he rated only 2.5% rather vaguely 'correct' responses (i.e., one informant judgement out of 40) in relation to his regional origin; 32.5% (13 out of 40) of the Rennes informants hazarded the guess that he came from Rennes or Brittany. Rennes and Nancy are about 450 miles apart, and this result is striking from the viewpoint of a UK speaker-listener.

The tentative conclusion that emerges from this is that one variety of French is perceived by a sample of 40 French informants as 'levelled', if what is meant by this is that regional features appear to have been largely

lost from the variety. The second conclusion, relating to social-class identification, can be interpreted as resulting from what might be seen as limitations of the study, as indeed can the first. The limitations that are relevant here are: (a) since levelling in pronunciation is the focus of interest here, differences of subject matter, lexis, grammar, etc., in the non-scripted Nancy extracts may well have influenced the judgements of the Rennes listeners and distracted them from pronunciation features alone; and (b) the uneven framing of questions A and B: A in particular, 'is the person more likely to be working-class or middle-class?', offers a 50 per cent chance of correct social-class identification, while B, 'can you identify the person's region of origin?', is more open and does not give the respondent any guidance as to what might be a correct answer.

Bearing these limitations in mind, the study does suggest that working-class features, most likely non-localised ones, are present in the speech of the Nancy sample and were largely correctly identified by the Rennes panel. Clearly, because data were collected concerning only the perceptual axis of variation, it is unclear how this pattern corresponds to a socially sharply differentiated pattern of production, although it seems reasonable to assume that it does. The results suggest that the effect was not localised, or rather that perception of social-class accent did not depend on the recognition of local features. The table below indicates that at least one non-localised linguistic feature may have provided a cue to aid social-class identification by the Rennes panel.

Table 1 Correlation between perceived rank order of Nancy speakers by working-class accent and deletion of 'l' and 'r' by Nancy speakers.

Nancy speaker	Perception of WC accent by Rennes informants (N/40)	% deletion of 'l' and 'r'
YWCM	37	83.7
OWCF	28	69.1
OWCM	35	67.5
YWCF	14	54.8
OMCF	23	44.4
YMCM	11	39.6
YMCF	2	28.6
OMCM	1	25.0

The table also shows a fairly close correlation between the Rennes panel's perceptions of the Nancy sample as working-class, and the latter

group's rate of deletion of the consonants 'l' and 'r' at the end of a word (as in *ronfle* 'snore', *lièvre* 'hare', etc.). While none of the Rennes respondents commented on this feature explicitly during the perceptual test, several of them did make observations regarding the working-class Nancy speakers such as: 'she eats letters; he doesn't finish his words'.[6] Although such remarks are imprecise and non-technical, it is likely that the respondents were referring to relatively high rates of deletion of various segments in the stream of speech. The deletion rates are ranked very much in line with social-class expectations, and in particular the quite large gap that separates the working-class from the middle-class speakers is noticeable, as is the older middle-class female speaker's production. It will be recalled that this speaker's regional provenance was correctly identified by several Rennes informants; in contrast with this, from a social-class point of view her pronunciation is situated where one would expect to find it.

These results suggest therefore that, on the basis of this admittedly slender and indirect data-base, social as against regional levelling is not taking place in French, in either perception or production. That is, class differences remain marked in speech, and in this example they refer to features clearly marked in spelling. A further study, described below, provides support for this tendency regarding social levelling.

The Nancy–Rennes study suggests, then, a general lack of awareness among the Rennes respondent group of distinctive localised pronunciation traits in the voice samples, and perhaps of (northern) French regional accent features per se. This is unsurprising if the most marked regional or local features are in fact disappearing following the overarching processes of standardisation and levelling referred to previously. This seeming lack of awareness appears at first puzzling when compared to results obtained by Kuiper (1999) in a 'classical' perceptual dialectology study which used the more usual mapping and rating methods (as opposed to direct linguistic stimulus) to tap into the perceptions of regional French of a panel of Parisian respondents.

Kuiper's 76 informants were given a map of France which was blank except for certain cities, rivers and mountain ranges, and asked to 'circle and identify in writing any regions "where people have a particular way of speaking"' (Kuiper 1999: 244). A composite map produced from these responses shows that Alsace-Lorraine was the second most frequently designated area (55/76, or 72 per cent of responses); in this it was preceded only by Provence (63/76), and followed by the Nord/Lille (44/76). The informants were then given a list of 24 regional varieties of French (Belgian and Swiss included though they are non-metropolitan) and asked to rate

them according to degree of difference from the norm (that is, the respondents' own variety), correctness and pleasantness. Alsace-Lorraine French rated very highly (or badly) for markedness on all three rankings: 20th out of 24 for degree of difference (where 24th was maximally different), 21st for correctness and 22nd for pleasantness. For Kuiper's Parisians therefore, Alsace-Lorraine French sits near the bottom of the perceptual heap, as they believe it to be strongly divergent from the norm, incorrect and unpleasant. But what the Rennes test results show is that when a different method is adopted, namely when judges are presented with authentic samples of Lorraine French (albeit urban, Romance-substrate Lorraine French), they perceive very little regional divergence, and are largely unable to link it to a particular region when they do.

Thus there appears to be a mismatch between these two different kinds of perceptions, elicited using different experimental tools, and corresponding to the perceptual in the imagination, prompted by the 'draw-a-map' method used by Kuiper, and the perceptual that responds to actual language data, as in the Nancy–Rennes study. Concentrating on the speech of Nancy, it can be suggested that the conflation by Kuiper's respondents of Lorraine with Alsace shows the link between the two in the informants' minds, having no doubt much more to do with outdated historical-political factors than linguistic considerations, since while many Alsace speakers continue to have a marked accent influenced by the Germanic substrate dialect still spoken there, all evidence points to a regionally neutral Lorraine accent. As regards the perceptions of Kuiper's informants of correctness and pleasantness, they are still vitiated by the Alsace–Lorraine conflation but do not go against our suggestion given above concerning the lack of social levelling in France, for they clearly imply a continuing hierarchy in speakers' minds that ranks the standard accent most highly, to the extent that the Parisian is the standard. (It is assumed to be so by Kuiper and his informants.)

These two sets of results suggest therefore that French is regionally but not socially levelled. To the extent that a comparison with UK English is useful, they stand in stark contrast to a situation where highly marked regional pronunciation features seem to be involved indissociably in the reduction of social differentiation. The lack of copious results on French precludes any confident statement, but it appears that the sociolinguistic situation in non-southern France has changed a good deal since Walter (1982: 52) felt able to state that: 'We need to recognise that geographical differences are, for the moment, more important in our regions than social differences'.[7]

Locating popular culture in popular language

In societies where social convergence or levelling is proceeding, the linguistic correlate is plain where the standard language is clearly distinguishable from its varieties, in a so-called 'language-plus-dialects' situation, even if the precise psychosocial mechanisms responsible for language change as a product of social change are hard to identify. UK English provides a clear illustration of this process, especially in pronunciation. In France, by contrast, the totemic status of the standard language finds expression both at institutional level, as manifested by language academies and linguistic legislation, and in the 'linguistic imaginary' of individual speakers. The French phrase can be taken as more or less equivalent to the 'ideology of the standard' discussed above, seemingly internalised by most speakers including those who have a non-standard variety as their vernacular. Allied to this is the tendency to characterise colloquial French as *populaire* or 'of the people', where empirical evidence shows that linguistic features dubbed *populaire* are in fact used in a variable way by all French-speakers (Bourdieu 1983).

The French situation is harder to characterise as composed of language plus dialects, because dialects are usually thought of as having a regional component. There is of course variation in spoken French, but as the perceptual studies discussed above seem to suggest, socially significant variation is nationally distributed for the most part. These remarks apply to what one might term 'urban *oïl* French' and exclude northern rural areas, the southern varieties, western Brittany, Alsace and the large Lille conurbation. It seems significant that the label *Chti*, applied to the inhabitants and language of the latter area, is unique, in contrast to various UK labels like Geordie, Brummie, Scouse, etc.

The foregoing remarks apply to a substantial majority of the French population. It was suggested above that variation is found mostly at the levels of grammar and lexis. The relative youth of the sociolinguistic enterprise means that rather few real-time studies have been carried out, those that compare snapshots of the state of a variable at two more or less widely separated intervals. Exceptions are studies of the negative particle *ne* and variable liaison, discussed below.

In pronunciation, for a close parallel with the situation in comparable countries, one would have to imagine a cluster of working-class Parisian features as innovating variants in generalised French. Very little of the kind appears to be happening. The only exception is a linguistic change which appears to be in progress in standard French: the 'fronting' of the low back mid-vowel, as in *joli* pronounced as giving the effect in spelling

of *jeuli*. Martinet (1969) analysed this change in functional terms, arguing that a complex system of back vowels, like that of standard French, will be susceptible to fronting, owing to the relative crowding of the vowel system. This is a functional (as opposed to sociolinguistic) argument that refers linguistic change to the physiology of the vocal tract. Evidence of fronting exists from the seventeenth century, in the form of disapproving comments by prescriptivists, and it may be that Martinet's functional argument is valid in historical terms, while more recent change has now taken on social significance. Recent research in the franco-provençal area (Low 2006) suggests a generational shift that sees female speakers having more fronting, and this can be analysed as a shift towards the supralocal French norm. This change is perhaps more plausibly interpreted as being socially motivated, because the speaker sample studied by Low lacked the vowel system upon which Martinet's argument was based. This appears to be a clear example of the 'change from below' that is in line with what is of interest here, although as was mentioned above, the mutation has a long time-depth and current change does not seem to be rapid.

In general, if linguistic convergence is currently taking place in France, it seems to be in the opposite direction, towards the 'northern urban spoken norm', for want of a better term. This dominant variety is distributed over at least two-thirds of the territory. The French situation therefore more closely resembles standardisation rather than levelling. At the same time the northern urban spoken norm or 'supralocal French' appears to be mutating from within. Almost all changes concern the vowel system. The standard vowel system is usually represented as comprising twelve oral and four nasal vowels.

No variation has been reported in supralocal French in the vowels [i], [y], [u], as in *lit, rue, roue*. Any variation between the pairs of 'mid-vowels' can be thought of in a functional perspective – i.e., one that stresses a trade-off between ease of effort and communicative efficiency. The six mid-vowels are conventionally represented in the following distribution (Figure 2). The values of the IPA symbols in the left-hand column are shown in the orthographic examples given.

The vowels /e/ and /ɛ/ are both found in open syllables (those not terminated by a consonant, as in the examples shown) and it has been pointed out (cf. Armstrong 1932: 85) that an intermediate variant in an unstressed syllable is common in this context. Gadet (1989: 92–4) has an analysis that suggests a simplification of the standard set of oral vowels from twelve to seven, pointing out that the system is vulnerable in view of the low 'functional yield' of the mid-vowels. By this is meant

	Open syllable	Closed syllable
e	aller; fée; j'irai; poignée	
ɛ	allais; fait; j'irais; poignet	belle; père
ø	feu; deux; malheureux	jeûne (noun); veule (adj.); –euse (suffix)
œ		jeune (adj.); veulent (verb form)
o	peau; dos	saule; rose
ɔ	philosophie	sol; dot; port

Figure 2 Distribution of mid-vowels in open and closed syllables
(cf. Valdman 1976: 57)

that few word-pairs are differentiated in meaning by the vowel alternations. The vowels /e/ and /ɛ/ have in principle a high functional yield, most frequently in their distribution in inflectional -*er* verb suffixes (infinitive, future, conditional, present, perfect and imperfect forms all have mid-vowel realisations), but Gadet points out what is indisputable, that their role in conveying the relevant semantic feature is subsidiary to that played by syntax. It certainly seems commonsensical to assume that context will almost always provide cues where a vowel neutralisation might be in danger of compromising the sense. Coveney discusses a counterexample, cited below, of a speaker in his Picardy corpus having a pronunciation midway between *j'aurai* and *j'aurais*, where the so-called *e-moyen* caused genuine difficulty in context in determining whether the future or conditional was intended (Coveney 2001: 77):

c'est le roi de la démerde / tu dis à Gérard euh / 'i faut': j sais pas moi **'j'aurai/ j'aurais** besoin d telle chose' – 't'inquiète pas: je vais remonter j te ramène tout'[8]

But it seems reasonable to assume that such cases of potential confusion are uncommon. The other two mid-vowel sets, /ø/ ~ /œ/ and /o/ ~ /ɔ/, are much less functionally productive, and indeed have a distribution in open and closed syllables that is close to being complementary (one is found in contexts where the other is absent), as Figure 2 shows. In particular, the vowels /ø œ/ famously contrast in just two minimal pairs (*jeûne* ~ *jeune*; *veule* ~ *veulent*).

Variation between the variants of the 'a' vowel is also essentially concerned with a simplification of the system. The back variant appears to be non-standard or regional in the pronunciation of 'a' in words like *pas* pronounced as [pɑ], [pɒ] or [pɔ], with the 'standard' realisation as

[pa]. Many young speakers frequently have the back vowel in sequences like *je sais pas, j'y vais pas*, etc., realised as [ʃɛpɑ], [ʒivɛpɑ]. This has a curious socio-stylistic effect as it seems to be used with special communicative intent, such as conveying a degree of condescension on the speaker's part perhaps, or apathy. This is, however, only one aspect of the story; some older, more conservative speakers retain [ɑ] as a phoneme in pairs like *patte ~ pâte*, and as a variant in the suffix *-ation*, as do some rural speakers. The vowel has a limited lexical distribution, and as Coveney points out, 'the very low frequency in the lexis of the back vowel /ɑ/ has led to its demise among most SF [supralocal French] speakers' (Coveney 2001: 188). If the vowel is in recession, its social distribution remains complex, seemingly being found in northern speech and in upper- and lower-class supralocal French speech, but less frequently in the middle of the social distribution (Gadet 1989: 94). In other words, it is a minority form that is peripheral both geographically and socially.

The variation described above concerns a simplification or 'implosion' of the vocalic system, from a maximum of twelve vowels to a minimum of seven. Gadet (1989: 89) describes the maximal system as 'including some variables which … are not functionally indispensable'.[9] Here 'function' is intended in the sense employed in the preceding discussion. The elements in the maximal system – redundant in this linguistically functional view – continue, however, to serve a sociolinguistic purpose, as indeed do all 'conservative' elements in a linguistic system. This assumes that the functionally redundant elements in the twelve-vowel system have correlates which are found in spelling and which therefore are not available to all speakers. The <â> grapheme corresponding to back 'a' is the most immediate example. Gadet (2007: 209) speaks of 'a gradual undermining of the prestige of the written language'.[10] This argument suggests therefore that the levelling of supralocal French pronunciation has to do with attitudes to literacy and the 'rationality' of the standard language as shown in spelling, rather than with a tension between the standard and its dialects.

Grammatical variation and change

Results in grammar which seem to provide direct information on change in progress in the use of *ne* are Ashby's 1976 and 1995 studies of negation in Tours speech (Ashby 1981, 2001), which suggest that the negative particle is disappearing from everyday spoken French. In 1995 Ashby returned to Tours and replicated as far as possible his 1976 study so as to determine whether a change in *ne* retention had occurred in Tours speech in the intervening 19 years. A total of 1,593 tokens of potential *ne*

retention were collected from 25 informants. The particle was retained in 250 of these, resulting in a 15.7% retention rate, in comparison with the 36.6% retention rate in the 1976 study. Other interpretations of this result are of course possible, but the most straightforward refers simply to a change in usage. Collateral evidence is in any event provided by Armstrong and Smith (2002), who reported a decline in the retention of *ne* in speech broadcast on public-service radio between 1960 and 1997, from 92.6% overall to 72.5%. The latter finding is of interest because public speakers such as radio journalists produce an approximation to the mix of linguistic forms they think their audience expects to hear (Bell 1984). At the same time serious radio journalists are commonly regarded as the custodians of the standard language. It is clear from a comparison of Ashby's diachronic study and Armstrong and Smith's results that professional speakers like politicians and broadcast journalists are not at the forefront of linguistic change, with the rest of the speech community following; nor does it seem very plausible that many speakers want to imitate the language they hear on the serious broadcast media, or that many linguistic changes originate in these formal, highly-planned varieties. It would appear therefore that serious broadcast journalists are at once the guardians of the standard language and participants in variation and change within it. The standard language is of course subject to change like every other variety; language in the serious spoken media is more formal than most, but still reflects, with a time lag, changes that are proceeding in more casual speech. This explains the large numbers of letters received by the BBC, and by *France Inter* and *France Culture*, complaining about the 'sloppy' pronunciation and non-standard accents of radio and TV announcers.

On the assumption that Ashby's findings in Tours speech are indicative of French as a whole, then it seems that the decline in *ne* retention observed in radio speech is paralleled by a similar change in spontaneous speech among the wider public. The declines in the two kinds of speech would therefore appear to be mutually reinforcing.

Smith (1996) reported further evidence of change in real time in regard to variable liaison, over the same period. If the decline in the retention of *ne* shows a weakening of the influence on speech of the standard written language, where the negative particle remains obligatory, the relation between writing and variable liaison seems more complex. This is because knowledge of spelling alone is not a reliable guide to the prescribed variable liaison forms. This means that upper-class speakers can or could use variable liaison confidently as a marker of identity, as

well as defining which variable liaison forms are or were to be used. It is sometimes suggested that the attitude of upper- or upper-middle-class speakers towards prescriptively correct linguistic forms is generally more relaxed than that of their immediate social inferiors, the lower-middle classes, perhaps because upper-class speakers interact in more exclusive social circles. Although robust evidence is lacking, the members of the highly-placed social classes notoriously take little heed of what outsiders think of their behaviour. Moreover, the social behaviour of the upper classes is (or was) almost by definition the 'best' behaviour, to be emulated by the socially ambitious middle classes. So far as language is concerned, these latter groups need to rely on education, and books more generally (including etiquette books) to learn the current version of the standard language or any other form of socially 'correct' behaviour.

The recent history of variable liaison appears to show it to have ebbed and flowed in response to large-scale social conditions; in particular, in response to the relationship between the upper-middle and lower-middle classes. Smith (1996: 22–3) suggests that in the nineteenth and early twentieth centuries, the *haute bourgeoisie* (the upper-middle class living on inherited income) used liaison more sparingly than the class below. Clearly, when a linguistic feature comes to be widely used, by groups other than the most prestigious, the latter group must find other forms with which to differentiate itself from those below it. This formulation is of course reminiscent of Bourdieu's (1983) notion of the linguistic market.

This example shows that the *haute bourgeoisie* might indeed have been more highly educated than less socially advantaged groups, but that education is not necessarily (or was not then) the key to mastering a prestigious area of linguistic variation. Parallels in English are the aristocratic use (now seemingly defunct) of forms which, when used by other social groups, are perceived as being uneducated; for instance, the use of *ain't*, or of non-standard *don't*, as in: 'Port don't do the liver any good' (Powell 1966: 39). A closer parallel still is in English upper-class attitudes to spelling-pronunciation, as exemplified by the scornful attitude of Wyld (1906: 366), a socially highly placed historian of the English language, who remarked of pronunciation that relies on spelling: 'careful speech is always vulgar'. Wyld would berate his students for not using upper-class, non-orthographic pronunciations such as 'weskit' for *waistcoat*, or *forehead* to rhyme with *horrid*.

In the period between about 1900 and the 1960s, the use of variable liaison probably saw an increase, with some liaison forms that had fallen into disuse being reintroduced: *voyons un peu, nous sommes arrivés,*

ils doivent aller (Encrevé 1988: 259). Again, this seems to be a case of linguistic change tracking social change, as Smith argues (1996: 27). The French nineteenth-century *bourgeoisie* had previously avoided certain liaison forms so as to distance themselves from the *petite bourgeoisie*, and this reflected their sense of social, and hence linguistic, unassail-ability. The crucial change in the early and mid-twentieth century was the increasing importance of education as a 'legitimating' element. Those who direct France are still drawn largely from the upper-middle classes, but the possession of inherited wealth and titles is no longer generally seen as sufficient qualification for accession to the commanding heights of French industry or administration. Social privilege now requires the sanction of a high degree of educational attainment, typically in a *grande école*.[11] This is because education, including to the highest level, is commonly perceived as being in principle open to all. (There is of course in reality still a very strong correlation between the social-class back-ground of students and their chances of admission to a *grande école*.) According to this view, propounded notably by Bourdieu and Passeron (1970), the educational system has two functions: first to perpetuate upper-middle-class domination, and secondly to conceal the first func-tion. Thus in the pre-1960s period, one can hypothesise that the high levels of variable liaison used by middle-class speakers responded to an association in the public mind between degree of education and the equitable access to power and wealth. Corresponding to the argument pursued so far, a generalised respect needs to be posited in this period for the values of education and the concept of the career open to talent that implies a willingness to tolerate some of the more socially exclusive mani-festations of level of education in language, an area of cultural practice in principle open to all but in fact dominated by the middle classes.

The more recent decline in variable liaison on public-service radio (Smith reports a decrease from 61.6 per cent in the early 1960s to 46.8 per cent in his own corpus, recorded in 1995/96) can be thought of in the framework discussed above that opposes meritocracy and populism.

The results discussed above are the only ones that suggest change in French in an informal direction. They are distinctive in showing change in the grammar, in the case of *ne* and in variable liaison, a complex area at the interface of pronunciation, morphology and syntax. Other areas of variation in grammar are the interrogative system and the relative pronouns. None of these areas of variation shows the interplay of regional and social factors characteristic of the UK and other countries, and indeed it is a curiosity of France that the regional component of social identity,

as expressed through pronunciation, has been largely erased. Bearing in mind Coveney's suggestion quoted above regarding the 'concrete' aspect of pronunciation and its close link to identity, the French situation is distinctive because variation is found above all in grammar and lexis. As was suggested above, these linguistic levels are more abstract, at least when contrasted with pronunciation, and lexis is more open-ended than the other linguistic levels in the sense that new words are learned throughout a speaker's lifetime. Many of these words will of course have socio-stylistic value, and it is a commonplace that adolescence is the time of life when slang is copiously used as a badge of identity. The *exception culturelle* discussed above is an area that merits further research and indeed confirmation. No methodology comes to mind immediately that would elicit French-speakers' intuitions of how variation on the three linguistic levels might relate to aspects of their social identity.

There is of course no default language available as a benchmark in the study of levelling, and Coveney's suggested link between pronunciation and identity applies perhaps more closely to the UK than to other countries. Coveney remarks further that 'producing ... sounds involves a series of physical acts which to an extent affect also our very appearance (notably the shape of the lips)' (Coveney 2001: 1). These remarks apply perhaps to French *national* identity, as French has a proportionally large number of highly rounded vowels (six of the twelve oral vowels). In contrast, English speech sounds, because they often betray regional and thus social identity, can more plausibly be thought of as bracketed off from variable grammar and lexis, in the way that Coveney suggests. In the absence of a high degree of regional marking in French, there seems therefore to be no reason why variation on the three linguistic levels should not function in essentially similar ways, even if for an English-speaker, grammar seems to be more 'cognitive' than pronunciation – perhaps because of the strong standardising pressures that seek to exclude, on grounds of specious rationality, features like multiple negation from educated discourse.

Marginal French

The sketch provided above suggests that the majority of French-speakers have a regionally levelled pronunciation, with variation in grammar and vocabulary representing perhaps its counterpart. Exceptions are on the margins of France (Alsace, Brittany, Lille, the south) and in rural areas (France continues to have a relatively large rural population). Indeed, many French-speakers appear to understand by 'accent' a rural patois. The further exception which has received a good deal of attention, both

from scholars and a wider public, is *le français des banlieues*. It would hardly be fair to say that the amount of attention devoted to these inner-city areas is a disproportion, in view of the deprivation and discrimination suffered by their inhabitants. But several scholars of linguistics have pointed out, first that *le français des banlieues* does not differ greatly from *le français populaire* spoken in other deprived areas, and secondly that any highly distinctive features that do characterise *banlieue* French do not appear to be spreading beyond the housing estates where the variety is concentrated. These features concern intonation and certain elements of pronunciation. One or two of these latter elements appear to be genuinely new, and are perhaps due to Arabic influence. But once again, it is noticeable that the *banlieue* influence is to be seen above all in lexis, *verlan* being no doubt the best known example.

Concluding remarks

This chapter has tried to explore the links between the levelling or populist tendencies of recent times, and their manifestations in language. That these tendencies have influenced many aspects of social behaviour is undeniable. Mention was made above of the casualisation of dress. It is, however, unclear to what extent dress, along with other 'lifestyle' patterns like hairstyle, and interest in aspects of popular culture that represent choices of consumption as well as self-presentation, are comparable with speech. The former seem to be subject to greater conscious choice than linguistic production, at least so far as pronunciation is concerned, and as mentioned above, participation in linguistic change means self-presentation through production as well as consumption.

The lexical level appears to obtrude most obviously on conscious awareness, and impressionistic observation suggests an informalisation of some vocabulary, for example in an increase during the period in question in the acceptability of taboo words and expressions hitherto labelled '*vulgaire*' by French dictionaries: those referring to parts and functions of the body. The lexical level is sometimes described as being the most superficial, perhaps because much variation in vocabulary proves ephemeral. The lexicon is of course open-ended, unlike pronunciation and to some extent grammar, and speakers continue to learn words in a way that contrasts sharply with sounds and grammatical structures. Words referring to the taboo subjects of sex and excretion naturally undergo variation, but the core terms are of long attestation and, as suggested, appear to be in process of change from below.

As mentioned above, some changes in grammar can be thought of as reflecting Gadet's suggested 'gradual undermining of the prestige of the written language' referred to above. Variable interrogation in colloquial French overwhelmingly favours the declarative structure in yes-no questions, as in *vous allez souvent à Paris?* Interrogatives like *quand tu pars?* illustrate the same principle. Normative disapproval of sequences of this type would focus on the fact that a genuine interrogative (request for information) should be realised syntactically as an interrogative, using noun–verb inversion. This argument ignores the obvious point that intonation also has an exponent function in the expression of interrogation, and illustrates the irrationality of much of the standardising discourse. Similarly, a sequence like *la femme que j'ai parlé avec*, responding as it does to natural constraints that govern ease of processing, nevertheless runs counter to the normative rule that forbids the separation, or 'stranding' in the jargon, of prepositions from their associated relative. Noam Chomsky, no particular friend of sociolinguistics, has nonetheless pointed out that many features of the standard language are a 'violation of natural law' that governs language (Chomsky 2003: 403–4), and that it is precisely for this reason that the standard needs to be taught explicitly and, it might be added, presented as rational.

The grammatical level is the most susceptible to speciously rational arguments (whereas pronunciation and lexis usually attract pseudo-aesthetic judgements, as has been seen), and if the 'rationality' of the standard is weakening it is perhaps legitimate to theorise this undermining in other terms than those used so far. In this context one might think about the social, cultural and linguistic mutations of this period in terms that tend to be the province of literary theorists. Binary opposites like reason and emotion, mind and body are after all psychosocial elements of identity that are perhaps linked more intimately to an individual's everyday experience than the sociological categories discussed above. Arguments that oppose reason and emotion are attended by the danger of golden-age thinking, and it need hardly be said that the non-prescriptive charge laid upon the scholar, faced with the facts of change from below, is to explore dispassionately their implications for popular culture and language. Saussure famously drew a comparison between an *état de langue*, or snapshot of a language at a given moment, and the disposition of chess pieces at a certain point in a game. The analogy holds in several important respects, but it breaks down where purpose or direction are concerned. Language change, and cultural change for that matter, have no discernible teleology. Hindsight may give a useful perspective.

Notes

1 'Le seul élément variable auquel on puisse recourir pour rendre compte du changement linguistique est le changement social … et ce sont les changements de structure de la société qui seuls peuvent modifier les conditions d'existence du langage. Il faudra déterminer quelle structure sociale répond à une structure linguistique donnée et comment, d'une manière générale, les changements de structure sociale se traduisent par des changements de structure linguistique.'

2 Sometimes you come across people who are the same age but who are more mature.

3 'La République, c'est la Liberté *plus* la Raison. L'Etat de droit, *plus* la Justice. La Tolérance, *plus* la volonté. La Démocratie, dirons-nous, c'est ce qui reste d'une République quand on éteint les Lumières.'

4 'Redoublement du sujet, redoublement du complément, incapacité de prononcer juste une seule voyelle, prononciation de bout en bout pégreuse, inculte: voilà entre quelles mains, entre quelles lèvres, est le sort de la culture en France. Voilà les «intellectuels» qui nous sauveront.'

5 'Le rayonnement de la culture française.'

6 'Elle mange des lettres; il finit pas ses mots.'

7 'Ce qu'il faut reconnaître, c'est que les différences sur le plan géographique l'emportent pour le moment, dans nos régions, sur les différences sociales.'

8 He's a real Mister Fix-it. If you say to Gérard er 'I need' I dunno, 'I'll/d need such-and-such' – 'Don't worry. I'll come back up and bring you everything' (Coveney's translation).

9 'Comportant certaines variantes particulières qui … ne sont pas indispensables au fonctionnement.'

10 'Un lent ébranlement du privilège à la langue écrite.'

11 French higher-education establishment recruiting the administrative and technical élite through competitive examination.

Conclusion

Diana Holmes and David Looseley

The ambition of this study has been to explore the diversity of ways in which the popular has been conceptualised and materialised in France. Whereas domestic and external accounts of French culture have spontaneously identified it with élite culture, we have argued that any rigorous analysis of it must integrate and engage with majority cultural practices. The relationship between state, national institutions and cultural production takes very particular forms in France, closely enmeshed as this relationship has been with a specific political history, and with the exceptionally strong presence of linguistic and literary tradition as a prized element of national identity. Popular culture itself and the discourses that have constructed and fought over it have been vital elements in the process of making and re-making national, as well as social and personal, identities. We have attempted to show that, despite transnational migrations and globalisation, a national specificity remains a given in any fully located view of French culture: to universalise or to generalise on the basis of an anglophone model (as anglophone Cultural Studies has sometimes done) is to ignore the particular, the material and the ideological realities of difference. And yet we would also claim that analysis of the French case is productive for a broader discussion of the meanings of popular culture in industrial and post-industrial Western democracies. France represents a particularly revealing case-study that delineates with exceptional sharpness the contradictions, tensions and ideals that attach to the concept of popular culture.

At the heart of the book are the especially contentious, shifting meanings of the word 'popular' when applied to culture in the French context. Perhaps, as we suggested in the Introduction, 'belonging to the people' is the only definition bland enough for all parties to agree on, but both key words in this formulation are, of course, open to multiple interpretations. Who are 'the people'? And in what sense do particular forms of culture

'belong' to them? All of our chapters have in fact shown in differing ways that in France such questions are broadly but intensely political – most conspicuously, perhaps, in the cases of television and language – but also ideological, as with the complex semantics of *chanson*. In Republican France, built on the twin yet sometimes contradictory principles of republican democracy and state *dirigisme*, popular culture has at one level meant a culture *taken to* the working class, a democratisation of high or élite culture with the aim of creating a politically and civically desirable common culture to enrich the lives of all. Educational and cultural policies, and significant portions of political and intellectual opinion on both Right and Left, have consistently attempted to foster a generalised national culture characterised by intellectual and linguistic rigour, knowledge of a shared cultural history and aspiration to aesthetic excellence. The corollary of this 'ideology of the standard', as Armstrong calls it in the context of language, has been a marked disdain for much of the quotidian culture consumed *by* the people, designated in France, even today to an extent, as 'mass' culture but corresponding to the primary meaning of 'popular' in English. Popular culture in this sense means music, novels, films, television that audiences (another version of the 'people') find pleasurably entertaining, and so choose to consume in large numbers. We have seen that the dominant French evaluation of such cultural forms has been pejorative: from the mid-nineteenth century quarrel over the *roman feuilleton* to early twenty-first-century debates over reality TV and *banlieue* speech, 'mass' popular culture has been characterised on the whole, by politicians, religious leaders, intellectuals and 'legitimate' artists, as an exploitative culture foisted on the people by market forces and consumed by them largely due to their failure to know any better.

Popular culture, then, has meant highbrow culture disseminated to the people, or lowbrow culture sold to the people. A third meaning, discernible at particular moments in both state and oppositional discourses, has been that of a culture arising authentically *from* the people. Definitions of what constitutes the people's authentic voice are, of course, as ideologically determined as definitions of the popular itself. In the latter half of the nineteenth century, the new ruling class preferred to confer authentic popular status on folk music, safely rooted in a rural past, than on the more irreverent, potentially oppositional tones of the urban *chanson*. Left-wing populist movements, particularly in the 1930s, sought to define novels set among the working class, in some cases written by proletarian authors, as authentically popular texts produced in some rather loose sense by a collective voice. In terms of consumption, however, the populist novel

never came close to challenging the mass appeal of more commercial, less committed forms of fiction. For a time, the Leftists of 1968 dreamed that, once liberated from the shackles of capitalist mystification, a truly popular culture would emerge, with revolutionary potential. But neither the popular reception of experimental, iconoclastic art nor the reality of popular taste in the 1970s and 1980s lent much support to this view.

Nonetheless, the ideal of a national popular culture that would support and legitimate the spontaneous voices and tastes of the majority has not gone away. Indeed, it has re-emerged, for example with Jack Lang's recognition of lowbrow forms and practices, or with some of the more imaginative TV programming such as the highly successful series *Plus belle la vie* (A Better Life). Attempts to broaden the very concept of culture have been more effective in the visual and musical spheres than in the literary, perhaps because of that sense of a uniquely serious and splendid literary tradition that is so central to French national identity. Even here, though, the gradual incorporation of French-language writers from beyond metropolitan France into definitions of French literature, and the call to acknowledge and respect most readers' desire for the pleasures of a good story – both of these most clearly articulated by the *Littérature-monde* movement – pursue the ideal of an inclusive and 'bottom-up' definition of popular culture.

As we have examined definitions of 'popular culture' within the fields of politics, music, literature, cinema, television and language, have we in fact arrived at a working model of what these two words ultimately mean? A de facto definition has necessarily underpinned the selection of a corpus in five of the six chapters: this has been largely quantitative for, imperfect as the evidence often is, the best clues we have as to what most people like in cultural terms are to be found in sales or audience figures or, in the field of language, in quantitative empirical research carried out by linguisticians. But our book does not merely observe what constitutes majority cultural taste in France: it also invites conclusions as to the enduring characteristics of the popular. Popular culture is made up of practices, texts and artefacts that articulate shared meanings, collective senses of what matters, of what is most feared or pleasurable. More than 'high' culture, it deploys repetition, the use of familiar forms, techniques, devices, to facilitate consumption and provide some degree of guaranteed, tried and tested pleasure. If repeated techniques are to maintain their pleasure-giving power, however, they require endless variation on the original model. The popular draws at once on deep, slow-moving currents of the human imagination, and on the immediately topical:

many of the most successful song forms, films, novels, TV programmes combine an appeal to fundamental myths (romantic love; triumphant human solidarity; transcendence of mortality) with an evocation, idealised or otherwise, of the most situated and contingent of realities. Another vital conclusion that emerges from our analysis is that audiences do not so much 'receive' popular culture as interact with it in a complex process vital to the construction of both personal and social identities. By articulating and giving form to emotions, ideas, apprehensions of the self and of others, popular culture shapes, inflects, cathartically relieves or, conversely, strengthens social perceptions and (in Raymond Williams's famous phrase) structures of feeling. We conclude that consumers of popular culture are no more passive recipients of what they read, watch, listen to or (particularly in the case of language) reproduce than are the consumers of any other cultural form, but that they bring to the encounter their own polyvalent subjectivities, and engage with rather than merely absorb the stimulus of the text.[1]

As we have seen, this more positive model of popular culture is not one that has been widely accepted in France itself. Despite the increased porosity of national cultural borders, we have observed the obduracy of the French tendency, across the political spectrum (whereas in anglophone countries it is associated with a right-wing stance), to deplore a falling-away from the high cultural standards that did and should characterise the nation, and to lump together a diverse set of contemporary cultural practices plebiscited by the majority as simply debased. Yet it is also true that the twenty-first century has seen a growing convergence of high and low towards what we can term 'middlebrow' culture, widely consumed and enjoyed, displaying many attributes of the popular, yet legitimated to some extent by academic, intellectual and political authorities. This is particularly visible in, for example, the evolution of distinctively French conceptualisations of *la chanson française* or crime fiction, or in the reworkings of romance by 'literary' women authors, and perhaps in Gadet's suggestion (Chapter 6, p. 222) of 'a gradual undermining of the prestige of the written language'. And even in television, that mass entertainment par excellence, we can locate accommodations, or at least negotiations, between highbrow and lowbrow in particular programmes and, most notably perhaps, in the existence of an entire channel describing itself as 'cultural', the Franco-German ARTE.

A dedicated Bourdieusian might certainly challenge any resolutely positive take on this evolution, seeing it as no more than the assimilation (with all the postcolonial negativity that word implies) of once opposi-

tional popular forms into a safe canon of respectability, as with the art discourse that is now commonly brought to bear on *chanson* and crime fiction, not least by academics. But what we can conclude is that these signs of a new middlebrow need to be understood in the wider context of a seismic transformation of France's cultural identity at the deepest level. French culture, acutely self-aware and self-assured for centuries, now seems to be undergoing an inexorable shapeshift: from a culture of the word to a polyvalent culture of the visual, the sonic and the digital: it is a culture no longer characterised solely by institutional legitimation and magisterial transmission but, increasingly, by interactive cultural democracy.

A shapeshift of this kind has of course been occurring throughout Europe and the West generally. But we have attempted to demonstrate that in France particularly it has been experienced as an identity crisis so fundamental and disruptive that it is still being diagnosed decades after it began; and the prognosis remains uncertain. Perhaps, then, the distinctive evolution of a French middlebrow – what we called in the Introduction a 'high popular' – may ultimately be read as a kind of therapeutic compromise. At any event, given that interactive democracy remains an evolving, elusive and contested condition in twenty-first-century France, the study of popular culture needs to be central to any understanding of contemporary French society, and thus to French Studies as an ongoing academic project.

Note

1 The model of the active consumer holds true for language (Chapter 6) in the sense that the individual practitioner inflects and selects rather than simply reproducing language patterns.

Bibliography

Adonis, A. and Pollard, S. (1997) *A Class Act: the Myth of Britain's Classless Society*. London: Hamish Hamilton.

Ahearne, J. (ed.) (2002) *French Cultural Policy Debates: A Reader*. London and New York: Routledge.

Ahearne, J. (2010) *Intellectuals, Culture and Public Policy in France: Approaches from the Left*. Liverpool: Liverpool University Press.

Allain, M. and Souvestre, P. (1932) *Fantômas se venge!* Paris: Arthème Fayard. First published 1911.

Anderson, B. (1991) *Imagined Communities: Reflections on the Origins and Spread of Nationalism*. Revised/extended edn. London: Verso.

Anderson, L. (1954), 'Book Reviews: French Critical Writing', *Sight and Sound*, 24:2 (October–December): 105.

Armstrong, L. (1932) *The Phonetics of French*. London: Bell.

Armstrong, N. and Boughton, Z. (1998) 'Identification and evaluation responses to a French accent: some results and issues of methodology', *Revue PArole*, 5:6, 27–60.

Armstrong, N. and Smith, A. (2002) 'The influence of linguistic and social factors on the recent decline of French *ne*', *Journal of French Language Studies*, 12:1, 23–41.

Artaud, A. (1978) *Oeuvres complètes IV*. Paris: Gallimard.

Ashby, W. (1981) 'The loss of the negative particle *ne* in French: a syntactic change in progress', *Language*, 57, 674–87.

Ashby, W. (2001) 'Un nouveau regard sur la chute du *ne* en français parlé tourangeau: s'agit-il d'un changement en cours?', *Journal of French Language Studies*, 11:1, 1–23.

Attou, K. (2009) Interview published in *Culture Communication: Le Magazine du Ministère de la culture et de la communication*, March, pp. 16–17.

Austin, G. (2008) *Contemporary French Cinema*. Manchester: Manchester University Press.

Bakhtin, M. (1984) *The Art of Rabelais*. Bloomington, IN: Indiana University Press.

Ball, R. (2000) *Colloquial French Grammar*, Oxford: Blackwell.

Barker, C. (2000) *Cultural Studies: Theory and Practice*. London: Sage.

Barthes, R. (1973) *Le Plaisir du texte*. Paris: Seuil.

Barthes, R. (1978) *Leçon: leçon inaugurale de la chaire de sémiologie littéraire du Collège de France, prononcée le 7 janvier 1977*. Paris: Seuil.

Bassan, R. (1989) 'Trois néobaroques français: Beineix, Besson, Carax, de *Diva* au *Grand Bleu*'. *La Révue du Cinéma*, 449.

Bazin, A. (1969 [1958]) *Qu'est-ce que le cinéma? I. Ontologie et langage*. Paris: Editions du Cerf.

Becker, H. S. (2008 [1982]) *Art Worlds*. Berkeley: University of California Press. Updated and expanded 25th anniversary edn. First published 1982.

Bell, A. (1984) 'Language style as audience design', *Language in Society*, 13:2, 145–204.

Bell, D. (1999) *The Coming of Post-industrial Society: A Venture in Social Forecasting*, New York: Basic Books.

Bellos, D. (1999) *Jacques Tati: His Life and Art*. London: Harvill Press.

Benjamin, W. (1973) *Illuminations*. London: Fontana/Collins.

Bergson, H. (1940) *Le Rire: essai sur la signification du comique*. Paris: Presses Universitaires de France.

Bernstein, J. M. (ed.) (1991) *The Culture Industry*. London: Routledge.

Biltereyst, D. (2004) 'Reality television, troublesome pictures and panics: reappraising the public controversy around reality television in Europe', in S. Holmes and D. Jermyn (eds) *Understanding Reality Television*. London and New York: Routledge, pp. 91–109.

Bourdieu, P. (1983) 'Vous avez dit «populaire»?', *Actes de la Recherche en Sciences Sociales*, 43, 98–105.

Bourdieu, P. (1984) *Distinction: A Social Critique of the Judgement of Taste*. Transl. R. Nice. London: Routledge. *La Distinction: critique sociale du jugement* (1979). Paris: Minuit.

Bourdieu, P. (1991) *Language and Symbolic Power*. Cambridge: Polity Press. Originally published in this volume in English; translated subsequently into French (2001) as *Langage et pouvoir symbolique*. Paris: Seuil.

Bourdieu, P. (2000) *Pascalian Meditations*. Transl. R. Nice. Cambridge: Polity. *Méditations pascaliennes* (1997). Paris: Seuil.

Bourdieu, P. and Darbel, A. (1969) *L'Amour de l'art: les musées d'art européens et leur public*. Paris: Minuit (1st edn 1966). Transl. C. Beattie and N. Merriman (1990) *The Love of Art: European Art Museums and Their Public*. Cambridge: Polity, 1990.

Bourdieu, P. and Passeron, J.-C. (1964) *Les Héritiers: les étudiants et la culture*. Paris: Minuit. English edn (1979) *The Inheritors: French Students and Their Relation to Culture*. Transl. R. Nice. Chicago: University of Chicago Press.

Bourdieu, P. and Passeron, J.-C. (1970) *La Reproduction. Éléments pour une théorie du système d'enseignement*, Paris: Éditions de Minuit. Transl. R. Nice as *Reproduction in Education, Society and Culture* (1990). London: Sage.

Bourdon, J. (1994) *Haute Fidélité: Pouvoir et télévision, 1935–1994*. Paris: Seuil.

Bourdon, J. (1999) 'Albert Ollivier', in J.-N. Jeanneney (ed.), *L'Echo du siècle: dictionnaire historique de la radio et de la télévision en France*. Paris: Hachette/ Arte Editions/La Cinquième Edition, p. 319.

Bradby, D. and McCormick, J. (1978) *People's Theatre*. London: Croom Helm.

Breton, A. (1930) *Le Second Manifeste du surréalisme*. Paris: Editions Kra.

Breton, A. (1972) *Manifestoes of Surrealism*. English transl. R. Seaver and H. Lane. Ann Arbor, MI: University of Michigan Press.

Brown, R. and Gilman, A. (1960) 'The pronouns of power and solidarity', in T. A. Sebeock (ed.), *Style in Language*. Cambridge, MA: MIT Press, pp. 253–76.

Brown, P. and Levinson, S. (1987) *Politeness: Some Universals in Language Usage*. Cambridge, Cambridge University Press.

Calvet, L.-J. (1981) *Chanson et société*. Paris: Payot.

Cannadine, D. (1998) *Class in Britain*. London: Penguin.

Certeau, M. de (1974) *La Culture au pluriel*. New edn L. Giard. Paris: Seuil, 1993.

Certeau, M. de (1980) *L'Invention du quotidien*, Vol. 1: *Arts de faire*. Paris, Gallimard Folio.

Certeau, M. de (1989) 'Pratiques quotidiennes', in C. Grignon and J.-C. Passeron, *Le Savant et le populaire: misérabilisme et populisme en sociologie et en littérature*. Paris: Gallimard/Seuil; first published in full in G. Poujol and R. Labourie (eds) (1979), *Les Cultures populaires: permanences et émergences des cultures minoritaires, locales, ethniques, sociales et religieuses*. Toulouse: Privat, pp. 23–9.

Chaplin, T. (2007) *Turning on the Mind: French Philosophers on Television*. Chicago and London: University of Chicago Press.

Chartier, R. and Hébrard, J. 'Les Imaginaires de la lecture', in H.-J. Martin, R. Chartier and J.-P. Vivet (eds) (1986), *Histoire de l'édition française*, Vol. 4, *Le Livre concurrencé, 1900–1950*, Paris: Promodis, pp. 528–41.

Chomsky, N. (2003) *Chomsky on Democracy and Education*, ed. C. P. Otero. New York and London, Routledge.

Cordier, A. (2008) 'The Mediating of *Chanson*: French Identity and the Myth Brel-Brassens-Ferré', PhD thesis, University of Stirling.

Coulomb, D. and Varrod, D. (1987) *1968–1988: Histoires de chansons de Maxime Leforestier à Étienne Daho*. Paris: Balland.

Council of Europe (2008) 'White paper on intercultural dialogue'. Strasbourg: Council of Europe, June.

Coveney, A. (2001) *The Sounds of Contemporary French*, Exeter: Elm Bank.

Coveney, A. (2003) 'Le redoublement du sujet en français parlé: une approche variationniste', in A. B. Hansen and M.-B. Mosegaard Hansen (eds), *Structures linguistiques et interactionnelles dans le français parlé*. Copenhagen: Museum Tusculanum Press, pp. 111–43.

Coveney, A. (2005) 'Subject doubling in spoken French: a sociolinguistic approach', *The French Review*, 79:1, 96–111.

Coward, D. (2002), *A History of French Literature*. Oxford: Blackwell.

Crubellier, M. (1974) *Histoire culturelle de la France, XIXe–XXe siècle*. Paris: Armand Colin.

Cuche, D. (2004) *La Notion de culture dans les sciences sociales*, 3rd edn. Paris: La Découverte.

Culture Communication (2009), newsletter, Ministry of Culture and Communication, no. 171 (June).

Currie, G. (1995) *Image and Mind: Film, Philosophy, and Cognitive Science*. Cambridge: Cambridge University Press.

Dauncey, H. (ed.) (2003) *French Popular Culture: An Introduction*. London: Arnold.

Dauncey, H. and Cannon, S. (eds) (2003) *Popular Music in France from Chanson to Techno: Culture, Identity and Society*. Aldershot: Ashgate.

Davet, S. (2009) interviewed in *Culture Communication* (2009), newsletter, Ministry of Culture and Communication, no. 171 (June).

Davies, L. (2008) 'French fall for the cult of the soap', *The Observer*, 23 November.

Debray, R. (1992) *Contretemps: éloge des idéaux perdus*. Paris: Gallimard.

Dehée, Y. and Bosséno, C.-M. (eds) (2009) *Dictionnaire du cinéma populaire français*. Paris: Nouveau Monde Éditions.

Deméron, P. (1980), 'Guy des Cars l'aristopopulaire', *L'Express*, 29.03–4.04, 1980. See Nathan 1990: p. 204.

Des Cars, G. (1946) *L'Impure*. Paris, Flammarion.

Des Cars, G. (1959) *Les Filles de joie*. Paris, Flammarion.

Dillaz, S. (1973) *La Chanson française de contestation: de la Commune à mai 1968*. Paris: Seghers.

Dillaz, S. (2005) *Vivre et chanter en France*, Vol. 1: *1945–1980*. Paris: Fayard/Chorus.

Donnat, O. (1998) *Les Pratiques culturelles des Français: enquête 1997*, Paris, Ministère de la culture et de la communication.

Donnat, O. (2009) *Les Pratiques culturelles des Français à l'ère numérique: enquête 2008*. Paris: La Découverte/Ministère de la culture et de la communication.

Donnat, O. and Cogneau, D. (1990) *Les Pratiques culturelles des Français*. Paris: La Documentation française.

Dubois, V., Méon, J.-M. and Pierru, E. (2009) *Les Mondes de l'harmonie: enquête sur une pratique musicale amateur*. Paris: La Dispute.

Dumasy, L. (ed.) (1999) *La Querelle du roman-feuilleton littérature, presse et politique: un débat precurseur (1836–1848)*. Grenoble, Université Stendhal.

Dumazedier, J. and Hassenforder, J. (1962), 'Éléments pour une sociologie comparée de la production, de la diffusion et de l'utilisation du livre', *Bibliographie de la France*, 2ième partie, 5ième série, no. 24–7, 15 juin–6 juillet.

Duneton, C. (1998) *Histoire de la chanson française*, 2 vols: 1 *Des Origines à 1780*; 2 *De 1780 à 1860*. Paris: Seuil.

Durgnat, R. (1962), 'A Mirror for Marianne', *Films and Filming* (November): 48–55.

Dyer, R. (1998) *Stars*. London: British Film Institute.

Dyer, R. and Vincendeau, G. (eds) (1992) *Popular European Cinema*. London/New York: Routledge.

Eco, U. (1986) *La Guerre du faux*. Paris: Grasset.

Encrevé, P. (1988) *La Liaison avec et sans enchaînement*. Paris: Seuil.

Favre, M. (1999a) 'Les Dramatiques, les télé-films', in J.-N. Jeanneney (ed.) *L'Echo du siècle: dictionnaire historique de la radio et de la télévision en France*. Paris: Hachette/Arte Editions/La Cinquième Edition, pp. 408–11.

Favre, M. (1999b) 'Les feuilletons, les séries', in Jeanneney, pp. 411–14.

Finch, A. (2010) *French Literature: A Cultural History*. Cambridge and Malden: Polity Press.

Finkielkraut, A (1987) *La Défaite de la pensée*. Paris: Gallimard. Transl. D. O'Keefe (1988), *The Undoing of Thought*, London and Lexington: Claridge Press.

Fléouter, C. (1988) *Un Siècle de chansons*. Paris: Presses Universitaires de France.

Flower, J. (1983) *Literature and the Left in France. Society, Politics and the Novel since the Late Nineteenth Century*. London and Basingstoke: Macmillan.

Forbes, J. and Kelly, M. (1995) *French Cultural Studies: An Introduction*. Oxford: Oxford University Press.

Freud, S. (1960) *Jokes and Their Relation to the Unconscious*. Transl. J. Strachey. New York and London: W. W. Norton & Company.

Freud, S. (1966–74) *Beyond the Pleasure Principle*, in *The Standard Edition of the Complete Psychological Works of Sigmund Freud*, Transl. and ed. J. Strachey. Vol. 18, London, Hogarth Press and the Institute of Psycho-analysis.

Friedan, B. (1965) *The Feminine Mystique*, London: Penguin. First published 1963.

Frith, S. (1998) *Performing Rites: Evaluating Popular Music*. Oxford and New York: Oxford University Press.

Frith, S. (2006 [1988]) 'The industrialization of music', in A. Bennett, B. Shank and J. Toynbee (eds) (2006) *The Popular Music Studies Reader*. London and New York: Routledge, pp. 231–8. First published 1988.

Frith, S. (2006 [1991]) 'The good, the bad, and the indifferent: defending popular culture from the populists', in J. Storey (ed.) (2006) *Cultural Theory and Popular Culture: A Reader*, 3rd edn. Harlow: Pearson Education. Frith first published 1991.

Frodon, J.-M. (1995) *L'Age moderne du cinéma français*. Paris: Flammarion.

Fumaroli, M. (1991) *L'État culturel: essai sur une religion moderne*. Paris: Fayard.

Gadet, F. (1989) *Le Français ordinaire*. Paris, Armand Colin.

Gadet, F. (2007) 'Identités françaises différentielles et linguistique de contact', in W. Ayres-Bennett and M. Jones (eds), *The French Language and Questions of Identity*, London, Legenda, pp. 206–16.

Gaffney, J. and Holmes D. (eds) (2007) *Stardom in Postwar France*. New York and Oxford: Berghahn.

Gilroy, P. (2006[1987]) 'Get up, get into it and get involved" – soul, civil rights and black power', in J. Storey (ed.) (2006) *Cultural Theory and Popular Culture: A Reader*, 3rd edn. Harlow: Pearson Education. Gilroy first published 1987.

Girard, A. (1978) 'Industries culturelles'. *Futuribles*, no. 17, 597–605.

Girard, A. (1982) 'Pratiques et politiques'. *Le Monde*, 8 December 1982, p. 13.

Glasson-Deschaumes, G. (2008) 'Négocier les differences: les pièges de dialogue interculturel', *Culture et recherche*, no. 114–15, Winter 2007/08, 19.

Gordon, R. B. (2001) *Why the French Love Jerry Lewis: From Cabaret to Early Cinema*. Stanford: Stanford University Press.

Gordon, T. (2004) 'A "Saxophone in movement": Josephine Baker and the music of dance', in J. Dutton and C. Nettelbeck (eds), 'Jazz adventures in French culture', special issue of *Nottingham French Studies*, 43:1 (Spring), 39–52.

Grignon, C. and Passeron, J.-C. (1989) *Le Savant et le populaire: misérabilisme et populisme en sociologie et en littérature*. Paris: Gallimard/Seuil.

Guardian (2009), 16 June.

Guibert, G. (2006) *La Production de la culture. Le cas des musiques amplifiées: genèse, structurations, industries, alternatives*. Nantes: Mélanie Séteun.

Hawkins, P. (2000) *Chanson: The French Singer-Songwriter from Aristide Bruant to the Present Day*. Aldershot: Ashgate.

Hayward, S. (1993) *French National Cinema*. London/New York: Routledge.

Hebdige, D. (1979) *Subculture: The Meaning of Style*. London and New York: Methuen.

Hennion, A. (2001) 'Music lovers: taste as performance', *Theory, Culture and Society*, 18 (October), 1–22.

Hesmondhalgh, D. (2006) 'Bourdieu, cultural production and the cultural industries", *Media, Culture & Society*, 28:2, 211–31.

Hewitt, N. (1999) 'Introduction: Popular and mass culture', *Contemporary European History*, 8:3, 351–8.

Hildesley, C. (1958/59) 'Cross channel', *Sight and Sound*, 28:1, Winter, 41–3.

Horn, P. L. (ed.) (1991) *Handbook of French Popular Culture*. New York: Greenwood Press.

Houston, P. (1963), 'The Front Page', *Sight and Sound*, 32:2 (Spring): 55.

Huston, N. (2006) *Professeurs de désespoir*. Paris: Actes Sud.

Huston, N. (2008) *L'Espèce fabulatrice*. Paris: Actes Sud.

Jameson, F. (1991) *Postmodernism; or The Cultural Logic of Late Capitalism*. London/New York: Verso.

Jeanneney, J.-N. (1999) 'Charles de Gaulle', in Jeanneney, J.-N. (ed.), *L'Echo du siècle: dictionnaire historique de la radio et de la télévision en France*. Paris: Hachette/Arte Editions/La Cinquième Edition,), pp. 377–80.

Jeanneney, J.-N. (1999) 'Jean d'Arcy', in J.-N. Jeanneney (ed.) *L'Echo du siècle: dictionnaire historique de la radio et de la télévision en France*. Paris: Hachette/Arte Editions/La Cinquième Edition, pp. 283–4.

Jeanneney, J.-N. (ed.) (1999) *L'Echo du siècle: dictionnaire historique de la radio et de la télévision en France*. Paris: Hachette/Arte Editions/La Cinquième Edition.

Jost, F. (2002) 'La télévision de jeux de rôles: généalogie et succès de *Loft Story*', *French Cultural Studies*, 13:39, October, 337–59.

Kermode, F. (1967) *The Sense of an Ending*. London: Oxford University Press.

Kermode, F. (1975) *The Classic: Literary Images Of Permanence And Change*. London: Faber.

Kidd, W. and Reynolds, S. (eds) (2000) *Contemporary French Cultural Studies*. London: Arnold.

Kuhn, R. (1995) *The Media in France*. London and New York: Routledge.

Kuiper, L. (1999) 'Variation and the norm: Parisian perceptions of regional French', in D. Preston (ed.), *Handbook of Perceptual Dialectology*, 1, Amsterdam: Benjamins, pp. 243–62.

Kuisel, R. F. (1996) *Seducing the French: The Dilemma of Americanization*. Berkeley, Los Angeles and London: University of California Press.

Kyrou, A. (1963) *Le Surréalisme au cinéma*. Paris: Le Terrain Vague.

Labov, W. (2001) *Principles of Linguistic Change: Social Factors*. Oxford: Blackwell.

Lançon, P. (2004) 'Ensemble c'est tout', *Libération* (15 April).

Le Monde (2001), 11 May.

Le Monde (2002), 14 December, *Télévision* supplement, pp. 4–5.

Le Page, R. (1989) 'What is a language?', *York Papers in Linguistics*, 13, 9–24.

Lebrun, B. (2009) *Protest Music in France: Production, Identity and Audiences*. Farnham: Ashgate.

Lecomte, M. (1999) 'La Mission culturelle de la télévision française', *French Cultural Studies*, 10:39, 39–50.

Leroy, G. and Bertrand-Sabiani, J. (1998), *La Vie littéraire à la Belle Epoque*. Paris: Presses Universitaires de France.

Lesueur, D. (1907) *Calvaire de femme*, Vol. 1: *Fils de l'amant*. Paris: Alphonse Lemerre.

Lévy, M.-F. (1995) 'Famille et télévision: 1950–1986', *Réseaux*, July/October, nos 72–3, 177–93.

Lévy, M.-F. (1999) 'Les Télé-clubs', in J.-N. Jeanneney (ed.), *L'Echo du siècle: dictionnaire historique de la radio et de la télévision en France*. Paris: Hachette/Arte Editions/La Cinquième Edition, pp. 525–7.

Lipovetsky, G. (1983) *L'Ere du vide: essais sur l'individualisme contemporain*. Paris: Gallimard (Folio).

London, J. (1903) *The People of the Abyss*. London and New York: Macmillan.

Looseley, D. L. (1995) *The Politics of Fun: Cultural Policy and Debate in Contemporary France*. Oxford and New York: Berg. Reprinted in paperback 1997.

Looseley, D. L. (2003) *Popular Music in Contemporary France: Authenticity, Politics, Debate*. Oxford and New York: Berg.

Looseley, D. L. (2005) 'The return of the social: thinking postcolonially about French cultural policy', *International Journal of Cultural Policy*, 11:2, 145–55.

Looseley, D. L. (2007a) 'Intellectuals and cultural policy in France: Antoine Hennion and the sociology of music', in J. Ahearne and O. Bennett (eds), *Intellectuals and Cultural Policy*, London and New York: Routledge, pp. 227–40.

Looseley, D. L. (2007b) 'Conceptualising youth culture in postwar France', *Modern and Contemporary France*, 15:3, 261–75.

Looseley, D. L. (2010) 'Making history: French popular music and the notion of the popular', in B. Lebrun and J. Lovecy (eds), *Une et indivisible? Plural Identities in Modern France*. Oxford: Peter Lang.

Looseley, D. L. (2011) 'Notions of popular culture in cultural policy: a comparative history of France and Britain', in D. L. Looseley (ed.), 'Policy and the popular', special issue of *International Journal of Cultural Policy* 1:4, 365–79.

Low, J. (2006) '/o/-Fronting in Roanne French'. MA Dissertation, University of Leeds.

Maffesoli, M. (1988) *Le Temps des tribus*. Paris: Klincksieck.

'Manifeste pour une littérature-monde en français'(2007), Forty-four signatories, *Le Monde*, 19 March.

Mannoni, L. (2000) *The Great Art of Light and Shadow: Archaeology of the Cinema*. Exeter: University of Exeter Press.

Margueritte, V. (1922) *La Garçonne*. Paris: Flammarion.

Martinet, A. (1969) 'C'est jeuli, le Mareuc!', in A. Martinet, *Le français sans fard*. Paris: Presses Universitaires de France, pp. 345–55.

Mast, G. (1979) *The Comic Mind: Comedy and the Movies*. Chicago: University of Chicago Press.

Mattelart, A. and Neveu, E. (2003) *Introduction aux Cultural Studies*. Paris: La Découverte.

Mayol, P. (1997) *Les Enfants de la liberté: études sur l'autonomie sociale et culturelle des jeunes en France 1970–1996*. Paris: L'Harmattan.

Mayol, P. (1998) *Développement culturel*, issue entitled 'Les Publics des concerts de musiques amplifiées', no. 122, June. Mayol is the unacknowledged author of this issue.

Mazdon, L. (1999a) 'The television talkshow in France: constructing audiences, constructing identities', *French Cultural Studies*, 10:1, February, 51–65.

Mazdon, L. (1999b) 'French televised debate and the public service ethos', *Modern and Contemporary France*, 7:3, August, 329–38.

Mazdon, L. (ed.) (2001a) *France on Film: Reflections on Popular French Cinema*. London: Wallflower Press.

Mazdon, L. (2001b) 'Contemporary French television, the nation and the family: continuity and change', in *Television and New Media*, 2:4, November, 335–49.

Mehl, D. (1992) *La Fenêtre et le miroir: la télévision et ses programmes*. Paris: Payot.

Mehl, D. (1996) *La Télévision de l'intimité*. Paris: Seuil.

Meillet, A. (1921) *Linguistique Historique et linguistique générale*. Paris: Champion.

Merton, R. K. (1968) *Social Theory and Social Structure*. Glencoe, IL: Free Press.

Michel, H. (1995) *Les Grandes Dates de la télé française*. Paris: PUF.

Middleton, R. (2003) 'Music, modernization and popular identity', in H. Dauncey and S. Cannon, *Popular Music in France from Chanson to Techno: Culture, Identity and Society*, Aldershot: Ashgate.

Migozzi, J. (2005) *Boulevards du populaire*. Limoges: PULIM.

Mills, C. W. (1956) *The Power Elite*. New York: Oxford University Press.

Milroy, J. and Milroy, L. (1991) *Authority in Language*. London: Routledge.

Mitry, J. (1965) *Esthétique et psychologie du cinéma*, Vol. 2. Paris: Éditions Universitaires.

Mollier, J.-Y. (2002) 'Le Parfum de la Belle Époque', in J.-P. Rioux and J.-F. Sirinelli, *La Culture de masse en France: de la Belle Époque à aujourd'hui*. Paris: Fayard, pp. 72–115.

Mollier, J.-Y. (2005) *Histoires de lecture*. Bernay: Société d'histoire de la lecture.

Moretti, F. (1998) *Atlas of the European Novel 1800–1900*. London and New York: Verso.

Morin, E. (1963) 'Salut les copains'. *Le Monde*, 6 July, pp. 1 and 11; and 7–8 July, p. 12.

Morin, E. (1972 [1957]) *Les Stars*, first published 1957; 3rd (rev.) edn 1972, Paris: Seuil.

Morin, E. (2005) *The Stars*. Transl. R. Howard. Minneapolis/London: University of Minnesota Press.

Nathan, M. (1990) *Splendeurs et misères du roman populaire*. Lyon: Presses Universitaires de Lyon.

Naves, R. (ed.) (1956) Voltaire. *Lettres philosophiques*. Paris: Garnier.

Nora, P. (ed.) (1984–92) *Les Lieux de mémoire*. Paris: Gallimard.

Olivier-Martin, Y. (1980), *Histoire du roman populaire en France*. Paris: Albin Michel.

Pasquier, D. (2005), 'La "culture populaire" à l'épreuve des débats sociologiques', *Hermès*, 60–9.

Paulus, T. and King, R. (eds) (2010) *Slapstick Comedy*. London/New York: Routledge.

Perkin, H. (2002) *The Rise of Professional Society: England since 1880*. London: Routledge.

Peterson, R. (1990) 'Why 1955? Explaining the advent of rock music', *Popular Music*, 9:1, January, 97–116.

Platten, D. (2004) 'Utopia and the Roman Noir: The case of Daniel Pennac', in A. Kershaw (ed.), *Impossible Space: Explorations of Utopia in French Writing*. Glasgow: Strathclyde University School of Modern Languages, pp. 206–36.

Portis, L. (2004) *French Frenzies: A Social History of Pop Music in France*. College Station: Virtualbookworm Publishing.

Poujol, G. and Labourie, R. (eds) (1979) *Les Cultures populaires: permanences et émergences des cultures minoritaires, locales, ethniques, sociales et religieuses*. Toulouse: Privat.

Powell, A. (1966) *The Soldier's Art*. London: Fontana.

Prendergast, C. (1986) *The Order of Mimesis: Balzac, Stendhal, Nerval, Flaubert*. Cambridge: Cambridge University Press.

Reader, K. (2003) 'Flaubert's sparrow, or the Bovary of Belleville: Édith Piaf as cultural icon', in H. Dauncey and S. Cannon, *Popular Music in France from Chanson to Techno: Culture, Identity and Society*, Aldershot: Ashgate, pp. 205–33.

Regev, M. (2007) 'Ethno-national pop-rock music: aesthetic cosmopolitanism made from within', *Cultural Sociology*, 1:3: 317–41.

Ricoeur, P. (1991) 'Life in quest of narrative', in D. Wood (ed.), *On Paul Ricoeur: Narrative and Interpretation*. London: Routledge, pp. 20–33.

Rigby, B. (1991) *Popular Culture in Modern France: A Study of Cultural Discourse*. London and New York: Routledge.

Rigby, B. (1994) '*Popular Culture' in France and England: The French Translation of Richard Hoggart's* The Uses of Literacy. Hull: University of Hull Press.

Rioux, J.-P. and Sirinelli, J.-F. (2002) *La Culture de masse en France: de la Belle Époque à aujourd'hui*. Paris: Fayard.

Robbe-Grillet, A. (1963) *Pour un nouveau roman*. Paris: Éditions de Minuit.

Rosello, M. (2003) 'Tactical universalism and new multiculturalist claims in postcolonial France', in C. Forsdick and D. Murphy (eds), *Francophone Postcolonial Studies: A Critical Introduction*. London: Arnold, pp. 135–44.

Rosen, P. (ed.) (1986) *Narrative, Apparatus, Ideology*. New York: Columbia University Press.

Ryan, M.-L. (2001), *Narrative as Virtual Reality: Immersion and Interactivity in Literature and Electronic Media*. Baltimore and London: The Johns Hopkins University Press.

Sabatier, B. (2007) *Nous sommes jeunes, nous sommes fiers: la culture jeune d'Elvis à MySpace*, Paris: Hachette Littératures.

Salgues, Y. (1957) *James Dean ou le mal de vivre*. Paris: Pierre Horay.

Sartre, J.-P. (1964) *Les Mots*. Paris: Gallimard.

Seabrook, J. (2000) *Nobrow: The Culture of Marketing, the Marketing of Culture*. London: Methuen.

Shiach, M. (1989) *Discourse on Popular Culture: Class, Gender and History in Cultural Analysis, 1730 to the Present*. Cambridge: Polity.

Simenon, G. (1988) *L'Age du roman*. Brussels: Éditions Complexe.

Sirinelli, J.-F. (2003) *Les Baby-Boomers: une génération 1945–1969*. Paris: Fayard.

Smith, A. (1996) 'A diachronic study of French variable liaison'. MLitt. dissertation, Newcastle University.

Snickars, P. and Vonderau, P. (eds) *The YouTube Reader*. Stockholm: National Library of Sweden.

Souvestre, P. and Allain, M. (1932) *Fantômas se venge*. Paris: Fayard.

Stiegler, B. (2009) 'The carnival of the new screen: from hegemony to isonomy', in P. Snickars and P. Vonderau (eds), *The YouTube Reader*. Stockholm: National Library of Sweden, pp. 40–59.

Storey, J. (ed.) (1998) *Cultural Theory and Popular Culture: A Reader*, 2nd edn. London: Prentice Hall.

Storey, J (2003) *Inventing Popular Culture*. Oxford: Blackwell.

Storey, J. (ed.) (2006) *Cultural Theory and Popular Culture: A Reader*, 3rd edn. Harlow: Pearson Education.

Street, J. (1997) *Politics and Popular Culture*. Cambridge: Polity.

Sturtevant, E. H. (1947) *An Introduction to Linguistic Science*. New Haven: Yale University Press.

Tanner, A. (1958) 'L'impossible cinéma anglais', *Cahiers du cinéma*, November, 30–8.

Temple, M. and Witt, M. (eds) (2004) *The French Cinema Book*. London: British Film Institute.

Thody, P. (1995) *Le Franglais: Forbidden English, Forbidden American*. London: Athlone.

Tinker, C. (2005) *Georges Brassens and Jacques Brel: Personal and Social Narratives in Post-war Chanson*. Liverpool: Liverpool University Press.

Todd, C. (1994) *A Century of Bestsellers (1890–1990)*. London: Edwin Mellen.

Todorov, T. (2007) *La Littérature en péril*. Paris: Flammarion.

Trudgill, P. (1990) *The Dialects of England*. Oxford: Blackwell.

Trudgill, P. (1992) 'Editor's Preface', in J. Milroy, *Linguistic Variation and Change*. Oxford: Blackwell, pp. vi–vii.

Trudgill, P. (1995) *Sociolinguistics*. London: Penguin.

Turner, G. (ed.) (2002) *The Film Cultures Reader*. London/New York: Routledge.

UNESCO (2005) 'Convention on the protection and promotion of the diversity of cultural expressions'. Paris, 20 October 2005.

Urfalino, P. (1996) *L'Invention de la politique culturelle*. Paris: Documentation Française.

Uricchio, W. (2009) 'The future of a medium once known as television', in P. Snickars and P. Vonderau (eds), *The YouTube Reader*. Stockholm: National Library of Sweden, pp. 24–39.

Valdman, A. (1976) *Introduction to French Phonology and Morphology*. Rowley: Newbury House.

Vanderschelden, I. and Waldron, D. (eds) (2007) *France at the Flicks: Trends in Contemporary French Popular Cinema*. Newcastle: Cambridge Scholars Publishing.

Vargas, F. (2006) *Dans les bois éternels*. Paris: Viviane Hamy.

Vargas, F. (2008) *This Night's Foul Work*. Transl. S. Reynolds. London: Harvill Secker.

Vernillat, F. and Charpentreau, J. (1977[1971]) *La Chanson française*, 2nd rev. edn. Que Sais-Je, Paris: Presses Universitaires de France. First published 1971.

Vilar, J. (1963) *De la tradition théâtrale*. Paris: Gallimard.

Walden, G. (2000) *New Elites: A Career in the Masses*, London: Allen Lane.

Walter, H. (1982) *Enquête phonologique et variétés régionales du français*. Paris: Presses Universitaires de France.

Warnier, J.-P. (1999) *La Mondialisation de la culture*. Paris: La Découverte.

Webb, J., Schirato, T. and Danaher, G. (2002) *Understanding Bourdieu*. London: Sage. Reprinted 2006.

Wheatcroft, G. (2005) *The Strange Death of Tory England*. London: Allen Lane.

Williams, L. (ed.) (1997) *Viewing Positions: Ways of Seeing Film*. New Brunswick, NJ: Rutgers University Press.

Williams, R. (1961) *Culture and Society 1780–1950*. Harmondsworth: Penguin. First published 1958.

Willis, P. (2000) 'Foreword', in C. Barker (2000) *Cultural Studies: Theory and Practice*. London: Sage, pp. ix–xxii.

Wyld, H. C. (1906) *The Historical Study Of The Mother Tongue: An Introduction To Philological Method*. London: John Murray.

Wyld, H. C. (ed.) (1936) *The Universal Dictionary of the English Language*. London: Joseph.

Internet sources

UNESCO (2005) 'Convention on the Protection and Promotion of the Diversity of Cultural Expressions'. Paris, 20 October 2005. http://portal.unesco.org/en/ev.php-URL_ID=31038&URL_DO=DO_TOPIC&URL_SECTION=201.html.

'L'édition: un secteur en mutation', 26 February 2008. http://www.ambafrance-cn.org/L-edition-un-secteur-en-mutation.html.

'L'Indépendance de la television en danger?', Nouvelobs.com, 2 July 2008. http://tempsreel.nouvelobs.com/actualites/20080626 (accessed 2 June 2009).

Attou, K. and DJ Zebra (2009) 'Michael Jackson Mix @ Francofolies 2009' http://www.youtube.com/watch?v=1-yRtNp8E8A.

'Un Appel de professionnels pour sauver la TV publique', Nouvelobs.com, 20 May 2009 http://tempsreel.nouvelobs.com/actualites/20080529 (accessed 2 June 2009).

'*Ensemble, c'est tout* d'Anna Gavalda', Avis des lecteurs', Evene-fr, no date. www.evene.fr/livres/livre.anna-gavalda-ensemble-c-est-tout-10582.php.

Index